FAIR GAME

A Young Girl's Odyssey Through the Not-So-Fabulous Fifties

T3-BEA-299

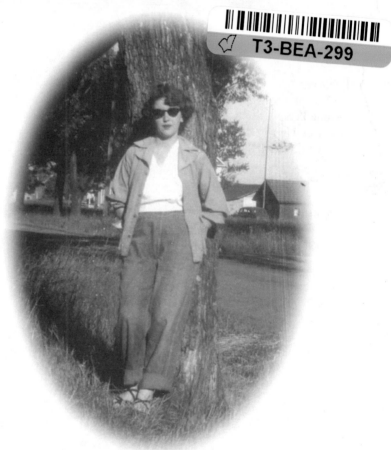

Savage

PRESS

Box 115, Superior, WI 54880 (715) 394-9513

Published by:

Savage Press
P.O. Box 115
Superior, WI 54880

715-394-9513

e-mail:savpress@spacestar.net

visit us at: www.savpress.com

Printed in the U.S.A.

FAIR GAME

A Young Girl's Odyssey Through the Not-So-Fabulous Fifties

by Frances Ethel Oliphant Gabino

Dedicated to the Social Outcasts: Creeps, Dropouts,[1] Rebels and Tramps of The Superior Central High School Class of 1953

[1]The enrollment for the Freshman Class of 1949-50, was 318. (Devil's Pi Vol. 28 #2 dtd 10/13/49). Four years later 255 students graduated. 63 students (20%) had dropped out. 39 of the graduating class maintained a 3.5 average for the four years. The author was ranked 135.5/255.

A writer who will not risk hurting someone's feelings is finally no more effective than a firefighter who will not smash a window.

–Scott Spenser

When she was good
she was very, very, good...

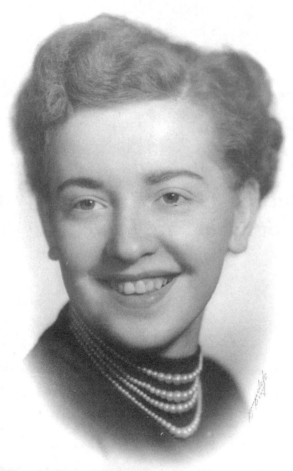

Frances Ethel Oliphant
"Let's have a talk, Feef."
College Entrance
Forensics - 4; Devil's Pi staff - 3;
Radio Comm. - 2; Twirlers - 1.

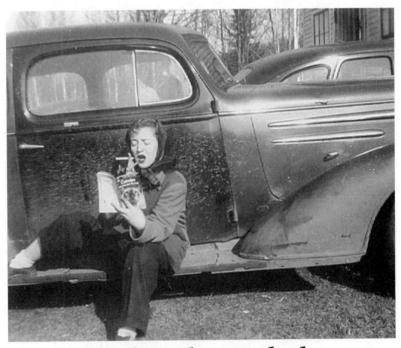

...when she was bad,
she was even better.

–Mae West

AUTHOR'S NOTES ───────────────

This book is the sequel to <u>Crocodile Tears and Lipstick Smears,</u> published in 1999. In that work I presented recollections of my childhood in WW II era Superior, Wisconsin. I introduced my extended family, friends and the social and economic forces that shaped all our lives.

<u>Fair Game</u> continues the story, chronicling experiences in 1950s Central High School, Superior, Wisconsin. You will be reintroduced to my family members and old friends and meet new friends and acquaintances. Except for my immediate family and myself, most, but not all names have been changed to protect the guilty, as well as the innocent. I neither apologize nor blame anyone for the inevitability of my fate. *Destiny has more resources than the most imaginative composer of fiction.* (F. Moore).

In the course of my research I lean heavily on my Central High yearbooks: the <u>Echoes</u> of 1950 through 1953; the <u>Devil's Pi</u>, our high school newspaper; and the Superior, Wisconsin and Duluth, Minnesota city directories. There I find a trace of the thread of my life – snippets of information on my activities written by fellow students or gleaned from the places I remember.

Hopefully memories will stir for others and they, like me, will get a better take on their own tumultuous, adolescent years.

Sex 101

She who is chaste was never asked the question.
—Congreve

The summer of 1949 was destined to be my last, as a virgin. It played itself out on a field of simmering sexual muddlement. It was the summer of my friendship with Bella Jones. I was fourteen. Bella was thirteen. Our friendship came about due to an adolescent altercation I had with my friend and nemesis, Doris Raleigh.

Doris had become annoyed with the attention I garnered after my ballet performance at a grade-school program. During afternoon recess she launched her attack. "You think you're so smart," she said. "You don't even know where babies come from." I blanched at her accusation.

How could she know? I blurted, "I do too! They come out of the mother's behind. Like kittens."

Doris and her clique hooted with laughter. Feeling as if I'd been pelted with rocks, I sprinted into Bryant Grade School. I vowed I'd never speak to my treacherous friend again. I drifted to a group of less daunting companions. Unintimidated, I found I could assert my own brand of dominance with them.

Bella was in that group. Petite and bold, she had been my sister Day's friend, until Day moved on to high school. We spent Sunday afternoons hiking three miles along Highway 35 to Greenwood Cemetery or the mile on 105, to Riverside Cemetery. There we kept our eyes peeled for signs of boys we knew in the cars that went by. Though few of our friends had vehicles, if they had stopped we would have been too wary to go for a joy ride. However, at the graveyards our brooding sexual curiosity was surfacing.

I was in the throes of unrequited love for my confirmation pastor. I was sure he would explain the facts of life in detail. All Reverend Ernst did was draw apples and talk about seeds. My mother once tried to explain the facts of life, but failed miserably. In the end, she said she'd

9

tell me when I was older. I decided to never ask her anything again. Instead, I gingerly broached the subject of sex with Bella.

Bella said, "I've seen horses do it. I think. At Monty Allen's riding stables." Her words sounded smart alecky to me. "And chickens must. That's how we get eggs."

"Yah, but horses don't lay eggs," I retorted. "Exactly what did they *do*?"

Bella replied in a matter-of-fact voice. "The male horse got on top of the female."

I was astounded by that information. "From the front or the back? Or did they lay down?"

Bella drew a deep breath. "From the back, you ninny. They couldn't very well lay down."

It irked me the way her rosebud lips curled into a little sneer when she thought she was right. "Well, people lay down when they do it," I snapped.

Bella sputtered, "How do you know that?" She rolled her hazel eyes like I was the dumbest person on earth. "Your mother doesn't even have a boyfriend!"

Anxious to put an end to her smarty-pants attitude, I said, "I've seen plenty of movies. The women and men always face each other when they kiss. I'm pretty sure that's how it starts."

Bella laughed. "Oh yah? You can't make babies with your lips. That much I know!"

"Just tell me about the horses, for Pete's sake."

Bella's words came out in a rush, "The male's thing went someplace inside the female."

I stared at her in disbelief, tried to equate the word with something...anything, in my limited resource of sexual lore. "*Thing*!?"

Bella raised her eyebrows and curled her lips. "Like your brother has. A thing."

"My brother!? I most certainly never saw him naked!"

"You baby-sit boys, don't you? You must have seen one." It was Bella's turn to be amazed.

Wrestling for control of the situation I shouted, "That dinky little weenie?! That's what they pee with. You're the ninny. You don't know any more than I do!"

* * * * *

One early Sunday evening, Bella stopped at our house on her way home. She was wearing a polka-dot, chiffon dress and white pumps.

Barely five-foot-two and petite, she was blossoming in the bosom area. Her angular face was made up in subdued pink rouge and lipstick. Thin black arches above her hazel eyes matched the hue of her short hair. Bella had the kind of beauty that always gave me an urge to check my own makeup. She looked very grown up.

My mother pulled the door wide and ushered my friend into the living room. "My, you look lovely, Bella. What's the occasion?"

Slightly disconcerted, Bella blushed. "I was at a baptism. At Cathedral."

Annoyed at being disrupted from reading the book <u>Anna Pavlova</u>, I slammed it shut. Ma shot me her familiar look of warning that silently said, "Be nice, now." That annoyed me. She knew full well our Sunday nights were reserved for peaceful pursuits –reading, listening to the radio, or singing along while Ma pounded out favorites on our old piano. My cheerful words camouflaged the agitated state I felt abruptly plunged into. "Hi, Bella. What's up?"

"Nothing. I just thought you'd like to take a walk." I knew immediately that she wanted to talk, probably had some news about boys or maybe even...sex.

Vaguely hopeful I'd get off the hook, I said, "I wanted to finish my book tonight."

Ma wouldn't hear of that. "Now Fran, you haven't been out all day. A walk will do you good." She liked Bella, trusted my friendship with her. She no doubt thought that I'd never get into any boy scrapes with a devout Catholic girl.

"Oh all right." I felt a stab of irritation that always rose when I thought I was being forced to do something.

I was sure I looked as disheveled as I felt in my brother's wrinkled flannel shirt and my own baggy overalls. My stretched-out bobby sox kept bunching under my feet. Every few yards I stopped to pull them up. Finally, I yanked them off and stuffed them in my overall pocket. We walked south on Oakes Avenue, turned on Central and headed west over the railroad tracks. I was anxious to learn what news Bella had. "So, what's so important you had to see me before you even changed clothes?"

Bella's voice was so low I barely heard her. "I got a ride home. *With a guy!*"

I stopped in my tracks. "*OhmyGod*; *OhmyGod*! What happened?!"

Bella nonchalantly replied, "Nothing, really. He did ask for my

phone number. I doubt if he'll call, though. He got a little nervous when I told him I was thirteen."

My breath caught at Bella's revelation. "BELLA! You should never tell them that! That's dumb. Especially when you look at least eighteen in that getup you're wearing." I felt her annoyance at my outburst, but pressed on. "I've told you. Guys are afraid of picking up girls like us. We're jail bait." That's what my brother called us. Though wearied by his constant labeling of me and my friends, I loved the sound of the term and its "danger ahead" connotation.

A car passed on the other side of the highway, its tail-pipe dragging, sparks spewing across the road. The guy inside stuck his head out the open window, "Hey!" he shouted. "You girls wanna joy ride?"

Annoyed at the interruption I shrieked, "Drop dead!" I looked at Bella. "You see. It's easy to get their attention."

We were approaching the turn off to Riverside Cemetery. Bella clutched my arm. "He's coming back!" Sure enough, I heard the sound of the rattling muffler. Its volume increased as the car's dim headlights, barely visible in the dusk, grew larger as it neared.

The car stopped alongside the road across from us. The guy stuck his head out the car window. "How'd you girls like to ride with me out to Oliver?" He sounded old and harmless. The car was in even worse shape than him. Rusted and noisy, it hardly fit the images I had of riding in a convertible, top down, my hair flowing around me like a wafting gossamer veil.

I looked at Bella. "How about it? Sounds like fun."

Bella sounded eager. "It'll be exciting. What the heck. We can always call someone from there if we have to."

That was the furthest possibility from my mind. For one thing, I didn't know anyone who had a car. For another, I wouldn't know where to find a telephone.

Bella and I crossed the highway, started around to the passenger side. The guy jumped out. "Over here, girls. That door doesn't work." An instinctive flutter of excitement from the danger of the situation coursed through me.

I stepped in front of Bella, walked over to the driver's side. Closer now, I noted he had on bib-overalls, with long-johns underneath. He smelled of cow manure and stale beer. "I'll get in first," I said.

"Jesus," he snorted. "How old are you two? You both look about twelve."

Bella snapped, "I'm sixteen for your information. I'm small boned for my age."

"What about your sister?"

"She's not my sister. She's my friend. And she's eighteen, like it's any of your business." Bella's snappish retorts seemed to amuse him.

"You're pretty feisty for your age," he said as he ushered Bella in beside me. "I like that." His eyes were fixed on Bella's behind. He shook his head as if waking from a dream. Reaching through the open back seat window, he pulled out two cans of beer. He sidled his long frame into the driver's seat, put one can on the floor, the other between his legs.

I felt Bella wriggle closer. Already up against the passenger door, I jabbed her in the ribs with my elbow. It was then I noticed there was no glass in the car window. The door itself was tied together with heavy wire. Before panic at the sight settled in me, the car lurched forward with a roar. In an attempt to calm myself, I leaned forward and flipped on the radio switch. Loud static blasted out.

"That doesn't work," our driver said. He turned it off. Snapping open a can of Schlitz, he asked, "Want a sip?" He passed the can toward me. I smelled its sharp odor, wrinkled my nose in distaste.

Bella accepted the can and took a long gulp. I decided it would be best if I, at least, kept my wits about me. I frantically tried to think of how I could relay my alarm to her. "Don't drink too much of that stuff," I said. "Your ma will smell it on your breath."

Bella laughed. "I can always chew gum." With that she took another gulp of beer.

I was sure she'd get drunk, worried that she'd soon be out of control. The thought of her drunkenness brought a twinge of disgust inside me. I decided to concentrate on my own survival. Guilt immediately descended. I recalled the Confirmation lessons I was learning from my heart-throb, Reverend Ernst. I offered up a little prayer, *Please God, keep us in your care, everyday and everywhere.*

As we barreled west on 105, my mind went topsy-turvy in panic. I figured Bella, being younger, expected me to take the lead in this adventure. I was beginning to doubt that I could live up to her expectations. I cautiously asked, "What's in Oliver?"

The man laughed. "Saloons, what else?" He snapped open his second can of Schlitz. "Maybe your friend would like a cigarette." He handed a pack of Camels across to me. His hand brushed Bella's modest bosom. She slapped it, with, what I thought was, not much

force. "Those are mighty sweet peaches," our driver said.

I took out a cigarette, lit it with a farmer's match from the box on the dashboard. My coughing jag brought gales of laughter from him and Bella. I was filled with anger at the thought of her collusion with the enemy. I threw the cigarette out the window. "I'm not used to Camels."

That made things worse. Our driver gleefully honked the car horn. Its bray echoed across the night. "Ha! You can't kid me, you've never smoked in your life."

"That's all you know," I snapped. "Besides, there's better things to do than smoke." Determined to change the subject, and maybe even get some information for later reference, I asked, "Do you live in Oliver?"

"Hell no, though you could call it my second home." His hog-like laugh was beginning to pall. "I live in Bennett." He caught himself. "I mean, near Bennett."

Filing that snippet of information, I plunged on. "What's your name?"

"Just call me Danny," he said.

Bella, swaying her head from side to side, began humming, *Danny Boy*. I remembered her rich alto voice was one of her attributes that prickled my jealousy. I jabbed her with my elbow. She shushed.

We were fast approaching the bright tavern lights of our destination. Rushing my words, I asked, "What do you do for a living?"

"For a little weasel you ask a lot of big questions. What about you two? What's your names? Mutt and Jeff?" Danny chortled at his stupid joke.

Before I could respond Bella said, "Bella and Fran." I was furious that she used our real names, poked her in the ribs. "Stop that," she complained and poked me back. I decided to clam up. Danny's arm was around her shoulder. She leaned toward him. I couldn't believe Bella was being so forward. Maybe she knew more about guys than she ever admitted. At least to me. I felt hurt and shut out. ◆

Crossroads

There's no road has not a star above it. –Emerson

In Oliver Danny zipped into a parking space in front of the Palace, a two story clay and brick structure. The tavern's flashing neon lights lit up the front seat. The door stood ajar, music and voices blared inside. "Come on," he said. "Let's go dancing."

Bella started sliding toward the driver's door.

I caught her arm. "We'd better not go in there. Someone might see us."

"What's the problem, kiddo?" Danny asked.

Bella slid back next to me. "We'll wait in the car." She sounded disappointed.

"The hell with you, then. I'll just grab a six-pack and be right out." Danny slammed the car door and sprinted up the tavern steps. I registered his straw-colored hair and elongated face before he disappeared into the tavern. *Maybe he's dangerous. Maybe I'll have to identify him.*

My words gushed from me, "Let's get out of here! We can go over to that restaurant and call someone." I'd noted the blinking lights of Mary's Place across the way.

Bella seemed surprised at my alarm. "Why? He's cute. Probably harmless, too."

"Oh yah, that's what you think. Men get goofy when they drink. You probably will too." There was an edge to my voice.

Bella snapped, "You're the one who wanted to get in the car in the first place."

"All I'm saying is that if he gets fresh I'm getting out of the car." I felt guilt at the prospect of abandoning her.

"Oh yah? How do you think you'll get home?"

"I'll walk."

That brought Bella's cloying laugh. "I can just see you hiking the five miles back to town." She shushed me as Danny loped back down the tavern steps, a six-pack under his arm.

He jumped into the car, backed out of the lot and turned south, away

from Superior. "Okay my little chickies, we're off!"

The car's dim headlights swept over the signpost that read Military Road. "Where we going!?" I spouted. "This isn't the way back to Superior!"

His laugh was sharp and brittle sounding. "Shut up and enjoy the ride."

Danny's car was about a quarter mile down the Military Road when he suddenly veered it onto a rutted driveway. We bounced along for a few seconds until he killed the engine and shut off the lights. We were engulfed in coal-black darkness. "I don't like this, Bella." My voice sounded shaky.

Bella didn't answer. I felt them grappling each other, tried to close my ears to the disgusting smacking noises of their kissing. It sounded like frogs plopping in a pond. Suddenly Bella whooped, "Don't do THAT!" She pulled away from him. Her body squeezed me against the passenger door.

Danny's voice sounded sinister. "Don't be shy. I've got something here you're gonna love."

Bella shrieked, "OH MY GOD! He's got his thing out!"

I shouted, "I'm getting out the window!" Somehow or other I crawled through the open space and ran, stumbling and falling, crashing to my knees, jumping up and running again. Finally, I tumbled into a ditch. Danny's car lights suddenly lit up.

Afraid he'd see me, I flattened my body against the wet, slimy ground. The lights swept in a circle as the car U-turned back to the main road. I lay sweating from exertion, felt dampness seep into my clothing. I had to get up. I listened to the silence of the night, heard a frog croak nearby, heard the calls of crickets. Then, something came crashing through the brush. I jumped up, ready to run for my life.

"Fran? Fran...are you here?" It was Bella, stage-whispering and sounding as if she were in tears.

I stumbled toward her voice, my outstretched hands meeting hers. "Oh my GOD! I thought he had you in his clutches! We've got to get out of here."

Bella griped, "My dress is all wet. My ma will kill me."

Though I couldn't see her face I sensed her panic. "Forget the damn dress!" I grabbed her by the wrist and pulled her forward to the Military Road.

Bella stopped. "My feet hurt," she said.

"Take those damn pumps off." I yanked her forward again.

"I can't. I'll ruin my nylons."

"Then take them off too!" I could not believe her stupidity. "What's more important? Your damn nylons or your ass?" I felt a twinge of shock at my own boldness. It worked though. Bella leaned against me, pulled off her shoes and nylons.

Without warning, headlights lit up the road behind us. I grabbed Bella's hand. Pulling her along, I vaulted across the ditch and crashed into the brush. "Lay down!"

We crumpled to the ground, lowered our heads until the car passed. "Geez, those cinders really hurt my feet." Bella sounded cranky.

"Never mind," I said. "It's not far to the highway. You can put your shoes on there." I tried not to sound snippy. All the time I was contemplating what our next move could be. Back on the road I asked, "Who do you know that we can call?"

"The only one I know besides my ma is my uncle. We can't call him, though."

"Well then, we'll have to hitchhike." The prospect did not appeal to me.

"But...that's dangerous." I knew what Bella meant. Maybe there were other scary men looking to pick up stupid girls like us.

"We'll wait until there's a car with women in it," I said, knowing that was highly unlikely. Meantime, for protection, I began picking up rocks from the side of the road and stuffing them in my pockets. We were nearing the bright lights of Oliver. I looked at Bella. She was a mess, her hair sticking out, dry leaves caught in the snarls. Her dress was loaded with wrinkles. The hem was torn and stained.

"Geez Fran, your jeans are all wet. And there's a rip on your shirt-sleeve."

Shit. My brother would have something to say about that. It was his favorite shirt. We stopped across the highway from The Palace. The parking lot was overflowing with cars. All of a sudden the tavern door flew open. A young woman came bounding down the steps. Her felt skirt billowed around her. I grabbed Bella's hand. We sprinted across the highway. As we neared, I noticed the woman was dabbing at her mascara coated eyelashes with a handkerchief. "What's wrong?" I asked. She flinched at the sight of us, like we were from outer space.

"Where did you come from?" She stopped blubbering, stuffed the hanky in the pocket of her white blouse. I noted her alabaster skin, highlighted by orange lipstick. Her black eyeliner was smeared around her eyes like thick circles defacing a political poster.

"Just down the road. Her boyfriend's car rolled over," I said, motion-

ing my head toward Bella. I was sure the woman didn't believe me, but pressed on. "We've got to get back to Superior. To find his dad." I could tell she'd already dismissed our problem and was reflecting on her own.

"Lot of good I am," she said, sniveling again. She pulled out her hanky and blew her nose. "My husband won't leave and I've got to work tomorrow."

"Maybe I could convince him." I sounded desperate.

"They won't let either one of you in. You're too young." She'd given us the once-over. I sensed she figured we were no threat. "I guess I could go back in. What should I tell him?" she asked, like she hadn't heard what I'd said.

Bella sputtered, "Tell him we're a couple whores who need a ride." She curled her lips then. "It's not like we're lunatics for Pete's sake!"

The woman drew a deep breath. "There's no need for sarcasm." Turning, she sprinted up the stairs. They both exited moments later.

The husband looked us up and down. "A rollover, aye? Boy, that must have been scary. Where's the boyfriend?"

I felt myself flush. "He stayed with the car."

"I'm Dick. This is Kathy." He had a nondescript face and didn't look at all tipsy. He gave us a little smile.

I smiled back. "At least we're okay. We have to get hold of her boyfriend's dad. Back in Superior." I didn't offer our names.

Dick and Kathy entwined their arms as they headed toward their car. Their obvious affection brought a pin-prick of envy inside me. Bella and I trailed behind them. Our saviors stopped alongside an old gray coupe. "It's a clunker, but it runs good. Still has the rumble seat. You two will have to ride there." Dick pulled down the contraption. Bella and I scrambled in. I was relieved at long last to be heading home.

The rushing wind, whipping Bella's hair around like a whirling dervish, made it difficult to hear each other's words. I shouted as loud as I could to her, "Don't ever, ever, EVER tell anyone about this!"

Bella shrieked, "Don't worry, I won't! And I'll never get in a car with a stranger either.

After we were safely standing at the intersection of Central and Oakes I dumped my rock collection. Guilty thoughts of our adventure descended. I vowed I'd try as hard as I could to be a good girl from that day forward and would never, never, *ever* think about sex again. ◆

The Games Begin

First fine careless rapture –Browning

I was pitched into the world of freshman high school without a clue. Bella was still in eighth grade at Bryant. None of my other closest grade school friends were in any of my classes, though we rode the city bus downtown daily. Once on that ride, the boys sniggered at the sight of old Monty Allen's horses copulating in the open fields between the Tri-State Fairgrounds and Twenty-eighth Street. *Bella was right*, I thought.

That Tower Avenue route ended at Broadway and Ogden, seven blocks past our stop at Belknap Street. I disembarked with the rest of the South End students and continued East on foot to Grand. If there was time, I rushed into Corky's and Harry's coffee shop[2] at the corner and smoked one cigarette.

I thought that after I emceed the opening day freshman get-acquainted meeting, I'd be riding high on the celebrity bandwagon. It was held in Central's small gymnasium for the purpose of explaining the procedure of electing officers.[3] Ma's old friend Selma Swanstrom was the co-chairman of that event. Both she and the chairman, Mr. Charles Aneda, had forgotten to assign a master of ceremonies. Miss Swanstrom approached me at the last minute, assuring, "If you're half as good as your mother at public speaking, you'll be great." I pulled off my starring role with self-assurance, feeling lovely in my sea-green, best dress and brand new, brown wedgies. My subdued makeup was accented by a permed, poodle-style hairdo. I welcomed the crowd of students without a hitch. My clearly enunciated words and strong booming voice oozed confidence.

As prescribed, I called for the nomination of a general chairman to explain the procedure for officer selection – each candidate was required to distribute petitions, with a minimum of twenty-five names needed to run. I was sure I would be selected for that simple-minded task. Much to my chagrin a boy – the tall, blond Adonis, Andy Anderson, took over. I good-heartedly relinquished the gavel, careful

to control the rage I felt boiling inside me. Worse, that devil-may-care, genial boy was eventually elected class president. It was the post I coveted with all my heart, though I never petitioned for it. I convinced myself that the election was all a sham. I would be the loser in the end and losing was unthinkable. I'd rather quit than lose.

My emcee performance would be lost in time to all but me. I blamed Miss Swanstrom for that setback. After the meeting, we freshmen exited the hall in a mass of riotous jabber. Snide remarks were heard from several quarters: "I heard Swanie's a real crab... That Swanie's a hoot... That old-maid's a B-itch!" The most ominous label was "Pinko." It came about due to Miss Swanstrom's strong support of the international language, Esperanto, and her travels to underdeveloped nations. The first semester with Miss Swanstrom in her Social Science class, Russia was the main topic of conversation. All the other freshmen Social Science classes were studying the history of Superior.

Her penchant for pop quizzes and unmarked maps drawn on the blackboard was especially hated by many of my peers. We were expected to identify every little country within Africa and the European continent. I loved the challenge – loved drawing maps. Miss Swanstrom wasn't at all adverse to smacking her ruler across the knuckles of the more raucous male class clowns either. I came to admire her spunkiness, as it brought to mind my Norse grandma, who had died the year before. Miss Swanstrom once said, "The teacher's union will be the strongest in the nation by the year 2000."

When I told Ma, she said, "Selma always was high on unions. And underdogs." And though Ma was a pillar of encouragement, "You can do anything, Fran." and "You're just as good as the rest of those kids." I wasn't sure where to start.

My alto voice sounded like a strident fog-horn, so freshman choir was out. I'd quit violin and cello, leaving orchestra participation closed, as well. My hopes for an "in" as a member of the American Legion, Leroy Doleysh Post Good Citizenship Club, had been dashed when Doris Raleigh won that prize spot. I knew I wasn't "perky" or short enough to be a cheerleader. I concentrated on my studies, determined to shine as a scholar. That lasted through the first semester, when, anxious to impress my confirmation pastor Reverend Ernst, I made the honor roll.[4] That fame was short-lived. In any case, it was nowhere near enough to gratify my unquenchable need for attention.

I did get on the twirling team. That came about due to my inside

track with head majorette Mary Jo Arthur. She and I were Mae Sterling dance students. We shared the spotlight each Thursday night at Braman's Studios in the Board of Trade Building on Belknap and Tower. In Mrs. Sterling's cavernous basement studio, I was the star in the ballet routines. I stood in front of our advanced class of budding ballerinas for the endless repetition of newly learned routines. Our long legged, dark haired, and willowy teacher always perched herself on a tall stool alongside the wall length mirrors. There she rapped out the dance rhythms on her ever-present drum sticks.

Mrs. Davis picked up the beat. She banged dramatic chords on the ivory-painted, spinet piano. The slightly humpbacked pianist wore long sateen dresses that rustled when she walked. Gobs of henna-colored hair were piled on the top of her overly large skull. Her face seemed forever bronzed due to the thick pancake makeup she wore. Full lips were painted in bright violet, her shaven eyebrows replaced by arched black pencil. Next to plain Mrs. Sterling, she resembled a peacock.

Mrs. Sterling wore ankle-length, full skirts and starched-white, long-sleeved blouses. She had shaven eyebrows, too. The thinly-penciled replacements were a pale charcoal hue. They emphasized her myopic eyes. Those dark orbs were magnified by thick, upper-rimmed glasses that Mrs. Sterling ceaselessly readjusted atop her Romanesque nose. She wore little makeup; a bit of pink rouge highlighted her prominent cheekbones. I loved the way she extended lipstick with the tip of her pinkie finger above her upper lip line, like two Alpine peaks.

"ONE-two-three plie', GRACE-fully now! Watch Frances! Keep the rhythm! FLOW-ing, GRACE-ful!" Sporadically Mrs. Sterling shouted, "STOP!" She would take one or two girls out of the lineup and assist them in a particularly difficult maneuver. Mrs. Davis, banging a chord, would nod her head in signal for me to continue.

After ballet, a few more girls arrived for tap dancing class. They congregated along the outer reaches of the dark studio expanse. Meanwhile, Mrs. Sterling, Mrs. Davis and I took a ten minute break. In a small room off the main studio we'd chat, sip coffee, and puff on pastel colored cigarettes from a gold colored box, with French writing on it. I was relieved that they never asked me anything about high school life. Our conversations centered on new dance routines and annual recitals. Sometimes I questioned Mrs. Sterling about her past, illustrious career. Prior to her marriage, she headlined area programs as Mae Toivonan, her maiden name.

I liked tap dancing, but knew my gift was ballet. I never minded tak-

ing my place in the row of girls behind Mary Jo. She shined at tap, so we seldom competed. I did experience a pang of envy when Mary Jo won the coveted solo in our *Varsity Drag* production. I felt vindicated later when I was appointed Mrs. Sterling's assistant. That brought with it my own starring role. I became teacher of the three to five-year-old toddler classes.

Ramrod-straight in body and mind, Mary Jo once commented, "You're a swell kid...and dancer." I valued her opinion, as few of my high school peers alluded to my dance talent. None attended our recitals or appearances at church socials or American Legion and Daughters of Norway programs.

Thanks to Mary Jo, my spot on the twirling team was destined to launch the "in" I so desperately coveted. I wasn't much good at the baton routines. One of the hard rubber balls on the end of my second-hand baton was loose. Sometimes if I got overly energetic the metal missile spun through the air and the ball flew off. Then that errant, jagged-edged baton became a lethal weapon whose target could not be predicted. I would abandon it for the safety of the gymnasium wall. My teammates scattered in opposite directions as the baton clattered to the hardwood floor. Luckily for me the baton routines weren't a prerequisite to being a squad member. What was required I had –good powerful legs and a strong enough constitution to withstand the cold winds that traversed the football field.

The 1949 Superior Central Vikings team sailed through a seven-game schedule, only losing the final contest to Hurley. By the sixth game on October fourteenth, at home, the entire school was hyped-up in anticipation of a season sweep. It was against our arch rivals, the Duluth Trojans. Our twenty-nine-member twirling team was, as always, on the job. It was a bone-chilling, cold and rainy night. I huddled together with the rest of the squad on a front bench waiting our turn. Shivering in my purple-wool, short-skirted uniform, my bare legs glowed red from the icy winds. My feet, freezing in white, unlined leather boots, were numb. And though I was sitting on my long winter coat like the rest of the twirlers, I didn't dare wrap it over me lest they think I was a weakling.

Like my teammates, my teeth chattered so badly it made conversation impossible. The only thing that kept us warm was the excitement of the match. We'd jump up with each yard of gained ground and join our voices in the, "Rah-rah, siss-boom-bah" shrieks of senior cheerleaders Arlene Belanger, Donna Pasell, Janet Jones, Marion Fudally, Marlene Stoich and Shirley Nelson. Those lively girls rhythmically wriggled

their hips and gave out cheers, the crowd attracted by their full, gored skirts with alternating purple and white stripes. Our school colors were carried out in their white blouses, stockings and shoes and in their purple vests and tights. With all my heart I envied, and at the same time, hated their pert and peppy performance. The sight cemented my resolve to escape the agonizing cold, and the heated spite that burned inside me, the first chance I got.

The football team was lead by everyone's heart-throb, left-half "Lum" Lundberg. Already spoken-for by freshman peer Jean Christopherson, full-back "Bud" Rich, scored in the second quarter. I missed the excitement, as my eyes were on right guard Ted Mercier, whom I adored. He was the only one of the football jocks who smiled and responded to my, "Hi!" when we passed in Central's hallways. He immediately replaced my confirmation minister on the top of the list as number one unattainable love.

The crowd was ecstatic by the time we twirlers strutted in formation at half-time.

The school band struck up, Onward Old Central. Mary Jo lead the parade, I brought up the rear. The rush of excitement from that first spurt of attention was fast palling for me. I reasoned that, like the roving spotlights, my short-lived fame would soon fade. So, why bother? Besides, the wind had shifted from the Northwest and the cold rain splattered my face. I was sure my black Mabeline mascara would soon be smeared all over my face.

The moment our group made our first turn back past our vacated bench, with horns blasting, confetti strewing the frigid air and pom-poms waving, I grabbed my coat and ran for the exit. I'd had enough of football to last a lifetime. ◆

2 - 1505 Grand Ave. Set on a triangle piece of land at Belknap, its front door faced Grand. Corky's & Harry's.
3 - 11/23/49 issue of the high school newspaper, Devil's Pi - front page report.
4 - ibid, front page.

Defense

Attack is the best defense. –Anonymous

Running north away from the stadium for the bus stop, I could hear the crowd's resounding voices fading in the distance behind me:

Central High, For dear Old Central High
For dear Old Purple and the White!
It makes no difference what you play
You are always in the right.
So, play the game, you must uphold your fame
You must let no one pass you by.
We will push, we will shove
For we're all deep in love
With OLD CENTRAL HIGH!

My pace quickened to a gallop. The East End bus for downtown was nearing the intersection. Just as I reached the stop light at the corner, it turned green. The bus shot ahead. *Damn!* I was about to scream and wave my arms at it, when a brown and beige 1950 Buick screeched to a halt in front of me. The door flew open. "Do you need a ride?"

Without a thought, I jumped in. "Thanks. I'm FREEZING!" I looked over at the driver. The bright streetlights on Belknap shined through the windshield onto his face. I felt my heart flutter. He was the spitting image of my current unattainable dream-boat, Ted Mercier. He had the exact same look of bewilderment that was SO dreamy, like when someone you love unexpectedly meets you on the street or in a crowded theater lobby. He had the self-same rosebud lips and cute, pudgy face.

"Where ya goin'?" he asked. His voice was soft and compliant sounding.

"To South End, if you're going that far." My voice trembled.

"You *are* freezing. I'll turn up the heat." He reached toward the dashboard and jacked up the heat. His hand brushed my bare knee, exposed when my coat had fallen open as I slid into the front seat. His

24

face reddened. "Sorry," he said.

I draped the coat over my knees. "That's okay." I felt my throat tighten. I coughed into the crumpled hanky I pulled from my coat pocket.

"You'll be getting a cold, I bet. I don't see how you could march in weather like this."

"Were you at the game?"

"I was sitting behind you."

A delicious excitement coursed through me as I realized he'd noticed me. "Really?"

"You're quite the marcher," he said.

I glanced at his face again. His cute lips were turned up at the edges. I immediately adored him and was dying to kiss him. "You're right about that. I about dropped dead. I'm glad the season's almost over."

"Will the twirlers be going to Hurley on the twenty-second?"

"I don't know and I don't care. I'm sure as heck not going." It suddenly dawned on me that my mother wouldn't be expecting me home until the game was over. "Could we listen to the game?" I asked.

"Sure." He turned the radio dial to WEBC. The game was well into the third quarter. The Trojans were threatening to score. "Sounds like the Vikings are having a time of it," he said. He turned the Buick south on Tower Avenue.

I decided to venture onto a different track with my shy companion. "I don't care. I only joined the Twirlers to meet guys." My laugh sounded hollow.

"You don't seem like that kind of girl."

Did I detect disappointment in his voice? "Well...I'm not shy, that's for sure." *Maybe I was wrong?* I changed my tactic. "I do a lot of dance recitals. Things like that."

"Really?" He sounded genuinely interested. "I don't know much about dancing"

"It's lots of fun. You should try it." I hadn't specified what kind of dancing I did. I decided to let him think it was ballroom dancing. I immediately imagined myself in his arms, swirling across a crowded dance floor to the strains of *The Blue Skirt Waltz.*

"What's your name?"

"Bud. Bud Winston," he said. "What's your's?"

"Fran Oliphant. I live at Sixtieth and Oakes." I was sure I'd given out too much information, but pressed on. "I've lived in South End all my life."

"Really? How old are you?"

I remembered to lie, knowing full well that if he knew I was only fourteen, he'd drop me like a hot potato. "I'm seventeen, going on eighteen. How old are you?"

"Twenty-four."

His revelation buoyed me. I could almost see my freshman girl-friend's mouths drop when I told them I'd been with an older guy. I just HAD to make this work. "Where do you hang out?" I asked, desperate for information.

"Around," he mumbled. I couldn't bear not knowing more.

We were passing the 58th Street Cafe. "Me and my friends hang out here a lot," I said. "It's a fun place sometimes."

"I've been in there. Where should I drop you?"

Oh no, I was LOSING him before anything began. "Could we just ride around for awhile? I don't have to be home until the game's over." I'd heard the announcer on WEBC talking about a third-quarter play. We had lots of time.

"Where would you like to go?"

"I don't know. Maybe out to Pattison Park?" The Buick sped ahead, past Sixty-fourth, out of Superior. We swept past Greenwood Cemetery. It began to drizzle again. The windshield wipers squeaked back and forth. My heart drummed to the rhythm.

"You're sure a quiet guy," I said.

"You think so? I guess I'm just kind of nervous. I haven't been around girls much, since I got out of the Navy."

"REALLY? That must have been exciting. I'd LOVE to see the world."

"It's not all that it's cracked up to be," Bud said. "I like Superior."

"I do too, but gee, traveling is so...well, you know, exciting." I racked my brain for something intelligent to say about the subject, then gave up. Time raced by. It seemed just seconds for the car to cover the twelve miles to Pattison Park. "Why don't we park for awhile? And talk some more," I suggested.

Bud pulled into a space between tall birch and elm trees that had lost most of their leaves. I felt a twinge of aggravation that it wasn't more secluded. "So," he said, "What d'ya want to talk about?"

"I don't know? Tell me about the Navy." I edged closer to him. He put his arm across the back of the seat. I leaned my head back, felt one of his fingers fiddling with the permed curls at the nape of my neck.

"There's not much to tell." He brushed his lips against the top of my

head. I thought I would faint from the tumultuous fluttering that rose and fell inside me. He smelled of Lava soap and fuel oil. Shifting his stocky frame, he unbuttoned his bulky plaid jacket. A vaporous warmth engulfed us. "Would you mind if I kissed you?"

I couldn't speak, nodded my head no. Our lips met. His felt soft and moist. I relaxed and let the sea that pitched inside swell over me. I was in heaven, sure I could hear the music that always accompanied love scenes that I'd seen in romantic movies. His lips moved to my face. He nuzzled my cheekbones, kissed my nose, my eyes. This was more than I'd ever imagined in my wildest daydreams. His lips moved to my ear, then down to my neck. I wriggled close against him, felt myself tremble. He stopped kissing me. "Don't stop," I said, unbuttoning my coat and letting it slide open.

"Are you sure?" he asked.

"I'm positive."

He hesitantly ran his fingers across my knee. I twitched with pleasure feeling the tingling sensation spread up to my throat. "You've got such soft skin," he whispered. His hand was on my thigh, his fingers cautiously moving closer and closer to my panties. "Do you mind?"

"Uh uh," I mumbled. When he reached the spot I'd been exploring on my own, I felt warm tears of joy well in my eyes.

He kissed me hard on the mouth then. I could hardly breathe. Without thinking I opened my mouth, felt his hot tongue exploring inside. I was drifting on waves of desire. He pulled his body away from mine. "We'd better get back. The game's over."

I hadn't even heard the radio. "Who won?"

"Central. Twenty to thirteen." He excused himself, mumbling, "Gotta water the lilies," and exited the car. Readjusting my coat around me, I suddenly felt drowsy from all the excitement of the evening. Turning the radio dial until I heard the dreamy voice of Russ Morgan, I looked out the window into the dark, fuzzy night. I pulled my glasses from my coat pocket and put them on. Bud was nowhere in sight. I lay down, my head under the steering wheel. Music drifted over me as I closed my eyes. *"Forever and ever, sweetheart please be true. Forever and ever I'll wait for you..."* I felt a blast of cold air and suddenly, Bud lowered himself right onto my face.

"Oh my God!" he hollered. He jumped back out of the car. "Did I hurt you?" His face was beet-red.

I'd sat up, yanked off my bent glasses and said. "I'm okay." I

wanted to tell him that he could never hurt me, but didn't.

Bud kissed me lightly then, and, with his arm around me, headed the car back to town. I snuggled close, gazing up at him like a purring kitten. His warmth surged through me. "Do you want my phone number?" I asked.

"I guess," he said, sounding hesitant. "What is it?"

"8140." I restrained myself from adding, you can call me any minute of any day.

"What's your's?"

"7496. But don't call. My mother gets upset." His words momentarily ruffled the bliss I was feeling. I let it pass. "Where should I drop you?" he asked.

"Sixtieth and Banks." I figured it would be best not to take any chances, in case Ma was watching for me. I could always say I'd been at my friend Lois'. Never mind that I never saw much of her anymore. Not since she began dating right-guard Oogie Sather.

Bud and I kissed briefly, more like pals than lovers. I exited his Buick and sprinted to my house. My body was burning, though it was icy cold outside.

I burst into the house. The exhilaration I felt quickly abated. The dark, first-floor rooms of our run-down, rented duplex always left me feeling somber and cold. Night time only increased the dimness of the cavernous three-room expanse. The dark, heavy furniture and old black-out shades added to its cheerless character. A dim glow from Grandma's ancient fringe-shaded floor lamp did little to brighten the space or my spirits. Ma was in Grandma's old rocking chair dozing. She was cocooned in a faded afghan. I bent down and kissed her. My sister Day and twin Howie, were nowhere in sight. "Where is everyone?" I asked.

Ma unwrapped herself from the afghan. "Who knows? Day never comes straight home from the game. I guess Howie's at the movies."

Oh shit. I could have stayed with Bud longer. It was then I noticed that Ma's eyes were red. She'd been crying. "What's wrong?" I asked.

"Nothing." She wiped her eyes with her sweater sleeve. I knew something must have happened. Ma never cried in front of us kids.

"Are you mad at ME?" I was afraid to look at her, sure she would read on my face the guilt that welled inside.

"It's Howard. He says he's going to quit school." Ma drew a deep breath, then quickly exhaled. It reminded me of Grandma Larsen. I

felt overcome with pity for my mother.

"He can't! He's too young." I'd not thought much about my twin since we'd started high school as I barely saw him there. It was as if our once close bond had been permanently severed. I'd assumed he had his own group of friends, like Day and me.

"He claims that everyone teases him," Ma said. I felt a twinge of pain realizing he was having a bad time of it. In truth I wouldn't have noticed anyway – or cared. "As it is he hates getting up, you know."

That was true. My twin never was an early riser. That's why he had given up his Duluth News-Tribune delivery route. "What'll you do?"

"I don't know." It was more of a plea than a statement. It reminded me that Ma had little control of us kids since Grandma died. Grandma had dominated our lives, taking full responsibility for our censure and restraint. Ever since her death Ma seemed to be at a loss as to what her role was – disciplinarian or friend. Sometimes I felt as if Ma expected me to solve her problems. My mother especially relied on me to keep the house in order, though I never had to cook. My duties involved organizing projects and helping her find things she'd misplaced. I was the one who answered the phone, in case it was a bill collector, or went to the door when someone banged there. I had become adept at making excuses and lying. In return she put all her trust in me. A flare of resentment surfaced at the thought of her dependence. I was tempted to tell her to stay home once in awhile, instead of running to all the meetings she attended.

To me, Ma was just keeping up appearances. She was acting like she lived in her good old days, when everything was perfect. She often spoke of those days, especially liked to emphasize that she and Grandma were more like sisters than mother and daughter. Still, I knew I could never say those spiteful things that hovered on the tip of my tongue. "Well, don't expect me to talk to him. He never listens to me." I desperately wanted to retreat upstairs. There I could recount the excitement of the evening and daydream myself to sleep.

"I know that," Ma said. "Maybe you could talk to the minister."

"No way! Howie won't even go to church. Besides, Reverend Ernst will be leaving next month."

"Oh." Ma seemed to shrivel from my words. She dabbed at her eyes with her handkerchief.

"Maybe you should talk to our dad," I suggested, though I knew it was stupid advice. He had abandoned the family when my twin and

I were two years old. We never saw or heard from him; our only connection was the sixty dollars a month he was required to pay for our survival.

"That's a laugh! He doesn't give two hoots in hell about us." I was totally taken aback by Ma's hostility, registered it as the first time she'd ever said anything antagonistic about our father. She pushed herself out of the chair. "Do you want some coffee?"

We went to the kitchen which was so dark, even in daylight we had to put the ceiling light, with it's forty-watt bulb, on. Though a large room, it seemed small due to the dingy gray walls and one window facing north. We kept the torn, opaque shade there pulled halfway down, so little light passed through. The back door was draped with blankets, its window broken long ago and never replaced.

Grandma's old, green-painted wood table filled most of the space. More often than not dirty dishes were stacked there as the enamel sink had no drain board. We only had three kitchen chairs, so when our family of four were gathered, one or another of us siblings would have to sit on a dark-green, wooden stool. That entailed removing a huge mother-in-law's tongue plant and setting it on the floor.

Next to the table was our two-burner gas stove. Ma filled the coffee pot with cold water and put it on the far burner, with its highest flame. Soon the coffee was percolating. With steaming cups of coffee in front of us, we slowly dunked sugar lumps into the hot brew, sucked the sweetness out until the sugar disintegrated in our fingers. It was a ritual Grandma had begun years earlier. Neither Ma nor I said so, but we severely missed not having her there to share it. The thought of Grandma gave me strength. "Should I check out Vocational School? Find out if he can go there before he's sixteen?"

"That would help," Ma said, a weak smile traversing her face.

Her apathy nettled me. *She's so helpless.* Guilt at the thought consumed me. I reached for her hand and squeezed it. "I love you Ma."

"I love you too," she said, putting her hand over mine. "We'd better get to bed, though. It's getting late."

In my upstairs sanctuary I quickly mouthed my evening prayer, "God bless Ma, Howie and Day. Please, please, please make things okay for us all." Drawing up an image of Bud's sweet lips, I drifted into sleep. ◆

Offense

*Stand in your own defense/or hide your heads like
cowards, and fly hence.* —Shakespeare

Howard started vocational school at the end of November. With
Reverend Ernst gone then as well, I realized neither of them
would see or hear of any of my transgressions. I was sure dark
forces resided in me. With those two males absent, the resistance to those
forces had been removed. The new love of my life, Bud Winston, hadn't
called either.

I pined for Bud, hungered for his touch. Saturday afternoons, I
recruited Bella to hike with me out to Greenwood Cemetery and back.
We took pictures of each other posing on the overpass railing outside
town. The two-toned Buick never appeared. When I found a picture of
his love-mobile in one of my twin's myriad auto magazines, I tore it out
and taped it to the wall above my mattress upstairs. We girls frequented
the 58th Street Cafe every day after school. Bud never appeared there
either. I would put money in the six-for-a-quarter mini jukebox above
the Formica table and play B12 –*Forever And Ever*– over and over. The
cook, dark eyed and mustachioed Nick, told me to stop playing it so
much. Bella and I, insulted, quit showing up after that.

I could not understand why Bud hadn't called. *Maybe I was too
pushy. Maybe I wasn't pushy enough. Maybe I shouldn't have let him
touch me so soon. Maybe I should have gone all the way. Maybe I wasn't
pretty enough for him. Maybe he's married.*

Desperate, I looked his name up in our phone directory. He wasn't
listed, but I matched the number he'd given me to an address and jot-
ted it down. I didn't dare call, though. I'd learned from <u>True
Confessions,</u> that a girl never, never EVER called a boy. A month after
our encounter, I took action.

It was frigid and dark by seven p.m. that November night. Ma, hear-
ing me bounding down from my upstairs hideaway, came to the hallway
door. I didn't put the light on, didn't want her to see I'd made up my face

31

with Day's new pancake makeup and the red lipstick I'd snitched from Mae Stewart's dime store. "Where do you think you're going?"

I took a chance, making my voice sound vexed and authoritative, "I'm meeting Bella after she gets through at church." My ruse worked.

"Okay." She sounded meek. "Just don't stay out too late." I was relieved I couldn't see her soulful eyes in the darkness.

I slammed the door behind me, made my way through the crunching snow to Fifty-eighth Street two blocks over, then two more blocks to Tower Avenue. Hoping no one from the cafe on the corner was watching, I crossed to Webster Park. As always I checked the neighborhood for Bud's Buick. It was nowhere in sight. I picked up my pace as my feet, inside rubber stadium boots, were beginning to numb. The deserted park was filled with dark trees that cast spooky shadows, making me uneasy. Once the park was behind me I breathed a bit easier. I hurried north on Ogden Avenue to Fifty-fifth Street and Stinson Avenue, checking the dimly lit street signs under each corner light pole. There was no traffic on any of the deserted side streets. It felt as if I was the only living soul on earth.

Out of my home territory, I wasn't sure I could find Bud's house. It was a long hike. After John and Hughitt, Cumming finally came into view. I knew house numbers well, determined which house was his – a small dark toned cottage. A light shown from the back of the house. I looked for a hiding place. A triangular copse of trees at the intersection was the perfect spot. I jumped the ditch there and plodded through a deep blanket of snow. Behind a thicket of brambles, I took up my vigil, stomping my feet to keep from freezing. It was a long wait. In the dead, cold silence my mind churned with replays of my first rendezvous with Bud. The sky seemed lighter than when I'd set out. Fluffy clouds moved overhead. A faint, silver-blue haze wafted across the full moon. The sky glowed in the northwest. A rainbow of purples, blues and whites, began to dance.

I felt a strange upheaval inside, seeing that peculiar Northern Lights display. It reminded me of something from long ago. Searching my mind, I finally remembered. This was the exact same copse of trees and brush that frightened me long ago when my siblings and I hiked to Bethel Church. I was standing one block over from Fairfax Hall, where we'd lived the year my twin and I were born. I remembered how I'd thought there were trolls residing here. Feeling strangely saddened, I was about to bound from my hiding spot when I heard a car in the dis-

tance. I hunkered down, pulled my white wool babushka off my head, afraid it would reflect the headlights. The car slowed at the intersection, then moved on. I looked up. It was Bud's 1950 Buick! I could barely restrain myself from running into the street.

The car pulled into an alley behind the house. I watched Bud emerge, watched his lumbering walk to the house. I vaulted from my hiding place; my feet felt like two blocks of ice. Stomping on the hard pavement to get the circulation flowing, I quickly took off running back down the center of Stinson Avenue, back home through deserted streets. I was shaking from the frigid air, but felt somehow vindicated. My love for Bud was meant to be. I wished it didn't hurt my feet so much.

By December I was a fitful student at best. I figured that after my one successful semester, the rest would be of little significance to anyone. I could carry a C average without putting forth effort. I drifted to a small group of low-performance girls, some of whom, the first chance they got, intended to quit school. They had forsaken our adolescent peer's social jostling and petty cruelties and struck out on their own.

Friendships budded in Miss O'Brien's Homeroom 208 with Tonya Westman and Dora Schmidt. I confessed my exciting adventure with Bud to them both with snippets of information like, "He put his hand in my panties!" I further embellished the account so much so that they both were convinced he had scored with me. Their attention and interest raised my self esteem. I loved the notoriety. I began emulating Tonya's dress and manner. Experimenting with clothes that hugged my body rather than hid it, I spent hours in front of the mirror trying to accomplish her style of dress and makeup.

Tonya had a fondness for tight sweaters and wired, cone-pointy bras, often stating, "If you've got it, you flaunt it!" I followed her lead. We were in the big time, having graduated from double A cups to an A and a B. And though the stays in my thirty-two A binder often cut into my tender skin, it was worth the attention. Secretly I thought Tonya's bosoms were more attractive, not only because of their size thirty-six B, but due to her towering height. To me she was a true Amazon, amplified by her raucous personality. She wasn't at all pretty, though.

Tonya's nose was button-small. Her lips were unpleasantly pouty due to the lower one looking swollen. Tonya's beady, pale eyes were vacant and somber. She was one of the first of the 1949 freshman class to dye her short, straight hair. It came out in a bright yellowish-orange shade. I complimented her on the color, afraid if I didn't, she'd do what

she always said when she was angered with someone, "I should bop the asshole a couple times." Being an Amazon, I knew Tonya thought nothing of resorting to physical force.

On the other side of the coin, it was great having a strong protector. She was notoriously mouthy with the guys at Central. Those boys took to hissing and shouting innuendoes about our sexuality whenever we passed in the crowded hallways: "Pig! Bimbo! Floozie! Sexpot!" Often their taunts burned my ears, though I willingly followed Tonya's lead. Sometimes, on days when she skipped school, I felt fearful, resulting in my bravado being less energetic.

Though all teen girls wore filmy nylon neck scarves, I was especially impressed by the diverse colors Tonya had acquired. She had a different color for each day of the week, alternated them to match her storehouse of tight sweaters. I thought they were fabulous and so practical for her. They were the perfect concealment for the purple-colored hickeys that Tonya collected every weekend and proudly displayed for Dora and me to admire. I only had two of those handy scarves and hadn't, as yet, begun my hickey collection.

Our compatriot, Dora, was a shy girl, though like Tonya and me, was blossoming in the breast area more rapidly than our female classmates. She had a brilliant smile, revealing perfect white teeth. Her lips were slightly curved, in a never changing Mona Lisa smile. Dora's unblemished skin and rosy cheeks never vaulted her into the coveted status of "socially accepted goodie-two-shoes," though. Like Tonya's and my family, hers could not afford to clothe her in cashmere sweater sets, poodle skirts or any other current fashions of the day.

We were the lowest of the low in the high school society pecking order. That unspoken tribal hierarchy consisted of five groups: 1. Athenae, Booster and Coquina Club members, jocks, cheerleaders -all good-looking, popular peers; 2. The intellectuals; 3. Geeks and creeps; 4. the average/nondescript who waffled from time-to-time through each group; and 5. The rebels.

Dora's painful shyness was a problem, too. She blushed ceaselessly, sometimes over such minor infractions as passing gas. After we'd learned her weakness, Tonya and I tormented her endlessly. Dora didn't seem to mind. She took to wearing fire engine red lipstick like Tonya and me, and emulating us in other ways. She achieved one of our unspoken goals in life. She acquired an older, steady boyfriend. I was working on acquiring a trophy in that field as well, plotting and plan-

ning my next encounter with Bud. For the time being I was content to write and rewrite his and my name over and over in the margins of my notebooks: *Bud....Bud Winston....Fran & Bud Winston....Fran Winston....Mrs. Fran Winston....Mrs. Bud Winston.*

Meanwhile, Tonya and I concentrated on being indecent and vulgar outside our classrooms. High school was no longer boring. It was fraught with sexual hazard, Tonya often shrieking, "Watch your back!" in warning, when one or another more adventurous boy tried to sneak up behind and snap the elastic on our bras. And though girls were expected to lack sexual desires, boys seemed ruled by them. Tonya often said, "Why should THEY have all the fun?" I wholeheartedly agreed with her.

Since my friends and I didn't fit in, we were labeled *bad girls*. We failed to be discreet, flaunted a casual attitude about sex. Our physiques were neon lights advertising availability. The *good girls* dressed primly and neatly, and waited for a boy to approach and ask them out. Neither Tonya nor I would be caught dead dating any of our high school peers. They no doubt felt the same about us. We knew from their remarks that they thought us low class and trampy. We could care less, flaunted our rebellious natures. Our favorite put-down was, "Drop dead you pimply pansies!"

As much as the boys harassed us, we, in turn, harassed our female peers. The knowledge that many of those girls stuffed their paltry bras with Kleenex or falsies was a special godsend. In spite of that fact, I sometimes used the same tactic. Lounging against our lockers at noon, we made jokes and snickered loudly at those less-endowed girls when they sauntered by. With a flip of their perfectly groomed hair, the prissiest amongst them would stick out her tongue. Heads together, they'd hiss just loudly enough for us to hear what they thought were perfect put-downs: "Tramps!" and, "Nymphos!"

We would respond in horrific shrieks of "Screw you!" or "Kiss my ass!" Then we'd extend our middle finger, though I didn't know what that gesture implied. I was learning a lot, directly and indirectly. I learned kissing led to French kissing, French kissing led to necking, necking to petting, petting to baring titties and then? Tonya wouldn't go beyond that point in her raucous reports of her adventures. I figured she figured I already knew, or else it was so horrendous even she wouldn't say it out loud. I could hardly wait to find out for myself. The opportunity for success in the on-going high school scoring game arose during Christmas break. ◆

Skirmishes

And of their vain contest appeared no end. –Milton

I was not looking forward to the holiday. It would be our family's second Christmas without Grandma. The first one had been disastrous. No tree, no gifts, little celebration, little food. This year I knew we'd all be making puny attempts at normalcy, putting everyone on edge. Ma, Howard and Day trudged out to the Pokegama River, sawed down a tree and dragged it home. While they were gone I got the house in order, washed windows, put Ma's piles of newspapers and magazines under the beds. I dared not throw them out as she insisted they contained articles she needed to keep. As hard as I tried to keep them in order, they multiplied. And the more they multiplied, the more I hid them. Order, to me, meant "out of sight, out of mind." My final task was dust-mopping and clearing off the dining and library tables. Those tasks done, I tramped upstairs and retrieved the myriad boxes of ancient decorations, stacked them in the parlor.

Sounding quarrelsome, my sister burst through the front door. She pulled off her coat and threw it across the sofa, screeching, "It's an UGLY tree!"

Always the arbitrator, Ma said, "Now Day, be nice. We did the best we could, considering how cold it was." She struggled with the tree trunk in her mittened hands, pulled and tugged it through the wide open door. A heavy aroma of pine filled the room.

Howie brought up the rear, stomping the snow off his engineer boots as he moved forward. He dropped his end of their burden in the middle of the room. "If lard-ass wasn't so lazy, we could have gone further into the woods!"

Ma lowered her end of the scrawny tree. "You'll have to help get it in the stand, Howard."

"No way! Let lard-ass do it." With that Howie pulled off a snow-caked glove and threw it at our sister. She jumped from the sofa, grabbed a throw-pillow and pummeled it over Howie's head. Our part-shepherd puppy Kawlija, ran at them yipping and nipping. That woke

our six cats, curled in their box behind the heater. They rose up, stretched, blinked their eyes and settled back down. All the while Day yelled, "Stupid jerk! I HATE you! I HATE you!"

Ma sank into Grandma's rocker, put a mittened hand across her eyes. I was afraid she was going to cry.

I rushed forward, attempted to pull Day's arm down. "Stop it!" My sister swung back and smacked me in the face with the pillow. I grabbed her waist, wrestled her to the floor. Howie joined in the fray, the three of us trying desperately to get a good whack at each other. Our yells echoed through the house: "Asshole! Creep! Moron!"

Ma jumped from the rocker. "That's IT!" She pulled off her mittens, ran from the room. We three jumped up, momentarily silenced by Ma's raised voice. Seconds later she charged out of the kitchen at us, swinging a broom over her head. Howard and I ran for the hallway, collided in the open door and broke into laughter. Day caught the brunt of the blow across her shoulders. The broom broke in two. Day wailed, ran into the dining room and threw herself on her bed. Kawlija, tail between his legs, ran for cover.

"I'm leaving!" Howard slammed the door behind him as he stormed out.

I looked at Ma. She stood frozen, the broken broom handle still in her grasp. I took it away from her, picked up the other half. I was shaking inside, desperately wanting to make things better. I went to the kitchen, filled the enamel coffee pot with water. Putting it on the stove, I lit the burner with a farmer's match. Day's sobs were fading. I prayed she would fall asleep. As soon as the water boiled I put in two scoops of coffee, lowered the gas and then added dry egg shells from the supply in an empty soup can on the table. "Ma! Come and have some coffee." I heard her stop alongside Day's bed, heard her weak, "I'm sorry," heard Day's muffled, "Oh shut up!"

Ma sat down at the kitchen table. "We'll manage," I said, parroting her favorite phrase when things got tough. "I'll help get the tree up. Then I'll decorate it."

My words seemed to calm Ma. She took a sip of coffee. "There's some wire on the shelf out in the shed. That should hold it."

Attempting a normal tone of voice, I said, "I found the tree stand upstairs. Boy, that's getting to be a real antique."

Ma sighed. "Your grandpa bought it during the war. It was one of the last metal ones they made in those years." We both avoided discussing the stormy scene that had just passed.

Fair Game

We got the tree stabilized and secured. Disaster struck again. I was busily unwrapping delicate old tree ornaments while Ma attacked the lights. The tangled wires from our four sets of multi-colored, large bulbs were impossible to unsnarl. Ma kept pulling and unwinding them. The more she worked, the worse it got. Glancing at her struggles from time to time, I felt more and more agitated. *If she'd been more careful when putting them away she wouldn't be having so much trouble.* Wielding her scissors, Ma accidentally cut into one strand, then, in a fit of defeat, cut them all apart. She threw the entire mess into an empty box. "I can't take much more." Sinking onto the sofa, she pulled a throw over her and closed her eyes.

"Don't worry about it," I said. "I'll get a set from Mae Stewart's tomorrow." I didn't want to think about where the money would come from. Carefully stacking the unpacked empty boxes, I took them upstairs. Pushing into the back bedroom, I barricaded the door and lay fully clothed on the mattress. I felt completely worn out, tried desperately to draw up an image of my heartthrob Bud and failed. My eyes filled with tears and I fell asleep.

I woke up late on Christmas Eve morning. Rushing through the unoccupied upstairs, I thundered down the stairs, through the cluttered hallway into the parlor. Dim sunlight shone through the streaked windows, reminding me I'd not done a very good job cleaning. The parlor was empty, the sofa bed unopened. Ma's throw was bunched on top. I called for her, got no answer.

The piano in the corner had been cleared of its knickknacks and ancient Norse treasures, replaced by Christmas decorations. A celluloid Santa, a snowman and reindeer centered the space, surrounded by Ma's ancient green, wire mini-trees, with their artificial snow trim. Other familiar pieces overloaded the space. Ma's Christmas sheet music was spread out, ready for playing. The tree, slightly tilted in the corner behind the door, looked barren and out of place. A fire was going in the Isinglass heater, the library table opposite, covered with a holiday runner. Ma's old green Depression glass candy dish centered that space. The matching candle holders were at either end. They held long red tapers. Ma must have been up early. I felt relieved that she'd recovered from last night's histrionics.

The dining room sparkled, too. A large expanse, it was crammed with seven pieces of furniture. I especially detested the fact we used it as both a bedroom and dining room. Grandma had once explained to me

that the practice was common in her day. I thought it awful as none of my friends had bedroom furniture in *their* eating areas. Ma insisted we never should eat in the parlor. So why would we eat in a *bedroom*?

There was barely space against the south wall for a huge sideboard, what with the windows on either end. Ma's vanity was angled alongside one window, the head of Day's leather sofa-bed overlapped the other window. A double-door chiffonier was at its foot. Grandma's round oak table filled the center of the room. Howard's single bed was jammed against the wall opposite. The kitchen door was at its foot, the coal-heater at its head. The heater jutted out across the arched parlor door.

My dislike of the room abated when I noticed Ma's vanity in the southeast corner had been cleared of clutter and dusted. It held newly-ironed red doilies. The sideboard and dining table were covered with Christmas-themed tablecloths. Both single beds were made, extra blankets carefully folded at their feet. I made my way to the kitchen.

The floor there was newly mopped and still damp. Strewn with newspapers, it smelled of bleach. The room itself was dark. Its north window offered precious little light. The back door was covered with a ragged blanket. Beyond the door was an attached wooden shed that we used for storage and root vegetables. There was a copper washing machine at one end of the kitchen. Opposite stood a broken down, cast-iron cook stove. We used the apartment-sized gas stove, for cooking. Greasy, black fuzz covered the wall above it. Our massive round table fronted the wall beside the gas stove. The sink alongside was minuscule. Neither of the two spigots supplied hot water.

I smelled freshly made coffee, touched the pot with my finger tip. It was still hot. Just as I poured a cup, I heard the front door bang open, heard Ma holler, "Fran! Come help me." I rushed into the hallway, took a cardboard box out of Ma's arms. It was loaded with groceries. "Where'd you get all this stuff!?"

"I was at the grocer's. Mr. Selden[5] let me put it all on my bill. He even gave me a set of lights for the tree. Said it was a gift."

"Why didn't you have the stuff delivered?" I was beginning to feel better, threw myself back in charge. "What about Day and Howard? Couldn't they help?"

"It was too late for deliveries. I pulled the stuff home on the sled. Day went shopping...at Mae Stewart's.[6] I opened an account there."

I couldn't imagine how Ma had managed that. Was afraid to ask. The image of Ma demeaning herself – sniveling and asking for credit –

was disgusting to me. I had seen it too many times. "Howard said he was going to go cut some branches...to decorate the piano." I couldn't believe my ears. Everything was rosy again. It couldn't last, though.

At noon there was a heavy knock on the door. Ma, my twin, and Day all looked at me. "Okay," I said, "I'll get it."

Standing at the door was a tall, gaunt man. He held a huge cardboard box. I opened the door. "Merry Christmas. Compliments of the Salvation Army!" I let him pass, helped him lower the box to the floor.

"Thank you VERY much," I said. He turned to leave. I yelled, "Merry Christmas," to his back. As soon as his car pulled away, I called Ma. She and my siblings came rushing into the hallway.

Ma looked perplexed. "What's THIS?"

"It's from the Salvation Army," I said. Howard was already digging in the box. He pulled out a popcorn ball.

"Oh for crying out loud. I suppose this was your aunt's idea." Ma didn't sound pleased.

"Who CARES!?" Day grabbed a box of ribbon-stripped hard-candy. "My favorite! And here's a whole bag of nuts!"

Ma pulled the bag from Day's hands. "Put it back. We don't take handouts."

I couldn't believe my ears. "Why not? We can use this stuff. Look. There's even a sack of potatoes! And coffee! We can always use that!"

"I don't know...it just galls me that Etta put our names in. I'm sure there are people worse off than us."

Howard piped up. "Oh sure. We're rolling in money." He'd unwrapped his popcorn ball, took a big bite, spraying popcorn pieces as he talked. "We'll try real hard to find room in the pantry...like that's loaded with food!"

"Don't get smart with me, young man." Ma shot a look of disdain at him. "You can put everything away."

Howard and Day lugged the box into the kitchen, stacked the canned goods –cream-style corn, flour, peas, pumpkin, sweet potatoes, sugar, and coffee– in the pantry. The fresh cranberries, fruit cake, marshmallows, onions, and potatoes were stored on shelves in the back shed. I retreated to the parlor, busily hung the one string of multi-colored lights on the tree. After the lights, I attached the ancient Christmas balls and foil stars, bells and globes with our old, wire hooks. The lights didn't cover the whole tree, but no one seemed to mind. Howie and I threw handfuls of tinsel in the empty spaces. With the one table lamp in the parlor off,

the tree lights on, it was enough to put us in a Christmas mood. We kept an eye out for our roving cats though, fearful one or another of them might try to whack at the Christmas balls on the lower tree limbs. Even they seemed subdued that night.

Day came into the parlor, filled Ma's candy dish with hard candy, dumped the acorns, almonds, Brazil nuts, hazelnuts, pecans and walnuts in Grandpa's old wooden, rosemaled bowl. "Where's the nutcracker and pick?" she hollered. Annoyed by her incompetence at finding things, I mutely pointed at the piano stool where they lay.

Ma hollered from the kitchen, "I put the chicken on to boil. We'll have it for soup tomorrow," she said. "Tonight we're having the Lutefisk I got from Selden's." Things were calming down.

Supper was perfect. We sat at Grandma's old, round oak table, set with her Haviland china, which hadn't seen the light of day since before my twin and I were born. We sat in the glow of candlelight until Howie complained, "I can't see what I'm eating!"

The Lutefisk and potatoes were delicious, boiled to perfection, doused with hot melted butter and sprinkled with dry mustard. I'd worried that Ma wouldn't be as good at that task as Grandma had been. We had carrots with the meal, thanks to the Salvation Army. None of us offered up any prayers of thanks. Later we gathered around Ma at her piano. We sang Christmas carols, though Howard insisted on having Ma endlessly play the hit of the day, *Rudolph The Red Nose Reindeer* over and over. None of us females protested, gladdened by his good mood.

Christmas morning we exchanged gifts, Ma was highly amused that all three of us gave her similar glassware. They were Mae Stewart specials that cost ten cents apiece and were wrapped with red ribbon and huge bows. Mine seemed especially amusing to her. The three dishes, graduated in size and nestled together, were not for candy as I'd thought. They were ashtrays. Day got a pair of second hand, black ice skates. She tried her best to look pleased. We all knew she would have preferred white. Howard got new boots and I got the huge, bright red vinyl hatbox that I ached for ever since I'd seen it at the Glass Block in Duluth. It would be the perfect tote for my dance gear. I could not imagine how Ma had managed.

We had fruit cake and coffee for breakfast, chicken soup and hot rolls for supper. By early evening everyone seemed content. Day lounged on her bed in the dining room, cracking open nuts and drop-

ping the shells in Ma's largest new ashtray. Howard had his nose in a Captain Midnight comic book. I was beginning to feel bored and slightly uneasy. I knew I'd have to remind Ma to call Aunt Etta, something she should have done hours earlier. Just then the phone rang. I hoped against hope it was Bud.

Ma looked up from her coffee cup. "Oh God, I suppose that's Etta. You talk to her. Tell her I've got a headache."

My heart sank when I heard Aunt Etta's voice. I told her that Ma wasn't well, and that we appreciated the box from the Salvation Army. Etta asked when we'd be out to her place for Christmas. "In a couple days," I said. Since she moved from South End, our visits were infrequent.

On December 27, after Ma left the house for an American Legion Past President's Parley Christmas celebration, I called Bella. She couldn't get out. I decided to go it alone. ◆

5 - Ordy Selden's General Merchandise, 5831 Tower Ave.
6 - Mae Stewart Variety Store, 5809 Tower Ave.

Scoring

There are two tragedies in life. One is to lose your heart's desire. The other is to gain it.
–George Bernard Shaw

In the best tone of voice I could muster, I asked my sister, "Can I borrow your green cardigan?"

Day put down the Agatha Christie book she was reading, pursed her lips. "If you wash it. It's as dirty as that filthy duster you're wearing." She raised the book in front of her face. I pulled the sweater off a dining room chair where it had been flung the night before. "I'll wear it backwards."

"Figures," Day said, not bothering to look up. "God forbid you should wash anything." She had me there. I hated hand washing clothes as much as I hated cooking.

"Where are my corduroys?" I was rummaging in the closet at the foot of Day's bed.

"Probably wherever you dropped them," she answered. I heard my twin snigger in the background.

"Don't get smart! You don't take care of your crap, either." I charged up the front stairs, burst into my backroom hideaway. The slacks were in a heap on the floor. I shook them out, pulled them up my bare legs over Day's pink silk panties, buttoned them, and smoothed the wrinkles with my hands. I rushed back downstairs in my bare feet, the duster flapping behind me, and grabbed a blanket off Howie's bed. Hanging it across the kitchen door I yelled, "You guys keep out. I'm going to take a sponge bath!"

I heard Howie snicker again, heard his snide comment to Day, "Like I'd want to see her ugly body."

When I finished I hollered at Day to bring me my bra. "Oh for God's sake," she said, "Do I look like a maid?" She pulled aside the blanket, handed it through. "You'd better not stay out all night."

I ignored her remark, concentrated on buttoning the cardigan and pulling it over my cone-shaped, wired bra. "Bring me a pair of socks!" Day threw the balled up bobby sox through. They landed on the

kitchen table. I retrieved them, pulled them on and slipped my feet into my hated, run-down loafers.

At Ma's vanity in the dining room, I carefully made up my pale, round face. My weak eyes stared back from the mirror. I couldn't find Ma's compact, decided to try a new look. I fluffed my face with white body powder, spotted my cheeks with her orange rouge. I turned to look at Day. "You got any orange lipstick?"

She rolled her eyes, grunted off her dining room sofa-bed, and pulled out her shoulder bag, hidden under a cushion. I made a mental note of her latest hiding place. She handed over the clear plastic tube. "You can have this one, it's almost empty."

I concluded that our successful Christmas celebration had put her in a better mood than usual. "Thanks. I'll make it up to you," I said. "Someday." She pursed her lips and went back to her reading.

I lined my eyes with black liner, buffed white powder on my lashes, and applied the Mabeline mascara my high-school friend Tonya had snitched from Woolworth's downtown. Finished with my preparations, I admired myself in Ma's vanity mirror. My hair was a bit wild looking. Grabbing Ma's brush, I pulled it through the dishwater blond strands, twirled them into a knot, securing it with a red rubber band. I figured it wouldn't matter that much anyway as I'd have to wear my babushka.

Pulling on my brown, fake-fur-trimmed stadium boots, I stood up and clonked to the hall closet. I donned my heavy, red plaid jacket, headed for the door. Howie hollered from the dining room, "Let the cats out. They like nookie too!"

Before I could screech "Screw you," I heard Day's raised voice, "Oh for Pete's sake, don't be so VULGAR!" I smiled to myself, reminded how easy it was to shock our virginal sister.

I didn't smile when I entered The 58th Street Cafe. There wasn't a customer in sight. I was about to leave when Nick, the cook, called out. "Hallo! Where you been keeping yous-self?" He'd come out of the kitchen, was wiping his hands on his greasy full-length apron. "You ain't been goin' to Elsie's I hope." His broken English amused me. I took a stool at the end of the counter.

"It's the holidays. I've been busy." Nick walked over, put a plastic-coated menu down. "I don't want any food," I said. "Ate enough to last me a week already."

Nick's laugh boomed. "I know wha' cha mean. How's about a cup-a-coffee?"

I had thought of coke, but changed my mind. If Bud showed up he'd figure I was older, what with drinking coffee. "Okay and bring me a pack of Pall Malls." I dug in my jacket pocket, pulled out my quarter and put it on the counter.

Nick was at the cashier's counter, slid back the glass door and extracted the cigarettes. "Yous shouldn't smoke. Yous too young," he said.

Lying, I snapped, "I'm eighteen!" I picked up the pack, opened it and lit up. Trying to look sophisticated, I leaned back and gracefully wafted my hand in the air. The cigarette fell from my fingers onto the floor. Nick's wide smile revealed a gold-filled, front tooth as he stomped out the cigarette.

"I can see yous really old," he laughed. "I spose you gotta boyfriend too?"

"I wish," I blurted, then caught myself, "Well...sort of."

"There ain't no sort of when it comes to LOVE! Who's it? Someone I know?"

"Maybe yes, maybe no," I muttered.

"Come on, tell Uncle Nicko." A sly grin crossed his lips. "Mebbe I help you."

Sure, I thought. *You'd like to help. Help yourself more likely than not.* "I don't think he comes in here much."

"Everybody comes to Nicko. Wha's the name?" He leaned forward, put his elbows on the counter. He smelled of cloves. Shaking a Pall Mall out of my pack, he lit it and blew a smoke-ring into the air.

What the heck, maybe he had some information. "Bud Winston."

"What!?" Nick stood up, raised one eyebrow. "He's old man. Too old for pretty girls like you!"

"He is not! He's only twenty-four." I was getting fed up with Nick's glib attitude.

Nick shook his head back and forth. "I don think so. He looks like old man to me. "I'm thirty. He looks worse than Nicko." He scrunched down, glanced at himself in the low mirror behind him. Slicking his hand over his coal-black, curly hair, he winked.

What a Casanova, I thought. Still...maybe he knew more about Bud. "Where does he work," I asked as I lit another cigarette and carefully took a puff.

"On Great Northern Railroad. He's section-hand. I think his old man get him job. They all do same in America. His nephew work there too."

"Is he married?" I really didn't want to know, but couldn't help myself.

"I don't think so. He live with mother and father. Out on Stinson."

"Does he come here every day?"

"Not much. Mebbe later. At eight usual." Nick seemed bored, walked away and began sweeping the floor. "You want me to speak with him?"

"NO! Don't you say a WORD or else I'll never come in here again." I glanced at the clock above the restaurant door. It was five minutes to eight. I butted my cigarette in the ashtray, rose from my counter stool and made my way to the ladies room in the rear of the restaurant, away from Nick's grating laughter. Pulling my glasses from my pocket I put them on and leaned into the mirror. I reapplied a layer of orange to my lips, undid my hair and fluffed it out. I draped my wool babushka around my neck, knotted and rearranged it over Day's green cardigan. The door chime jingle caused an immediate fluttering in my stomach.

Nick's voice rang out, like he was yelling through a megaphone, "Hallo boys! I got special dinner tonight. Ham and the scalloped potatoes."

I exited the bathroom. Before pulling my glasses off, I surveyed the scene. *Damn, no one's at the counter*. The four rear booths were empty, too. The high wood back on the front booth blocked my view. I sauntered past toward my counter seat. There were two men sitting there talking. I glanced sideways at them. *OhmyGo*d! One of them was Bud. I almost tripped with excitement, managed a timid, "Hi." He looked up, his quizzical glance sending me reeling inside. I kept walking, heard his companion ask, "Who's that?"

"You got me," Bud replied.

"She's cute. I wouldn't mind giving her a tumble." The guy's laugh was high-pitched and raucous.

"Jesus," Bud said. "Give it a rest."

I sat down, lit up a Pall Mall. I tried to calm myself by taking a deep drag. I saw Nick watching me from behind the pass-through window to the kitchen. He raised his eyebrows, shook his head yes and winked. *Damn*. I wished I could escape, but was afraid that would be too obvious. "I need more coffee," I bellowed.

Nick hollered back, "Help youself!"

I got up and went behind the counter. With coffee pot in hand, I poured myself a cup. Bud was watching me, smiled his adorable smile. The coffee spilled over onto the counter. "Oh shit!" I sputtered. Glancing up I noted that Bud's captivating lips had broadened into a wide grin. "Now do

you remember?" I asked. He blushed as he nodded his head yes and looked away. His shyness registered on my mind. I'd have to take the lead. My chance came when Bud and his companion got up to leave. As they approached the cash register I made my move.

I flashed my friendliest smile, willed my face to radiate sensitive compassion. "Could you give me a ride home?" A maxim I'd recently read, flashed in my head: *Manner, not gold, is woman's best adornment.* Bud's face reddened. Before he could respond Nick, who'd rushed from the kitchen butted in.

"She pretty girl. But...too young for you!"

It was my turn to blush. "I am not, you creep! Mind your own business!" I felt my eyes burn, tried to control the rage inside from bringing up angry tears. I pulled on my jacket, rushed out. I could hear Nick's laughter through the door I'd slammed behind me. *The asshole,* I thought. I wiped at my eyes, forced myself not to cry. All the while I was slipping and sliding on the icy sidewalk. Halfway down the block I heard car engines revving up behind me. I slowed my pace. At the corner of Fifty-ninth Street, the headlights from a slow moving car illuminated me from behind. My huge shadow loomed onto the crusted snow and ice. The car pulled over; the door opened. "Get in!" It was Bud.

Just then a second car sped past. I heard the driver's raucous yell, "Cherry picker!"

I jumped into Bud's car, slammed the door. "Who's that jerk?"

"My nephew. Ignore him. He's a smart ass." Bud headed the Buick toward Pattison Park. "I'm sorry. I didn't recognize you at first. You look so pale."

"It's the makeup," I rubbed at my face with my mitten. My heart was thumping so wildly it made me breathless. "Where we going?"

"Nowhere special. We'll just drive around, maybe park for awhile?"

"Okay... whatever you want." I sounded vague and submissive. I racked my brain for something to say, worried that I'd blurt out something inept, like, "I adore you!" or, "Take me. I'm yours," phrases I'd read in the steamy novels I had recently become addicted to. I turned on the radio. Gene Autrey's voiced blasted *Rudolph The Rednosed Reindeer.* "I hate that song," I said.

"I think it's pretty cute."

I looked at Bud. His smile captivated me. Waves of anticipation flooded through me. *Would this be the night? Would I remember it forever and*

ever? Would I be good enough for him? I glanced at his face again. His expression had changed. His jaw seemed set. It was an aspect I'd not seen in him before, but welcomed it. Now I wouldn't have to take charge. "I was wondering...why you didn't call?" I immediately regretted my words. "I 'spose you were working. Or something."

"I just didn't think I should."

"Why not?" I tried not to sound hurt, though his words stung like a paper cut.

"I figured you're too young. Like Nick said."

This was not good. I wasn't sure if I should lie again. Before I could decide Bud spoke.

"I wanted to. Still do. But..." He put his arm across the back of the seat. "Come here."

I snuggled close and looked up at his darling lips. "I don't see what the problem is. Age doesn't make any difference to me."

He kissed my forehead; I raised my face. "In a minute," he said and turned the Buick into Greenwood Cemetery. I shivered at the prospect of his lips on mine. The headlights pierced through the dark cemetery expanse, briefly illuminating silent granite gravestones. Names on the largest stones glinted back: Gonser, Block, Lee, Tharge, Quinn, Olson. I was thankful we weren't at Riverside, where my grandpa and grandma Larsen were buried. A pang of guilt descended. We were plunging through a dark forest of huge, black fir trees. Their looming shadows seemed to tilt inward around us. I snuggled closer to Bud. He moved his free hand tight around my waist. "You're not superstitious I hope?"

"No. I don't know anyone out here." I closed my eyes though, just in case there was a name I recognized. Bud pulled into a side road and shut off the headlights. The dim dashboard light and motor's soft hum lulled the wild turmoil that raged inside me. As my eyes adjusted to the night, I could see lights from a single car zooming south on the highway.

Bud lowered his face to mine and kissed my lips, sending me into a tailspin of rapture. I opened my mouth, let his warm tongue explore the reaches inside. I tentatively reciprocated. His mouth tasted like peppermint. The heady aroma of musk engulfed me. As we kissed, Bud gradually moved his hand inside my jacket. I leaned forward, let him slide it off me. He drew his tongue out of my mouth, kissed my nose. "You're so... sweet," he said. I couldn't speak; my heart thundered inside me. I held my breath in anticipation of his next move. His hand glided to the front of my

sweater. I restrained myself from gasping aloud. He slowly kneaded my breast; I raised forward, stretched to him. Wave upon wave of longing surged from my toes up through my neck. He kissed me hard on the mouth. In the silence I could hear our heavy breathing, could feel his heart pounding in his chest. He drew up my sweater. I helped him pull it off. His arms encircled me; I felt his fingers struggle with the hooks on my bra. Suddenly it snapped free. I sat up, let him slide the contraption down my arms, off my hands. Lounging back, I propped my head against the passenger door. In the glow of the faint dashboard light I watched his face. His eyes momentarily fixed on my breasts. He gently cupped the left one with his hand. I flinched in pleasure at his touch. He opened his mouth, slowly touched my nipple with his warm tongue. Wave on wave of warmth undulated through me like an ocean surf with its impending crash of foamy breakers. I heard my muffled words: Oh... my... God!"

Bud looked up at me. His eyes seemed to smile. His sweet rosebud lips, damp as morning dew, sent me into another tailspin of rapture. "Do you like that?"

"Oh, yes! Don't stop." I arched my back; my breasts seemed to pulsate with each thud of my heart. "Kiss them again," I whispered.

He leaned down; I circled my hand through the soft curly hair on his head. I wanted him to go on forever. He stopped. Rising to his knees, he pulled off his mackinaw jacket, threw it in the back seat. A white T-shirt gleamed in the darkness under his denim shirt. He pulled them out of his overalls, unzipped his fly. "Unbutton your slacks," he said. I quickly obeyed. He lay back on me; his hand slipped into the side of my corduroys. I raised my hips. His hand slid back the crotch of my panties. His fingers on my lull'la created an explosion. I gasped aloud. "Am I hurting you?" he asked.

"No. Don't stop." I felt his finger gently probe inside me, felt a surge of warmth. My body was aflame. I heard soft little moans emanate from somewhere inside me. I was in a dream – everything muted and levitated. Bud shifted his body; he pressed something hard and firm against my stomach as he tugged down my panties. Suddenly it was between my legs, gently pushing against my lull'la. A sharp pin prick of pain caused my raised knees to tremble. I heard Bud exclaim, "You're a virgin," as if surprised. His thrusting movements slowed and then in a gush of dampness, it was over. "I'm sorry," he said as he pulled away. "I didn't want to hurt you."

Still reeling on waves of dreaminess, I hugged him. "I love you," I said.

"No you don't, it's all hormones." Though I didn't understand them, his words prompted an uneasy anguish in me.

"I don't care what you say. I do love you."

"Shush," he said as he reached in his glove compartment and pulled out a handful of Kleenex. "Clean yourself up." He handed the Kleenex over, then slid out from behind the steering wheel and disappeared into the darkness beyond the car.

I wiped myself as best I could, rolled down my window and threw the crumpled Kleenex out. Retrieving my panties and corduroys from the floor, I wriggled into them, then struggled into my bra and sweater and pulled on my jacket. All the while I fought a curious melancholy. I'd gotten what I wanted. I should be elated. Brushing the feeling off, I concentrated on recapturing the events of the night. Voices drummed in my head...*Don't stay out all night. Yous too young. He's old man.* With a toss of my head I shook them away.

Bud jumped back in the car, retrieved his jacket from the back seat. He looked over at me. My heart skipped a beat at the sight of his beloved lips. "I could get in a lot of trouble if anyone found out about this."

Crossing my fingers in my mittened hands, I said, "I'll never tell anyone. Honest." I had already formulated a million questions for Tonya. The first one that popped into my head was, *Do you think we made a baby?*

"I'll call you in a couple days." Bud put his arm out. I leaned against him, felt secure again. Music vibrated in my head, playing over and over like a stuck record: "....*then all the reindeer loved him as they shouted out in glee, Rudolph the Rednosed Reindeer, You'll go down in his-to-ry!*" ◆

Fumbling

What's lost today may be won tomorrow. –Cervantes

"You're still a virgin, you idiot!"

I bristled from Tonya's unexpected comeback to my scoring-in-Bud's-Buick chronicle. "I am NOT! I felt his thing." My face burned in anger and rancor. I didn't even care if she bopped me one.

Tonya, using words I'd thought were only reserved for our nemeses continued, "You stupid asshole! You didn't bleed. You would have if he did it right. He probably just stuck it between your fat thighs."

I blanched at her cruelty. Dora looked alarmed. Her face flamed as she hesitantly defended me, "Not all girls bleed the first time. Maybe he was being careful."

Tonya, throwing a pile of books out of her arms onto her locker shelf, pulled on her jacket and slammed the door shut. The sound of steel clanging against steel reverberated in my ears. "You're an asshole, too!" Dora's eyes filled, bringing instant pity in me for her.

"You don't have to be such a bitch." I turned my back to them, hunched over and fumbled with my combination lock, expecting Tonya's blow to fall. I flinched when the noon-day buzzer blasted through Central's hallways.

"Oh for Christ's sake," Tonya snorted. "Let's go have a smoke."

Dora and I loped up Belknap behind Tonya. Passing our usual off-limits coffee shop, Corky's and Harry's, we rushed west in the 1100 block –past Standard Oil, Bridgeman's, McDonald's Careful Cleaners, Rosberg's Shoe Hospital, The Belknap Variety Store, Little Chef's, and People's Drugstore. I turned in at Connelly's in the second block. "Not here, you idiot!" I knew then that Dora and I were in for a big-time lecture. Connelly's always had a long line of customers, making it impossible to talk without being overheard. That would have been impossible in Corky's at Grand and Belknap too, what with the body-to-body wall of teens that jammed the noon-day haunt. It was always fog-thick with cigarette smoke, and dimly lit.

We were heading west in the 1200 block, racing past Belknap Hardware, Rockliff Radio and Appliance, The First Evangelical

51

Covenant Church, Tuverson's Gas Station and Rev. Bergstrom's house on the corner. We crossed the intersection, picked up speed as we passed Christ Lutheran Church and the three houses beyond the church. "You have to eat something in Cronstrom's, else they won't serve you," I said, "I don't have any money."

"Oh shut up. I've got enough for hamburgers." Tonya bounded into the busy restaurant at 1316-20 Belknap. She slid into a back booth. There, before the waitress could recite her curled-lip litany, "You can't just sit around here drinking cokes," Tonya snapped, "Three burgers with onions, no fries, one large coke, three straws." Looking fearful at Tonya's aggressiveness, the waitress scribbled down the order and scurried off to the kitchen. Tonya leaned forward, "Listen to me," she said. "This asshole you humped with is probably a dope. Drop him else you're never going to get any good sex."

"I don't want to. I love him." I felt my face redden. "His lips are adorable."

"What the hell do lips have to do with anything? You don't know a damn thing. You think you need him, what you really need is a good piece!" My eyes wavered as I scanned the crowded restaurant, hoping no one had heard Tonya's raucous outburst. She slapped her pack of Pall Malls on the table. "Here, take one." She and I lit up, Dora shook her head no. Tonya blew smoke out her mouth, then inhaled it back up through her nostrils. I registered the action, promised myself I'd learn how to do that someday.

Tonya leaned closer, "Listen you two, you gotta get your act together if you're going to hang-out with me." She smirked then, adding, "Remember, we're a team, the one and only non-virgin club of Central High!" She hooted at her joke. Dora giggled nervously. I laughed too, though I didn't appreciate Tonya coming up with the idea. Her assumption of power filled me with rancor, and I tentatively formulated plans in my mind to assume control. I knew I'd have to tread easy when the time came, though. I calculated her age. She was fifteen, a year older than me. In another year she'd be quitting school. I'd have plenty of time.

$$*\qquad*\qquad*\qquad*\qquad*$$

The misguided attention I got at school still wasn't enough for me. What I wanted was Bud's love, though I did often meet him. He'd pick me up in his Buick as I sauntered down Tower Avenue from the bus stop. Sometimes we'd meet down the block from the 58th Street Cafe, though he ignored me inside the cafe. There Bella and I end-

lessly sucked on straws inserted in our Coca-Cola bottles, and practiced blowing smoke rings or pulling smoke up through our nostrils.

My secret encounters with Bud continued through March when I turned fifteen. All were consummated on the front seat of his Buick in Pattison Park or Greenwood Cemetery, and once, on a greasy blanket in a railroad switching tower near Stinson Avenue. I began suspecting that the act itself was incomplete thanks to Tonya's treacherous accusation. And though I worried night and day that I'd get pregnant, my periods came as regular as rain. Then I worried that there was something radically wrong with me. I was consumed with that dread and with the possibility of losing Bud.

Finally, after reading up on the subject of how to put a spark in your love-life, I decided to make Bud jealous. I'd latch onto his nephew, Joe Dickenson. I'd heard lots of gossip about Joe, knew he was not adverse to feminine wiles. He was 5' 11" with dark curly hair and a subdued manner in public. HE never ignored me at the cafe. Often when I passed, in his low-pitched, nasally voice he'd hiss, "Hey Babe, when ya gonna give me a tumble?"

One Saturday afternoon in early April, at my post with Bella on the end stools closest to the door in the 58th Street Cafe, Joe burst in with his sexy strut, drawing the eyes of all us teen girls congregated there. He lunged forward, arms akimbo and in a quiet, intimate voice lowered his face to my ear, "Light of my life...this must be my lucky day." All the while his small slant eyes were scanning the cafe expanse like a furtive vulture hunting carrion.

A flutter of delight from his attention filled my breasts. "Sure is," I answered, willing my voice to sound as low and seductive as his. "How 'bout tonight? I'm free...and willing."

Joe's roguish, dark face lit up. "Why wait? We can head out right now if you're game. Meet me down the street."

I wriggled into my brother's black and white Pendleton jacket, yelled over my shoulder to Bella, "See ya later 'gator!" and headed out the door. The sidewalk was wet with puddles of melting snow. I hurried up the block to Fifty Ninth Street. There, waiting for Joe's old black Studebaker sedan, I began to doubt my luck. Maybe he was teasing.

Maybe making Bud jealous wasn't such a good idea. Maybe I was being stupid. *Oh hell, I'd be better off going home.* Just then Joe's jalopy screeched to a halt at the crosswalk spraying muddied snow and ice toward me. I jumped back, swore, "SHIT!"

His nasally voice sang out from the car's rolled-down-window, "Get in!" I slid onto the vinyl seat next to Joe, slammed the door shut. "Geez, don't break it!" I looked over to see if he was kidding. He wasn't.

"Sorry," I said. "I thought maybe it wouldn't close," leaving silent my opinion that the damn car was a wreck. It sure wasn't anything like Bud's shiny Buick.

"SO," Joe began, "I hear you're screwing my uncle." I felt something deflate inside. *How COULD Bud have told him about our love.* Fighting the turmoil that burst inside me, I vowed I'd *never* speak to Bud again. The thought strengthened my wavering determination to make him jealous.

"I guess you can call it that," I countered. "Half the time he doesn't know what he's doing." Guilt descended realizing I'd betrayed my love. In the same instant anger alleviated the guilt.

Joe continued, "I always figured he was stupid about sex. He never talks about it. It's almost like he's embarrassed. Christ, it's the most natural thing in the world!"

Joe's words scared me. *Ah Geez, I've gone too far now.* "Well...Bud's really nice. And I like him a whole lot."

"Yah, but what's the good of that if you don't get your cookies off?"

I had no idea what Joe was referring to. "Where we going?" I asked.

"We'll take a jaunt out to the Drive. It's pretty warm now. A good day for a roll in the hay." Joe cackled at his unintended rhyme.

I ignored his slick chatter, so much like the high school taunts I tolerated on a daily basis. So far so good. Maybe I wouldn't even have to do it. NO ONE screwed in daylight as far as I knew.

"First I gotta take a run up Fifty-eighth. Duck down so no one sees you." I instantly remembered gossip I'd heard that Joe was going steady with Angie Dannenhoff, and knew she lived on Fifty-eighth between Banks and Oakes. A prickle of excitement overcame me. I was now *the other woman*. I was sure that Tonya couldn't top that. Then too, I must be special to Joe, seeing as how he trusted me to join in his little hide-and-seek game. I knew that the blond, curly-haired Angie was considered one of the prettiest girls amongst her class of sophomores at Central –the epitome of goodness and virginity. As the car sped past her house on Fifty-eighth street, I crouched down and held my knees between my finger-crossed hands. *Please, oh please, make this work!*

"Okay, the coast's clear," Joe said. He veered the car west on Butler Avenue to Highway 105. Soon we were racing toward Billings Drive. "I know the perfect spot out here." Halfway into the Drive the car swerved

onto a side road and came to a halt under overhanging tree branches. Joe shut off the motor and got out of the car. "Come on!"

"Out there!?" I felt uneasiness at the thought of someone seeing us. "It's daylight."

"No one's around. The cops only patrol at night. We won't be long anyway." Joe had the trunk of the Studebaker open, pulled out a folded square of heavy gray tarpaulin. "This'll keep us dry."

I edged out the passenger side. My loafers sank into a mud-hole. Cold water seeped over their edges. "Damn! My feet are sopping wet!"

"You should've jumped that ditch. Come around on this side, it's drier." Joe waited until I caught up to him. He grabbed my wrist, pulled me forward.

"Geez, it's kind of chilly. Maybe we should go back to the car."

"Hell no! Screwing in cars is for idiots." We were descending a hillock, heading for an open expanse encircled with tall, dry grass. The sun reflected on the muddy Pokegama river water just beyond. "It's really balmy now...spring has sprung!" Joe sounded exhilarated.

"It feels like winter to me."

"Don't worry, you'll warm up. Help me with this tarp." Joe had unfolded and flapped the tarp open. I grabbed one end and between us we maneuvered it into the center of the space. "I gotta take a leak. Be right back."

I stood staring at the river, wondered if I'd made a mistake. Joe seemed pretty sure of himself; maybe it would be okay. I lowered myself to the ground. The tarp was cold to touch. I pulled my mittens out of my pocket, put them on. I felt a chill, wrapped my arms under my body and rocked back and forth.

"Okay babe, get ready!" Joe bounded out of the brush, threw himself down next to me and rolled onto his side. "Give us a kiss," he said.

I leaned to him. Our lips met. His were cold and rough, so different than Bud's soft, moist lips. As we kissed Joe pulled me closer. I could feel his hand fumbling for the zipper of my overalls. "Open up," he said. I concluded it would be better to have him think I was experienced. I shifted my position, took off my mittens and unbuttoned my overalls at the waist. He jerked down the zipper. Our kiss ended as his hand moved inside my panties. I tried to conjure up memories of Bud's touch and failed. Both Joe's quick, deft hands suddenly pulled down my panties and overalls to my knees. I turned my head away as he unzipped his own pants and mounted me. The first stab of pain brought my loud, "OUCH!"

"Geez," Joe said, "Looks like Bud never finished the job." He continued, though each stab of pain made me flinch and jerk under him. "That's it, baby," he said, sounding short-of-breath, "Keep moving." I bit my lip to keep from crying out, though somewhere inside me I could almost hear bubbles of relief bursting. *THIS is sex, no doubt about it.*

After Joe rolled off me and I stood up, I was astounded to see a trickle of blood slowly descending my inner thigh. "Oh my God! I'm bleeding!"

Joe's raucous laugh nettled me. "Ha! I gotcha!" He was bouncing up and down like a jack-in-the-box. I looked away, afraid I'd see *it* inside his undone trousers. "Old Uncle Bud's going to shit!"

"Oh shut up, and get me some Kleenex."

He zipped up his pants and bounded up the hill, returning with a box of tissues. "Be sure you wash yourself up real good when you get home. Rubbers don't always work."

I briefly wondered when he'd put the rubber on, wondered what it looked like. "I always clean myself good," I snapped, though inwardly I wished he'd been more specific. I'd heard about women taking douches, but had no idea what the procedure was. Guys probably didn't know either, though it seemed to me Joe would know everything. At least he acted like he did. I decided to prompt him with a mystifying joke Tonya had once related. "Did you hear about the little girl who went to the soda fountain one hot day and ordered a douche? She told the druggist, 'My mother says they're very refreshing.'"

Joe exploded with laughter. "Pretty funny," he said, but disappointedly, didn't pursue the topic. "You're cute. Lotsa fun, too. Do you care if I give your number to my buddy, Beef Krittan?"

"Beef? What kind of name is that?" Though I didn't like it, it felt good to ape Joe's flippant ways. I was flattered by his compliment, too. Maybe I WAS okay. If HE found me attractive surely other guys would. I was enjoying our camaraderie, as well. It felt good to be friends with a guy. Maybe I'd used the wrong approach with Bud. I vowed not to make that mistake again.

"He's got a football build, you know, beefy. And he's damn good-looking. You two would hit it off."

Before I could think, I was jotting my phone number on the back of an envelope that Joe handed over. Momentary panic from the realization of what I'd done abated after we returned to his car and head-

ed back to town. Joe turned the Studebaker onto my street and pulled to a stop in front of my house. Bud never did that. He always dropped me a block or two away. "See ya kiddo," Joe said, then gunned the motor as I hopped out of the car and adroitly evaded the spray of mud and slush. I couldn't avoid the remarks of my twin and his boisterous madcap friend Lonnie, though. They had stopped their slush-shoveling task on the pathway to our porch and were watching me.

"Who's the boyfriend?" Lonnie hooted. With the back of his hand he wiped away the saliva that constantly sprayed from his lips when he talked.

"He's NOT my boyfriend," I snapped.

"We know THAT," my twin Howie spouted. "No guy would date YOU!" He and Lonnie burst into cackles. They returned to their task as I bounded up the steps onto our porch. I overheard Howie say, "Wasn't that Angie the slut's, boyfriend?"

I turned and shrieked, "You damn juveniles! You don't know nothing!" With that Howie hoisted his shovel and flung slush at me. "Moron! –it's YOUR jacket you're getting dirty." I retreated into the house, cursing. "I HATE guys!"

Day was on the couch reading as I entered the living room. "You got any Kotex left?" I asked. "My period started."

My sister looked at me over the top of her book. "Geez, you sure get them fast."

Her remark nettled me. "What are you doing? Keeping track?" All the while I was dying to get to the bathroom to wash up. There was no way I wanted to be pregnant by Joe, or anyone else, for that matter.

Ma hollered from the kitchen. "Fran? Where have you been? Mrs. Sterling called. She wondered why you didn't come to class today."

I looked at my sister. "Don't tell her I got my period again," I said.

"Oh yah? What'll you give me to keep quiet?" Her words reminded me that I owed Howie a quarter. He'd seen me snitch a mini-notebook from Mae Stewart's, hadn't said anything until we'd left the store, then said, "You owe me for keeping my mouth shut."

"A pack of cigarettes," I said. "Soon's I get my baby-sitting money."

My sister lunged off the sofa, went to the hallway closet and extracted one Kotex pad. I put it under a pile of magazines on the stairwell. Removing my coat, I went out to the kitchen to face Ma. "I had to finish a report for school. I called Mrs. Sterling yesterday and told her. She must've forgot."

Ma's solemn eyes looked quizzical. "Where did you go to do the report? At the 58th Street Cafe?" Her words were unusually biting.

My mind churned in panic. "NO...who said that?!" I took a chance and added, "Howie?"

"No...no one said anything. I know you and your friends go there all the time." Her voice was accusative, though her languid eyes wavered.

I sensed her discomfort and quickly took the upper hand. "AFTER we do our schoolwork!" My voice rose. "God knows I don't get any peace and quiet around here!" I felt sorry as soon as the words were out. They were the ultimate insult to Ma. I knew she was consumed with guilt that she couldn't control the constant battling and bickering that my siblings and I tormented each other with. Still, repressed spunkiness couldn't be so easily quelled. "May I read the report?"

I panicked, wondering how I'd get out of THIS mess. Then I remembered a report from the month before that she hadn't seen. "Later. I have to rewrite it. Right now I've got to PEE!" I ran from the room, grabbed the hidden Kotex and thundered up the stairs to the bathroom. There I checked my panties. I had stopped bleeding. I washed myself and the panties with cold water from the one working sink tap and hid the Kotex pad behind our unconnected bathtub.

After supper I sat on the footstool in front of Ma's rocker and read her my old essay, titled "My Best Friend, My Mother." Her eyes glistened in pleasure at my presentation, dispelling the guilt that was eating inside me. I silently vowed to change. My vow lasted a full week, thanks to Tonya's absence from school, which Dora confided was due to her taking off with a trucker. She added in an awe filled voice, "I think Tonya's in love!"

The following Saturday night, after I'd just gotten in the house from my ballet classes at Braman's Studios, I heard the screech of wheels out front, accompanied by the loud bray of a car horn. I ran to the front window, pulled up the green, opaque shade. It was Joe Dickenson's car and someone was with him. Before Ma could rise from her rocker, I pulled down the shade, grabbed my coat off the couch where I'd thrown it and headed out, yelling back, "It's Bella and her boyfriend! We're going for a ride!"

The guy who jumped out was tall, with blond curly hair and a square-cut jaw. His broad smile revealed perfect, white teeth. "Hi Frannie, I'm Beef." I noted the heavy letter-sweater he wore, in Cathedral's colors of blue and gold. I couldn't see the number on the back, though.

Fumbling

I felt a slight uneasiness going with two guys, still, if I didn't I was sure they would keep honking the car horn, attracting the attention of the neighbors. That would cause terrible pain to my mother, who detested any hint of scandal. In any case, I was sure I could handle the situation. "You should have called first," I said, then slid in next to Joe. "What are YOU doing here?"

"Beef's car is in the garage. I'm your driver tonight."

"Yah," Beef piped up. "He can drive and I'll drink." His laugh was deep and coarse.

"I can't get in any taverns," I said, feeling a twinge of distaste. It was a good excuse to escape their clutches, too.

"Don't worry about it. We'll figure something out." Joe patted his hand on my thigh. I brushed it away. There would be no escape for me.

"And after he's through driving, I'll take over!" They burst into raucous laughter. Knowing immediately what Beef meant, my mind churned in panic. *I've got myself in a real fix this time. Nothing much to do about it, though. Go with the flow, like Tonya always said. Maybe drinking would make it easier.*

"No problem. You can wait in the car and we'll bring you a couple beers. Okay kiddo?" Joe looked at me and winked.

We were speeding south on Highway 35, approaching Pattison Park. He turned the car onto County C and revved the motor. "Don't go so fast," I said. A vision filled my head of the car crashing into a ditch with the resultant Evening Telegram headline: "YOUNG GIRL AND TWO MALE COMPANIONS KILLED ON HIGHWAY." I imagined Ma's horror and shame, shook the image away. "SO," I said, "Did you hear about the moron who got locked in the grocery store and starved to death?"

Joe and Beef laughed. "That's the spirit," Beef said. "We're going to have FUN tonight!" Joe blasted the car horn as the Studebaker headlights cut through the gloom. Misty rain began to streak across the windshield. The car's windshield wipers squeaked into action, dragging the dampness away.

"Guess the woods'll be pretty wet tonight," Joe said.

Beef hooted. "Yah, good thing you fixed that broken window in back. I'd hate to get my ass wet."

I closed my ears to their alarming chatter. I drew up pleasant thoughts of Bud's lips on mine. I relived our secret trysts, prayed that he'd forgive my risky conduct. I immediately justified myself, *I'm only*

trying to make him jealous. Other thoughts pressed in. *Why should he care? He never took me on a date, like these guys are doing. He never said he loved me. Maybe he didn't even want* to see *me. I was the one who started our romance. I was the only one who kept it going.*

"You're awful quiet." Joe's words jarred me from my daydream.

"I was just thinking," I said.

"About old Bud, I'll bet!" With that Joe threw his arm across my shoulders and pulled me tight. "He's a loser. Forget him."

"Yah," Beef snorted. "WE'RE winners!" With that they both whooped, "Look out girls! Here we come!" Blinking white lights on the road ahead advertised our destination, Hoffer's Bar. I had no idea where we were. I'd lost track of the turns and twists on the back roads we were traveling long after we'd passed Four Corners, gave no thought of how I'd ever get home or when. I vowed to be strong.

The guys jumped out of the car. Joe yelled back at me, "I'll be right out, with a couple beers for you!"

"And a pack of Pall Malls," I hollered. Maybe they'd think I was too expensive a date, a gold-digger, something I'd heard was the supreme put-off to guys.

The car, parked alongside the low stoop in front of the main entrance, was beginning to feel cold, the gentle rain, now a steady patter. Rivulets of streaming water made paths on the windshield, like snail tracks. I could hear loud music and laughter emanating from behind the walls of the small building. I switched on Joe's radio, nothing happened. He'd taken the keys into the tavern with him. It occurred to me that I should go in and ask him to turn the car on so I'd get some heat. Just then he came bounding through the tavern door, his leather jacket over his head, two cans of beer in his hands. I leaned over and opened the door.

"Geez! It's shit out here!" Joe handed the cans over, dug a pack of Pall Malls out of his jacket pocket. "This'll hold you til we get back."

"It's COLD out here! Turn the motor on," I blurted, restraining the urge to tell him he was a jerk.

"You won't take off will you?"

"How the hell can I? I don't know how to drive." I wished I could. Wished I could speed away from everything.

With that Joe inserted the car key and turned on the ignition. I slid the heat indicator to high. "I won't be long." He slammed the door and bounded back into the tavern.

Fumbling

I opened a can of Schlitz, took a long gulp. It was ice cold and bitter tasting. Opening the Pall Malls, I lit one and took a deep drag, pulling the smoke up through my nose. Five more gulps of beer and the can was empty. Rolling down the window I threw it out with such force it bounced off the side of the tavern wall, alarming me. From the din inside I decided no one would hear anyway. I opened the second can, guzzled it down. I wanted to get drunk, wanted to blur what I knew was inevitable. Looking out through the rain, things began getting fuzzy and my head throbbed. *Oh Geez, I'm going to puke!*

I rolled down the window, stuck my head out. The beer upchucked from my throat and slid down the side of the car. *Geez, I should have ate something before I went out.* I felt another wave of nausea. The puke blasted so fast I couldn't get my head out the window in time. It sprayed the windshield, slithered down the front of Howie's Pendleton jacket. I jumped out of the car, knelt and scooped up rain water from a puddle, splashed it down the front of the jacket. *Oh Geez.* Another wave of nausea. I let the vomit spew into the wind, hoping against hope it wouldn't rebound. It didn't. I looked up at the dark sky, let the rain wash down my face, not caring if my makeup ran, not caring what happened next.

I heard Beef's raucous yell, "What the hell are you doing out here!?" He staggered around the front of the car, caught me around the waist. "Come on, nookie time!" He pulled me backwards. We fell onto the back seat of the Studebaker.

I could smell beer on his breath, wondered if I smelled as bad. Readjusting myself, I lay back and closed my eyes, prayed I would pass out as wave on wave of dizziness swept through me.

Beef was fumbling with his pants, pulled them down to his ankles, then spouted, "Take your's off! I ain't got all night!" At that moment I envisioned us from above –envisioned moonlight on his bare, white behind. I fought the urge to laugh out loud. Beef was pressing and probing his *thing* against my legs. I decided to keep them together. For the first time I felt as if I was in charge. In my own shaky state I could tell from his actions Beef was too drunk to know if he'd hit the target. When he finished he rolled off and crumpled into the corner of the back seat and promptly fell asleep. I got out and slammed the door, got in front and slammed that one too. Nothing could wake him.

I pulled my telephone-dial-painted-compact out of my pocket, wiped at my face with the puff, pulled out Day's tube of orange lipstick, slashed it across my bare lips. Adjusting my clothes I jumped

from the car and dashed through the rain into the tavern. I was determined to make my stand. Joe was leaning against the long oak bar, his hooded slant eyes gazing at a tall, buxom blond next to him. I tugged his arm. "Come on, let's go!!" The blond looked me up and down and, laughing, sauntered toward the other end of the crowded bar.

Joe's bleary gaze fell on me, "What the hell...?"

I forced myself to sound angry and strong, figured if it worked with Ma, it would work with this creep. "I can't stay out all night. If you're going to screw me, get it over with!" I turned and stomped out into the rain.

Joe came dashing behind me. "Holy Jesus! What got into YOU?"

"Oh shut up!" I jumped into the car, pulled down my pants and waited for him to get on with it.

"Let's get in the back," he said.

"Can't. Your sexy friend's passed out there."

"Oh shit." Joe leaned forward, kissed me hard on the mouth. "You're some piece," he said, laughing.

It was midnight by the time we got back to town. By then, with the windows wide open, all three of us had sobered enough to have calmed down. We rode in silence until we got to my house.

"Listen," Joe said, "I'm sorry we got so drunk. And rough."

"No problem," I said. "That's life." I bounced out of the car as if I'd just returned from a jaunt down the street.

Joe hollered at my back, "You're some kid!"

Inside I quietly tiptoed past Ma's rocker where she huddled sleeping. I crept to the kitchen, washed in the sink and slowly made my way up the stairs to my retreat in the back bedroom. Barricaded alone in that safe place, I recounted the events of the night, felt hot tears well up. Maybe my Central High tormentors were right. Maybe I was a tramp. For sure Tonya had it right. I was an idiot. ◆

Coaching

The master loseth his time to learn
When the disciple will not hear. –Chaucer

Early the next morning I cautiously descended the stairs. I was sure no one was awake, hoped I could avoid contact with my mother. Entering the living room I saw that the sofa-bed had not been opened. Ma's afghan was balled up on the rocker. She must have slept there all night.

I passed through the darkened dining room, saw my sister and brother curled under heaped, worn blankets fast asleep –Day on the leather couch, Howard in the single bed beyond the coal heater. I skirted Grandma's oak dining room table. The overflowing, unsightly mess on top of the table filled me with disgust. Papers were strewn hither and yon together with an errant nylon stocking, an open bottle of ink, ripped envelopes with their contents scattered. A crusted coffee cup sat beside a tipped over water glass. Gray water spots blemished the oak finish. The mess reminded me that it would soon be house cleaning time.

Ma sat at the old, green-painted table in the kitchen. She held her china coffee cup with it's missing handle in both hands. Her lips seemed frozen to the rim, blank eyes stared into the middle distance. She looked rumpled and tired. A pang of deep sympathy and shame pierced me. I so wanted to comfort her, but didn't know how. I forced an airiness into my voice that I didn't feel. "Good morning."

She gazed at me, a hurt look in her eyes. "Where did you go last night? I was worried sick."

"I was with Bella and her boyfriend. We went out to the country."

Her eyes seemed to harden. "Are you sure?"

Yes!" My voice sounded angry.

"I don't think so. I called her house and talked to her. She had no idea where you were." Ma's voice was soft and accusative. It made me wish she would yell, wish she would lash out.

I turned away from her scrutinizing, sad eyes and reached for the coffee pot, willed my face not to redden. "Okay. So I was out with a guy. What's wrong with THAT?"

She seemed to wither in front of me. "Oh Fran...the neighbors..."

"I don't CARE about the damn neighbors! It's none of their business WHAT I do!" My hand shook as I poured the coffee into a mug on the table. "They're a bunch of busybodies!" I sank into a chair across from her. "It's not like we're high society, for Christ's sake!"

"Don't swear." I sensed Ma's energy returning. "I only want what's best for you. A person's good name is all they can depend on in this world. And... I don't want you to go through what I did."

"Geez, you've already got me pregnant! I thought you trusted me. I didn't DO anything for Pete's sake!" It surprised me how easy it was to lie to her.

My mother rose from the chair, steadying herself as if she thought she was going to fall. "I do. It's just that... you don't know how men are. You're so young." She poured herself another cup of coffee. "I could tell you a story..." her voice trailed off.

I was anxious to change the subject. "Well tell me, then!" I hoped she would at long last tell me what went wrong with her and my dad.

"I don't...know. I shouldn't." She sank into her chair. "It's such a long time ago..."

"You NEVER talk about those kind of things. I WANT to know." I lowered my voice, touched her hand. "I won't say anything to anyone."

Her words came out soft and hesitantly, "It was... during the First World War." Confusion filled my head, but I didn't dare interrupt her train of thought. "I was dating Deak Collier."

Unable to restrain myself, I blurted, "Who was HE!?"

"I met him in high school. He was my first boyfriend. I felt sorry for him."

"WHY?! Was something wrong with him?" I imagined a cripple, or maybe even a blind boy. Worse, maybe he was disfigured, ugly.

"He drank so much."

"That's not so bad." I envisioned Joe Dickerson and myself. We'd been drunk, but we'd survived. "Unless he drank all the time."

My mother didn't seem to hear me. She went on, that far-off look returning to her eyes. "He said he started drinking real young. I think he was drunk most of the time."

"Why do you suppose he got like that? Was it his family? Or what?"

Coaching

"They accused him of killing his mother."

"WHAT!?" I leaned toward her, straining to hear her words.

"They had a farm on Darrow Road, and he used to go there in the summer, and he was running the tractor or something. His mother came out to the field and she got her foot caught in the machine. In those days you didn't have a car. And there was no ambulance going out or anything. She bled to death..."

The scene blazed across my consciousness. I could see red blood slowly draining the woman's life away. "Oh Geez!"

"...and the family blamed him. He was so young...twelve years old. That's when he started drinking."

Ma's words were riveting. I felt compelled to get all the facts. "When did you meet him? When did you start dating?"

Her voice took on a low drone, like the buzz of a pesky mosquito on a summer's night. "I was nineteen...in my senior year at Central. I'd missed a whole year of school when I got yellow jaundice. We were the same age. He was born in March, two months before me. He came back to school to take up an extra subject that he had failed or something and my music teacher, Anna Williams Roberts was his mother's sister."

I hated Ma always explaining family relationships. But I knew if I interrupted her, she'd get off track. It reminded me how her and Grandma's stories dragged on. After Grandma died Ma seldom talked. Her stories seemed to have dried up and been buried with her mother.

"She was a widow, married to a Williams and had a daughter that was in high school with me. And then Mrs. Williams married old Judge Roberts and...she took me aside and warned me against having anything to do with Deak. But by then I'd started to like him and I felt sorry for him. I'm sure he didn't kill his mother on purpose. It was an accident. But they kept reminding him. And so...she told me that he wasn't any good...that he was...that I would be hurt. Well, she was right in that. But then, who knew ahead of time? He had seen me talking to her and he said, 'I suppose my aunt warned you against me.' And I said 'yah.' And he said, 'What do you think?' And I said, 'Whatever happened in the family is none of MY business.' Besides, I thought I was old enough to think for myself."

I was dying to ask her if they had sex, tried frantically to find the right word. I knew Tonya's term, screwing, would never do. "Were you... intimate?"

"Not right away." Her voice was so low I had to strain to hear her.

I decided on a different tactic. "Did Grandpa or Grandma ever tell you the facts of life?"

"Oh no."

"Well, how did you find out?"

"Kids. From kids. My girlfriends used to say I was lying –that I didn't know anything, when I told them I'd not started my period. Because they started to get their periods at age thirteen and I didn't until I was sixteen. They thought I wouldn't admit it. But that wasn't true. I was just older."

"What did Grandma say about it?"

"Nothing."

Now I knew why she'd been so hesitant with me on that subject. I didn't comment, though. "Didn't anybody explain it to you?"

"No. Of course boys always talked...I thought they were filthy. But I didn't...know about babies. Nobody explained about babies... or anything."

"What about the kids you hung around with? The girls. Did they know anything?"

Her saga was beginning to sound familiar. We at least had that in common.

"Not really... these two girls, Mary...someone or other, I don't remember her name... and a Swede girl that went to the Pilgrim Lutheran Church... they were younger than me and my best friend, Molly... they talked a lot. We all took sewing together. We had to go to a fitting room to try on what we were sewing. When Molly and I went to the room together we goofed around so much with those wire dress forms that were on wheels. We'd dance with them and sometimes they'd fall over. Pretty soon Miss Snodler wouldn't let us go together. She sent those two young girls there with us. To keep order I guess. They chummed together and they were younger than us, but they were telling us about going out with boys... and having intercourse and they said they'd go behind the church and... I used to be so shocked. And I was shocked at this Gudrun from Concordia. She was younger than me too. She was telling about her and some boy going behind the altar in the church. And I thought, 'Oh dear me, they're such sinners."

Ma's friends sounded like me and Tonya. We were sinners, too. Ma had been a goodie-two-shoes. We had nothing in common.

"My biggest surprise was one day when my two closest friends told me about their sex life."

Coaching

I didn't want to hear about her friends. I wanted to hear about her. "Deak never tried anything?"

"Oh sure, but I wouldn't give in."

"But you did later?" It felt as if my mouth was hanging open, startled at her frankness. I wished we'd had this conversation a long time ago.

My mother pressed on, "I had been going with Deak for quite some time and we never had sex. After my two girlfriends... one was Hazel Crain... she was in love with this Harry Haukers who owned a butcher shop on Marine-on-the-St.-Croix. Her father was a Soo Line telegrapher and they moved from place to place. Mr. Crain would get a job at certain depots and they'd have an apartment above the depot. Mr. Crain was at Belden, Wisconsin when I knew them. Hazel and Mabel & Myrtle came up to Superior to go to school. Hazel was my age. There was a younger girl too, Arbutus. But she didn't go to school. So then Myrtle and Mabel went to the Blaine and Hazel came over to Central."

I wondered what THAT had to do with anything, but kept quiet. I knew that somewhere in her story Ma would get to the point. I tried as hard as I could to be patient.

"Hazel was so in love with this Harry, but her mother was a snob. Mr. Crain was a German. His family had a crest...their name was a 'Von' and Mrs. Crain was a piano teacher. He was nice...Mr. Crain. The mother didn't like this Harry, so Hazel had to sneak out to go with him."

I was sure I knew where my mother was heading, but wasn't sure I wanted to hear it. I felt uncomfortable anticipating Ma's shame, much less admitting my own. Still, her tale was too compelling to ignore. "What about you and Deak for Pete's sake!?"

She seemed to jerk awake from some long ago dream. "Well, let's see," she said. "Oh, yah...this one day Hazel asked me if I had intimate relations with Deak and I said no. And she said, 'Why haven't you?' And then she went on to tell me about her and Harry. Every time they had a chance they'd sneak away. And she was telling me how wonderful it was...and...she urged me to give in to Deak. I was so shocked, you know. Well, not so much as I was at my friend Molly, because her family were the mainstays of Bethel Church. Those kids never did anything wrong. So Molly and I were on the streetcar together and lo and behold she goes on and tells me about how much fun she was having with HER boyfriend."

I got a little confused with the swiftness of Ma switching from her friend Hazel to her friend Molly, but again, I figured there was a thread in the story somewhere. I'd just have to wait.

"Molly was teaching school already...at Cornucopia, Wisconsin and she met this Clarence guy. So I really was shocked at her, because she was supposed to be...well, you know, so perfect and upright."

I couldn't bear it any longer, blurted, "So, that's how you found out about sex. But what about Deak? When did you finally get intimate?" I already calculated that she was at least twenty-years-old. Really old, in my book.

"We went steady. He had a good job at the Daisy Mill in East End. Mr. Kreeks liked him a lot. But on the weekends you couldn't find him. He'd be drunk. That was before Molly got a teaching job. She worked at bookkeeping like me. I worked at the Footroom Shoe Rooms. She got a job in an insurance firm down in the Columbia Building at Broadway and Tower. She was getting into all kinds of messes then. Even before she went to Cornucopia."

"And you didn't?"

"No...I was faithful to Deak."

"But you didn't have sex?" I was getting annoyed, wondering if Ma would ever get to the point.

It was as if she never heard me, as if I wasn't even there in front of her. "Deak was in the National Guard. They were called down to Mexico in 1916. Company I and Company B from Superior went down. A lot of those fellows were boys that I went to high school with. I didn't go to bed with Deak until he came home from there."

"Was Deak romantic?" I was aching for details. Aching to compare her experience with Deak to mine with Bud, but I knew that would be impossible.

"Oh sure."

"Did you like him a lot? Did you want to marry him?" I realized that I myself was longing to marry Bud. But how could I? He didn't even love me.

"I didn't want to get married, as long as he was drinking."

I gingerly broached the subject I was dying to know. "Where did you and Deak go when you made love?"

"Different places."

"Like where could you go?"

"We did go up to my bedroom when Ma and Pa were at the Eau Claire

Lakes." She chuckled then, saw my quizzical look. "Molly was going with this George. She and he were downstairs. He got smart with her and she kicked him and he passed out. Then she threw a bucket of water on him. Oh my God, was he mad. He was German." Ma laughed aloud. "Molly had a case on with another guy. She wasn't allowed to bring boyfriends home though, so they used to come to our house. Anyway, Deak and I went...well, we snuck around a lot. His older sister had a cabin on Minnesota Point and we went there a lot. We necked at the movies, too –at the Cozy Theater on Fifty-eighth Street and at the Opera House."

"When you were dating, did Grandma put the kibosh on it?" I couldn't imagine my strict grandma tolerating any foolishness. Maybe I could get Ma to see that I was in the same position she had been in.

"Grandma Larsen was strict to a certain extent. We were pals, though. People thought we were sisters, because I took part in the lodge work with her."

I had heard that all my life and didn't appreciate it. "Yah, but she wouldn't have been such a pal if she knew about you and Deak, I bet." There was an edge to my voice.

"My dad and mother liked him."

She wasn't going to follow my lead. "But he wasn't even Norwegian!"

"I know. I think that's why they liked him." She chuckled at the thought.

The story was beginning to bore me. I could not see the point for one thing, and for another, I was convinced my mother and I were complete opposites. She'd been a goodie-two-shoes in high school. I was more like her over-sexed friends. I got up, rinsed out the coffee pot, refilled it with cold water, and put it on the lit gas burner.

"So...why did you break up?" I assumed as much, seeing as how he wasn't my father. I had noticed over time my mother ranted about my father more and more. She probably hated men, like Grandma had. Ma would never understand my situation.

"Not long after the boys came back from Mexico, they were called up again. They were sent overseas. Deak was in France. In the fighting. He wrote all the time. And I wrote every day. He was a private, maybe First Class."

"What happened with him? When he came back from the service, was he changed?"

"He didn't change any. He was an alcoholic."

I wanted to scream at her, wanted to end the torment of listening to Ma's long, drawn-out recital. "But you loved him. A lot. What *happened?*"

"I picked up the Telegram one night and there it told about Deak's marriage. In Superior."

"He didn't tell you!?"

"He came to the house after he got married. That's when I had small pox. He wanted to come and explain. I wouldn't listen to him. I told him there was no explanation –to leave me alone. I didn't want to see him ever again. It was a terrible hurt, because I thought we were going to get married and evidently he didn't love me. He had the other girl on the string. She was from East End, where he had worked before the war. So he went away."

"He never tried to get in touch with you again?"

"No. I told him not to." She breathed a deep sigh, rose and scooped coffee into the pot on the stove, added the dry egg shells and lowered the flame. Sinking back onto the chair, she looked at me. I sensed there was something she was determined to say.

Questions burst from my lips. "You never saw him anymore? Did they have children? Did you keep track of him? Is he dead? Did they move away? Did you miss him? Did you cry?" I envisioned her sprawled across her bed sobbing hysterically.

"Oh sure. I was in bed for days crying." She was back there. Her gaze wandered somewhere beyond my shoulder.

"What did Grandma say when you broke up? It was way before my father, wasn't it?"

"Oh yah."

"Was Uncle Gunnar around? What did he think?"

"He liked Deak. He knew him from high school."

"What about Grandpa? Was everyone surprised that you didn't marry Deak?

"I don't know. I never talked to them about it. And no one asked."

"So who did you date after you broke up with him."

"Nobody. Nobody special." She got up again and poured us fresh coffee.

I knew the time had come. I knew she was going to lecture me. I made one last attempt to escape, to be her *pal*, like Grandma had been. "You probably weren't wrong. He probably was drunk all the time."

"He always promised he was going to quit drinking." Ma had

returned to the past. "Her name was McManus I think." She shook her head as if clearing it. "The point is, Fran you can't trust men. Once you do what they want, you're finished."

I was taken aback by the abruptness of her statement. "I haven't done anything Ma, honest." I felt my face flush. "Besides, it's different now, guys aren't like that." *She doesn't know anything. How can she? She's old, fifty-five already. She'll never understand.*

"They'll always be like that. Trust me. I know."

I knew differently. I knew my love would last. "I do trust you, but you don't trust me." I felt tears well, brushed them away with my fist. Guilt raged inside, and fear –fear that she could see through me. I was just no good. My agony increased. I felt sobs rack through me.

Ma came around the table, encircled me in her arms. "I only want what's best for you. You have so much potential. You could be a famous ballerina. I've always said that."

How can I? We're poor. Worthless. No one ever made it in our family. Besides, that's her dream. My thoughts brought another rush of tears.

My mother tightened her arms around me. "I'll never, EVER give up on you either. Remember that."

My head instantly cleared. *I'll change. Tonya has. She's going steady. She's in love. But... maybe it's too late. I really like guys. Ma hates them. And... there's so many adventures waiting. Ma calls them messes. She can't understand –eating her heart out for that one guy all these years. That's dumb. Alone and lonely. I have no intention to end up like that. Yet –I don't want to hurt her. I'll be more careful.*

As luck would have it, Ma got a job –dog sitting for the Wagnills, who lived on Sixtieth and Ogden. She spent eight hours a day there with Princess and Moccasin Mike, the two bulldogs of the childless, employed couple. The rest of her time was consumed with club meetings. My siblings and I were basically, on our own. ◆

The Blue And The Gold

Every gaudy color is a bit of truth. –N. Crane

I decided to switch allegiances after Ma's bombshell lecture. I would only get involved with Cathedral High guys –the blue and the gold. Then, I was sure, there would be little chance my Central peers, or my prissy, virginal sister, could learn of my antics. Little chance word would get back to Ma. I'd noted Day's snide remarks were getting too close for comfort, like, "I'm not as dumb as you think," and "I do hear things, you know!" In any case, freshman year had wound down. The annual dance recital would soon follow. Then I would be free for summer fun. In the meantime, my new plan required new friends.

Tonya had become a different person, one I didn't like. She no longer seemed interested in our snappish patter. Often she looked at me in disgust when I spat out our favorite epithet to our volatile tormentors, "Get screwed!" Once she focused her vacuous gaze on me and said, "Don't be such a juvenile!" I felt crushed by Tonya's meanness.

Dora had toned down, too. She and Tonya were wrapped up in comparing notes over their steady boyfriends. I couldn't understand why they'd let guys come between us. I hadn't done that while enthralled with Bud. I didn't think I would ever put him, or any guy, ahead of my friends. And though I wouldn't admit it, I felt envious. They had steadies. Bud was lost to me. I moved on, took up with some new girlfriends. I soon had my own little band of rebels. Among them were Madeline McDonough and Ella Cleary.

Madeline was an attractive girl, thin, with dark, thick hair. Her huge brown eyes seemed clouded with silent rage –especially when someone called her Maddie. Her ashen clear skin and fine features brought to my mind 1940s film star Hedy Lamarr. I liked Madeline's testy personality, too. More often than not her perfectly arched red lips, were curled in a sneer. She was a lackluster student who skipped school a lot, resulting in her catching the wrath of Miss Lemon, the Dean of Girls, who was the Booster Club advisor too. Those two positions put Miss Lemon on my list of arrogant authority figures. There

was something else that cemented my friendship with Madeline, though. She had a brother in the U.S. Army, stationed in Korea. I got his address from Madeline and immediately wrote to him:

Dear George:

My name is Frances. I'm a friend of your sister. I'm 5' 4" with light brown hair and gray eyes. We're in high school together. My favorite subjects are Art and English. I've been in dance school since age ten and dance in recitals every year. I like to dance a lot. Red is my favorite color. What's yours? It must be fun being in the Army. I would love to travel. I hope you will write to me.

Your friend, Frances.

I was thrilled to hear from George:

Dear Frances:

Thank you for your letter. I like to get mail. I'm eighteen. How old are you? I have dark hair and eyes and am 5' 7" tall. I'm sending a picture. Would you send me one of you? I hope you write again soon.

Your friend, George.

The picture showed Madeline's brother sitting on a crate in front of a tent, his rifle across his lap. His small, tight handwriting on the back stated, "Me cleaning my rifle, getting ready for action." George was the most handsome boy I had ever seen. After his signature I filled in a line of X's and O's and put the snapshot in my wallet. When I showed it around I told everyone he was my steady boyfriend. I was enamored with the idea of him being in combat, though I had no interest in what George was doing in Korea or in the events unfolding there. I sent him a picture Bella had taken of me. I was posing on the cement railing of the Highway 35 overpass, leaning back, my right leg on the railing and the left one dangling in front. My right hand held down my tangled hair. George wrote back, "You're a real cute kid!"

When I told Madeline, she said, "I'm glad you like my brother. He's kind of shy." She laughed then, "Maybe we'll be sisters-in-law someday." [7]

Ella was stout, five-foot-three, with a round face and pock marked skin. Her short-cropped hair was straw-colored. In spite of her heft, she appeared pixie-like due to pale, grape-like eyes and a pug nose. A timid girl, Ella had attended Cathedral High for a while, then transferred to Central. I was thrilled to learn that her brother, Boomer, was on Cathedral's Blue and White football team. "Maybe Boomer could introduce us to some of the Cathedral guys," I suggested.

"I doubt it. He thinks we're juveniles."

"We could ask him for a ride to a game or something," I said.

"Hmmm. I don't know."

Ella, Madeline and I were sitting on the base of the statue of James J. Hill in front of Central. We'd just finished our lunch, sandwiches brought from home and Cokes that we'd got out of the machine in school. Our eyes were closed, our faces turned to the sun. I felt its warmth on my face, imagined myself in a convertible, the top down, my hair flowing out behind me.

"I wish I knew someone with a car," Madeline said.

I opened my eyes, looked at Ella. "You DO! Ella's brother. Come on. Just ASK him, Ella."

"I suppose I could. What should I tell him?"

"We'll go home with you after school. We'll tell him I missed the bus. Then we'll get him to take us for a Coke. Where those guys hang out." I was the only one of the three of us who rode the bus. Ella lived with her family in an apartment above the Agnes Beauty Clinic on Belknap. Madeline lived on Nineteenth, between Banks and Oakes. They both walked home.

"He won't spend any money on us."

"He won't have to. We'll buy." I dug in my shoulder bag, pulled out change. "I've got about a dollar. What have you got?"

"Fifty cents," Madeline said. "That's enough."

"Great! Let's meet here after school." I got up and sauntered back into Central, the girls trailing behind me. The bell rang as we climbed the stairs. Separating, we made our way to our afternoon classes.

After school we three met as planned and promenaded west four blocks to the Cleary home.

I was awed by their place. I had never been in a downtown apartment. I especially liked the two huge windows that fronted Belknap street, envied the view. I imagined sitting there in the dark looking down on the street, imagined the street lights casting dim pools of light on the pedestrians there. I guessed it would be like sitting in a dark theater, watching a drama unfold.

After Ella introduced us, Mrs.Cleary, a small, quiet woman, disappeared beyond a door off the long, three-room expanse.

"She has to make dinner," Ella said. "My dad gets home at five."

Madeline and I sauntered around the small living room. I noted the unkempt cot in one corner, the dust-caked coffee and end tables. "Does your ma work?" I asked.

74

"Why do you care?" Ella sounded irritated.

"No reason. I just wondered." I smiled in good will, afraid Ella would put the kibosh on our plan.

Suddenly the door we'd entered off the long hallway behind us, flew open. "I'm home!" It was Boomer. He bounded into the living room, threw the books under his arm onto the cot. He was tall, with flashing blue eyes and wavy hair, one shade lighter than Ella's. Freckles spread across his long face. They thinned down his ruddy neck to the edge of the collar on his open, white shirt. His Cathedral letter-sweater made him seem bulkier than he was. His serious expression reminded me of Joseph Cotton, in The Third Man. I'd seen that movie when I'd daydreamed of being a spy, but identified more with the villain, Orson Welles, than with Cotton.

"Hi," I said. "I'm Frances and this is Madeline."

He didn't respond, looked over at his sister. "What do you guys want?"

Ella's face reddened. "Fran missed her bus. We thought you could give her a ride home?"

"Where does she live?" He sounded annoyed, brushed past us and looked down to the street.

"South End. I'll buy you a Coke," I said, sounding hopeful.

"What about gas? Cars don't run on air."

I was taken aback by Boomer's snide remarks. Silence briefly settled over us until Madeline blurted, "Oh for Christ's sake. This is stupid. I'm leaving." She stomped out of the apartment, slamming the door behind her.

"Nice kid," Boomer said, snorting. "Come on you idiots," he motioned to the door. "I'll give you a ride."

Boomer's two-door DeSoto was parked across the street on Belknap. Ella got in front. I squeezed past the passenger seat into the back, fell sideways as Boomer stepped on the gas and the car shot ahead.

As he braked the car at Ogden for the red light, I saw Madeline loping across the intersection. Her long hair wafted out behind her, her dolman-sleeved, shortie-jacket was wide open. She looked neither left or right. A dark scowl traversed her face.

"Let's pick her up," I said. "She has to walk all the way to nineteenth."

"Oh Christ!" Boomer still sounded annoyed, but when the light changed, he pulled alongside Madeline and hollered, "Hurry up! I haven't got all day."

Madeline raised an eyebrow, curled a lip and crawled in beside me. "Where we going for Cokes?" she asked, smirking.

"Wherever Boomer hangs out," I said.

"Oh, that's your game," Boomer said. "Looking for your boyfriends?"

I bristled. "We don't have any boyfriends. Like it's your business."

"Oh yah? I heard you got the hots for Beef Krittan."

Damn, word must have got out. "I know him, if that's what you mean."

"Oh?" Boomer looked over his shoulder at me. "Is that what you call it?"

"Oh shut up," I snapped. "You think you're SO smart."

Ella piped in, "Why don't you both shut up. You sound like a couple of juveniles."

Madeline and I laughed at Ella's unusual hostility.

"Yah. Ella's right." Madeline said. "Just calm it down, okay?"

I drew a deep breath. "I'm sorry, Boomer." I didn't feel one bit apologetic, but had learned early to acquiesce to guys just to keep the peace. "Where do you hang out?"

"The White and Blue.[8] They let you sit around half the night without eating. We'll go there." He turned the DeSoto onto Tower, raced it three blocks north. There he zipped into a parking space in front of the restaurant. "Just don't make asses of yourselves," he warned.

The long narrow expanse of the cafe's seven booths were overloaded with guys. Cigarettes dangled from the corners of their mouths, smoke hung in the air. They all looked up, checked us out. Someone shouted above the crowd, "Hey Boomer! Where'd you find all the jail bait?" I recognized Beef's raucous voice. When he saw me, his eyes wavered. He looked away. The four guys with him snickered. Like Beef, his friends were bulky and rough looking. I knew immediately that he'd spread the word.

"They're my sister's friends," Boomer said. "They're buying."

Ella, Madeline and I plodded behind Boomer single-file. I was relieved he walked past Beef and his friends. Boomer stopped at the last booth. There were three guys seated there, their heads bent over the straws in their Coke bottles. "Hey guys!" Boomer slid into the booth next to two of his friends, motioned for us to squeeze in the other side.

I went first, then Madeline. Ella stood looking at the small space left for her, "You sure you can't make more room?" She wedged herself in next to Madeline.

I moved closer to the guy on my left. "Sorry," I said as he squeezed himself against the wall.

"That's okay," he mumbled. I noted his deep, sensitive dark eyes and one-sided smile.

"That's Stevie Stefanski," Boomer said, nodding at the boy next to me. "This is Frankie Hoolihan in the middle and Hans Webber, on the end. They're Cathedral's pride and joy." The three guys mumbled their hi's.

"I'm Fran," I said. "This is Madeline and Ella."

"We know Ella," Frankie said. "She's the little sister, right?" Ella flushed, bringing chortles to all four guys.

I'd felt a catch in my throat at the sight of Frankie's dancing, raisin-brown eyes. They seemed overflowing with laughter. "SO. Are you all football guys?" I asked, making direct eye contact with him.

"All except me." Frankie smiled back with his eyes. "I'm a lowly freshman." His crooked nose gave him a kind of ruggedness that I liked. He reminded me of a grown-up Huck Finn, with his mottled, flame red hair and heavily freckled, ruddy face.

"But not jail bait, like us," I countered. That brought laughter all around.

Boomer turned and yelled for the waitress, who was serving Cokes to the over-loaded booth in front of us. "Can we get some service, here?"

The waitress gave Boomer a crushing look, her lips curling as she spoke. "How many Cokes this round?"

"Four," I piped up. "And I'll pay for them."

"That's a switch." She turned on her heels and stomped up to the high, front counter with its ten stools. A short-lived flame flared up from the grill opposite as Bob, the owner, threw a hamburger on it. I was surprised anyone would actually eat in this dingy, greasy-spoon cafe.

I turned my head away from the scene. "SOooo, Stevie and Hans are football heroes?" I flashed my widest grin.

Hans piped up. His voice was high-pitched and whiny, "Not us. Boomer is though. The girls are nuts about him!"

Boomer laughed. "Yah, like I go steady?"

"You could. But you're too smart," Hans countered. "You're always reading." I'd noted Hans' rounded shoulders, pale, acne-infested skin. He wore large, clear-framed glasses, magnifying pale, owl-like eyes. *Probably a brain.* The thought filled me with distaste. I never liked guys smarter than me, immediately concluded he wasn't my type.

I twisted in my seat, looked at Stevie. "You must be the quiet one in the crowd."

"He's being coy." Hans' childish cackle cemented my resolve to ignore him.

I did note a certain reserve in Stevie's dark eyes, like he was gazing into a private space. "Nothing wrong with that," I said, grinning at

him. He grinned back.

"I never get a chance to talk with these guys around," he said. His voice was deep and reedy, causing me to give him another glance. I liked what I saw.

"Just like when you're with Frances," Madeline snickered. "You never get a word in edgewise." I jabbed her in the ribs. She jabbed me back, "Knock it off." She sounded threatening.

I looked at Frankie and laughed. "It's tough being a star,"

He smiled a lovely, eager smile. "I know what you mean."

The waitress arrived with a tin Coca-Cola tray loaded with seven Cokes.

"I only ordered four," I said, sounding perturbed.

"Don't worry about it." Boomer dug in his slacks and extracted a five dollar bill. "I'll buy this time."

The waitress pulled out change from her apron pocket, slapped it on the table and stomped off.

"Nice gal," Frankie said. "Like your money's not good enough?"

"She's probably tired." Ella flushed as all our eyes focused on her. "WELL? You wouldn't like running back and forth all day!" I sensed her remark was aimed at me, wondered at the hostility in her voice. "I'm ready to go whenever you guys are," she said.

Madeline snapped, "Geez, we just got here." I wasn't surprised that her hostility matched Ella's. I glanced at Boomer's sister. She looked hurt. Madeline must have noticed it too. "Okay, okay." she said, "As soon as we finish our Cokes."

We all sucked on our straws in silence until the slurping noise of the last dregs of Coca-Cola signaled departure time. "I'm finished," I said.

"Let's hit the road." Boomer got up with us three girls. His friends stayed put.

"We'll hang out a little longer," Frankie said. "I'll see you around, Fran." As we made our way to the front door I glanced back. Frankie was leaning out of the booth watching me. Our eyes met. I waved at him. I knew in that instant I'd be hearing from him. Soon. ◆

7 - It would never come to pass. On August 24, 1950 the following article appeared on the front page of the Superior Evening Telegram: *Private First-Class George McDonough was killed in action in Korea on August 12, according to word received by his mother from the War Department. Mrs. McDonough had received five letters from her son on August 8 and in them he related experiences he was having in Korea, but did not mention where he was stationed.*
8 - 1212 1/2 Tower (the other half of the building housed the American District and Western Union Telegraph companies).

Foreplay

It was the lark, the herald of the morning. –Shakespeare

The following day, the rest of the Central students and I blasted out of our high school doorways, the final buzzer blaring behind us. I noticed a crowd gathered on Grand Avenue. I beckoned to Madeline and Ella, straggling behind me. "Come on! Let's check out the excitement."

We pushed through the mostly male throng. They were jammed in a tight knot around a sparkling-black, Model-A Ford. Murmured oohs and ahhs filled the space. "Where'd you get this lu-lu?" Someone asked. "Who fixed it up?" "Does it run good?" The questions came so fast I couldn't catch if anyone was answering.

I shoved forward through the crowd. There, leaning against the open door, stood Frankie Hoolihan. His foot was on the running board, his pant-leg hitched above his white sox and scruffy, brown loafers. I noted that the thin belt on his tweed trousers was too long, the pants themselves baggy. I immediately suspected that they were hand-me-downs and felt a twinge of pity for him.

"Hey Frankie," I hollered, waving my hand.

A wide grin filled his ruddy face. His eyebrows rose in obvious pleasure. "Hi! Wanna go for a spin?" He hauled up his pants and crammed his white shirt down inside. My eyes fixed on his muscular, freckled forearms, revealed beneath rolled-up shirt sleeves. Brushing back a curl on his wide forehead, Frankie stood to his full five-foot-six height. His hands fisted on his hips, legs set apart like a drill sergeant. "Let her through!"

The crowd parted. I ambled up to Frankie. "Can Madeline and Ella come too?"

"Sure! The more the merrier!" He opened the passenger door, bowing as he motioned me to get in. The guys in the crowd hooted as I put my foot on the running board and Frankie held my elbow, assisting me into the front seat.

Madeline vaulted into the back. Ella carefully wrapped her long, full skirt around herself, bent down and slid in next to Madeline.

Frankie sauntered around the front of the Model-T. My throat caught at the sight. There was something rugged and appealing about his loose-boned, easy gait.

The car tilted as Frankie jammed his broad frame behind the wheel and turned on the ignition. He clutched the stick-shift, jiggled it into gear. I slid closer. His huge hand, clasping the black knob, smacked my knee. "Sorry," he said. The car quivered and began to move. "She takes a while to get going."

I turned my head, saw a phony smile cross Madeline's perfect lips. "Do you think we'll make it," she sneered. Ella giggled, quickly covered her mouth with her hand.

"No problem!" Frankie turned the car left at the corner. We circled Cathedral of Christ the King and entered the slow moving, westerly traffic on Belknap. "Where do you girls want to go?"

"How 'bout Pattison," Ella piped in.

In the rear-view mirror I saw Madeline feign an open-handed slap at our friend. "Idiot! It'll take all night to get out there!"

Ella ducked. "You're so mean," she said, moving closer to her side of the back seat.

"What's your problem?" Madeline sounded surly. "You got the curse?"

Afraid she was embarrassing Frankie, I twisted in my seat and glared at her. "For Pete's sake! Be nice."

"No problem," Frankie said. "I got sisters. They're always acting up." His smile broke like sunshine across his face, filling me with longing.

"We could just swing through Billings Park, couldn't we?" I was imagining the two of us strolling hand-in-hand along the narrow paths there.

"No problem." Frankie pressed the gas pedal to the floor. The Model-A shook across the intersection at Belknap and Tower. "Gotta get a little speed up to make the overpass." Frankie pumped the pedal again. We creaked up the incline, rattled along the top of the concrete span. Below us the Lake Superior Terminal and Transfer Railway Company yards were bustling with activity. Row-on-row of boxcars bumped slowly along on the winding tracks, switchmen at their posts, linemen waving flags like football fans at an afternoon match. The Model-A slowed at the crest of the steep hill. Frankie pulled back the gear-shift. His hand hit my knee again. A locomotive below suddenly blasted its shrill whistle. Covering my ears against its agonizing wail, I

barely heard Frankie shout over the din, "Hang on! We're heading down!"

The car shot ahead and jolted down the incline. Madeline and Ella shrieked like roller coaster riders. I looked over at Frankie and shouted, "A couple of idiots!"

The Ford slowed to a snail's pace. Frankie pumped the gas pedal and shifted into gear again. The car groaned forward.

"Geez," Madeline yelled. "Are you sure the damn thing won't stall?"

"No problem," Frankie shouted. He glanced at me and winked. His lively, smiling eyes filled me with a surge of desire. "We're almost there." Just before the entrance to the Arrowhead Bridge, he turned the car south. We bounced past the driveway leading up to the Gitche-Gumee Club. I didn't hear a peep out of my friends in the back, but imagined Madeline, lips curled, teeth gritted, rolling her eyes at Ella. I was grateful she didn't make any snide remarks. The car weaved and shook. Frankie adroitly steered it along the wide curves, past the tightly wooded expanse of the park.We rattled over the stone bridge at its entrance onto the blacktop roadway.

I turned and looked at my friends, willed myself not to sound sarcastic, "See. I KNEW we'd make it."

"Barely," Madeline sneered.

Ella leaned forward. "I think it's fun!" She lowered her voice. "Frankie is SO cute."

After we parked, the girls headed for the first point. I waited for Frankie to exit the car, then led the way to the steps that descended to the bathing beach. "We can sit and watch the kids."

"Sounds good. Too bad we don't have swimming suits." He caught up to me, touched me in the small of my back. "I'd love to see you in one." I smiled up at him as we descended the stairs. The beach was empty.

"I wonder where everyone is?" I made my way to the first row of concrete steps that led up the hill from the beach. A clump of birch trees alongside the steps cast mottled shadows over the flat surfaces. The low hanging foliage on their branches slowly wafted in the breeze, beckoning us. I sat under their canopy.

"They're probably home eating," Frankie said. He lowered his bulky frame next to me. I felt his thigh against mine, felt a surge of heat. He put his muscular arm around my waist, pulled me close. His lips tasted like spearmint. I relaxed and let the familiar surge of rapture transport images across my mind. I saw us kissing, imagined us lying on a

bed of moss, imagined strains of the theme music from Gone With The Wind. I leaned back. Frankie's lips moved to my neck. I envisioned Rhett Butler sweeping Scarlet O'Hara up Tara's winding staircase. I lifted my hands to his shoulders, clung to him. The tingling effect of contact blazed through me. His mouth was at my ear. "We should find some bushes," he whispered. "In case your friends show up."

We moved along the path away from the beach staircase, sauntered up an overgrown, steep, rutted trail that led back to the parking lot. Halfway up the hill Frankie took my hand and led me through the undergrowth to a dense circle of bushes. "This looks good." With his arm around my waist, he guided me to a moss covered space. "Nobody will see us here." He kneeled down, put out his hand. I clasped it, felt his strength. Lowering myself next to him, we kissed. Tumultuous waves of passion surged inside me.

"Pull up your skirt," Frankie said. "We'll have to make this fast." He unzipped his pants. I followed his instructions, lifted my full ballerina skirt to my waist. He rolled on top of me, slid my panties to my knees. Instinctively I lifted my hips in invitation, felt the heat of his body radiating toward me. I closed my eyes, felt the rhythm of sex beating inside as I molded myself against his body. The surging physical excitement was over in a flash. "I gotta go leak," Frankie said. He jumped up and disappeared behind a tree. I rose, yanked up my panties and straightened my disarranged clothes.

Just as Frankie returned, I heard Madeline yelling, "Fran! Where are you?"

"That was close," Frankie said. Circling my waist with his arm, he guided me up the steep path.

Madeline was standing at the top of the sloping bluff. "What were you guys DOING?" she shouted.

"We took a stroll along the beach," Frankie said.

"Oh yah? WE didn't see you." She turned and yelled for Ella. "They're here! Must've had a quickie."

"Geez, Maddie," I said, "Get your mind out of the gutter."

"ME! You're the slut. And DON'T call me Maddie. EVER." She stomped back toward the car.

"She's such a bitch," I said, smiling at Frankie.

He pulled me close and kissed me. "You're the only one I'm interested in." He squeezed me tight again. "We'll have to come out here at night. Alone." ◆

After Play

And it must follow as the night the day. –Shakespeare

Frankie called me early the following evening. His voice sounded hoarse and tinged with warmth. "Can I pick you up tomorrow night?"

A shiver of excitement coursed through me. "I guess so. But it'll have to be after nine. Thursday nights I'm at Braman's. For dance classes." I held my breath, hoped he wouldn't change his mind.

"I can handle that." His words had music in them. "See you then!"

I hung up the phone, felt a tingle of anticipation at the image of Frankie and me together. It was then I noticed Ma standing in the kitchen doorway. There was an odd mingling of sadness and wariness in her pale, blue eyes.

"Who was that?" she asked, moving to a kitchen chair.

"Madeline," I blurted. "We're going on a double-date tomorrow night. To the movies."

"On a school night? And what about your dance classes?"

"I don't have any homework," I countered. "And Mae will let me out early so we can catch the last show." I moved to the table, sat across from her and lit a Pall Mall. "Besides, I'll be home by midnight." The niggling guilt that always settled in me when I lied, returned.

"Which movie?" She spoke slowly, her voice pensive, like she was feeling her way. "In case I have to get hold of you."

"I don't know. Probably something at the Beacon." I blew a smoke ring into the air, watched it float past the table and diffuse.

Ma frowned. "I wish you wouldn't smoke, Fran."

"You said I could as long I paid for my cigarettes myself," I spouted. Instant guilt descended. I jumped up and stubbed the cigarette out in the sink behind us. "Want some coffee?" I asked, hoping to dispel the tension.

Ma raised herself with glacial slowness. "I'll do it." She moved to the stove. "I brought some hotdish home from the Wagnells. We can heat it for supper." She stood at the stove preparing the coffee in a pose of weary resignation.

Watching her, it occurred to me that Ma was drowning in the uncontrollable circumstances of her life. Worse, I wasn't willing to do anything to help. I racked my mind for something cheerful to say. "Why don't you play your piano tonight?"

She seemed to perk up. "I guess I could. But maybe Day and Howie won't appreciate the racket."

"Racket! You play beautifully!" I beamed at her. "The hell with them, anyway. They're nitwits." I jumped to my feet, encircled my arms around her waist. "No matter what, Ma, I DO love you."

"I know," she said in a flat, toneless voice.

After supper Howard, as usual, bolted from the room. He yelled back to us from the parlor on his way out, "I'll be at Spenser's, working on his cars!"

Day rose and dumped her dirty dish in the sink. "I'm going downtown. To meet my friends."

"What friends?" Ma demanded.

"Sondra and Nellie." She sounded belligerent.

"Don't get sassy with me, young lady," Ma countered in her best, authoritative voice. "I just like to know who you're with."

"Don't worry, you know them." My sister glared at me. "Too bad you don't care who she's with. But then I'm not perfect, like her." She rushed from the room before Ma could respond.

I helped clean up the kitchen. Ma seemed to unwind in my company. "It's so nice having you to myself," she said. "I wish we could spend all our evenings like this."

"I wish we could, too... but... with school and dance classes twice a week and..." I stopped short of saying guys, "...you working," I continued. "It's not easy." I felt a hard fist of guilt grow in my stomach.

"I know." Ma wiped her hands on her apron, pulled it over her head and hung it on the hook behind the back door. "Let's just enjoy tonight. Tomorrow's another day."

At her piano Ma drummed out her favorite, ancient pieces. Much of the sheet music was tattered and patched with yellowed, Scotch tape. I turned the ragged pages and leaned forward to read the words as we sang the verses together, to *Memories*, *Love Ship*, and *Among My Souvenirs*. Souvenirs was my favorite among those sentimental titles. I especially loved the line, "...I find a broken heart amongst my souvenirs," as it reminded me of my first love, Bud Winston. Thoughts of him brought an ache of regret to my throat. Glancing at my moth-

er's face, I noted how she pinched her lower lip with her teeth. I wondered who she was remembering...her first love? Or, maybe my dad? I didn't dare ask, afraid to disturb our bliss.

When she'd had enough of remembrance, Ma banged out livelier numbers, nodding to the beat. *Alexander's Rag-Time Band* topped the list, followed by WW I relics. I knew those pieces were really old, as they had her maiden name, Marie O. Larsen, scrawled in her perfectly looped handwriting, above their titles. Our voices bounced off the ceiling as we sang the words to, *Good-bye Broadway, Hello France, Over There*, and *When Johnny Comes Marching Home Again.*

At Ma's urging the performance ended with numbers from recitals I'd danced in. I cleared a space in the dining room and rolled back the rug. Donning my tap shoes, I bounced through *Bloomer Girl, Harrigan, Turkey In The Straw*, and *The Varsity Drag*. The last number always brought our puppy Kawlija tearing out of his box behind the heater. He nipped at my feet and yapped incessantly until I stopped. Exhausted, I fell onto Howie's bed gasping for breath, Kawlija wriggled next to me and licked my face. Ma jumped to her feet and clapped her hands in admiration. "You are so talented!"

We retired to the kitchen to enjoy a cup of coffee together. Amazed how fast the time had flown, and afraid Ma would want to bring up the subject of my next night's date, I feigned a splitting headache. "I'd better get to bed, now," I said.

Ma sighed in agreement. "It was such a lovely evening. Thanks to you." She rose and extended her arms. I glided into them and embraced her. I felt an overwhelming relief that everything was back to normal. "You go ahead," Ma said. "I'll wait up for Day and Howie."

In my upstairs hideaway, film clips of my anticipated date with Frankie flashed across my consciousness. None of them came close to matching the actual outcome. ◆

Mooning

Let us make an honorable retreat. –Shakespeare.

The Model-A was parked in front of Braman's the next night. Frankie lolled against the passenger door as I exited the studio. I strolled up to him, swinging my red vinyl hat box alongside me. "Hi Frankie! How's it going?"

"Great." He opened the passenger door for me. "How come you got slacks on?"

His interest in my clothing nettled me. I thought I looked sexy in the hip-hugging pants. "They're not slacks. They're peddle-pushers," I snapped. I'd even tied my yellow blouse just below my breasts, leaving a triangle of skin showing. *You'd think he'd comment on that.* "I always wear these after class. They're comfortable."

"I like skirts," he laughed.

Ignoring his remark I slid onto the front seat, pulled my hatbox in after me and threw it in the back. Frankie slid in beside me. Noting his baggy corduroys and wrinkled T-shirt I was tempted to tell him he looked like a bum, but didn't.

"I could have dressed up," I said. "But I didn't think we were going to the movies." My gibe sounded snappish, but didn't seem to faze him.

"No problem." He turned on the ignition. The Ford rattled out of the parking space and crawled south on Tower Avenue to Twenty-first Street. "We'll take a different route tonight." I wondered at the oily tone that had crept into his voice.

"What's wrong?" I asked. "You sound different."

"Different than what?" He shifted the gear and pumped the gas. We were ascending the Twenty-first Street viaduct. The car jerked along like a gimpy sailor. "You're the one that's different."

I decided that he was probably right. "I guess I'm just tired." I leaned toward him, put my head on his muscular shoulder.

"That's more like it," he said.

By the time we entered the park, night had fallen. Thick clouds obscured the moon. The dim headlights of Frankie's car extended

barely a foot in front of us. We passed the main entrance. "Where we going?" I asked.

"Down the road. There's a perfect spot by the second point."

"You mean the Girl Scout Circle?" I remembered the area. I'd spent summer picnics there during grade school. It was called Girl Scout Point –a circle of brick benches on its apex, surrounding a fire-pit. An uneasiness crept inside me. I was sure it would be a major wickedness to defile that sacred place where virginal girl scouts probably still frolicked and roasted marshmallows, like my troop had done.

"No, the next one," Frankie said.

I was at once relieved and wary, glad he knew where we were going. All the while I wondered at the vastness of the park grounds, wished I was more sure of my bearings. Soon the car rattled off the winding trails and pulled to a stop. Looming trees cast monstrous silhouettes against the dim sky.

Frankie and I got out of the car. Closing the door, I leaned against it, waited for him to make the next move. "Now what?" I asked.

"I'll just grab a blanket," he said. "Then we'll find my favorite spot." His shoes crunched on the graveled roadway under him.

"What about wood ticks?" I'd suddenly envisioned creepy, crawly insects attacking us.

"It's too early for them," Frankie said, taking my hand. "Don't worry, Frannie. It's safe here." I blanched at his use of that hated name, but didn't say anything.

He walked briskly into the dense forest, hunching his shoulders to avoid the low tree branches. I swayed slowly along behind him. I was afraid to break the threatening stillness that closed in on us. My mind drifted to textbook pictures of near-naked savages silently plodding barefoot along narrow trails. I peered into the darkness, which, with each step of rustling leaves under our feet, deepened. A strong odor of musk and night dew filled my nostrils. We seemed to be on a high bluff. The treetops above us stirred like whispering voices. It all felt strange and haunting. The back of my knees began aching as we descended further and further down the incline.

"Take it easy, now," Frankie said, "It's real steep here." We reached a break in the trees. I could just glimpse the clouds above us.

"Okay, this is the spot." Frankie spread out the blanket. I immediately began undoing my peddle-pushers, pulled them and my panties down, anxious to get it over with and escape our spooky surroundings.

Frankie must have been thinking the same thing. He undid his corduroys, pulled them down. His white shorts gleamed in the darkness. I turned my head as he took them off. I was about to lower myself to the blanket, when suddenly, the entire area blazed in floodlight. Disconcerted, I briefly wondered which of my starring ballet-performance-positions, I should assume. Frankie's voice brought me back.

"GEEZ!" he bellowed, "Let's get out of here!" He grabbed my hand and stumbled ahead, holding onto his pants with his free hand. I caught a glimpse of his bare behind, pale and shiny under the brilliant spotlights.

Jolting behind him with one hand on my peddle-pushers, I tugged them to my knees as I ran. Hesitating for a second, I let go of Frankie and pulled the pants to my waist. He grabbed my right hand again. With the left, I held on to the waistband of my peddle-pushers. We cast giant, jerking marionette-shadows in front of us. All the while people shouted out of the brilliant light behind, "STOP! HOLD UP!"

Frankie and I rushed ahead in lunatic flight until suddenly, he stopped in mid-track, as if he'd remembered something. I fell against his back. He turned and, with me blocking the light, pulled up his pants.

"Geez," he said, "I forgot. There's a cliff down there. We could of ended up in the bay!" He sounded breathless and frightened. "We'll have to face the music."

A movie scene immediately flashed across my mind –G-men in front of their antiquated cars, their Tommy-guns at the ready. Dread flooded my mind.

We stumbled our way up the incline, Frankie in the lead like a lumbering Kodiak bear. I kept in his shadow as much as possible, hopeful no one would recognize me. The spotlight followed our every move, making it impossible to see. We both kept our heads down. Our eyes focused on the overgrown footpath until we were out of the woods.

I was relieved to see we were right next to Frankie's Model-T. There was a vehicle parked behind it, impossible to identify in the brilliant harsh light that never wavered. I turned my back. Frankie raised his hands in a don't-shoot pose, then stage whispered to me, "You go ahead. Get in the car." With my foot on the fender, I scowled into the spotlight. Raucous laughter broke out, but no one spoke.

Frankie sauntered back and disappeared into the relentless glare. Seconds later I heard low voices and more raucous laughter. When Frankie returned, he said, "At least it wasn't the cops. Let's get out of

here." It seemed hours before the old Ford kicked in and we were on our way out of the park. The spotlight went out, but the vehicle behind us didn't move. I didn't dare look back at it.

"Who were they?" I asked.

"Nobody important," Frankie said. I immediately suspected they were his Blue and Gold Cathedral buddies, but didn't say so. I was already scheming to drop Frankie. Both of our interrupted, disastrous adventures were scary enough to make me decide we weren't meant for each other. Besides, he was only a freshman. My sights were set on senior jocks.

The oncoming summer of 1950 would bring plenty of opportunities to achieve my goal. ◆

Season Sweep

*I know I am but summer to your heart
And not the full seasons of the year.* —Millay

At the June, "Starlets of 1950" recital, my *Deep Purple* toe-dance-solo brought raves from the audience of relatives. I was thrilled to receive a huge bouquet of flowers from my teacher, Mae Sterling. That short-lived, electrifying moment never quite matched those that followed, though. Out of school, with dance classes behind me until August, I was ready for fun with a capital F.

My summer frolics were a veritable *MacNamara's Band* of Irish-Catholics, with a few Polish Catholics thrown in for good measure. The first was Stevie Stefanski, followed by guys with nicknames like, Hoop, Jimbo, Moose, Rat, Tex, Weasel and Worry. Their nicknames brought to my mind the monikers of Times Square characters in the Damon Runyon stories I was reading. Stevie's was the only real name. Our encounter was typical of the hormonal hysteria that consumed me that summer.

Bella and I were on our regular Sunday afternoon stroll out Highway 35 to Greenwood Cemetery. My sister, Day, was with us. That came about at home, when she insinuated her way back into Bella's confidence by saying, "How come you never ask ME to go with?" I knew she knew she had a chance with Bella. They'd been friends first.

Ma made matters worse by urging, "You girls really should have an older person with you. In case someone tries to pick you up."

Thinking to myself, *that's our plan*, I glanced at Bella. The familiar little purse of her lips told me she was thinking the same thing. In any case, I never thought of my sister as a guardian. To me she was a juvenile and scared of her own shadow. But I didn't want to upset Ma and cause a scene. So, reluctantly, I agreed to let Day tag along.

My sister and I bickered all along the route past the city limits to the highway overpass. Our verbal thrusts and accusations kept culminating in childish snipes like, "Did too!" and, "Did not!" or "Shut up!" and, "You shut up!" Finally, sounding exasperated, Day asked, "How come

you don't like me?" Just beyond the overpass she and Bella stopped. Day's languid eyes, which were exactly like Ma's, took on the same soulful guise. "We're sisters. We should be friends."

Detesting the way Day fawned around people she wanted as friends, I refused to fall into her trap. "I don't like goodie-two-shoes for one thing," I said. "AND...you've got no tact."

Day frowned. "It's called honesty. You sure don't have THAT. You're always lying."

I bristled from her accusation. "YOU'RE the liar. Making everyone think you're a virgin. Give me a break!"

Bella snickered. "She IS your sister, you can't get away from that."

I scowled at my friend. "I don't see you hanging around with your sister!"

Bella glowered at me. "Oh yah? She's only nine. How am I supposed to manage that?"

Day laughed. I slapped my sister's arm. She whacked me across the back. "Geez, take it easy," I said. "An amazon like you could hurt someone." My sister screwed up her face and stuck out her tongue. I extended my middle finger at her. "You see, Bella? She IS a juvenile. We should have left her at home."

Day blurted, "Yah? You'd like that. So you could pick up some guy and screw him."

My sister's words disarmed me. I had never heard her talk like that. "SEE!" I shouted. "I KNEW you were a bitch. You've probably screwed plenty of guys yourself!"

"I have NOT!" Day's face glowed pink. "I intend to get MARRIED before I lose MY virginity." She picked up her pace, walked ahead of us down the highway.

I looked at Bella. "She's SUCH a creep. Wait and see. She'll ruin our fun." Infuriated at my sister, I hollered at her back, "You run around with a bunch of sluts, you know. Birds of a feather, stick together!"

Day stopped and waited for us to catch up. In a low, threatening voice she said, "You watch your mouth. Sondra and Nellie are nice girls." I clammed up, anticipating the words she always spouted when she got mad at me. "There's plenty of things I could tell Ma about YOU!"

Sick of her constant threat, I raised my voice, "Oh yah, like WHAT!? Spit it out!" Noting Bella's eyes widen, I hoped Day's revelations wouldn't turn her against me. I enjoyed our jaunts together,

enjoyed my role as leader alongside her tenuous role, as follower. I was sure, given the chance, she would love to take the lead.

Day broke my thoughts, "Like your NON-VIRGIN club!?"

"Oh for Pete's sake. That's a JOKE!" I glanced at Bella. A shadow of a smirk crossed her lips. I knew then that she was on my side. "You see? My sister's not only a juvenile, she's dumb." Silently vowing to be more careful around Day, I waited for her next barrage. It never came.

A car had slowed across the highway during our squabbling. It was rusted and dirty. I couldn't even make out the model. Bella shouted, "Hi guys! Where you going?"

The car stopped. It was then that I saw the occupants in the front –Stevie Stefanski was driving. Frankie Hoolihan was next to him and Hans Webber was on the end. Frankie hollered, "Come on Frannie! We're going to Pattison."

Day hesitated. "Do you know them?" she asked.

I assured her, "They're nice guys –from Cathedral."

We bolted across the highway, with me in the lead. We regrouped behind Stevie's clunker and ambled to the passenger side. I heard Frankie say, "You get in back, Hans. I want Frannie up front." I blanched at his familiarity. He and Hans got out. Frankie clasped my arm. I shook off his hand and slid in beside Stevie. I noticed two other guys in the back seat. "Who are they?" I asked.

Bella piped up, "I know one of them. Collie Bodin. He's a senior at Cathedral."

"The other one's Jake," Hans said. He looked at my sister. "What's your name?"

"Maizie," she said, using the name her friends called her and one that I detested.

Frankie slid into the car, next to me. My sister and Bella were still standing on the highway shoulder. Frankie twisted in his seat. "You girls will have to pick a lap," he laughed.

Bella leaned down, looked inside the car. "What's your last name, Jake?"

The guy furthest over, clothed in Army fatigues, said, "Jansen."

Bella scrambled into the back, crawled over Collie and settled on Jake's lap. My sister was still hesitating.

I hollered, "Oh for Pete's sake. Get in."

I heard Han's squeaky voice, "You can sit on my lap." He squeezed in beside Collie. My sister followed. She carefully lowered

herself onto Hans' lap. Somehow I hated what I figured were her goodie-two-shoes tactics.

I looked at Stevie Stefanski, who, like me, had turned to watch the back seat maneuvering. I felt a flutter inside at the sight of his dark, gorgeous eyes. They were soft, watchful eyes, that missed nothing. Velvety thick eyebrows shadowed them. I detected an exotic appeal in Stevie's gaze. Noting his slightly cleft, square chin and full lips, I imagined those lips on mine. I edged closer to Stevie. He turned on the ignition and started the car. The vehicle rattled south to Pattison.

After we reached our destination and piled from the car, we headed toward the beach. It was a warm, breezy afternoon. The park was overflowing with picnickers. Families were gathered in groups, some at the wooden tables, some standing over stone grills, others playing softball or catch. Small children ran pell-mell across the grassy expanse, screaming and tackling each other.

Bella and Jake led the parade. They strolled alongside each other looking mismatched, with her in a tight, starched overblouse and carefully pressed peddle-pushers. I suspected she, like my sister, even ironed her bobbysox. Jake looked bedraggled, his fatigues wrinkled and grubby. I guessed he'd just returned from some grueling Army camp-out and hadn't had time to change.

My sister looked prim in her white blouse, carefully tucked inside shiny-clean overalls. She gazed at Hans like a love-sick cow. Her freckled, make-up-free face exuded a healthy glow. The sun reflected off her glossy-red, short hair. Pulling my hand across my own straight, dish-water blond mane, I became acutely aware of my wrinkled, full skirt and peasant blouse. I always thought the gypsy costume from two recitals ago was exotic looking. Now I wasn't so sure.

Collie was strolling alongside. He had a squat wrestler's body and a pale, moon-face. His crop of kinky, auburn hair was oiled down and reeked of Vitalis hair tonic. Every so often my sister glanced at him and grinned. I knew she was reveling in the attention from who I was sure she perceived as two eligible suitors. She glanced back at me every so often and smiled her simpering, "Look at me," smirk. I decided to ignore her.

Frankie was attempting to hold my hand. I brushed it away. We were nearing the park pavilion. I slowed my pace. Stevie, who had been tagging a little behind Frankie and me, caught up to us. "Let's go hike... around by..."

Frankie interrupted him. "I gotta take a leak before we do anything." He bounded toward the men's room.

Stevie finished his sentence, "...the falls?"

I tilted my head in the direction of Big Manitou. "Come on!"

Stevie looked around. "Where'd everyone go?" he asked.

I put my hand on his and gave it a little tug. "Probably down to the beach. We can meet up with them later."

Stevie hesitated. "What about Frankie?"

"Forget him," I said. "He'll find us if he wants to."

Stevie sounded hesitant. "I thought he was your boyfriend."

I forced a light and trivial tone into my voice. "I don't HAVE a steady boyfriend. I like to experiment." I widened my smile, looked into his eyes. "Come on. I don't bite."

Stevie relented. We hurried around the pavilion, sprinted across the spacious green lawn in front of it and bolted across the highway. The clamor of voices and fun-making on the east side of the highway behind us ebbed. We slowed and followed the narrow, winding trail downhill next to Big Manitou Falls. The noise of its roaring waters matched the tingling exhilaration I felt at escaping our companions. I extended my hand. Stevie clasped it. His hand was warm and moist.

Other couples were strolling the well-worn trail, their arms entwined. We moved slowly past them.

Stevie hesitantly put his arm around my waist and guided me to the last lookout below the falls. There we stood gazing at its plummeting waters that always reminded me of root beer. I raised my face to him. Lowering his head, he kissed me. Waves of desire, like the misty spray spewing up from the falls, spilled through me. I clung to him, felt the familiar surge of longing.

Stevie guided me to a concrete bench alongside the railing. Sitting there close against him, lyrics sang in my head..."*Lover, when you're near me...*" We kissed again, heard voices. A couple strolled past. They leaned against the railing and embraced.

Stevie pulled away from me. "So," he said, "Are you enjoying your vacation?"

"Yah," I said. "But the time's going so fast."

"I know. Pretty soon we'll be back in school."

I searched his dark eyes. "I thought you already graduated."

Stevie was gazing into the near distance. "I'll be a senior this year," he said.

I brought up my sweetest smile. "That'll be an exciting time. With football, I s'pose?"

He grinned. "And boxing, and Drama and the Student Council. I'm going to take Forensics, too. And Debating. Who knows? I might even get on the Prom Court or the Carnival Committee."

I winced from his recital of activities, realizing he was more than just a jock. He was an all-round star. "I suppose you're a good student, too?"

"I've been on the honor roll for the last three years. Hope I can keep it up. They say the last year's the toughest."

I felt a twinge of regret at his revelation, thought, *I could do that if I wanted to.* "I wouldn't know." I said. "I was only an honor student for one semester." I heard myself asking another question, one I didn't want an answer to. "So? Are you going steady?"

"Sort of," Stevie mumbled. "Well...yes." Then, as if in apology, "We've been dating since junior high."

Feeling a pinprick of annoyance, I blurted, "Do you have sex with her?"

Stevie reddened. "Oh no! She's a nice girl." Pearls of sweat gathered above his upperlip. He wiped them away. "I...you know what I mean," he mumbled.

I sure do, I thought, but couldn't formulate the words. "I guess she's like my sister," I said. "Saving herself for marriage." I briefly wished I'd done that, realizing what a good catch Stevie would have been. Music roared in my head..."*Til the end of time. Til each mountain disappears. I'll be there for you, to care for you, through laughter and through tears...*" Regret filled me that I'd not met Stevie sooner. I banished that thought. *Get real. Love never lasts*, replaced it.

Stevie's hand on mine cleared my head and brought me back. "I hope I didn't offend you," he said.

"Why would you think that?" I didn't wait for an answer. "I know lots of guys like you. You're too serious. Lighten up." I noted a flash of –was it pity?– in his angelic eyes. I looked around. The couple had moved on. "So, I said, "Are we going to do it or what?"

Stevie blushed. His handsome face took on a shy expression. "Here!?"

"We could go back and take that footbridge to the other side of the falls. Nobody walks there." I drew my lips in a tight smile and glanced at his face again.

A secretive look flashed in Stevie's dark eyes. "I'm game," he said.

Fair Game

On the other side of the falls, we hurried along the overgrown, empty paths. They wove deeper and deeper into the forest of thick brush and trees. The thundering noise of the falls behind us faded like a far away echo. We stopped when the trail fell away into a rutted, unpaved path. Brushing aside the overhanging foliage, Stevie grabbed my hand. He led the way to a huge fir tree. Most of its lower branches were gone. "This looks good," he said. "You can lean against the trunk. Then your skirt won't get dirty."

I stumbled through the brush and stood beside him, thinking, *This is a first.*

He encircled me in this arms. Our lips met. The heated passion I usually felt eluded me. Even as his hands moved up and down my body, I felt my concentration slip. I dutifully backed against the tree trunk though and raised my skirt. With my eyes closed, I gripped it's hem between my teeth. I felt Stevie's hands pull at my panties. He crushed me to him. He was trembling. I felt an uneasy embarrassment for him and tried to call up pleasant thoughts. They eluded me, too. All I could muster was a terrible pity for him. It quickly transferred to his unknown girlfriend. *God*, I thought, *She'll never know what she's missed.*

His inept lovemaking quickly over, Stevie disappeared into the woods. I wiped myself with my panties and flung them into the brush.

Stevie came lurching through the trees opposite. His eyes evaded mine. Glancing at his watch he said, "We'd better go. They'll be looking for us."

We tramped back along the narrow trail and crossed the highway. Stevie walked in front of me, his pace so fast I couldn't keep up. Up ahead, I saw my sister. "There's some of them," Stevie said, sprinting away from me.

My sister was sitting on a bench overlooking the beach. Hans and Collie sat on either side of her. She was chattering in baby talk to two towheaded toddlers whose parents stood nearby beaming at the attention their darlings generated. *Typical, of Day*, I thought, *flaunting her so-called maternal instincts for the benefit of those guys.*

I bounced up to the group. "Where's the rest of the gang," I asked.

My sister looked up. "What do you care. You and Stevie took off like bats out of hell."

Hans piped in, "Yah. Frankie's all pissed."

Before I could snarl back, Stevie spoke. "We took a stroll down to the falls. I thought Frankie was behind us."

Just then the object of our conversation came loping down the hill. "Geez," Frankie hollered, "Where'd you guys take off to?" He looked wild. Seeing his unkempt hair and frowzy clothes, I wondered what had ever attracted me to him.

Bella came tripping along, her hand in Jake's. "Where did you guys disappear to," she asked, sounding like she didn't care one way or another. She rolled her eyes up at Jake. "We walked through the whole park twice."

Feeling aggravated, I barked "Geez, can't a person take a damn stroll without the whole world going ape!?"

My sister put in her two cents worth, "Ignore her. She's always crabby."

I bristled, "Shut up! All of you." I ran up the hill and burst into the park pavilion. At the concession stand I pulled a dime from my skirt pocket and bought a vanilla ice cream cone with a sugared cherry on top. As I exited the pavilion, Bella and my sister came sauntering along, chattering like bosom buddies. The sight nettled me. All five guys were traipsing behind, their voices low and secretive. I hoped I wasn't the subject of their conversation.

I moved ahead, ambled toward the parking lot. All the while I slowly licked the dripping ice cream off its crispy cone. Bella and Day caught up to me. In a peevish tone of voice my sister said, "You could've bought us a cone."

I smirked at her. "What about your boyfriends? I didn't see them offer to buy you anything." She scowled at me. I could tell she couldn't think of a quick enough comeback. I grabbed the advantage, "Oh well, what can you expect from juveniles?"

Bella scowled. "Jake's not a juvenile! He's been to Japan. He even speaks the language."

I fell in alongside her. "Big deal," I said. "He looks like a loser to me."

Looking extremely annoyed, Bella snapped, "I don't care. I like him. A LOT!"

Mimicking her tone of voice I said, "More than Ralphie? You had the hots for him last weekend."

Bella giggled, immediately dispelling the enmity I'd felt between us. "You're right," she said. "But Ralphie's a big drunk. Every time we're at Hoffer's Bar he's soused."

My sister chirped in, "I'd like to go to Hoffer's with you guys some Saturday night."

Bella blurted, "Sure. You're always welcome."

I kept silent, thought, *No way am I going out with Miss Prissy again*! We were nearing Stevie's car. "What a heap," I said. "It's a regular Rat Mobile."

Bella and Day broke into laughter. "That's a good one," my sister said. She shushed me then, as the guys were fast approaching.

Without a word, Stevie got into the driver's seat. Frankie slid in beside him and turned to Collie. "Come on," he said, "You can ride in front."

I ignored their cruelty and crawled into the back seat just as Stevie turned on the ignition. The engine sputtered and grated and then died. Stevie hollered out the window, "Hey Hans! Take a look at her, will you?"

Hans, with my sister trailing alongside, went to the front of the car and lifted the hood. I could hear Day asking questions as he tinkered under it. "What do you need her for," I hollered. "She doesn't know a damn thing about cars!" No one responded to my outburst.

Seconds later Hans yelled, "Start her up!"

Stevie tried the ignition again. The motor turned over. "She's running!" he hollered.

Hans slammed down the hood and wiped his hands on his overalls. Clasping my sister's elbow he shouted, "Let's pile in!"

Jake bounded into the back seat next to me. Bella quickly followed, settling on his lap. Hans got in next. My sister lowered herself onto him.

The car jerked out of the parking lot. Bella and my sister fell forward. "Geez!" Bella yelled, "Do you think we'll make it?"

"No problem," Frankie hollered over his shoulder.

"Easy for you to say," I snapped. "You're not jammed in like a sardine."

Everyone hooted except me. I fumed all the way back to town. It was especially disgusting to me to sit and listen to the two couples whisper. I stared out the window, knowing they'd be sneaking quick kisses, too. *Idiots*, I thought.

Halfway along the route I spouted, "We'll *all* get out at Central and Tower." I didn't look at my sister or Bella. I knew they wouldn't dare take off with five guys if I wasn't along. I was sure I'd won that skirmish.

<p style="text-align:center">* * * * *</p>

The rest of my summer fun with a capital F, wasn't as annoying as the Stevie encounter. Most were quick and furtive couplings –on the Tri-State-fairground grandstand benches; on the sands of

Season Sweep

Wisconsin Point; in bushes and out-buildings behind county taverns; or on back seats of cars parked off Winter Street and camouflaged by the tall grasses there. The usual spots, like Riverside and Greenwood Cemeteries and Billings Drive were ever popular, together with Billings Park.

Along with my frantic activities came endless nights of mental torment. I prayed constantly, begged not to be pregnant. When my period came around I was sure I'd been forgiven. In time, that belief was replaced by another notion. Maybe I had been punished. Maybe I was condemned to barrenness.

I had a respite from my frenetic "Fun" half-way through the season. After sex on a bed of poison ivy on Minnesota Point blistered me and kept me inside for a week, it gave me time to reflect on the steamy activity I'd been engaged in. I began writing in a small, red notebook. My first recording was of a wedding I'd attended in Foxboro, Wisconsin: *Saturday night was really fun at the Axelson wedding dance. I had sex with three guys. I wonder how I ever was able to handle three at one time –two brothers and a cousin. Oh well, never underestimate the power of a woman. Especially when that woman's drunk!*

My jottings brought the realization that many of my conquests were related –brothers, cousins, friends of friends. It was then I decided to record each in my little notebook. *Hell*, I thought, *Men keep little black books, so why can't I?* I did take the precaution of hiding it in a Folgers coffee can on the highest shelf in our back shed, though. All thoughts of pregnancy, forgiveness and retribution slowly faded from my consciousness.

By August I was gaunt-looking and jumpy. Often I longed to find that special, steady boyfriend. A mind-boggling and frightening event was destined to set me off on that quest. ◆

Foul Plays

Crooked counsels and dark politics. –Pope.

O ne Saturday evening in mid-August, I descended the bus at Sixtieth and Tower, after my first dance class of the season. A pickup truck screeched to a halt alongside Sather's grocery on the corner. I was about to bellow, "Drop dead!" when I recognized Ella. I'd not seen her since June. She popped her head out the rolled-down, passenger window.

"Hey Fran! Wanna come out to Billings Park with us?"

There were two guys in the truck and another girl. I didn't recognize any of them. The girl was seated on the lap of the guy in the middle, her back to me. She turned her head. "Come on! It'll be fun!" It was Madeline.

I stretched to get a look at the guys. "Who are they?"

"They're from Duluth," Madeline spouted. "Friends of my brother."

"Okay... but... it doesn't look like you've got much room in there."

Ella pushed open the door. "You can sit on my lap. I don't think you'll crush me." The guys hooted.

I crawled into the vehicle, settled on Ella. Swinging my hat box of dance paraphernalia in behind me, I wedged it against the windshield. "Run me home for a sec," I said. "I'll drop this stuff off." I glanced at the driver. He had a gaunt face; his crew cut, platinum blond hair stuck up like mini-spikes. "What's your name," I asked.

"Joe, Joe Blow."

His buddy hooted. "And I'm Billy Bob!!"

"Stop that silliness," Madeline barked. "It's Joe and Bob. They're from Duluth. Lots of fun, too."

I thought I smelled beer and wondered if I should take a rain check. Just then Ella leaned forward and whispered in my ear, "Come with. It'll be safer if there's three of us." I sensed that the adventure was Madeline's idea and she'd talked the ever cautious Ella to go along for the ride.

We had reached my house. "Pull over. I'll be right out." I ran up our decrepit porch steps, pushed open the door and dropped my hat

box on the floor. "I'm going out to Billings Park with Madeline!" I didn't wait for a response, slammed the door behind me and ran back to the truck. Wedging myself onto Ella's lap, I pulled the door shut. Joe hit the gas pedal and we were off.

I had enjoyed jaunts to the Park up until my two calamitous visits with Frankie Hoolihan. Ma, Howie, Day and I, used to picnic there when we kids were little. In those days it was full of people. Now it was deserted. But it was late in the day. I guessed most people were home at their supper tables. I drank in the sights –the beautifully wooded area of high bluffs intersected by ravines and the rock stairs leading down to the swimming area. I pictured the cliffs there that formed long rows of rock seats like a Greek amphitheater. Joe pulled into the circular parking lot at the very end of the entry driveway. We all piled out. I noted that Madeline and Bob were holding hands, leaning into each other. I wondered what Madeline saw in him. There was something awkward and milk-fed about Bob. Like a calf. His face looked pasty and pale. Worse, he was half-a-head shorter than her. *Oh well*, I thought, *To each his own.*

"You girls want a beer?" Joe was reaching into the back of the truck. He pulled up a tarp and extracted a six-pack.

Madeline snapped, "We're too young," Bob squeezed her tight and kissed her nose. I looked away.

"I'll take a smoke, if you've got one," I said.

Joe reached in his shirt pocket and pulled out a pack of Luckies. "These okay?"

I took a cigarette. He struck a match. Leaning forward, I held his hands in mine and lit up. Ella was hovering alongside. Joe offered the pack to her. "No thanks," she said. "They're not good for you." Joe rolled his eyes.

Madeline and Bob moved away from us and headed toward the lone bench overlooking St. Louis Bay. "I think they want to be alone," I said. "Let's go down to the boathouse." We turned and made our way along the weaving, blacktop path back toward the park entrance. Ella walked in the middle, me on her left and Joe on her right, chug-a-lugging his can of beer. I noticed his jacket pockets were sagging from the weight of two more cans.

The boat house was down an incline, situated along a deep, idyllic inlet. The sun was behind us. Dusk was beginning to fall. The half-light reflected golden against the thick clusters of birch trees. Their treetops

stirred with the whisper of a warming breeze. I felt my senses reach into the oncoming night. *Why couldn't I always feel this calm, this serene*. Ella's nasally voice disrupted my thoughts.

"We'd better not stay long. It's going to get dark soon. And spooky." Her words brought visions of me and Frankie that disastrous night, three months earlier. I brushed them from my mind.

Joe hooted. "A chicken in the crowd?" He gulped his can of beer, crushed it in his paw-like hand and tossed it down the hill. The can clattered against a tree trunk, then ricocheted back onto the path. We descended the steep hill, walked onto a planked overpass into the deserted boat house. It was a barren, wide open space with screened windows on four sides. We moved to the north side, stood looking down on the inlet. A family of ducks glided along the shore, occasionally dipping down under the waterline. Silence filled the twilight. I walked away from Ella and Joe, found a bench in the corner and sat down. I was feeling dreamy eyed and relaxed. I heard the fizzle of beer from another can that Joe opened. The shadows inside the gaunt building were deepening. I could just make out Ella and Joe's silhouette against the dim window light. They were in a close embrace, kissing. A spasm of envy ignited in me. "We'd better go," I said.

They turned; Joe's hand brushed Elaine's behind. "Stop that!" She slapped his face.

"BITCH!" Joe's big hand struck her cheek. "NO ONE slaps me!"

I felt a twinge of panic as Ella screamed and began wailing. I knew her voice would echo across the water. I was sure the well-heeled residents along the park drive would call the police if they heard any ruckus. "Shsss..," I said, running to her and putting my arm around her shoulders.

She brushed it away. "OH SHUT UP! I knew he was a creep the minute I saw him."

"Shut up, you stupid cow!" Joe advanced. I jumped in front of Ella. The back of his hand caught me on my forehead. I felt the sting of pain. It was my turn to scream.

Mustering all my courage I pushed him back with my opened palms. "Get the hell away from us!" He stumbled and fell against the wall behind him. Ella and I bolted out of the boathouse and ran back up the path.

We were halfway along when I heard Joe thundering behind us, bellowing. "You damn prick-teaser! I'll bust your ass when I catch you!" His words sounded slurred.

We were lurching and sliding, all the time Ella was screaming, "HELP! My God! He's going to KILL US!"

By the time we reached the parking lot I was gasping for breath. In the dimness I could just make out Madeline and Bob running toward the truck. Bob stopped in his tracks at the sight of us. "What the hell's the problem?"

Ella blurted, "Your smart ass friend's trying to KILL us!"

"Oh for God's sake," Madeline blustered, "Don't be such an ass! He's harmless."

"He's NOT!" I screeched.

Just then Joe came tearing back along the path from the boat-house. "Come on," he hollered, "These fuckers can WALK home!" Joe jumped into the truck. It's headlights burst on, spotlighting Ella, me, Madeline and Bob.

In the distance I heard the wail of a siren. In an instant a black and white squad car pulled alongside the truck. Two burly young officers jumped out. One ran to the pickup, threw open the door. "GET OUT!"

Joe, looking pallid, slid out from behind the wheel. The officer shoved him against the truck. "What's going on here!?"

The other officer, with flashlight in hand, was inspecting the back of Joe's vehicle. He pulled up the tarp. "Geez... look at all the beer cans! You guys had quite the party!" He sounded gleeful.

Madeline piped up. "WE weren't drinking!" Bob encircled her with his arm.

The first officer pulled Bob away from Madeline. He slammed him against the truck next to Joe. "Don't you know it's illegal to give minors beer?"

Bob looked ashen. "We didn't," he said, his voice shaky. "We were going to take those empties to the dump."

"SHUT UP!" The officer looked at us girls, motioning with his nightstick. "Get in the squad! We're taking you downtown." I peered at the metal name-tag next to his badge. The small letters spelled out, R. Porter. He was incredibly handsome.

A second patrol car tore up the driveway, its siren blaring, the red light on its roof cutting into the dusk. "The punks can ride in Ray's squad," Officer Porter said to his partner. The driver of the second car bounded out. Swaggering toward us, he pulled Joe's hands together and snapped a pair of handcuffs on them.

My thoughts whirred and jerked in alarm as I envisioned myself in

handcuffs. *My God, what will I tell MA!?* A sense of things spinning out of control descended. I silently vowed to be strong. The second officer came around the pickup, looked us girls up and down. He pulled open the back door of the squad. "Get in! NOW!"

Madeline was the first to move; Ella stumbled behind her. I filed in behind the two of them. Inside the car Ella began to sob. "Oh my God. My dad will kill me."

Madeline had a murderous look in her eye. "Stop whining," she said. "We didn't do anything wrong. They can't charge us." I hoped she was right. The squad we were in tore through the darkened streets of Superior, siren blasting. The second vehicle blared behind us, its headlights filling the back seat of our car with light. We three girls huddled against each other, heads down. I prayed no one we knew would see us.

The patrol car screeched to a halt in front of the five-story City Hall, at Broadway and Hammond. The second squad zoomed past, turned into the parking lot behind the ominous looking building. To me it resembled a military citadel, with its stone face and narrow, upper windows. I noted the bright first floor lights. Their huge picture windows, with green opaque shades pulled half-way down, looked like giant, shrouded eyes. The two squadmen jumped out and pulled open the back doors. Porter shouted, "VAMOOSE!"

We girls tumbled out of the vehicle, ascended the concrete steps. We walked slowly up the flight of marble stairs inside. Standing in the middle of the dimly-lit, spacious lobby, was the policewoman, Miss Stromlind. She was short, with dark, carefully coifed hair. She wore an unadorned navy-blue suit and pale blue, crisp looking blouse, buttoned to her neck. To me she resembled a Lutheran deaconess. "You girls come with me," Miss Stromlind barked.

Madeline, Ella and I trailed down the cold, dark hallway behind her toward police headquarters at the back of the building. Just inside its double doors Miss Stromlind pointed to the first door on her left. She motioned to Madeline. "You, in there," she said. At the next door, she nodded at Ella "You, in here." At the last door, before she could say anything, I turned the knob under its frosted-glass window and sauntered into the room. Miss Stromlind flipped up the light switch. Florescent light flooded the room. "Sit down," she ordered, indicating an oak, curved-back chair in front of a huge, wooden desk. I slumped into the chair, fixed myself into a silent, sullen pose. She left the room.

It was an hour before Miss Stromlind returned. I felt frozen to the chair. The room was cold and dank. It exuded a musty odor, like the lean-to shed attached to the back of our duplex. All the while I fidgeted, my mind in turmoil. Scenarios of what I was in for played across my mind. My eyes took in the room. The huge wooden desk filled most of its space. The top was bare except for a black telephone and a small lamp. The lamp's glow reflected on the desk surface. My gaze fixed on the spot so hard my eyes began to water. It was then I noticed that there were several scratches in the veneer, like someone had gouged it with a hunting knife. My gaze wandered to the walls. Like the low ceiling, they were painted in a dingy shade of mustard gray.

The room felt like it was closing in on me. I remembered Wilkie Collins' A Terrible Strange Bed, that I had once read. That tale of terror told of a man lying on a canopied bed and slowly realizing that the top was inching down, as if intent on crushing him. I shook away the image. A sense that someone was in the room with me descended. I turned and looked behind me. On the left side of the entryway a large, oak framed photo hung. I recognized the scowling face of Edgar J. Hoover, Chief of the FBI. On the other side of the door was a framed photograph of Joseph M. McCarthy, U.S. Senator from Wisconsin. Both pictures were autographed. I squirmed in the hard chair, afraid to get up. I listened to the unbroken silence with a vague sense of unreality, heard the slow, endless tick of a pendulum clock on the wall opposite. It reminded me of the clocks in William Cullen Bryant grade school. My time at that haven of education seemed so long ago and so safe.

Suddenly a woman's horrific scream pierced the silence, followed by a heavy thud. Someone sobbed, "Don't hit me! Please." I put my elbows on the chair arms, covered my ears with my hands, and willed myself not to cry.

Miss Stromlind reentered the room. I sat up straight, forced a blank, determined look. Her small hard face was flushed. She marched to her desk. Her low, cleat-heeled, oxford shoes rapped against the tiled floor, like a hammer striking steel.

She lowered herself into the chair behind the desk, pulled open a drawer and extracted a form. "Now, let's get some facts," she said. Her voice had a flat sound, like a wooden spoon scraping a saucepan. Her small eyes met mine. They were aloof and icy cold. "I want your full name, address, birth date and the names of your parents."

I lowered my eyes, mumbled my responses.

"Speak up," Miss Stromlind barked. She kept writing. When she finished she turned the form over. I met her steel eyed gaze. "So, you girls were drinking."

"We were NOT!" My voice sounded defiant.

"That's not what your girlfriends said."

She's lying. "I don't care what they said. We WEREN'T drinking. I don't even KNOW those guys. They're Madeline's friends."

"Are you in the habit of getting into vehicles with strangers?" There was an edge to her voice that put me on guard.

I snapped back, "Madeline and Ella are my friends."

A smirk crossed the policewoman's face. "Some friends. From what they said you're the wild one."

A danger signal went off in my head. *Oh my God, maybe they HAD said something. No, they wouldn't. She's trying to trick me.* I straightened in the hard chair, determined not to yield. Enunciating each word clearly, like I was in front of an audience giving a speech, I said, "Then they lied."

Miss Stromlind looked down at the desk. Silence descended. The relentless tick-tock, tick-tock from the pendulum clock behind her, began to hammer in my head. Far away a siren stretched across the night. Miss Stromlind drummed her fingernails on the desk. I fixed my gaze on the second hand of the clock, blinked as I realized it was almost ten p.m. Ma would be getting alarmed. I jerked away the image of Ma sitting in her rocker, waiting for me to come home. Miss Stromlind pushed herself out of her chair and rose. She walked around the desk and hoisted herself onto it. Her short legs dangled in front of her. Pulling her A-line skirt below her knees, she looked at me again. "So," she said. "Which of those guys did you have sex with?"

"WHAT!?" I was taken off guard. My face reddened. "NO ONE had sex tonight!"

"That would be easy to verify, you know."

I panicked at the thought that she'd bring someone in to examine me. "They wouldn't find anything!"

"But you HAVE had sexual relations, haven't you?"

"NO! Not tonight." As soon as the words were out I knew I'd made a big mistake.

A smug look traversed her small, square face. "You know you're jail bait, don't you? We could put you away."

"I haven't done anything wrong."

"Maybe not tonight. What about other nights? You must be involved with someone. What's his name?" Her words were rushed, coming at me like whizzing bullets.

I tried to stay composed. "I SAID, I haven't done anything wrong."

She seemed not to hear. "When you had sex with this guy... did he have an orgasm?"

A vision formed in my head. I saw myself writhing on the front seat of Bud's Buick. Shaking away the image, I met Miss Stromlind's eyes. They seemed veiled and pitiless. "I don't know what you're talking about," I said. I had searched my mind in vain for the word, *orgasm*. As much as Tonya used to reveal during our friendship, I had never heard that word.

"For God's sake! Did he pull out? Did you feel something wet on your legs?" Miss Stromlind slid down off her perch, walked around the desk and sank into her chair.

I shook my head in confusion, felt an uneasy, creepy sensation on the back of my neck. I pulled my hand across my eyes, thought, *Geez, Isn't she EVER going to stop?* When she spoke again, her voice seemed softer. I looked up.

"You can tell me, Frances," Miss Stromlind said, trying to sound sympathetic. It wasn't working. "I won't even tell your mother."

I knew that was a lie. I remembered two South End girls who had been picked up for being in a vehicle that tore up the East High school-grounds. Miss Stromlind told them she wouldn't report the incident to their folks if they told her the guy's names. They relented and spilled the beans. Before the girls had even gotten home from school, Miss Stromlind had told their parents. The story hit Central the next day in a big way.

Miss Stromlind's raised voice interrupted my thoughts. "Whatever you say will stay within the walls of this office."

I have to tread carefully. I forced my voice back into a low monotone. "That's fine, except I don't have anything to say." I suddenly envisioned Ma in her rocker, again. *She'll cry when she hears what happened. Maybe she'll even blame me. That wouldn't be fair. I haven't done anything wrong. Not this time. It's almost laughable, me getting picked up for something I haven't done. Most other nights I was at fault.* I banished my thoughts and in a slow decisive voice said, "It's getting late. When can I go home?"

Miss Stromlind slammed her hand on her desk. "Oh for Pete's sake!" She picked up the receiver on the black phone on her desk, barked into it, "Get Ray Masterson to take these girls home." I rose to leave. "Just watch your step," Miss Stromlind said. "I'll be keeping an eye out for you."

We three girls sat in silence as squadman Masterson drove down Hammond to Belknap and let Ella off in front of the beauty shop. After Madeline got out at Nineteenth and Banks, the squadman said, "Get in front." I obeyed his order, kept silent all the way to South End, though the officer smiled and attempted a conversation.

"I suppose you go to Central?" I nodded my head yes. "Do you like school?" I nodded no. When he pulled up in front of our dilapidated duplex, he reached over and clasped my arm, pulled me toward him. "Give us a little good night kiss," he said.

I panicked. "LET GO, YOU ASSHOLE!" Jerking out of his grip I pushed open the passenger door. As I ran toward the house the squadman turned the spotlight on me. I heard him holler through the open squad door, "SLUT!" I thundered up our porch stairs. The squad screeched down Sixtieth Street toward Tower Avenue.

Ma was standing in the doorway. "What in the WORLD is going on!?"

I felt a wave of tears burst inside. Sobbing, I screamed at my mother, "NOTHING! Just leave me alone!"

I raced up the hallway stairs two at a time. Slamming the door of my hideaway, I grabbed a chair and wedged it under the doorknob. I heard my mother's footsteps. She rapped softly on the door. "Fran, please let me in."

"NO!" I wailed. "I don't want to talk to anyone. EVER!" Waiting until I heard her go back downstairs, I threw myself onto my mattress and sobbed until no more tears would come.

My prayers that night, that Ma would never hear of the incident, went unanswered. She was called to juvenile court the following week. ◆

Time Out

Time rolls his ceaseless course. –Scott

On Ma's court date I stayed home from school. I didn't want to face my friends, Madeline and Ella. I spent the morning in frantic activity, cleaning house. With each new task, nervous flutterings filled my chest. When I scrubbed the kitchen floor, my hands grew red from the steaming, bleach-laced water. I kept dunking the tattered, flannel rag into the bucket depths. I reasoned the pain was just punishment for putting Ma through the heartache of defending my actions to an authoritative judge. She would defend me, of that I was sure.

Whenever I paused to wring the sopping cloth over the pail, water splattered my thighs. I'd purposely chosen to wear a pair of old shorts so that I would feel the hard floor on my bare knees. I savored the pain, welcomed it. In my mind's eye I was a crawling supplicant, ablaze with guilt. I inched along the uneven wood floors, that, to me, all the scrubbing in the world could never get clean. The acrid odor of bleach radiated a sense of cleanliness.

My frantic activity was alleviating the nervous tension built up inside me. I moved on my knees backwards across the expanse, sweeping the cloth back and forth in ever widening circles. I felt the door behind me against my bare feet. Using the door knob for leverage, I pulled myself up. Grasping the handle of the wash bucket, I carried it through our back shed and flung the filthy water across our dry, mud caked yard. The stream of soapy liquid gushed across the tract like a slithering boa constrictor and disappeared into the cracks traversing the bone dry clay.

I pulled a Pall Mall from the pack in my shirt pocket and lit up. Sinking onto the back stoop, I felt a rivulet of sweat meander down my cheekbone into my ear. Another one dripped off my nose. I pulled the back of my hand across my face. Looking up at the overcast sky, melodramas filled my head as I tried to imagine what Ma was going through. Nothing matched the events she related when she got home at noon.

When I opened the door and saw Ma's face my heart sank. She looked drawn and old. An image formed in my head of a front page

picture that I'd seen in the Superior Evening Telegram of Korean War combat veterans. Their eyes stared blankly into space. Ma had the same look in her eyes. My mind mechanically went over and over the scene I was sure was about to unfold, Ma, yelling and crying, me sobbing for forgiveness. Instinctively, I hugged her. She felt cold and seemed to stiffen from my embrace. I tagged behind as she made her way through our dim parlor and dining room to the kitchen. The newspapers I'd strewn on the newly washed floor were still damp. They caught on the bottom of Ma's pumps as she shuffled to her chair by our huge, green-painted table. I kneeled and pulled the ragged newsprint from her shoes, clapped it into a ball and flung the papers into the wastebasket under the sink.

"There's fresh coffee," I said as I grabbed the enamel pot and poured the steamy brew into two cups I had put out in readiness for her return.

Ma raised her head. Her eyes took in the dim kitchen surroundings as if awaking from sleep. "Thanks for cleaning," she said. "I've had so much on my..." her voice trailed off. I sensed she knew her excuses wouldn't fly with me. "It's so nice coming home to a clean house," she continued, her voice low and blurred.

"I figured I'd better do something," I blurted. "I get nervous just sitting around."

She didn't seem to hear. "Did anyone call?" She asked. "The Wagnell's? The..." Her words trailed off again.

An alarm went off inside my head. "No," I answered. "They knew you weren't coming to work today." I immediately thought this latest crisis had pushed Ma over the edge. "Are you okay?"

Ma slowly raised her cup and took a sip of coffee. "Yah. I'm just dragged out. I could sleep for a week."

It was then I noticed how red Ma's eyes were. "You've been crying." I wanted to comfort her, but didn't know how. I laced my fingers and pulled them back and forth against each other. They felt numb. My mind drifted into a fuzzy haze. I racked my brain for comforting words, but found none.

With a helpless wave of her hands Ma suddenly pushed her words across to me. "It was just SO degrading..."

I felt compelled to cry out, "I'm sorry, Ma." The words caught in my throat, but I pressed on, "I can't tell you how sorry I am." Forcing myself not to cry, I searched her face for the anger and grief I was sure she'd built up against me.

Ma's face looked clear, almost bloodless. Two minuscule red dots grew on her high cheekbones. "I know you are. I'm not talking about that." She stiffened in her chair. Crossing her arms, a deep frown creased her forehead. "I was SO shocked to see your dad sitting in that court room when I walked in."

"What!?" I could feel the irises in my eyes expand. "Why was HE there? He doesn't care about us."

"Exactly!" Ma's voice was gaining strength. "I suppose the judge thought he should be there. Men. They don't understand a thing." She breathed a deep agitated sigh. "Anyway, I was so shocked I couldn't help but sob."

"Oh no..." A deep sense of grief and shame at Ma's distress, filled me. "What did he have to say?"

"Nothing. Of course, nothing." She unfolded her arms, took another sip of coffee. "When I finally calmed down Judge Dahl lit into Damer."

"Really?" I felt a smirk cross my lips. "Then, he didn't say anything about me? The judge didn't say I'd have to go to reform school? Or anything?"

"That's what's so idiotic about the whole business. Judge Dahl must have read the complaint. He probably figured it was all silliness." Ma rose from her chair, retrieved the coffee pot and refilled our cups. "In any case, he never discussed it. He lit into your father."

I felt giddy and relieved. I leaned toward Ma, anxious to hear the rest of her recital. "What did the judge say to father?"

"First, he said, 'Do you ever call the children and take them out?' Damer said, 'No, he didn't.' The Judge asked, 'Why not?' So your dad said, 'Well I didn't think I'd be welcome.' So then Judge Dahl asked me if I ever refused him and I said, 'No, he never called.'"

I was beginning to feel a whole lot better. "Good," I said. "Father deserved to be bawled out."

Ma went on with her story, "Damer really put his foot in his mouth then." Ma's lips turned up slightly, like a sleepy cat. "He had the nerve to tell Judge Dahl that he'd given Howard a gun and Howard had sold it."

Oh Geez, I thought, remembering my twin's actions from the year before. "Did the judge get mad at you?"

"No," Ma went on. "Judge Dahl asked me about it and I said I gave Howard permission to sell the gun. I said I didn't think it was right that Damer gave Howard a gun."

"So, what did Damer say?"

"Nothing. Except his face got real red."

I was pleased with Ma's obvious strength in that crisis. It gave me the sense that, if she wanted to, she could stand up for her rights. She could be strong. A new admiration for my mother sprouted inside me. "So... everything worked out okay?" My voice sounded hopeful.

"Well... yes." I wondered at the hesitation in her voice. "I could tell Damer was seething, but I didn't care. I told Judge Dahl that when a man called and asked me if I had given permission for Howard to sell the gun I said I didn't object one bit." Ma's strength was amazing me. "If Damer had known one darn thing about his son he'd have known Howard always wanted to earn money. That's why he didn't like school. He wanted to work. To make money. That's why he sold it, to make money."

I didn't want to hear about my brother. I wanted to hear about my situation with the judge... and, with my father. "So," I said, "My name didn't come up at all?"

"Well, yes," Ma said. "In the beginning, when the judge read the complaint, or whatever they call it." I was sure she wasn't going to pursue the subject, but suddenly, a light went on in her eyes. "Oh... darn! I just remembered something. Before the judge started bawling him out Damer said he'd heard that you were... how did he put it? A tramp! And he had the NERVE to say he was disappointed because he always felt that I was such a good mother. And that you kids were doing so well."

Ma's revelation floored me. "Where did he hear THAT?"

"Probably from that policeman, Ray Masterson. The one that hollered at you after he drove you home that night. Damer and him went to Cooper School together."

I sank in my chair, stung. "How could he say anything? That stuff is supposed to be confidential."

"I know. But then I'm not sure who told Damer. Believe me though, if I WAS sure, I'd have spoken up."

I looked at my mother again, realizing that behind her complacent nature she had a fierce, protective way about her. "Did the judge ask him who said those things about me?" I was dying for details.

Ma was searching her mind. "Let's see... I think he alluded to it. But Damer wouldn't say who it was. Men. They all stick together. Always have. Always will."

I could tell she wasn't going to pursue the subject. "You know," Ma said, slipping back to her recital about my twin, "When Howie got his first check at Cornwall[9] he turned it over to me. It was for forty

dollars. Imagine! He was so proud that he could give me some money."

"What about the judge?" I snapped. "Did he say anything more about me?"

"No," Ma continued, "He never mentioned you or the incident again."

I felt troubled by my own disappointment.

"You know what really gets me mad," Ma said. "I forgot to tell Judge Dahl about the doggone deer rifle."

"What deer rifle?" I asked, even though I was sure Ma would launch off on another tangent.

"When your dad said he was going to leave, he wanted my brother Gunnar's deer rifle. Your grandma said he could take it, but if Gunnar came home and wanted it back, Damer would have to give it to him."

I didn't see the point of Ma's tirade, but knew it would be impossible to get her off the track.

"I don't know what happened to Gunnar's rifle, but your dad... he bragged about giving Howard a gun. He didn't like it because Howard sold it. I should have said, 'Well, what happened to Gunnar's rifle?' I don't know to this day what happened to it."

Ma rattled on about the damn deer rifle. All the while I contemplated my luck at escaping punishment for my crimes. My worry that I'd end up in reform school quickly abated as well. It brought the realization I was one lucky girl. I had been given a second chance. On the other hand, I knew I was obliged to try harder to change my ways.

My campaign began the very next day when I tried out for Central High's Radio Commission. ◆

9 - Cornwall - A TV cabinet making factory at the junction of the Great Northern and Northern Pacific Railroads and North 62nd St.

Trying Out

No one knows what he can do until he tries. –Publilius

The <u>Devil's Pi</u>[10] reported the results of the Radio Commission try-out in huge letters on its front page:

Students Chosen For Commission

A week ago try-outs for the Radio Commission were held. Judges were Mr. Lyle Maves, Miss Delores Dryor, Mr. John Lilja, Mr. Verner Anderson and Miss Agnes Currie. Each student who tried out read a sentence over the public address system. No names were given. The judges listened in their rooms and rated speakers on voice, diction, clarity and enunciation.

Seventeen members were chosen. They are: Rita Kotter, Geraldine Walt, Paul Maier, Bob Donnick, Charles Anderson, Frances Oliphant, Phyllis Ansell, Joan Tepoorten, Gail Springer, Joan McKenzie, Rita Ansell, Jim Moe, Sheila Edelstein, Katherine McGinnis, Joyce Pederson, Margaret Cook and Sunny Brown.

There are a few new rules for announcements. All announcements about outside activities must have the principal's approval.

Announcements must have the adviser's and writer's signatures.

Mr. Maves, adviser, said that he hopes this year's commission will be as good as last year's.

Mr. Maves had a quiet air of authority and a rare warmth. With his long, bony face and deep-set, pale eyes behind rimless glasses, he brought to my mind an image of Icabod Crane. Like most all Central's male teachers, Mr. Maves wore dark suits with white shirts and conservative ties. His quiet demeanor was emphasized by thin lips. He was an unassuming and empathetic coach, who treated all his

announcers with respect. I got the notion that Mr. Maves was capable of being shocked though, so I never acted up in his presence.

I also came to believe a career in radio announcing would be extremely glamorous. I concentrated on doing my very best. At the top of my lined notebook I carefully printed in boxed letters: THE PURPOSE OF THE RADIO COMMISSION: To encourage student participation in school activities and to aid the school in giving announcements. Under that heading I printed our duties as well: Direct, instruct and inform. I read and reread the statements until they were indelibly imprinted on my brain. Whenever anyone asked what my job on the Radio Commission entailed, I repeated its purpose and duties by rote.

Every morning during the first part of second hour, students at Central High heard a melodious three-note gong and then, "Good morning. Here are your announcements for today!" We were divided into pairs; each pair gave the announcements for one week. My teammate was Phyllis Ansell.

Phyllis was an honor student, whose kindness and friendship took the edge off my feelings of inferiority around Sophomore class "brains." She had short dark hair and a full, olive-toned face and was half-a-head shorter than me. Phyllis was everything I was not. I came to admire her deep, resonant voice, her self-assurance and her reserved intelligence. Phyllis was always fashionably dressed in the prevailing craze of the day –plaid skirt, with crispy white blouse and dark-toned cardigan. I appreciated the fact that she didn't flaunt herself like other high school fashion plates, whom I perceived, had cultivated a put-down attitude toward me and my friends.

Phyllis and I took turns banging out chimes on the small xylophone with its miniball wand. We then took our places on either side of the standing microphone, grasping our sheaves of announcements. The thought of the 1,193 Central students listening to my voice always staggered my imagination. I envisioned myself a female Walter Winchell pronouncing, "Good evening Mr. and Mrs. America and all the ships at sea..." I even came to believe I was better than that radio icon. His bullet-fast delivery was not something Mr. Maves encouraged. We learned to carefully enunciate each sentence in slow, deliberate tones of voice. I was a bit miffed that we weren't allowed to mention our names. I was sure that was why my classmates didn't dog me in droves wanting my autograph.

After our stints in front of the microphone, Phyllis and I parted. And though I considered her a good friend, we never socialized. I

gathered a new group of friends, from sophomore classmates in Mr. Gradin's homeroom 136, with its even mix of fifteen girls and fifteen boys. Mr. Gradin also taught Biology during the first hour.

My new friends included North End resident Isobel Mueller and Marie Murello, who lived in Borea, a small community south of Superior. I especially liked Marie, whose two handsome brothers, Julio and Philip, were seniors. I thought maybe, through her, I could attract their attention. Unfortunately both boys were intensely shy and seemingly not interested in girls. At least not in me. The other problem was that the Murello siblings boarded the county bus immediately after school, so there was little opportunity to waylay the brothers.

Like Julio and Philip, Marie was extremely shy. The cheeks on her moon-shaped face seemed permanently ablaze. Whether from an off-color joke or a teacher calling on her in class, Marie's humiliation was palpable. As hard as I tried to ease her pain –sometimes by interrupting Mr. Gradin before he called on her– I knew she suffered incalculable torture. Marie's huge brown doe-eyes were perpetually edged with tears, though she seemed relaxed when she and Isobel and I leaned against our lockers during noon hour.

There we ate sandwiches from our bagged lunches, flaunting the school policy that food should only be consumed in the cafeteria. None of us ever set foot in that lunch room. To me it was the domain of the elite. I was sure I'd be the object of ridicule if any of them found out I ate liver sausage sandwiches with raw onion and catsup. My two friends were in complete accord with my feelings. Marie always kept one foot inside her locker, the other one out. It was as if she were bracing herself in case a hall monitor would descend and try to drag her off to the Dean of Girls office.

Everything about my friend Isobel seemed to sag –from her long, thin face and lanky hair to her sad eyes, to the uneven hems on her unfashionable skirts and dresses. Isobel laughed a lot at my gibes and jokes though, and seemed to have no problem with the open criticism from our teachers over her inability to bring her grades up. I always felt rankled at the torment she suffered from her North End neighborhood peers. Often I lashed out in Isobel's defense when one or another of them sauntered by and hissed, "Hey Izzie... when ya gonna get a brain!?" I would snap, "When your acne dries up!" Or, "When you get lucky!"

My old friend Madeline was in Mr. Gradin's homeroom, too. Ever since our run-in with the steel jawed Miss Stromlind, she avoided me

like the plague. And though pained by her treachery, I refused to try to win her back. "Her loss, my gain," is what I told Marie and Isobel. In truth, I was annoyed that I would never learn anything about Madeline's encounter with the obnoxious Stromlind. The more Madeline snubbed me, the more I was sure she had ratted on me. I couldn't confirm anything with Ella though, as she had been banished to Cathedral by her father. I did learn that Madeline had a steady boyfriend, and that as soon as she was sixteen she was going to marry.

"That's how it is when girls go steady," I cautioned Marie and Isobel. "They drop their best friends." I could tell by their eyes that my new, virginal girlfriends were awed by my wisdom. They gasped aloud as I told them of my summertime adventures. When I said I'd done it standing up against a tree with Stevie Stefanski, they were especially nonplussed. Isobel blurted, "I thought everyone laid down!" I repeated the events that lead up to my encounter with Miss Stromlind, too. Slightly embellishing the account, I claimed it was me who slapped Ella's date. I didn't worry about Madeline being there to put in her two cents. She sat glowering at us from across the room. And though I enjoyed their company and the attention it generated, I longed for more worldly companions. I found one in fourth hour study hall, held in Central's library.

I rushed to one of the square, oak study hall tables and took a seat. Three girls already occupied chairs there. I had decided I didn't want to sit with any boys. It was part of my new vision for myself. The last thing I wanted were distractions in my quest for good grades and maybe even a slot on the sophomore honor roll.

I recognized two of the girls at the table –Avis Andrews and Roberta (Bobbie) Klenke, both juniors, like my sister Day. They were sitting opposite each other. Across from me was the third girl. She was furiously writing shorthand in a steno book. I was sure she was a senior. She had the smug look of success that most of them exuded. I noticed a lapel pin on her grey suit. It was a small octagon of varnished wood fastened to a minuscule metal bow. I was sure it was from a California redwood tree. A feeling of gratification coursed through me at the thought of acquiring a friend who had actually traveled widely.

A sign-in sheet lay in front of me on the table. I wrote my name alongside number one, noting we were at table sixteen and slid it over to Bobbie. She signed it and passed it across to Avis. The last one to sign was the girl across from me. When she finished she handed the paper to Bobbie and ordered, "Take this up front."

Bobbie glowered at her. "You take it!"

"No way," our partner across from me said.

Rising from her chair, Avis snatched the paper out of the girl's hand. "Shut up, you two. I'll do it." She got up and shuffled to the librarian's desk across the room, returning seconds later. "You guys sure are chicken shit," she said and sat down.

When the librarian Miss Dryor, started calling roll, I concentrated on listening for the fourth girl's name. Miss Dryor began at the furthest table on the north end of the cavernous room. Her powerful voice echoed through the huge space. Many of the names were familiar to me. I was surprised to hear Tonya and Dora were in the room and were still together. I had assumed that they both had quit school by this, our sophomore year. A few tables away from them Miss Dryor called my sister's name. I raised myself slightly to get a better look and to wave at her. Miss Dryor stopped her task to say, "We have some rules set down against disruptive behavior."

I sank back into my chair, felt heat rise up my neck and face.

Miss Dryor snapped, "No talking during study period. No food or drink in the room, and no removal of more than three books at a time from the shelves." She returned to her roll calling task. All the responses were in low monotones of "here." When she reached our table and called out my name, she mispronounced it, "Frances Elephant." The mob of students burst into raucous laughter.

"Present!" I bellowed. Another ripple of laughter filled the hall.

Miss Dryor raised her voice, "SILENCE! I will not tolerate any disruptions!" She continued her routine, calling Avis and Bobbie's names then, "Jill Rochet." The girl across from me, who had not looked up from her studies the whole time, raised her head and in a clear, melodious voice answered, "Present!"

I immediately opened my notebook and jotted, "Jill" in the margin next to my Biology scribblings.

Jill tore a page from her steno-book and wrote something there. Folding the paper in half, she slid the note across to me.

I carefully unfolded the paper and read, *"What did you do THAT for?"* I turned the paper over and wrote, *"Sometimes I forget names."* I slid the paper back to Jill.

She read it, crumpled it and stuffed it in her suit pocket. Tearing out another piece of paper, Jill speedily wrote for what seemed an interminable period of time. Her second message read, *"I didn't mean*

118

THAT. I meant, why did you get on your high horse with Miss Dryor? You should know these teachers are always looking for a scapegoat to make themselves seem better than they are."

I instantly scribbled back, *"What's a scapegoat?"*

Jill wrote, *"An object of ridicule."*

I replied, *"You sure are smart."*

She answered, *"I'm studying Psychology. Why don't we meet at Bridgeman's after school? I really have to get this shorthand done now."*

"Wow!" I thought. *This Jill is really smart!* I got up and headed past the low railing fronting the book stacks on the east end of the room. In the science sector I began looking for books on biology. I was hoping to find one that was simpler than the required textbook Mr. Gradin was using. Except for the section on reproduction, to me biology was incomprehensible and boring.

Moving along, I passed a display of mental hygiene pamphlets under the bank of windows facing east. My eyes wavered and settled on some of the titles: <u>Fitting In, Dating, Sex Education, Are You Popular?, Are You Ready for Marriage?, Choosing Your Marriage Partner,</u> and <u>Controlling Your Emotions.</u> Carefully looking around me, I pulled <u>Controlling Your Emotions</u> off the rack. Flipping through it I read about RAGE, FEAR AND LOVE. The protagonist's picture depicted dark circles under his eyes that made him look like a drug addict. He was supposedly having a hard time controlling his emotions. Examples told of him losing his temper. Other emotions –like sexual desire– were, disappointedly, unmentioned. The author did, however, write that repeated emotional outbursts "might lead to a permanently warped personality." By the end of the ten-page tract, the story's hero learned he was happiest when reason triumphed over feelings.

I slid the pamphlet back onto the rack, thinking, *"What a crock!"* Glancing around again to make sure no one was watching, I pulled out <u>"Are You Ready For Marriage?"</u> It was just as inane as the first booklet, recounting a couple of fresh scrubbed high school seniors who want to get hitched and whose parents disapproved. The lovebirds visit a marriage counselor. Rather than help them elope, he helps them understand that they don't know much about each other and should wait until they're older to tie the knot. It ended with the happy couple reading a copy of <u>Marriage and The Family</u>.

I slapped the pamphlet down, thinking, *These are as bad as those grade school Dick and Jane books*! It occurred to me then that I must still have hopes for a steady boyfriend. *Maybe I unconsciously want to change in spite of my track record. Odd*, I thought, *This must have something to do with Jill.*

I moved from Biology to Psychology. My glance fell on, <u>Theories of Personality</u>. Flipping through the table of contents I turned to page forty-nine, *The Psychosexual Stages of Development*. The first three paragraphs were loaded with unfamiliar words: erogenous zones, psychosexual stages: oral stage, and anal stage. My face blazed as I slammed the book shut. Someone hidden behind the racks hissed "SHSSS!" I spit back, "Shut up!" and rushed to my seat.

I vowed that as soon as I got the chance I'd question Jill about the words I'd just read. My eyes glazed as I looked at the clock over Miss Dryor's desk. Two more minutes and the 3:49 dismissal bell would ring, followed by the 3.51 mass evacuation of Central High.

I glanced across the table at Jill. She had already closed her steno book and stacked it on top of a huge volume lying in front of her. She drew her lips in a tight smile and fastened her gun-metal-gray eyes on mine. "Don't forget –Bridgeman's." Just then the bell reverberated in my ears. The noise was as startling as Ma's ancient Big Ben alarm clock that jolted me out of bed every school morning at 6:30 a.m. The study group emitted a collective shout as their chairs scraped the hardwood floor and we all made a mad dash for the exits.

I rushed to my locker, threw my Biology manual onto the shelf and stuffed my notebook into my shoulder bag. I hollered a quick, "See ya tomorrow," to Marie and Isobel, who had already begun their rush in opposite directions out of Central. Slamming my locker door, I snapped my combination lock shut and half-turned the dial to make sure it was secure.

I was swept along in the crowd of students charging the exits. Up ahead I spotted Tonya and Dora. I slowed my pace. Too late. Glancing around her, Tonya caught my eye and hollered, "Hey Elephant! Wanna go for a cigarette?" She halted by the front door. Dora kept moving, calling back over her shoulder, "My bus is coming! See you tomorrow!"

I didn't want to get involved with Tonya again, wasn't sure what to say to her. "I gotta date," I lied.

Tonya's raucous laugh grated my nerves. "A quickie?" she asked.

Ignoring her snide remark, I countered, "So, you're getting married."

Trying Out

We were heading down the wide, concrete front steps of Central. "Eventually," Tonya replied. "He's on the road right now. Gives me a chance to play the field." She broke into boisterous laughter. The trio of girls ahead of us turned their heads and curled their lips, sneering.

At the bottom of the staircase I stopped. "I'm meeting my date around the corner. I'll catch you later."

Tonya's pouty-looking lips curved into a sarcastic smile. "Don't screw your brains out," she said and loped away from me. I glanced at the straggle of students sauntering past, relieved that they hadn't heard her.

I waited until Tonya disappeared down the block before I headed for Bridgeman's. I tried not to hurry, though I felt like breaking into a gallop. The thought of my good luck at finding a friend like Jill spurred me on. Little did I know I'd once again be "trying out." ◆

Passing In Review

It is as foolish to make experiments upon the constancy of a friend as upon the chastity of a wife. –Johnson

Jill was waiting for me outside Bridgeman's, looking annoyed. "The seats are all taken," she said. "Where were you?"

"I got stuck with Tonya Westman. She's a real drag." I fell in alongside Jill, a bit taken aback at how short she was. Her stubby legs were encased in sheer nylons, her feet crammed in a pair of gray pumps that matched her tailored suit. Still, she looked trim and efficient.

I suddenly felt inappropriately dressed in my baggy, red pullover and wrinkled, black skirt. I buttoned Ma's flared jacket and bent to yank up my bobbysox. The stretched out anklets had slipped down under my heels. *Hells bells,* I thought, glimpsing my scruffy shoes. I loped forward, hoping Jill wouldn't notice them. She hoofed along like a construction worker. Stretching her neck up at me as she talked, Jill said, "Let's walk downtown. The buses on Belknap are all crowded. Anyway, I hate transferring."

Noting that Jill's arms were overloaded with three bulky volumes, I asked, "Can I carry some of your books?" She handed one over to me. It was titled, The Five Lectures on Psychoanalysis. It weighed a ton.

"What bus do you catch?" Jill asked as we headed west on Belknap Street to Tower Avenue.

"South Superior. What about you?"

"Billings Park," she answered. "Our passes are good until five, though, so we've got lots of time." We strolled the seven[11] blocks on Belknap to Tower, in silence. Jill halted at the intersection. "Let's go to Grant's," she said.

I had only been in Grant's Cake Shop and Restaurant[12] once, with my dance teacher, Mrs. Sterling. I was sure it was way too expensive for me. "I... don't know" I stuttered, "I haven't got much money... on me."

"Don't worry. I'll pay." We crossed the street. Halting in front of Grant's, Jill said, "You find a seat and I'll get us a couple coffees and a cookie or something. Okay?"

"Wow," I thought, *"She's not only smart, she's got money!"*

Jill pulled the cafe door wide. "Here, take my books." Loaded down with her heavy tomes, I hurried up the two marble steps. On the top step I stumbled. Jill caught my arm and steadied me. "You sure you can handle yourself?"

I avoided Jill's eyes and carefully made my way to a small, white-laminated table with two bentwood, ice-cream parlor chairs. There I dumped Jill's books on the floor and sat down. The heavenly aroma of fresh-baked pastries enveloped me. Everything inside Grant's was eye-straining white, from its tiled floor and walls, to the enamel white, tin ceiling. A long chrome railing divided the bakery section from the cafe tables and the low, gleaming white counter. I reveled in the antiseptic beauty of it all. Three people sat on the black leather and chrome counter stools, sipping coffee. They all looked old.

I recalled my lunch date with Mrs. Sterling, recalled noticing that there were no teens around. I glanced to my right. The four other cafe tables were empty but the two booths were occupied. A trio of matronly ladies sat in one. They were fashionably put out in subdued, dark suits. Two of the women were in navy-blue, the other one in black. All three ladies wore matching pill box hats with filmy, short veils. The women's low voices hummed like sedated bees. A lone man sat in the second booth. He had the Superior Evening Telegram spread out in front of his face. I turned away, feeling addled, like I was walking on tiptoe. It was clear to me that this was not the place to bring up the subjects of erogenous zones or pyschosexual stages.

Jill appeared with a tray that held two cups of coffee and a plate of two sugared donuts. She put them on the table and then propped the tray against the chrome railing alongside us. She sat down and carefully slid one of the china saucers with its dainty cup in front of me. I waited for her to make the next move.

"I heard you're on the Radio Commission," Jill said. "That's pretty impressive."

I felt myself blush. "No big deal."

"Oh yah? They usually only pick seniors." Jill pulled two napkins from the chrome holder and handed one to me. I watched as she unfolded her's and lay it on her lap, then followed her lead. "That's not going to stay there," Jill said. "Take your coat off."

I blushed again. "There's six sophomores on the Commission," I said, fumbling with my jacket buttons and letting the coat fall open.

My napkin slid to the floor. I bent, picked it up, and stuffed it in the neck band of my sweater.

Jill's face clouded. "I tried out. They didn't pick me though." She was carefully cutting her sugared donut into four small pieces.

I looked down at the table. "I don't have a knife," I said. Jill handed her's over. As I cut my donut, the knife slipped from my grasp and clattered to the floor. I was sure everyone was staring at me when I retrieved it. *The hell with this*, I thought. Wiping the knife on my napkin, I cut the donut in half.

"I should have gotten two knives," Jill said.

"That's okay." I picked up a donut half, leaned forward to keep the sugar from dropping all over the place and took a bite. "I thought the selection process was pretty fair. They didn't know our names when we tried out."

"Don't talk with your mouth full," Jill said, sounding just like my mother. "There's always a catch with those try-outs if you ask me."

"I'm sorry," I mumbled, racking my brain for a new topic of conversation. I was beginning to wish I had never met Jill.

She daintily extended her pinkie finger as she held the china cup. "It's not your fault." She took a sip of coffee. "Anyway, I'm pretty busy, what with applying for college scholarships and with my boyfriend."

My ears perked up. "You're going steady?"

"I'm engaged."

Jill's revelation set me back on track. My mind fast forwarded to my dream of acquiring a steady boyfriend. "Did he give you a ring?" I blurted, though I hadn't noticed one.

"I'm pretty sure I'll get a diamond at Christmas," Jill said. "Both our families will be together then."

I was studying her face as Jill talked. Her most remarkable feature was her luminous, eyes. They seemed a little wary at times, though. When she talked, her carefully plucked eyebrows rose a trifle. She seemed to have a competent way about herself. I was sure she had an encyclopedic mind, what with all those heavy books she lugged around. I half listened as she droned on.

"Did I tell you my brother will be in from New York in December?"

The words 'New York' bounced around in my head. "New York CITY!?" The three demure ladies in the booth across the way turned their heads slightly and scowled. I lowered my voice, "You've got a brother who lives in New York City? Wow!"

"New York State," Jill said. She smiled in a controlled, unmirthful way. She had a perfect keyboard of teeth. "He's at a military academy in Poughkeepsie. In the Hudson Valley." From the tone of her voice I was sure I was supposed to be impressed.

I tried my best not to sound disappointed. "Really? That must be nice." I was losing interest in her family recital, but felt I had to say something. "Were you ever out there?"

"We lived in New York State when I was a kid," Jill said.

Now THAT'S interesting, I thought. "Where exactly?" I was fascinated with geography, recalled how well I'd done at map drawing in Miss Swanstrom's social science class last year.

"Poughkeepsie is between Albany and New York City, on the east bank of the Hudson River."

My mind locked on New York City again. "Did you ever get to New York City?" The words felt delicious rolling off my tongue.

"Once. When I was little."

"Wow. That must have been exciting!"

"Not really," Jill said, sounding bored. "All I remember is the locked gates on the store fronts. I guess it was early in the morning, so nothing was open." She pulled the square glass ashtray into the middle of the table. Taking a pack of Pall Malls from her suit pocket, she offered me one. I took it and fumbled in my shoulder bag for a match.

"Here, I've got it," Jill said. She drew a matchbook from her pocket and struck a light for me. Eyeing me through the flame of the match, Jill lit her cigarette and shook the match out. "I'm hoping to get into Vassar. So I'll be near my brother."

I had no idea what Vassar was. "How wonderful," I mumbled, straining to sound enthusiastic.

"It's the best woman's college out East." She drew her lips into a faint smile. "My brother's got two years left at the academy. We're very close." Jill waved at the waitress, who had come around the counter with a pot of coffee. "Could we have a pot?" Jill's voice sounded strident. I felt a sudden pang of ire. I glanced at the trio of ladies across from us. They were leaning forward, their voices low and secretive.

The waitress approached our table and lowered the white container onto it. "That's what I was heading this way to do." Her lips drooped at each corner, like she was about to say something really nasty. I hoped she would. Instead, she stomped away.

"I really hate snooty waitresses," Jill said. Her cheek muscles stood out as she clenched her jaw. "Enough about me. Now, what about you? Are you going steady?"

"I'm... not... right now," I said, racking my brain for a lie. "I was dating a guy out in South End, but he died." My stomach turned over in panic. "He... a... was killed in an accident." My face felt hot.

Jill had picked up the coffee pot. She paused in mid-air as if frozen. "How tragic!" she said. "When was that? Where? In Superior?" I almost felt bad at the sympathetic look that filled Jill's small, oval-shaped face.

Guilt overcame me. "It wasn't really that tragic," I said. "He already had dumped me and married another girl." My mind churned in alarm as I searched for a conclusion to my fanciful story. "They were killed in a head-on car accident in Texas. On their honeymoon." I'd remembered the exact catastrophe that had happened to our landlord's daughter last year.

"Isn't that what happened to Betty Hannum?" Jill snapped. She poured herself a cup of coffee and put the pot in front of me, turning it so the handle faced me.

"Ah... yah." It took a minute for me to recover. I should have remembered Betty and Jill were in the same class. Jill's eyes were studying mine. There was an odd mix of wariness and amusement in them. I picked up the coffee pot and poured myself a half-a-cup of the steamy brew. "The papers didn't write up Bud's death," I said. "Ah... because he... wasn't from around here. He was from... Milwaukee."

"Really!?" Her face took on a wise, family friend look. "Are you sure?"

"Of course!" I snapped. "He used to come up here on vacation."

"Okay, okay." Jill smiled her toothpaste smile. "The point is, you're free now. Right?"

I sighed in relief. "Yah, I guess you could say that. I date a lot, though." Flashes of my adventures with some of the Cathedral boys were playing across my mind. "Nothing serious."

"Good," Jill said. "Then I can fix you up with my brother? When he comes in from New York?"

The thought of a blind date threw my stomach into a turmoil of alarm. "I'll think about it," I said. "What's he like?"

"A real sweet kid," Jill said. "Looks a lot like me." She chuckled. "He's got two more years at the academy."

"Wow," I said, "A college guy."

"No. He's in high school. It's a military high school."

Shit, I thought he was in college. "That's nice. I guess."

Jill looked at her watch. "We'd better get going. Our buses will be coming pretty soon."

On the corner in front of the Board of Trade Building[13] we stood chattering until Jill's bus pulled up. She boarded the bus and waved from the window as it moved off.

I stood contemplating our conversation. *Geez, all that for a blind date! I guess I better be more careful who I make friends with.* I vowed I'd be more choosy. Just then the South End bus sped through the yellow intersection light. It ground to a halt a foot beyond the assembly of we five or six passengers. The door unfolded and the driver barked, "Step lively! I'm running late!" ◆

11 - From Grand to Baxter, to Cumming, to Hammond, Hughitt, John, Ogden & Tower.

12 - 1427 Tower Avenue - Grant's.

13 - 1507 Tower Avenue - Board of Trade.

Sitting In Judgment

It is easier to be critical than to be correct. –Disraeli

I stood aside to let two elderly ladies board the bus. Sprinting up the steps, I flipped open my wallet and showed my school pass to Mr. Wright, the driver. He looked at his watch and scowled. "Just move along," he said in a irritated tone of voice. Mr. Wright was my mother's friend, Jennie's, husband, and a real crab. Even though I'd been to their house numerous times, when I rode the bus without Ma he never acknowledged me. I figured he figured I knew too much about him. And I did. Mr. Wright had been an amateur baseball player in some minor league when he was young. A pitcher, he was known as Lefty Wright and, Ma told me, he was a philanderer.

Once, when we were at their house, Lefty came home late from work. After Jennie questioned him, he hollered and swore at her right in front of us. Ma and I left before we got to have coffee and Jennie's fantastic chocolate cake.

The big jerk!, I thought as I headed to the back of the bus. Just as I was about to sit in the last seat by the exit, I heard someone call my name.

"Hey, Fran!" I looked behind me. Bobbie Klenke was sitting all alone on the wide rear seat. I rushed toward her just as the driver stepped on the gas and the bus lurched forward. Falling onto the seat next to Bobbie, we burst into high pitched laughter. I looked up in time to see Mr. Wright watching us in his rearview mirror.

"Keep it down!" he hollered. The eight or ten passengers dispersed throughout the bus turned and stared. Bobbie stuck out her tongue.

"I see you're running late, too," she said. "Me and Avis stopped for a Coke." Like Jill, Bobbie was extremely short. Their personalities were completely opposite though. Bobbie was bubbly and lively. "That Miss Dryor in study sure is mean," she said. "I felt sorry for you."

I wasn't sure how to react to Bobbie yet. "No problem," I said. "I can take it." All I knew about her was that she lived beyond the city limits, past

Sixty-fourth street, and that she was a junior, like my sister and Avis. I decided to bide my time before I committed myself to yet another friend. I lowered my voice, "Boy, that damn bus driver is a jerk."

"Yah," Bobbie said. "I think he likes girls. He's always making remarks."

"REALLY!? He wouldn't dare with me," I said. "My ma knows him. She says he's a philanderer."

"A what!?" Bobbie's small, dark eyes lit up.

"A lady's man, I guess." We both laughed, then caught ourselves as Mr. Wright was glowering at us in the rearview mirror again. "What's Avis like?" I asked, anxious to change the subject so as not to draw Lefty Wright's wrath. The image of Avis, tall, red-haired and freckled face, immediately popped into my mind. I thought she was a real hayseed, from out in the country. "She lives in Poplar doesn't she? Or Nebagamon?"

"Hell, no," Bobbie replied. "She lives downtown. And, she's a barrel of laughs. Right now, she's got big problems, though."

I lowered my voice and looked into Bobbie's lively, dark eyes. "She's not PG, I hope."

"No. Nothing like that." I noticed Bobbie hadn't even blushed.

I re-examined her drab face. It was flat and broad, like a boxer's. Her nose and lips were almost too small in proportion. Her wiry dark hair was cut short, revealing jug ears and high cheek bones. "What IS her problem?" I asked, thinking, *do I CARE?* Though I was always anxious to hear about other people's problems, I felt annoyed having to drag their stories out of them. Bobbie seemed amused. "Come ON!" I said. "Tell me! I can keep a secret."

"You better," Bobbie replied, sounding threatening. I thought, *she's probably pretty tough. Like Tonya. I'd better be careful or else she might bop me one.* Bobbie took a deep breath and lowered her voice. "Avis's father threw her out of their house."

I was totally amazed. "Why?" I asked, immediately getting the notion that fathers sure were mean. And uncaring. *Dads treat females like dogs.* The thought made me feel thankful my father wasn't around.

"He found out she was going steady," Bobbie continued.

"What will she DO?" Even though I barely knew Avis, I felt sorry for her, realizing I wouldn't have anywhere to go if I was thrown into the street.

"She moved in with her aunt. Downtown –on Baxter or John or somewhere. I forget exactly which street." Bobbie seemed pleased at my reaction. "I'm going to move out of my house after I graduate. And go into nurse's training."

I remembered my conversation with Jill. "Is that like going to college?" I asked. "Jill Rochet's going to Vassar next year. In New York, I think." I prayed Bobbie wouldn't ask me anything about Vassar.

She turned her head and looked me full in the face. Shifting uneasily, as if hesitant to reveal her next thought, Bobbie suddenly blurted, "Jill's full of shit." I gasped in utter astonishment. She turned her head and looked out the bus window. "I think your stop's coming up."

Recovering, I said, "I'll ride to Sixty-fourth Street with you."

"I'm getting off at Central," Bobbie said. "I got a baby sitting job tonight."

"Fine. That's only a block over from me. I'll get off with you." With that I pulled the bell cord signalling the driver. As we rushed to the exit old Lefty Wright slammed on the brakes. The bus jerked to a stop at Central Avenue. Bobbie and I stumbled forward. The folding doors slid open. Bobbie exited first, leapt off the bus. I bounded down in back of her. Before the door even closed, the bus pulled away in a cloud of exhaust. "ASSHOLE!" I yelled, sure Mr. Wright wouldn't hear me over the roar of the bus motor.

Standing face to face on the sidewalk, I said to Bobbie, "Now, tell me what you meant by that remark about my friend Jill." I was trying hard not to sound belligerent. In reality I was more curious than angry.

"Your friend?" Bobbie burst out, sounding shocked. "I didn't think you even knew her."

I felt my face heat up. "I... a... had coffee with her. At Grant's Bakery. After school." I waved my hands in a helpless gesture. "She asked me to go with." Bobbie scowled. "Hell. I never pass up a free cup of coffee," I said, smiling in good will.

"You're a real card, Fran." Bobbie laughed a kind of trilling laugh of sympathy. "Anyway, I know that Jill can be real persuasive. Did she fix you up with her brother?"

I felt my mouth drop. "How did you know that?"

"She does that with everyone. She tried to sweet talk me into dating him last summer." Bobbie said.

"How come you didn't go?" I asked.

"Blind dates are the pits. I should know. I've had plenty of experience."

"Me too," I said. I was beginning to like Bobbie. There was something direct and lively about her. I concluded she was straight forward and clear headed, qualities few of my other friends possessed. I decided to take a chance on her. "Which way you heading?" I asked.

"Over to Ogden." She glanced at her nurse's watch. "I gotta use the bathroom at that Standard Station[14] first." Bobbie started across to the east side of Tower.

"I'll tag along." I'd never used the public bathroom there, wondered what it looked like. I followed Bobbie as she made her way to the yellow stucco building. It was a long, one story structure. "Do you know the guy that owns this station?"

"No. But I know one of the guys that works for him. He's a junior at Central. Curly Pirkovich, from Oliver. Where all those Slovaks, or Serbs, or whatever you call those foreigners, live."

"I know him!" I said. "He's kind of girlish, isn't he?"

Bobbie cackled. "You got that right. He's a riot, though." A bell tinkled as she pushed open the front door of the Standard station. There wasn't a soul in the small cluttered office. Bobbie stepped over to a door on our left that was painted bright red. Pushing it open, she yelled, "Hey Curly! I gotta water the lilies. Where's the key?"

A strong odor of fuel oil and gas fumes assaulted my nostrils. Glancing over Bobbie's shoulder, I noticed someone's overalled legs sticking out from under an old, gray Ford coupe. Whoever was under there had on a pair of filthy engineer boots. Bobbie sauntered over and kicked the bottom of the left one. The guy rolled out from under the Ford on a low creeper. Bobbie jumped back, "OH MY GOD!" she hollered. "I'm sorry, I thought you were Curly."

The guy on the creeper rose slowly, he was clasping an oily rag in his clenched fist. He was tall and lanky. Wiping his hands on the rag, he dropped it on the badly stained cement floor. Putting both hands on his hips, he bent his muscular torso backwards and made a slow circle with it. I felt a flutter inside me, lay my hand over my heart. I heard Bobbie's voice from far away, like an echo, "Who... are... *you?*" she asked.

"Mike Janicovich. Curly's not here yet." His voice was low and melodious. It set my heart thumping inside my throat. I stepped back out of range of his incredibly dark, haunting eyes.

Bobbie rushed past me into the office. "I am SO embarrassed," she said.

Mike strolled into the room. Without a word he walked to a small desk against the opposite wall. I noted his indolent, tomcat grace as he strode past. Shafts of electricity coursed through me. Pulling a drawer open, Mike extracted a skeleton key and silently handed it to Bobbie. *Shit*, I thought, wanting to encircle him in my arms and kiss him right then and there. *Who needs high school twits, when HE'S available.* I had no doubt he was available and even if he wasn't, I intended to win him one way or another.

Bobbie grabbed the key and bolted out the front door, calling over her shoulder, "You coming, Fran?"

"I'll wait here." I glanced at Mike and drew up my friendliest smile. From somewhere deep inside me Tony Bennett's latest hit song played across my mind —*Because of you, there's a song in my heart...*

Mike stood uncomfortably still, not uttering a word. I thought I detected a glint of masculine interest in his dark eyes, though. I imagined a supple, hard body under the baggy, one-piece denim work suit he was wearing. "Do you own this station?" I asked.

"Nope." The husky tone of his voice was a definite turn-on. It made me shiver. "I'm a working stiff."

"Nothing wrong with that." Feeling befuddled with longing, I blurted, "Have you got a girlfriend?"

Mike's long tanned face colored slightly. "Not really." He brushed back a wispy curl that had fallen onto his forehead. I noted his broad fingers, imagined them stroking my body. His ink-black hair was greased down with hair oil. My eyes fixed on the thick, curly locks. "You got a boyfriend?" I wondered at his bad grammar, but let it pass.

"I'm free as a bird!" My voice sounded too airy. "Well... not exactly THAT free," I corrected myself. "I date occasionally. When I find the right guy."

Mike's steely dark eyes shot me a hungry look. "Maybe we could..." His voice was interrupted by the stringent jangle of the station doorbell.

Bobbie lunged back inside. Trailing behind her was Curly Pirkovich. "Hey Frannie," he hollered, throwing me into a state of agitation. He glanced from me to Mike. A wary look crossed his small eyes. "Whatta you doing here?"

"She's with me," Bobbie piped up. "I had to use the john."

Curly looked relieved. "Here," he said, throwing a brown paper bag at Mike. "My ma made you a sandwich."

Adroitly catching the bag, Mike mumbled, "Thanks." He glanced at me, raising his thick eyebrows in resignation and sank into the desk chair.

Curly burst out at Bobbie. "So, Shorty, whatta ya been up to? Hiking the highways?" His raucous laugh filled the small room. Though his wide smile was cute, I didn't much appreciate his manner. He was a loud mouth. In Central's hallways he shrieked obscenities at me and my friends. I decided the first chance I got I was going to tell the new love of my life about that. I didn't much want Mike to get the wrong impression of me.

Bobbie rolled her eyes at Curly and smacked his arm. "Shut up, big mouth!" she hollered. I glanced at Mike to get his reaction. He winked at me. Bobbie nodded toward the door, "Let's blow this joint," she said. I followed her out. We sauntered east on Central to John Avenue. "That Curly's usually more fun," Bobbie said. "He was acting kind of shitty tonight. I wonder what got into him?"

I smiled a knowing smile, "He's probably jealous of me," I laughed.

Bobbie hooted. "I thought I noticed something going on between you and Mike," she said. "Like... electricity?"

"And how," I said. "He is SO dreamy."

"You think so? I think he's a big rube myself, though he is awful handsome."

I shrugged my shoulders. "To each his own. At least he's not a juvenile. Like Jill's brother."

Bobbie hooted again. "I think you're right about that. Imagine her trying to fix girls up with her tin soldier brother. Give me a break."

I suddenly felt as if Bobbie and I had been friends for years. "You know," I said. "You're a smart kid!"

"Naw. It doesn't take any brains to figure that Jill out. She thinks she's so smooth, like she's from New York City. Hell, that Poukeepsee place isn't much bigger than Superior!"

"I know," I said. "She tried that with me, but I knew better." I was remembering my session with Jill, decided I'd try to keep clear of her.

Bobbie stopped in front of a huge house[15] at the corner of John and Central. Its broad porch stretched all the way around the building. I recognized it as the mansion I used to stare at out the windows of Bryant grade school across the street. I'd daydream that it was my family's house. Once in art class I'd drawn a picture of it and told my second grade teacher that we did live there. Bobbie looked at her

watch, "Time to get to work," she said. "I'll see you tomorrow. In school."

"Okay," I said. "Have fun." I tracked back west on Central, glancing at the Standard station as I approached the Tower Avenue intersection. Mike was out front pumping gas into a long, low Buick with sleek fins. Curly was nowhere in sight.

"Hey," he hollered, "Come see me sometime! I'm here alone tomorrow."

"Will do!" I waved back at Mike, crossed the street and headed home. All the way the words to Tony Bennett's hit, whirled in my head *...because of you the sun will shine ...the moon and stars will say you're mine ...forever and never to part.* Thoughts of Mike enforced the unconscious decision I'd already made not to date Jill's brother. It wouldn't be easy to get her off my case, though. ◆

14 - Glen's Standard Station, 6028 Tower Avenue.
15 - 1524 Central.

Respite

Repose is a good thing, but boredom is its brother.
—Voltaire

In spite of my attraction to Mike Janicovich, I hesitated launching any move on him. Fragments of determination to toe the mark in school had settled in me. I longed to be good, wanted to be someone who my mother and my friends could look up to. Thoughts of acquiring a steady faded into the distance. Leaving my options open, though, every day after school I rode the bus one block past my stop to Central Avenue in hopes of catching a glimpse of him.

It was November 1950. I was fifteen and brimming with optimism. Everything was going well, in spite of my heavy lineup of two art classes, history, language arts, biology, the Radio Commission and ongoing dance classes.

My mother showed me my art teacher, Miss Margaret Rehnstrand's graduation picture in an old Central yearbook. The finger waved style of Miss Rehnstrand's short, gray hair had not changed since her youth. To me she epitomized Tennyson's, Lady of the Lake[16] Ma commented that the Rehnstrands were a refined, well-educated family. She added, "None of the three girls –Margaret, Vera or Jane, ever married. They're all devoted to teaching." And though she didn't say so, I was sure Ma felt I should pursue the same goal.

To me, Miss Margaret Rehnstrand was an ancient, wispy woman, who never raised her voice in anger. Soft spoken and kind, she was very receptive to my artistic talents. We were learning to make murals. Surprisingly, I loved the mechanical part of the task. We laid out our designs on graph paper, then calculated the size from its mini squares to transfer onto a five-foot-long piece of white, wrapping paper. I despised math of any sort, but its application to the art project enthused me. I chose a sports theme, with a majorette, the central figure. I intended to do the whole creation in chalk. One day as I stood over my work station transferring figures onto the huge sheet of paper in front of me, Miss Rehnstrand glided over. "Your idea is very creative," she said. "Perhaps

135

when you finish it, we can display it at the art exhibit next month." Her words raised Miss Rehnstrand[17] to the top of my list of favorite teachers.

I was also enrolled in Mr. Tony Yaworski's Commercial Art class. There my project was carving a piece of Ivory soap into a replica of an elephant. My unbounded eagerness for that undertaking was spurred by the fact my surname was derived from *oliphant*, the ancient ivory battle horn Scottish warriors blew. Upon that disclosure to Mr. Yaworski, he stated, "You must have inherited your mother's intelligence." He then confided that he knew of my mother's community activities from articles he had read in the Superior Evening Telegram. "Community service is an admirable calling," he added.

Mr. Yaworski was a spirited mentor whose deep, melodic voice sent shivers of pleasure through me when he spoke. A tall, dark-haired man with receding hairline, his eyes were warm and compassionate. He had a physical presence that reminded me of Reverend Ernst, my confirmation minister, whom I had adored and who was lost to me.

I was less than enthusiastic with my history teacher, Mr. Marvin Crowley. I did however, manage to memorize all the historical dates he insisted we master. He plodded back and forth in front of the class, the heavy history text open in his oversized right palm, his wide face just inches from the page. Mr. Crowley was the freshman football coach, too. I fantasized that one day he would forget where he was and toss the tome like a passed football to one or another of the jocks in our classroom. I was amazed that Mr. Crowley was even athletically inclined. He trudged along like a bobbing chicken, a cowlick sticking straight up from his thinning hair. Everything about his posture screamed "lumbering lout," his stocky frame emphasized by the double-breasted suits he wore. Though his face was pleasant enough, his eyes seemed squinty, like he was staring into the sun. More often than not they wavered and focused out the bank of windows behind us students. I labored through the basic requirements of Mr. Crowley's class without much difficulty, and without any desire for a starring role.

Language arts, with Mr. Donald Jay, was where I shined. I loved writing essays and though my spelling was appalling, Mr. Jay never graded me less than B+, though he continually circled my misspellings in red. Once he commented, "If you concentrated on your grammar and spelling, you'd be an A student."

Mr. Jay was baby-faced and unthreatening. He looked like Lord Byron, whose picture graced my mother's old <u>One Hundred and One</u>

Respite

<u>Famous Poems</u> book. Like Byron, his thin, oval face culminated in pouty lips and a cleft in his pointed chin. One late night in my upstairs hideaway at home, I read Byron's words –*Enough, enough, my little lad! Such tears become thine eye; If I thy guileless bosom had, Mine own would not be dry.*[18]

The words immediately brought to mind Mr. Jay. And though the word *bosom* aroused a fluttering inside me, I never associated it with my mentor. To me he was the ultimate intellectual. In addition to language arts, he taught Latin, and loved poetry. As much as I revered him, Mr. Jay just wasn't my type.

Mr. Robert Gradin, on the other hand, was cute, and sexy. He was my homeroom and biology teacher. A small-framed man, Mr. Gradin was boyish, though I was sure he was old. His elongated skull seemed permanently perched askew on his round shoulders, like a robin listening for earthworms. He had faded blue eyes that twinkled when he spoke. His wide smile revealed gapped front teeth that my old friend, Tonya, once said was the sign of a sexy personality. Energetic and gleeful, Mr. Gradin was not the least bit ominous. I never took his persistent cajoling that I'd fail if I didn't bring up my grades, seriously. Once when he reprimanded me, I gazed at the sickly green, peeling paint on the walls behind him and said, "This room needs a good dye job."

After the hooting and laughter subsided, I felt bad. A hurt look had clouded Mr. Gradin's face. "That's enough," he said. His serious tone of voice clued me to the fact I'd overstepped an invisible boundary. After that incident I vowed to be more careful about what I said to him in the classroom.

Our witticisms back and forth during homeroom continued, though. At times they verged on the risqué. Mr. Gradin loved my moron jokes. He once said, "You sure have a fine sense of humor." I suspected he'd overheard me regaling my friends with the salacious details of my encounters with guys once or twice between homeroom and biology class. I may have unwittingly raised my voice for his benefit. And though I buckled down in most of my classes, I didn't give a hoot about biology. To me it had nothing to do with my world. The harder I tried to understand the subject, the less I grasped it. Every day I pored over my biology textbook and notes. It didn't help. Being at the study hall table with Jill, Bobbie, and Avis, did little to promote my success in the subject, either.

Fair Game

My expanded set of friends and complicated interactions were the biggest of a few minor problems that arose in school. I felt tense in their presence. Holding Jill at bay, as she continually suggested we meet after school, increased my discomfort. At the same time, I tried to avoid close encounters with Bobbie. I was afraid she would push me into Mike's arms. Jill and Bobbie's enmity for each other didn't help. I wanted to be friends with both of them. It felt as if they were pulling me apart. I was sure that one day my lies would catch up to me. Lying for and about myself to Ma seemed a lesser evil than deceiving my friends. In Ma's case I saw myself as protector. With my friends I was the one who needed protection. The lies cushioned my fear that my past erotic adventures would resurface and consume me. I yearned to walk a straight and narrow path. Everything came to a head one afternoon in study hall.

I entered the library in a state of nervous dread. Bobbie and Avis were already seated across from each other. "Hi," I said, forcing a bouncy tone of voice as I sank into the chair next to Bobbie.

"Hi kiddo! Did you get to talk to Mike yet?" Bobbie was laying across a pile of books, her head tilted toward me.

Avis leaned forward. "Who's Mike?"

"Fran's latest dream boat. We met him last week out in South End."

"Oh shut up!" I snapped, surprised at my own irritability. "I'm not interested in guys anymore. I've got too much homework to do."

Bobbie hooted. "Since when!?" Her small face quickly took on a conspiratorial glint. "*I* know what your game is," she said. "Pretty clever." She turned to Avis. "I bet it's her new plan to get Jill off her case. Miss New York is trying to hook Fran up with her tin soldier brother."

The two girls stifled their giggles with their hands. I glanced at the clock. It was one minute to the hour. Jill strolled over and took the empty chair opposite. She beamed at me, ignoring our table mates. "Hi! How you doing?" Just then the last bell blared through the crowded library and silence descended.

Miss Dryor began roll call, everyone dutifully responding in appropriate, reserved "heres." She even pronounced *Oliphant* correctly. I noted Bobbie and Avis rolled their eyes when she called Jill's name. Once Miss Dryor's task was completed a ripple of relief spread through the room. Chairs scraped on the hardwood floor as students rose and headed for the book stacks.

I was about to get up myself when Jill slid a piece of paper across

to me. I unfolded the note and read, *My brother called from New York last night. He's anxious to meet you.*

Sensing Bobbie leaning toward me trying to read Jill's note, I turned it over and wrote, *I'm pretty busy. Dance classes. Biology. I HAVE to buckle down.* I glanced at Bobbie. A knowing grin spread across her puckish face. She rose and nodded to Avis. They got up and sauntered to the book shelves across the room. I slid Jill's note back to her.

After reading my message, she yanked her shoulder bag off the back of her chair. Crumpling the note, Jill stuffed it into the depths of her purse and dropped it to the floor. She tore a fresh piece of paper from her steno book and wrote quickly.

Jill's note said, *I can help you with biology. How far along are you?*

A sinking feeling filled my stomach. I wrote back, *We're studying osmosis.*

Jill answered, *I'll dig out my old notes. I've got some great charts that'll help. My brother will be in town next month.*

I felt my face glow as I turned her note over and answered. *December's pretty busy. We have to visit all our relatives.*

Jill's next note threw me into panic. *He's coming home the first week of the month. You can go to the Christmas dance with him.*

I quickly scribbled back, my writing barely legible even to me. *I detest school dances.*

She replied, *There's always movies.*

I felt myself giving in. I wrote, *I'll think about it. What's your brother's name?*

Jill smiled as she read my words. Her next message shattered my resolve. *Harold. Give me your phone number.*

Feeling as if I were fast sinking I carefully wrote in huge, block letters, *8140.*

Jill pulled her shoulder bag up from the floor and extracted a black address book. My eyes wavered as she recorded my phone number there. Looking up, Jill mouthed, "What's your address?"

I opened my spiral notebook and tore out a page. There I carefully printed, *5927 Oakes* and slid the paper across to Jill. It had occurred to me that Harold probably had a car. *At least Bobbie won't see us*, I thought. A vision of Mike Janicovich burst into my mind. The thought of him brought with it a wave of queasiness. I rose from my chair so fast it crashed to the floor, breaking the deadly silence of the library. Red faced and shaking, I rushed to Miss Dryor's desk. "May I be excused?"

I asked. My voice sounded tearful. "I've gotta go to the bathroom."

Miss Dryor raised her head from the book in front of her, "Three minutes," she snapped. "And try not to make so much noise." A scowl traversed her dry, thin face.

In the cavernous, tiled bathroom I leaned over the first sink of twelve and splashed cold water on my face. Looking around to be sure I was alone, I entered one of the wood paneled cubicles, extracted a cigarette from the pack in my skirt pocket and lit up. Sinking onto the toilet seat, I took two deep drags. The squeak of the main door brought me to my feet. Quickly throwing the cigarette into the toilet, I flushed it and exited. Bobbie was standing over one of the sinks.

"What's with you? Did Jill give you the shits?" I blanched from her raucous cackle.

"NO. I needed a cigarette. Want one?" I handed my pack of Pall Malls over.

Bobbie waved it away. "Better not," she said. "Dryor's going to suspect something if we don't get back right away." I sensed she wasn't through with me. "Did you get Jill straightened out?"

"Yah. She's going to help me with my biology, though," I said, covering my tracks in case Bobbie ever saw Jill and me together.

Bobbie looked pleased. "Good. Meantime you and I HAVE to get back to business. Meet me at the bus stop after school. We'll pop into the gas station out in South End."

"Can't," I said. "I've got dance class tonight." I was relieved I had a truthful excuse. Bobbie wouldn't give up, though.

"Tomorrow, then," she said. We sauntered down the dim, brown-painted corridor back to study hall.

What the hell, I thought, *Things can't get much worse.* I was wrong. ◆

16 - Idylls of the King (1875) - Lord Alfred Tennyson (1809-1892).
17 - While touring Europe in 1962, Miss Rehnstrand lost her life on August 2, when the bus she was riding overturned into Lake Lucerne, Switzerland.
18 - Childe Harold's Farewell to England - Lord Byron (1788-1824).

The Bohunk

Sweet Tenants of this Grove. —Cowper

Bobbie and I were heading home from school, waiting at Belknap and Tower for the South Superior bus. I was grateful she was with me as my glasses were buried deep inside my shoulder bag. My near-sighted gaze made it impossible to read the sign on the low, stubby vehicle. All I saw was the blur of its ivory and burnt orange color as the bus bore down Tower Avenue toward us. When it stopped, I noted the number along the side of the front door, 356. *Oh no! Mr. Wright's bus.* I pushed my way up the two front steps behind Bobbie. Lefty Wright was in a higher state of rage than usual, what with the mob of teens pushing their way onto his bus. "GET THE HELL TO THE BACK!" he hollered, his eyes blazing.

Feeling strangely devilish at his display of crazed behavior I smiled broadly and chirped, "How's it going, Mr. Wright?" The laughter and hooting that burst around us brought the driver to his feet. His face grew red and blotchy. "We ain't moving until you bastards settle down and MOVE TO THE BACK!"

Everyone immediately shoved and pushed each other until we were squashed in like sardines. Lefty sank to the driver's seat and stepped on the gas. The bus roared down Tower Avenue, skipping all the stops until we hit Fifty-third Street, where the first of we South Enders got off. All the while Bobbie and I kept silent. It was impossible to talk without shouting over the cacophony. By Fifty-seventh Street things quieted down and we even got a double seat near the rear exit.

Bobbie leaned toward me. In a low voice she said, "I'd like to get to know that Curly Pirkovich better."

Puzzled, I looked her full in the face. "I heard he was a fairy," I said.

"Naw, couldn't be. Those Bohunks are pretty over-sexed from what I've heard."

I felt strangely resistant to her choice of words. "That's not nice. Calling people names."

Bobbie's small face clouded. "Bohunk? That's what they call themselves!"

Always afraid of hurting people's feelings, I asked, "Are you sure?" The tension I felt in the library in Bobbie's presence rose a few more notches.

"Geez," she said, "Don't get so huffy." The bus was nearing Central Avenue. Bobbie suddenly pulled the signal cord just as the doors closed at Sixtieth Street. The bus started moving away from the curb.

Lefty slammed on the brakes. "God Damn it!" he bellowed, "Why didn't you get off when you were SUPPOSED to?"

Mortified at the attention we generated, I whispered to Bobbie, "Let's get off here." We moved with exaggerated nonchalance to the exit door. Just as I lowered my foot to get off, the bus lurched a few feet forward. I grabbed one of the steel poles beside me and steadied myself, waiting for Lefty to pull the door release lever.

Lefty braked again. I turned my head in time to see him scowling at us in the rear view mirror. "Have a nice evening," he sneered.

On the sidewalk, I took one last stab at resistance to the pull of Mike Janicovich. "I'd better get home. I've got a biology test on Monday."

Bobbie's eyes dilated with sudden anger. "Oh shit," she said. "You PROMISED you'd go over to the gas station with me."

Annoyance crept into my voice. "I did not! You must be hearing things."

Bobbie kicked at the grass alongside the pavement with the toe of her loafer. "Come on... it's early. You've got all weekend to study."

I felt the last obstacle fall away. "Well... I guess I could tag along."

Bobbie's pencil-thin lips broke into a knowing smile. "Don't give me that. I know you're dying to hook up with Mike."

We crossed Tower Avenue. Sauntering along the east side of the street, we shuffled through the small mounds of dry, brown leaves that had begun collecting on the sidewalk. They flew up and scattered like frightened sparrows. The wind was suddenly sweet, the air pungent with hints of winter, my favorite season. Swan-like clouds glided across the sky above us. I was beginning to feel extremely light-hearted. "It would be fun if you and me and Mike and Curly could double date."

Bobbie took a little skip ahead of me. "That's the spirit!" Turning, she stopped and held up her hands. "Now," she said. "Here's the plan."

I halted in my tracks. "We need a plan?"

"Yah. You go in first. Ask for the toilet key. I'll meet you back by the door."

"Okay," I said. "But what if they're not there?"

Bobbie sounded exasperated. "You can STILL go to the toilet, can't you?"

"Okay, okay." We were in front of the station. The double, outside garage doors were down. No one was in sight. "Here goes nothing," I said. I waited a second for Bobbie to hurry around to the side of the low building before I entered.

The tinkling bell above the door announced my presence. There, right in front of me stood Mike Janicovich. He had on overalls and a tight, short sleeved T-shirt. I felt a catch in my throat. Bent over a huge tire, he slowly rotated it between his legs. I drank in the sight of his muscular, tanned forearms. Shafts of electricity coursed through my veins. "Hi, there," I said, willing my voice to sound seductive. Mike gave a little jerk of alarm. I could see muscles ripple across his broad back. He looked up.

"Oh! It's you." The genial tone of his voice set my heart thudding. "It's about time you showed up." He rolled the tire away and propped it against his desk. His admiring gaze filled me with longing. He moved closer. I could almost feel the heat from his body. "Come here," he said.

Reeling a little as I moved forward, I felt his warm hand on my shoulder. He caught me around my waist and pulled me to him. I nestled against his supple body. When he bent his head, I met his lips. The contact felt feather light. Closing my eyes, waves of desire crashed through me. I pressed against him in a body caress. He kissed me hard. Coming up for air, Mike gave me a hug, ending it with a firm pat on my fanny, "That's enough for now."

I braced myself back against the entry door, my knees feeling shaky. "Wow," was the only word I could muster until I caught my breath. "You are some kisser!"

"Had lot of experience?" he asked.

I felt my face redden. "No... not... really."

"Probably all city boys. What you need is a Bohunk, like me."

Feeling slightly ill at ease, I heard myself stutter. "Ahh... what's a Bohunk?"

Mike's gilded laugh rippled through me. "I'm Serbian. We're all Bohunks to most people."

I wondered if he was testing me. Wondered what the point was. "Everyone's the same to me," I said. My mind was circling the words, *Serbian and Bohunk. What were they anyway? Some fraternal group? Like the Elks or the Moose, or the Sons of Norway maybe?* As much as I wanted him to explain, I kept silent.

Mike seemed to relax. "Good," he said. "I got no time for bullshit."

Suddenly I felt the door I was leaning against push open. It was Bobbie. "GEEZ, she shrieked, "Where the hell were you?"

My face blazed as I stepped away from the door. I had completely forgotten about our plan. "I... a... was..."

Mike's deep laugh reverberated through the gas station office. "Me and her were getting acquainted," he said. "Don't tell me. You gotta use the toilet."

It was Bobbie's turn to redden. "Well... yah." Her gimlet gaze swept the small space. "Where's Curly?" she muttered.

"He'll be here later." Mike turned with a quick snap of his shoulders and strolled to his desk. I watched his swaying gait, restrained myself from rushing across the room and jumping piggyback on him. Pulling open the desk drawer, he took out the washroom key and dangled it on its wire cord in front of Bobbie's face.

Bobbie snatched it from his hand and with a nod of her head, motioned at me to follow her out of the station. I dutifully tagged behind her. Inside the closet sized washroom with its heavy odor of disinfectant, Bobbie lashed out, "For Pete's sake. This was NOT my plan."

Her antagonism was getting oppressive. "A dumb plan, at that," I snapped.

Bobbie was digging in her purse. "Oh yah? What makes you think you can do any better?" She pulled out a tube of lipstick, opened it and leaned into the small mirror over the yellow-stained wash basin. Slashing a streak of the tangerine hue across her thin lips, she glanced at me, looking hopeful.

"Well... I could find out what time Curly's coming back." I felt relieved when she smiled. I hated confrontations. "You stay in here and I'll go find out," I said, my mind fastforwarding to the prospect of being alone with Mike again.

"Fine," Bobbie said, "Just make it quick."

"I will!" Dashing out of the minuscule washroom, I rushed into the station office. Mike wasn't there. I called out, "Mike! Where you hiding?"

"Back here. In the garage!"

I rushed out of the office through the red garage door. Mike was leaning over the open hood of a battered old Chevy. "Quick," I said. "What time is Curly coming back?"

"I'm not sure. Probably around closing. Nine o'clock?"

I hurried up to him. He stood back, his arms wide. I threw myself into them. Sweeping me off my feet, Mike swung me around. I surrendered myself to the crush of feelings that drew us together. As he lowered me back onto my feet, I leaned against his muscular length for support. The tingling effects of our contact spread through me like lightening. Wrapping both his arms around me, he kissed me in the hollow of my throat. I felt a low groan rise from deep inside me. "Oh damn," I whispered. "I gotta go, now."

"Get rid of your friend," Mike said as we disengaged. "I'll close shop for awhile."

Breathless, I gasped, "I'll try."

"Try hard," Mike said.

Back in the washroom with Bobbie, I reported my bad news. "Shit," she said, "I can't hang around here until nine."

"Me neither." I was already plotting how to get rid of her. "I'll walk with you to Sixty-fourth Street," I said. "Then I have to get home."

"Okay," Bobbie said, looking disheartened. I would have felt sorry for her if my head wasn't filled with images of Mike and me locked in a passionate embrace. She handed the washroom key to me. "Here, take this back."

"NO... you take it back," I said, fearful of losing control if I encountered Mike again. "I have to pee," I lied.

Bobbie left. Moments later we were strolling south on Tower Avenue toward Sixty-fourth Street, three blocks away. I carefully threaded my way over the railroad tracks, just beyond the gas station. The uneven, rotting railroad ties were partially hidden by tall clumps of dry weeds. As a child I had once tripped there and got slivers in my knee. Their removal with a hot sewing needle had been a shock I never forgot.

We passed the creamery where the thick, green ivy that traversed its walls in summer had turned a deep, reddish brown hue. In the next block, the rays of the setting sun cast dappled shadows through the last of the remaining elm tree leaves. One or two residents were out in front of their small houses, sweeping dried leaves off the pavements. I felt a strange sadness at the sight, barely heard Bobbie's chatter. My head suddenly over-

flowed with images of every love scene of every romantic movie I'd ever attended. It seemed to take hours for us to reach the city limits. As soon as we did I stopped. "This is it, kiddo," I said. "See you Monday."

Bobbie was standing motionless, as if expecting me to say something else. "Remember," she said. "The first chance we get we'll hook up with Curly and Mike."

No way in hell, I thought. "Okay," I said. "See ya." I was already a quarter of a block up the street, moving away from her. I waved and retraced my steps back to the Standard station.

The low stucco building looked deserted, the shades on the front window drawn. As I approached I noticed a piece of cardboard taped to the front door frame. I read the black, color-crayoned note: *Out to Super.* Supper was misspelled. I tapped on the glass with my fingernail. The door swung open. Mike reached out his hand and grabbed me by the wrist, pulled me inside. He slammed the door and locked it.

"We've got about an hour," he said as he swept me into his arms. His mouth moved over mine in sensuous exploration. My world stood still. I heard nothing, not even the whisper of a sound as wave on wave of yearning swelled inside me. All the while he was waltzing me through the open door between the office and the garage. My knees felt as if they would give way. With his huge hand in the small of my back, Mike steadied me. "Hang on," he said, guiding me to the Chevy he'd been working on earlier. "Now. Get inside."

Slightly taken aback, I looked into the car. The front seats were gone. The back seat lay open, like our old sofa bed at home. An Army blanket was spread across them, two pillows propped against the back of the car. I heard Mike's voice from far away. "It's real comfortable," he said. I wrapped my full skirt around me and crawled into the space.

Mike leaned into the open, front window. "I'm going to take you up now. Don't worry, it's perfectly safe." I watched as he sauntered over to a lever and pushed it down. The car began to rise. He hollered from below, "It's a hoist!" I carefully crawled to the open window and peered over its rim as the car hoist jerked to a stop. Mike propped a ladder against the back of the car. He began moving up toward me. "Open the back so I can get in." I dutifully pushed the door open. Maneuvering in alongside me, Mike said, "Just like downtown." He pulled the door shut behind him.

I lay back waiting in heart-thumping anticipation for his next move. "Take your clothes off," he said. My face blazed. I'd never gotten naked for anyone, wasn't sure I could.

"Do I have to?" I murmured

"Don't get shy on me now, Fran," he said, moving his handsome face close to mine. The clean smell of Lava soap canceled out the pungent fumes of gasoline that rose up from below us. I felt a wild surge of pleasure as his mouth opened over mine. I lay back, let the billowing physical excitement flow through me. His heart thundered against my breasts; a gentle moan escaped his lips. He rolled back away from me, dug around behind the pillows. "Here," he said. "Put this over yourself and take off your clothes."

I took the light-weight flannel blanket and threw it over my head like a tent. Pulling my clothes off with controlled speed, I peeked out from under my shroud. Glimpsing Mike's naked chest, my willpower slipped away. I threw back the blanket in invitation. He moved close against me. Swinging the quilt over the two of us, I succumbed to pure, gasping passion. The sensual heat of his naked skin set me aflame. I felt myself stretch out against him with loose-limbed grace, met the full force of his passion with an equal force of my own. I felt myself tremble from a world of wondrous, new sensations. With a fevered groan, Mike suddenly jerked away from me.

His hunger for me satisfied, we lay back, rested and made love again. No thoughts of school, of dancing, of family or friends intruded on my bliss. As far as I was concerned nothing existed beyond the cocoon of Mike and my body locked in passion in that raised Chevy in the middle of Glen's Standard Service Station on Tower Avenue. I envisioned us from above, bathed in an aura of shimmering light. I hoped against hope that the pleasure would never end. Mike's tumultuous voice shattered my bliss.

"It's getting on toward nine," he said. "I don't want Curly to catch us." He hugged me and kissed me hard, his arms solid and strong around me. I clung to him, wanting the kiss to go on forever.

Disentangling himself, Mike threw the blanket back over my head and crawled down out of the Chevy. I quickly dressed and waited for him to activate the car hoist. Seconds later the car slowly descended. Mike was fully dressed, his arms wide. "Come here," he said. I fell into his arms. "I can't give you a ride home. But you can call me and we'll go some place nice." He handed me a Standard Station business card. "Here's the number."

I brushed my lips across his. "I'd better clean up. Give me the ladies room key."

147

"You can use the one inside," he said, pointing to a door along the back wall of the garage.

I washed as best I could with the rough paper towels from the dispenser on the wall. A dizzying burst of joy filled me. I was sure that down the road, Mike would end up being my one and only steady. Maybe I would even marry him someday! We'd practically done everything I suspected married people did. Sudden panic filled me. I racked my brain trying to remember if I'd pronounced, I LOVE you, during our frantic love making. I was sure I hadn't. The thought buoyed my spirits. At least I'd learned enough not to scare this one away. *My one true love*, I thought, then corrected myself, *Okay —my second true love*.

Mike was waiting in the office, the lights out, the door standing ajar. "You'd better get going." He patted me on my fanny as I headed out the door. Half way down the block from the station I turned. The long, low building blazed with light. I bolted up Central Avenue, my head spinning with visions of Mike and my body entwined. All thoughts of biology and Bobbie and Jill and Jill's brother, Harold, evaporated. They would resurface soon enough. ◆

Anticipation

When there is no hope, there can be no endeavor.
–Johnson

At dance class the next day, I could not concentrate on the task at hand. My ten, pre-school students were oblivious to my plight. As usual, they stumbled through their soft-shoe number, staring at their feet, nervous that I would stop them and set them back on track. I didn't. My neglect seemed to spur them closer to perfection.

I banged out the two-four beat with the drumsticks in my hands as if in a trance, my instructions shouted by rote, "Skip! Left foot back, now forward! Again! Turn!" Mrs. Davis bobbed her overlarge skull to the beat, her huge, watery eyes focused somewhere in the far distance. Her pounding piano rendition of *Harrigan* couldn't even take my mind off Mike and our sensuous writhings of the night before. At the chorus, in the exact correct spot, my mini-tappers did a perfect right-foot, flap-step forward, left foot up, arms akimbo and burst into song : "*H! - A! -* double *R! - I! G - A - N -* spells Harrigan!" Their mothers, watching on the sidelines, clapped wildly. It reminded me that I should praise the little darlings. "WONderful!" I screeched, sounding overly enthusiastic. All I wanted to do was to get away and telephone Mike. But first, I had to confer with Mrs. Sterling in her cubicle off the main studio.

"You seemed distracted," Mae said. Her perfect, pencil arched eyebrows rose. "Do you feel okay?"

"Hmm, I... a... DO feel a little queasy," I lied. "I guess I'm tired. I had to stay up late and study. For a biology test on Monday."

Mae's myopic eyes, behind her Coke-bottle-thick glasses, softened. "Why don't you go home early? I'll take your next classes for you." She handed me three singles.

"That's too much," I said. "You only owe me a dollar."

"It's okay," Mae said, "Consider it a tip."

I restrained myself from jumping up and hugging her. "Gee, thanks. That's real nice of you. I would like to get home."

149

In the ladies lounge I quickly pulled off my leotards. Catching a glimpse of my body in the full length mirror clothed just in a bra and pink panties, I slipped them off. I gazed at my nakedness, tried to imagine it through Mike's eyes. A wave of embarrassment brought heat to my face. I pulled the underwear back on and stepped into my slacks. Slipping on my blouse, I thundered up the stairs from our basement studio and burst into the upper reaches of Braman's, intent on using the telephone.

There in the corner lounge chair sat Ma. *Oh shit*, I thought. There was no way I could make the call now. She would be too suspicious and bombard me with questions I couldn't answer. Whenever she looked at me, I was sure Ma could read my thoughts. How could I ever find a lie good enough to conceal my feelings about Mike? I couldn't bear her suspecting I would do the things Mike and I had done.

Suddenly the Braman parrot bobbed up and down on his stand and sang out in his high-pitched squawk, "HELL-o!" I jerked away my thoughts, all my inner warning systems on alert. Before I could ask Ma what she was doing there she rose, took my jacket off the coathanger next to her and handed it over.

"Good. You're through early. I thought maybe we could take in that movie at the Beacon."[19]

"It doesn't start until noon," I snapped, sounding peevish.

Ma, always the diplomat, lay her hand on my shoulder. "We can stop and eat, first," she said. "I've got enough money for us both."

I immediately felt sorry. "I'll pay for lunch," I said. "You can get the movie."

We sauntered up Tower Avenue to The White And Blue restaurant.[20] The streets were teeming with Saturday morning shoppers. Every block or so Ma stopped to talk with a friend or neighbor, leaving me feeling annoyed and worried. *Mike'll think I don't want to see him. Maybe he'll get mad and dump me. Maybe, now that he got what he wanted, he's finished with me.* My eyes filled.

I heard Ma's voice from far away. "What's the matter?" she asked.

"Nothing." I turned to look into the window of Lightbody's Apparel Shop.[21] "Look at that gown. Isn't it gorgeous?"

Ma moved closer to the window. "Really nice," she said. "Too bad Grandma's not alive. She could duplicate it real easy." Ma went off on a tangent about Grandma's sewing talent. I let her rattle on until we reached the White and Blue.

Anticipation

I held the door for her, "You first," I said, figuring it would give me a chance to check and see if any of the rowdy Cathedral boys were there. They were.

"Hey Frannie! How's tricks?" It was Frankie Hoolihan. Squeezed into the front booth with him were Stevie Stefanski, Boomer Cleary, Hans Webber, Collie Bodin and Jake Jansen. The sight of that motley group instantly brought with it the thought that just seeing me would rile them into some evil plan. Months ago they had stopped driving past our house honking their car horns at all hours of the night. But, I reasoned, anything could set them off again.

My attempted smile of good will felt weak as I silently passed the troop and followed Ma to the booth behind them. Their voices lowered. I was sure they were comparing notes about me and hatching plans. Their laughter rose and fell like thunderclaps as I settled onto the hard, wood seat. I glanced at Ma.

She looked alarmed. "Are those boys friends of yours?"

"They're Cathedral guys. Friends of Bella's," I said. All the while my mind was in turmoil. *Geez, if Mike ever found out about all those guys...* a vision of my little red book in the Folgers coffee can on the shelf in our back shed, burst into my head.

Ma's brow furrowed. "They certainly are rowdy. For Catholics."

Just then the waitress appeared. Rolling her eyes, she snapped her gum and shouted at them, "Shut up or you're OUT!" She smiled at us. "Now ladies, what can I do for you?"

"Two hamburgers with fried onions, and two coffees, black," I said.

"Are you sure you've got enough?" Ma asked.

"Oh yah. Mrs. Sterling paid me today."

We were silent as we ate our lunch and sipped coffee. I was back with Mike, reliving our turbulent love-making in the Chevy. *God, please let him be there when I call.* Ma's insistent voice broke my thoughts.

"FRAN! Did you hear me?"

"What?" I focused my eyes on hers.

"We'd better get going. We've only got fifteen minutes. I want to catch the news."

In the darkened theater the narrator of the RKO movie short boomed, "TIME MARCHES ON! Chinese Communist Troops attack in North Korea and then pull back in what later appears to be a warning." I closed my mind to the flickering black and white images of enemy troops clothed in bulky, quilted uniforms and ear-flapped hats as they

151

swarmed over snow-covered hills and valleys. All I could think of was Mike and the terrible agony I felt at not being able to telephone him. "President Truman announces a ban on U.S. shipment of goods to Communist China," the newscaster rattled on. He soon switched to national news: "There are now 2,200 drive-in movie theaters, twice as many as last year." I imagined Mike and me at The Stardust Drive-In[22] making out on the front seat of a Buick. *A Buick?! That was Bud's car*, I remembered. I didn't even know what kind of car Mike had.

The credits for the main feature Born Yesterday, began. I whispered to Ma, "I've got to go to the toilet," and rushed up the aisle to the lobby. Pulling a nickel from my coat pocket, I hurried toward the wood-encased telephone booth. There was a man inside, leaning over the telephone receiver and talking excitedly. *Damn! Hurry UP!* After what seemed an endless amount of time, I tapped on the glass. He turned, pulled open the folding door and snapped, "Get lost!" Heat rose on my face as I hurried back to my seat.

Ma hissed, "For crying out loud, it took you long enough!" The people around us shushed loudly. Ma and I turned our faces to the screen.

Promptly empathizing with the star Judy Holliday, as Billie Dawn, I was sure that, like Billie, I was an ignorant, brassy blond. I wondered if Mike thought I was brazen and loud-mouthed. As the story unfolded, a scrap iron tycoon hired a journalist to educate his ex-chorus-girl mistress, Billie, resulting in her falling for her tutor. My loyalties wavered. I thought William Holden as the tutor, was a sexy and charming lover. I felt more attracted to Broderic Crawford, the junk yard tycoon. He had the rough sex-appeal that had drawn me to Mike. The riotous behavior of Billie Dawn brought hoots and laughter around us. All the while I was stifling a strange, terrible sadness. By the end of the movie I was engulfed in tears. Thankfully, Ma didn't notice. She was crying, too.

It was just after four o'clock by the time we exited the theater. I knew there was no way I could hurry Ma along. And no way I'd get a chance to call Mike. Tagging behind, I followed her on her meandering trek across the street. Inside Roth Brothers,[23] we trailed through the notions department, on to the hats. Ma tried on three or four small, veiled creations, each time turning to me and asking, "How does this one look?"

I continually mumbled, "Fine." I knew she wasn't going to buy any.

When a clerk approached to ask, "May I help you?" Ma smiled pleasantly, responding as usual with, "No thanks. I'm just looking." I was

grateful it was late in the day so there weren't many people around. She sauntered to the back of the store with me in tow. Pressing the button next to the iron-grated elevator door, she said, "Let's go up to the mezzanine, I have to make a payment."

The elevator cranked to a halt and the door slid open. As we entered, the uniformed elevator operator warned, "Watch your step!" Like all the Roth Brothers operators, she couldn't get the elevator floor lined up properly. Every once in a while people tripped if they weren't careful. "Face front, please," she said as she slid the door closed with her white gloved hand. We slowly jerked up the one-half-flight and got off.

I took a seat in one of seven oak chairs spread out in front of the balcony railing. Ma was already deep in conversation with Lois Nelson, who was head cashier at Roth Brothers and a neighbor in South End. I gazed over the vast first floor, checked the clock above the front entryway. It was almost four-thirty. I forced back the tears I felt welling in my throat, knowing the gas station closed at five o'clock on Saturdays. We'd never get home in time for me to call. I couldn't use Roth Brother's phone either, as Ma would be sure to see me get up. I knew she would rattle on for at least fifteen minutes as she and Lois's mother were long-time friends. I was sure that she had all kinds of gossip to transmit to Lois. After twenty minutes passed I got up and walked over to the cashier's cage. "MA," I said, sounding vexed, "It's getting late."

Lois smiled at me. "Hi Frances. We miss you at Luther League." If I hadn't liked her, I would have thought of some snide remark. Lois was a faithful Bethel Church member. I thought highly of her, even though her red-haired, freckled face reminded me of my sister, Day, whom I didn't like. Though single, I thought it admirable that Lois had such a good job.

As it was, I smiled back and said, "I'm kind of busy. With school... and dancing."

I turned to Ma and scowled. "Come ON, let's go." She said her good-byes to Lois and headed for the elevator. "Let's take the stairs," I snapped. "That elevator gives me the creeps." *With my luck*, I thought, *the damn thing will crash and I'll be killed. Then I'll never see Mike again.*

We descended the worn, circular wood stairs behind the elevator to the main floor. Out on the street I said, "Our bus is due in five minutes."

"Let's take the next one," Ma said. "I could use a cup of coffee." Ma moved ahead of me, sauntering north to the end of the block. There we entered Kresge's Dimestore.[24] Ma sidled onto a low stool at the empty lunch counter. Before the harried looking waitress even turned away

from her dish-washing task, Ma said, "I'll have a cup of coffee and a piece of apple pie. With a scoop of vanilla ice cream, please." The waitress looked at her watch and scowled. I noted that she had a gravy-stain on the front of her starched, yellow and white uniform.

Geez, I thought, *SHE wants to get home, too. Maybe her boyfriend's waiting for her. Maybe she can't get to a phone. Like me.* I looked at the waitress and forced a sympathetic smile, "Just coffee. Please." She gritted her teeth and turned away.

Drawing out the last piece of pie from it's smeared glass case, the waitress slapped a scoop of ice-cream on top. She put the plate in front of Ma and filled two brown mugs with coffee from a dented, metal pot. As she slid a mug across to Ma, the coffee sloushed onto the table. She grabbed a wet cloth and sopped it up. "Thanks," Ma said, sounding snappish. She looked over at me. "You seem kind of edgy, what's the matter?"

"Nothing." I sipped the tepid, strong brew, felt an overwhelming desire to hurt my mother. "It's just... well, I really wanted to get home. To study for my exam." My voice sounded whiny.

"I'm sorry." Ma's languid eyes took on the hurt, sympathetic guise I hated.

I knew the look was supposed to make me feel guilty. But I couldn't today. *It's all her fault,* I thought. "You're always sorry," I snapped. "What good is that?" I knew my words stung Ma, but I didn't regret them.

She turned away from me and gobbled down the rest of her pie. Quickly finishing the last dregs of her coffee, Ma signaled the waitress and paid the check. "Come on then, if you're in such a big hurry. We'll walk over to the end of the line." We sauntered side by side in silence to Broadway and Ogden. The bus hadn't pulled in yet. Feeling grim and depressed, I took a cigarette out of my purse and lit up, waited for Ma to lecture me. She didn't. We stood slightly apart and silent, staring into space. When the bus arrived and the doors opened, we boarded. I was grateful that Lefty Wright wasn't the driver. I took the first double seat and turned my face to the window. My mind felt numb with grief and guilt. Ma struck up a conversation with Mrs. Fregard, who sat opposite. Their droning chatter couldn't dispel the wild images of Mike and me in the Chevy that played and replayed across my mind.

By the time we got to Sixtieth and Tower and descended the bus, Ma was back to her old self. "So," she said. "What should we do this evening?"

"I don't feel like doing anything. I told you. I have to study."

"We could play checkers. Or maybe you should practice your Evelina number. I bought the sheet music yesterday."

"I said I don't feel like doing anything." We were nearing the Paul's house, half a block from home. Mrs. Paul was sweeping her front porch. *Oh God*, I thought, *Another half hour before I can escape.* I was aching to barricade myself in my room and daydream about Mike.

Mrs. Paul stopped her sweeping task. "Hello, Marie. Hi, Fran." She was, as always, dressed in a sparkling clean, starched cotton dress and apron. Every hair on her head was tightly curled and in place under a hair net.

"Hello, Lena," Ma said. I smiled at Mrs. Paul in silence, thinking how odd it was to hear the two women address each other by their first names. I would never be allowed to do that. "How are you?" Ma asked.

"Fine. I'm waiting for Lois to get home. She's late again."

My friend Lois was going steady with Oogie Sather. I wondered if Mrs. Paul knew. The thought threw my mind back into turmoil. *Oh God, I HOPE Mike'll want to go steady.*

"I suppose she's busy with her girlfriends." I was sure Ma's remark was directed at me. Lois and I had drifted apart since entering high school. I was sure my mother didn't appreciate not knowing any of my new friends as well as she knew Lois and her family.

Mrs. Paul's face clouded. "I hope so. You never know nowadays what young girls get into. You're lucky Frannie is devoted to her dancing."

There was a touch of pride in Ma's smile. "Yah, Fran's doing real well. In school, too."

Oh God, I prayed, *PLEASE make them shut up!"*

The two women launched into their long review of our mutual neighbors and their activities. It seemed hours before I was freed from the torture of listening to them. As soon as I got inside our door at home, I thundered upstairs to my hideaway and threw myself across my mattress on the floor. I'd lost all hope of seeing Mike again. I sobbed myself to sleep. Little did I know that this was the beginning of a downward spiral to indifference and loss. ◆

19 - 1322-24 Tower Avenue, Beacon Theater.
20 - 1212 1/2 Tower Avenue, White & Blue Restaurant.
21 - 1402 Tower Avenue, Lightbody's.
22 - Highway 35 and Albright Road, Stardust Drive-In.
23 - 1321 Tower Avenue, Roth Bros.
24 - S.S. Kreske Co.; 1303 Tower Avenue.

Losing Ground

Procrastination is the thief of time. —Young

I spent most of Sunday in my hideaway, feeling grim and gray and distant. My biology book and notes lay untouched next to me. Cocooned in blankets, I replayed every disaster I imagined I had endured. Topping the inventory was my short-lived romance with Bud. Each moment, from my first attraction, to the culmination of my love on the front seat of his Buick, whirred back and forth across my mind. Every disturbing second trying to make Bud jealous, followed. I couldn't bear to replay my wild, sexual antics of the past summer, or my run-in with Miss Stromlind, or my recent, torrid writhings with Mike, though. I buried my head in my pillow and fixed on the thought that I was completely unlovable and worthless. *How can I believe I can be a better person?* I pulled the blankets over my head, drew into myself to a spot no one could reach.

By ten p.m. I was tired of being miserable. My growling stomach told me I needed food. I readjusted my wrinkled clothes from the day before and crept down the stairs. Ma was huddled in her afghan in Grandma Larsen's huge rocker, sleeping. The Sunday Tribune, still clutched in her hands, was spread across her lap. Our ancient, brass floor lamp cast just enough light to guide me past the piano, into the dark dining room, and help me avoid bumping into any of our old, huge pieces of furniture there. I could just make out Day and Howie's lumped forms loaded down with blankets in their separate beds against opposite walls.

The dim night light over our immense old table in the kitchen barely illuminated its surface. My huge shadow crept around the kitchen like a giant demon. Dirty dishes were stacked on the table next to a clean plate and silverware left out for me. A bowl of hotdish centered the space. Afraid of waking everyone, I decided not to heat it. I slid onto a chair and scooped cold food onto my plate. After three helpings I snuck back upstairs. In the bathroom I sponge bathed with cold water,

then made my way to my room. Propping myself against my pillows, I forced thoughts of any future with Mike Janicovich out of my head. I decided to take one last stab at studying for my biology test.

Suddenly, through my open window, I heard two cars screech to a halt in front our house. Horns blared. Someone hollered, "Hey Frannie! Come out and play!" Raucous laughter echoed through the silent neighborhood. I heard Ma in the hallway unlocking the front door. Her voice rang across the night, "Get out of here or I'll call the police!" Engines revved up and the cars took off. They headed west toward Oliver, the racket slowly fading into the distance.

I heard Ma's footfall on the staircase. Quickly shutting off the lamp next to my mattress, I scrunched down under the covers. When she got to my door Ma tapped lightly, "Fran? Are you in there?" The door opened. "Fran?"

I snapped on the light, feigning confusion. "What... ah... what's the matter?"

Ma's voice softened, "Oh, I thought you went out."

"Out? Why would I go out?"

"Didn't you hear that racket?"

"What racket?"

"Never mind," Ma said. "Go back to sleep." I waited for her to descend the stairs, picked up my biology book. It was past midnight by the time I finished cramming. My efforts proved to be a waste of time.

Mr. Gradin, his face expectant and shiny, stood in front of our tiered classroom giving instructions for the biology test. "Spread yourselves across the room so there's an empty place between each of you." I sat stiff and unyielding, waiting for Isobel and Marie to move. They pushed back their chairs and rose from the long table we shared with two other students. Isobel's wan face looked whiter than usual as she moved across the room. Sliding past me, Marie rolled her enormous, brown eyes. Her blazing cheeks emphasized her moon face.

Once everyone was settled in their designated places, Mr. Gradin sauntered up the low, flat stairs and handed a sheaf of stapled papers separately to each of us students. "Don't look at the questions until I tell you to," he ordered.

I glanced at Ivan, the closest student in my row. Flipping through the papers, he mouthed, "Jesus. This is the shits!" I gave him a keep-your-mouth-shut look, afraid he'd get me in trouble with Mr. Gradin. Ivan stuck out his tongue and slowly rotated it over his lips, leaving

them wet and glossy. I turned away, squelched the disturbing tingle I felt in my breasts. Ivan was one male peer I paid attention to. He seemed more mature than most of them, what with the stubble on his square chin. All the other guys our age still had peach fuzz. Ivan's hang-dog expression was unthreatening and even a bit sexy. And though we often huddled together, exchanging the latest obscene jokes and gestures, he never tried to make a move on me. He seemed real sure of himself. I liked that in a guy.

Mr. Gradin's authoritative voice rang out again, "Has everyone got their three sharpened pencils ready?" Murmurs of consent filled the room. "You have forty-five minutes to complete the test. Ready, Begin!"

Flipping back the cover page, my heart gave a little skip of delight when I saw that the exam format was multiple choice. Reading the first question, waves of nausea flooded through me. *Which of the following synonyms best describes osmosis? A. Infiltration; B. Juxtaposition; C. Perforation; D. Protraction.*

OhmyGod! I racked my brain for the definition of synonym. *It's not fair!* I thought. *We're only supposed to learn about synonyms in English.* I glanced at Ivan. His head was down, his pencil gripped so tightly that the knuckles on his hand were white. Across the aisle from me I heard Marie gasp. Her face was blazing redder than ever, like she was about to explode. I closed my eyes and prayed for guidance, then speedily checked B. The questions that followed were just as mind boggling. I felt a roaring of blood in my ears as I slowly struggled through page on page of unfathomable enigmas. The seconds ticked away.

All the A students finished first. Each one walked up front and laid their papers on Mr. Gradin's desk. He smiled and gave them a knowing nod. *Brown-nosed bastards*! I thought. After minutes, Mr. Gradin rose from his chair. "Time's up! Pass your papers forward." The only students left in the room were Isobel, Marie, Ivan and me. I was sure Mr. Gradin would feel obligated to lecture us. I was right. He sauntered back and forth in front of our tables. "This is the first test of the semester. Your grades reflect your attitude. If they're bad, I expect you all to get busy and toe the mark. I am not adverse to failing each and every one of you." His limpid blue eyes seemed focused on mine. I noticed the usual twinkle there had vanished. I felt heat rise up my neck. "You're excused, now." He turned and marched back to his desk.

Marie, Isobel, Ivan and I hurried into the corridor. We still had ten minutes before our next classes. "Wanna go have a smoke?" I asked.

Both girls nodded their heads no. Looking like they were still in shock, they wandered toward their lockers.

Ivan said, "You'd better cool it, Frannie, you're in enough trouble already."

"So are YOU!" I snapped, pulling up a bravado I didn't feel.

"Yah, but the difference is, I don't care." Amusement lurked in Ivan's eyes. They were wise little eyes, strangely veiled and dark. "I'm taking off for Canada next week. School's for losers," he said. His voice suddenly sounded smooth and sexy to me.

I gave him a second look. He had a long, narrow, brown face with two deep seams below his cheekbones. They gave the impression that he was older. His dusty-black, crew cut hair was thick and shiny. It matched the stubble on his chin. I wondered if he had hair on his chest. "Are you sixteen already?" I asked.

"Yah. I was held back in grade school once." He kept locking his dark eyes on mine as he talked. "I can leave this joint any damn time I want."

"Geez, I'd like to quit myself. Especially after today's test." My words surprised me. I'd never even thought of quitting.

He and I were slowly slogging down the corridor on the first floor. Up ahead I saw the telephone booth. I immediately remembered Mike Janicovich. "You got a nickel?" I asked. "I gotta make a phone call."

Ivan thrust his thin, long hand into his tight corduroys and pulled out a nickel. Handing it over he said, "You know what? We should skip school today. You game?"

Before I could mull over the prospect I blurted, "Sure. I'll have to call my Ma though. You got another nickel?"

Ivan dug in his pocket and handed me the coin.

I pushed into the wood encased telephone booth and slid the door closed. The light came on. Extracting the business card Mike had given me two days earlier from my skirt pocket, I deposited a nickel into the coin slot. I carefully dialed 9-8-0-1. Though I was sure he would never speak to me again, I felt I had to explain things. Deep inside I still harbored the hope that someday he would become my one and only. The phone rang three times before anyone answered.

"Glen's Standard Service! Glen speaking."

OhmyGod, ohmyGod, I thought. *I hope he doesn't hang up on me.* In my best radio commission speaking voice I said, "May I please speak to Mike Janicovich."

"He's not here!" Glen said. "Who's calling?"

I slammed the receiver into its cradle, leaned back against the booth. *Where can he be*, I thought. *I know he starts work at ten. Maybe he told Glen he didn't want to talk to me.* I heard a tap on the door window, slid back the door.

"You got a problem?" Ivan asked.

"No." I smiled reasuredly. "I dialed the wrong number." Closing the door, I deposited the second nickel and called Ma at Wagnell's, where she was dog-sitting.

"Ma? I'm at school." My voice was weak and shaky. "I'm feeling really sick." Ma sounded concerned, agreed to call the school office and get me excused.

"You go right home to bed, now," she said.

"I will," I lied.

Ivan was leaning against the wall alongside the telephone booth. He straightened his shoulders as I stepped out of the cubicle. "Everything okay?" I liked the deep, sympathetic tone of his voice.

"Oh sure. Just had to get some things straightened out." I forced my best friendly smile at him. Just then the second period bell erupted. Students came pouring out of Mr. Moe's science classroom around the corner. One of them rushing by was Curly Pirkovich.

Ivan shrieked, "Hey Curly!"

Geez, I thought, *Don't tell me they're friends.* "Do you know Curly?" I asked.

"We're in shop together. He's a card."

Curly lumbered over to us. "Hey Ivan. What's up?" He glanced at me. I detected the same suspicious glimmer that had crossed his eyes when he'd seen me with Mike two weeks back. "Hi, Frannie."

I mumbled "Hi," and clammed up. Just as they launched their blather over the basketball team that all the boys in Central seemed obsessed with, it occurred to me that maybe, if I was careful, I could get some information from Curly. At the first opening I blurted, "So, Curly, you still working at the gas station?"

I could tell from his blank, pale eyes that he didn't have a clue as to what I was up to. "I only help there when Mike's around."

"Oh?" I said, forcing nonchalance into my voice. "Did he quit?"

"Naw. He had to take off for Pennsylvania. For a funeral or something." Curly turned away from me. "Listen, Ivan. I gotta get to class. I'll talk to ya later." He rushed down the hall away from us.

Ivan looked over at me. "You look kind of pale. Maybe you real-

ly are sick."

Ivan's voice filtered through my reverie. "I'm just fine. Now." My thoughts had taken me away. I was reliving my moments with Mike up in the Chevy at the Standard station. I sighed in relief, believing that maybe I still had a chance with Mike. "Let's get the hell out of here," I said, my voice sounding bouncy and alive again.

Outside, huge flakes of snow were fluttering down from the overcast sky. I tightened my light jacket around me. "I guess winter's upon us!" I skipped in joy, turned my face to the sky and let the soft, cool snowflakes melt on it.

I felt Ivan's touch, let him slip his hand into mine. We sauntered north on Grand Avenue swinging our arms. The wet snow was melting as it hit the uneven sidewalks along our route. Puffs of snow began gathering on the trees along the boulevard. Ivan stopped in front of a beat-up Ford. I ducked under an overhanging tree branch. The branch bobbed, raining snow on my head. Ivan was right behind me. He brushed the flakes off my hair. "Looks like we're going to have an early winter."

The passenger door squeaked as he pulled it open for me. "Let's take in a movie," he said. "There's a double-feature at the People's Theater."[25] I slid into the passenger seat feeling strangely relaxed and expectant, thinking how nice it was to be with someone who had money. Ivan slid in next to me. "I know the guy that runs the projector. He always lets me sneak in the back door."

When we got to Broadway and Tower Ivan drove the car around the block and turned into an alley behind the People's Theater. The back of the buildings were shabby looking, with peeling paint and chipped concrete. Ivan pulled into a spot alongside the theater. Three tin garbage cans were turned over, their rotting contents spilled across the alley. As we alighted from the car, a scrawny black cat backed out of the closest can and shot up the alley away from us. The indentations from his cloverleafed footprints quickly filled with a dusting of snow.

Ivan moved below a small window on the top floor of the theater building. Leaning back, he put two fingers to his lips and whistled. The shrill noise reverberated in my ears. An unshaven face, topped by white hair, appeared in the window above us. "Ivan! I'll be right down." Ivan motioned with his head for me to follow him. There were four, bricked-over windows at the back of the two-story structure. The bricks were a shade lighter than the rest of the crumbling cement work. I wondered where the handle on the mammoth steel door that

centered the back of the theater was. Seconds later the door groaned open. "Quick! Get inside." The gnome-like projectionist reminded me of Quasimodo in the <u>Hunchback of Notre Dame</u>. A cold shiver fluttered through me.

The back of the theater was dark and musty smelling. I edged close along the wall behind Ivan as he followed our gimpy guide. We emerged alongside the heavy, dark drapes that shielded the entry to the theater. "I'll catch ya later," the old man said and disappeared.

I'd never liked the People's Theater –not since Ma warned, "Don't ever go in that filthy movie house alone." It was small and dingy and reeked of urine. I stumbled on the ragged carpeting as I inched down the narrow aisle with its two rows of seats on either side. "Not down there," Ivan stage-whispered. I could barely hear him over the blasting speakers spewing sounds of thundering hoofs and shooting six-guns from the ancient Tom Mix feature that filled the screen. I felt Ivan's hand in mine. I followed him to the last row of seats. He guided me to the two furthest seats against the wall. I sank into a rickety wood chair. As my eyes adjusted to the light, I noticed there were only five other people scattered through the theater, all men.

I scrunched down in my seat, remembering how much I hated Westerns. Ivan threw his arm around me. Startled, I turned to look at him. He lurched forward, his puckered lips meeting mine. The kiss was quick and dry. A vision of Ivan's damp lips from earlier in the morning filled my head. Ivan's thin fingers tiptoed up under my skirt. I crossed my legs. His hand pressed my knees apart. In a flash his fingers were inside my panties. I sighed deeply, more in boredom than excitement, thinking, *Geez. Guys are SO horny.* His fingers felt thick and rough. Quickly pulling his hand away, he grabbed mine, guided it to his crotch. Not sure what he expected, I squeezed hard. "OW!" Ivan blurted. "Not so rough!"

I leaned to his ear. "I don't know what you want," I whispered
He chuckled then, "Didn't you ever jerk anyone off?"
"WHAT?"
Ivan's raucous laugh burst out so loud the five other patrons turned and shushed us. "Go screw yourselves!" Ivan hollered. He jumped up, "Let's get out of here." We hurried out the way we'd entered. The snow was falling thick and steady. A heavy layer covered Ivan's car windshield. He began brushing the snow off with his bare hands. I clambered into the passenger seat and waited for him to fin-

ish. Seconds later his car was barreling toward South End. When we reached the fairgrounds Ivan turned the car in and parked it behind one of the boarded up concession stands there.

"I should be getting home," I said, even though I knew my words fell on deaf ears.

"I'll just be a sec," Ivan said.

Our bodies came together in quick, interlocking rhythms and though Ivan's passion seemed genuine, I felt untouched by it. My mind wandered back to the Chevy and Mike Janicovich. I was sure I would never reach that level of joy again.

His fever for me quelled, Ivan seemed embarrassed and shy. "I can do better," he said. "You should come to Canada with me. We'll screw our brains out." His words brought a wave of disgust in me. I knew I could NEVER go with him. He just wasn't my type.

"I'd really like to go," I said, searching for the right words –words that wouldn't hurt him. "But my mother would probably send the police after us."

Ivan turned on the car ignition. Back on Tower Avenue, we headed to my house. "Is your Ma home now?"

"Yah," I lied. I had felt a warning bell go off. He probably thought he could come in and screw me there. I was right.

"Too bad. I thought we could knock off another quick one."

"No way!" I was surprised at the strength in my voice.

Ivan chuckled. "I was just testing," he said.

The word testing riled me. "I don't LIKE tests," I snapped.

Ivan laughed aloud then. "No matter." His face took on a serious look. "Listen Frannie, I want you to think about my offer. To go to Canada with me. Give me your phone number. I'll call you in a couple days and see if you've changed your mind."

The windshield wipers were sweeping mini piles of snow into their corners. The snow came down so fast it gave the appearance of a whirling, white kaleidoscope. I peered into the swirling flakes. I briefly imagined how nice it would be to run away and leave every agony behind. "I'll think about it," I said. I could never leave without knowing what would transpire between me and Mike. It would be a long time in coming. Meanwhile, there were other disasters lying in wait for me. ◆

25 - 1018 Tower Avenue, People's Theater.

The Voice

Thy voice is a celestial melody. –Longfellow

I spent the rest of November eating my heart out over Mike. Every other day I called the station, trying to get his boss to tell me when Mike would be back. Glen became more and more agitated. One day he said, "I don't know who you are and I don't care. All I know is if you keep calling I'll get the law on you." Visions of falling into the clutches of the policewoman, convinced me to stop my telephone campaign. It was time to confront Curly.

The next morning at ten minutes to ten, I waved my arm at Mr. Gradin. "What is it?" he snapped, his small, bright face clouding. Ever since the disastrous test, resulting in my D grade, Mr. Gradin's friendship had waned.

"May I please be excused?" I asked. "I have to go to the bathroom."

Mr. Gradin sighed and rolled his eyes. "Go ahead," he said.

I rushed down the corridor and stood waiting outside Mr. Moe's classroom. When the bell rang and I spotted Curly, I shrieked, "Hey Pirkovich!"

He cautiously approached. "What's up sexy?"

I restrained myself from cursing him out, noted the suspicious glint that always appeared in his dim eyes when he saw me. "I was just wondering. When's Mike due back?"

"Oh ho! That's your game?"

"Oh shut up," I sputtered, "My brother's looking for a job. I just thought if Mike's not coming back, maybe Glen can use some help."

"Oh yah?" I could tell Curly didn't believe me, but I didn't care. "I thought your brother worked at Cornwall," he said.

"They're laying people off again," I lied.

"Well he can forget Glen. Mike's still got a job there."

"But he's not back yet! Maybe he isn't coming back at all?" I felt my face flush at the thought of losing Mike forever.

"He is too!" Curly snapped. "He decided to stay out in Pennsylvania until after the holidays. His family always goes there for

164

Christmas." A frown crossed his face. I could tell he knew he'd said too much. He quickly changed the subject. "You gettin enough nookie? I can always send you a few live ones." Curly's rough words and riotous, booming laugh galled me. "I heard you prefer Catholics," he continued.

"You're just jealous, you flaming pansy!" My raised voice caused Curly's broad face to redden.

"Bitch!" He hollered. A clutch of guys in the corner by the telephone booth whistled and hollered, "Cat fight! Cat fight!" Curly rushed down the hall away from me. I stomped off in the opposite direction.

Inside the girl's washroom I stood shaking, forcing myself not to cry. I was convinced my chances with Mike were gone, was sure that Curly would pass on all the nasty gossip he seemed to know about me. *Hell, why bother*, I thought, suddenly realizing that I couldn't do a thing about Mike. Our love was doomed.

<p style="text-align:center">* * * * *</p>

The seething sexual fervor burning inside me would not be quelled in spite of constant worry I'd get pregnant. I was sure there was nothing I could do but lay back and take my chances. The waning days of 1950 duplicated the summer fun I'd found so exciting and frivolous. I could always reform next year, I reasoned. All I ever did was fall in love with male body parts, anyway –dreamy dark eyes, broad shoulders, tall, willowy frames, thick curly hair, a certain cute twist to full lips. Any or all those attributes could set me aflame. Never mind that nine times out of ten the encounters were on car seats in the pitch blackness of frigid Northwoods nights.

I could hardly have determined the color, let alone the expression in any of their orbs. Their broad shoulders were more illusion than reality as well, since most of the guys wore heavy, plaid, flannel shirts or letter sweaters and bulky, leather jackets. They most certainly never removed their clothes like Mike had done. I didn't know how I could have even determined their height either, except maybe for a quick glance when they invariably mumbled, "I have to take a piss," and jumped out of the car.

Thick curly hair was attractive, but that was often a mirage, especially on occasions when the grease from those Samson-like locks left dark smudges on my bared breasts. As to their lips –as hard as I tried to maneuver my mouth towards theirs, it was a marvel if they kissed me at all. Because I seldom saw it, I never fell in love with the primary, male body part.

My fascination with anatomy rose and fell from tryst to tryst, though never in my wildest dreams did I imagine I'd be enamored with a voice. The Duluth DJ was my first and only vocal infatuation. The sonorous timbre of his speaking voice reverberated in my very bones the day he telephoned for a date. It left me breathless, and, as strange as it may seem, I immediately fell in love. Again.

He lost no time in announcing his name, at once bringing to me the realization he was –*a celebrity!* My thoughts churned in anticipation of the attention I'd garner in biology class on Monday, where I had taken to regaling my virginal classmates with salacious details of my adventures.

"Who gave you my phone number?" I asked, more in curiosity than in wariness. I had become alarmed at the number of guys who knew guys who told guys that I was easy.

But this guy was older, had an impressive job, and, consequently, would have money to spend.

"That's for me to know and you to find out," the DJ said, an edge to his voice that should have raised my suspicions. Unfortunately this was long before my survival antennae were fully developed. Besides, he quickly recovered his composure and continued, "Are you free for dinner tonight?"

Wanting to scream, YES!, I fought for control and calmly replied, "That depends on where we'd be going and the time." Then, not wanting to kill my big chance at a *real* date, instead of writhing on the back seat of a Buick in Greenwood Cemetery, I added, "I guess." I felt like kicking myself as soon as the words were out.

"I was thinking Green's on Superior Street. At say, seven?"

OhmyGod, ohmyGod, the liveliest spot in town! What could I wear? In a mature voice barely recognizable as my own, I answered, "That's fine, I'll be ready at seven." I gave him directions to my house and hung up.

It was my lucky night. Ma had left the house early for her American Legion banquet. The arguments, recriminations, and tears wouldn't be forthcoming from that quarter. Sis Day was at a friend's house. No need for bribery or wrangling to borrow her always clean, neatly pressed undies. Howie was running loose with his raucous cohorts somewhere in the neighborhood, sparing me his obsessive taunts and "sex maniac!" accusations.

I quickly pulled Ma's navy-blue, rayon tunic-dress from her closet, rummaged in her dresser drawer and extracted her favorite satin

slip and nylons. Borrowing Day's new garter belt and Saturday panties, I found my own, one-size-too-large bra, slung over the back of a chair. Retrieving the set of falsies I used to fill the spaces of that thirty-four-A contraption from their hiding place in the closet, I spread everything on the sofa. As always, the sight of the falsies evoked my annoyance. *When, if ever, are my paltry breasts going to grow!?*

I moved to the kitchen and took a vigorous sponge bath in the sink. No time to heat water for a bath in our galvanized tub. Sponge baths always brought to mind a favorite joke: *When you sponge-bathe you wash everything possible, then wash possible, too!* All the while I thanked my lucky stars that I'd set my hair in bobby-pins the night before.

Time raced. Sitting in front of Ma's vanity mirror in the underwear I'd pilfered, I carefully applied bronze pancake foundation and fluffed beige powder over it. In Day's drawer I found her auburn eyebrow pencil and mascara, cursed silently at the pastel shade of her lipstick. I'd have preferred fire engine red. Ma's dry rouge, blended on my cheekbones, and Desert Flower cologne doused behind my ears and in my meager cleavage, completed the ritual. In a cloud of reeking vapors, I brushed out the tight pin-curl ringlets and fashioned my brown hair in a knot at the nape of my neck like 1940s film star, Greer Garson. I stepped into Ma's dress skirt, shimmied it up to my waist, pulled the matching tunic down over my head and stood to inspect myself in the mirror. With lit Pall Mall gracefully poised in my fingers, I took a deep drag and blew a smoke ring at my image. I convinced myself I looked twenty-one years of age, at the least.

Shoes! OhmyGod, OhmyGod, I panicked, *Ma's probably wearing her best pumps.*

After tossing and rooting in the shoe closet, I seized on a pair of brown loafers, having decided it made little difference. I'd have to wear my zippered, stadium boots anyway, due to the streets still being icy and snow-covered from a recent storm. Apart from the good sense of that selection, it occurred to me that my date could very well be short. When we went dancing at Green's, I was sure he'd appreciate my thoughtfulness. I pulled the boots on, heard the honk of his car out front. Vexed that my full-length winter coat was at the cleaners, I grabbed my plaid, wool jacket, put it on and grabbed my shoulder bag.

Trying to look as sophisticated as Scarlet O'Hara descending the staircase in <u>Gone With The Wind</u>, I felt my throat catch in pleasure at the sight of his chrome-plated, two-door Pontiac, gleaming in welcome

on the street. The passenger door stood ajar, the radio blasted, <u>Hello Young Lovers, Wherever You Are</u>. As I approached I caught my first glimpse of my celebrity date in the dim ray of the ceiling light –the sight caused me to halt in my tracks. The good news was that he was wearing a dark suit, white shirt and tie. The bad news? He was fat, beady-eyed, and downright ugly! His pimply, balloon-face, bathed in the shaft of yellow light brought to mind a leering troll.

"Come on, I haven't got all night," he shouted. His voice, the voice that barely three hours earlier had besotted me, evaporated, like puffs of fetid breath on the cold night air.

I slid onto the car seat. Ma's rayon skirt, charged by static electricity from the frigid air, inched up my backside, leaving me bereft of a buffer between bare thighs and cold vinyl. Jerking forward as if goosed, I quickly raised myself and adjusted the skirt. At the same instant the DJ leaned across me and slammed the car door shut. His chubby, hairless hand brushed my chest. I lurched back.

"Don't get your ass in an uproar," he said, snorting like a hog. "I'm not a tit man."

His greasy words slid by me. I restrained my urge to gag from the strong whiff of Noxema that emanated from him, felt a twinge of pity too, remembering my own horrendous bout with acne not so long ago. Maybe I was too judgmental. He was, after all, taking me to dinner. Just in case though, I edged as far away as possible.

"You'd better lock that door or you'll fall out. What's your problem, anyway? I don't bite." He gunned the motor and shot away from the curb, pointing the car directly ahead, instead of turning left to Tower Avenue.

"I thought we were going to Duluth."

"I gotta see a guy in Oliver, first." A sudden flashback to Mike Janicovich filled my head. *He lives in Oliver! No. He's in Pennsylvania, now. Damn.* The DJ turned up the radio volume. The strains of "Anytime... you're feeling lonely... anytime... you're feeling blue..." filled the shroud-like silence that settled between us. I concentrated on the few lighted buildings on our westerly route out Highway 105 –the Lindner house and the depot on the right, the Andersons off to the left and the Hudaceks on the main highway. Halos of yellow light falling on white snow danced past. Ice patches on the road ahead zipped toward us, then vanished under the car, giving the illusion that they were moving and we were standing still.

The music blared on: "... anytime you feel downhearted ...that's the

time I'll come back home to you." As we neared the turnoff to Riverside Cemetery, I finally found what I thought was the perfect conversation opener. "Do you like country western music?" I leaned down and dug out my cigarette case from my purse on the floor.

"I only like what we play. That hillbilly stuff is for assholes. There's a lighter in the dash."

I ignored his rudeness, breathed a bit easier as I pushed in the lighter and waited for it to pop out a second later. Lighting up, I looked over at him, tried to decipher his mood. In the murky glow from the dashboard lights, his face looked wary, his flaccid lips fixed in what? A sneer? The car shot forward. The panic I'd felt at the notion he might be taking me to Riverside Cemetery like some of my sophomoric dates were prone to do, subsided.

Zooming a few yards past the entrance to Billings Drive, he suddenly slammed on the breaks. The Pontiac skidded to a halt. He shifted into reverse. The car lurched back and headed into the Drive. Anger rose inside me as we bounced across the frozen ruts, the headlights cutting deeper and deeper into the darkness ahead. *What an asshole*, I thought. *This whole date thing was a trick to get in my pants. Maybe he isn't even a disc jockey. He's no different than the rest.*

"What the hell do you think you're doing?" My angry words brought with them a determination that I would never let this moron touch me. I clutched the door handle waiting for the chance to jump if need be, but the car was going too fast.

"Don't pull that prick-tease act with me. From what I've heard you're a hot number."

"Maybe I'm fussy," I shot back.

"Shut up and give me a fag."

I reached down and pulled out my orange celluloid cigarette case with it's logo, TAKE ONE YOU CHEAP BASTARD. I'd decided it would be safer to humor the creep and handed the case over. His paw-like hand brushed mine. It felt clammy. He took the case, noted the logo.

"Pretty funny," he said, not laughing. Propping his elbow on the wheel, he yanked a Pall Mall from the pack and lit up. He veered the car into a rutted turnoff and stopped.

"What's it gonna be? A piece of ass or a walk in the woods?"

"Screw you," I hollered. Grabbing my purse, I pushed open the door and jumped out. I ran as fast as I could back to the Drive. My

heavy boots crunched the frozen snow under foot. I heard him start the motor. I knew in a flash I should head away from the main road. He'd be sure to think I'd be trekking back to town. I jumped the ditch, sprinted down a hill, veered left and crashed down an embankment, shredding Ma's nylons. My arms flayed in front of my face, breaking away dry tree branches as I ran. Stopping for a moment, I listened for the sound of his Pontiac. The sound of its motor faded in the distance.

Suddenly I felt exhausted. I sank to my knees behind a tree. The black dead silence descended on me like a cold tarpaulin. *Now what?* I thought. I was hardly dressed for a hike in the woods. Normally I'd have been in corduroys or jeans and wearing my long winter coat. At least I'd made the right choice when I opted for stadium boots instead of three inch pumps. My ears and hands began to feel icy. I pulled open my shoulder bag, dug around in the clutter and found one mitten and, *oh joy*! –my white wool babushka. I put it on. No cigarette case though. *The bastard*!

I pulled the mitten on, shoved my other hand into my jacket pocket and stood up.

Snow caked my skirt, leaving wet patches of rayon clinging to my thighs. I began to get visions of my frozen body lying spread-eagle in a snow bank. I knew I had to get back to the road. I lunged up the embankment.

On the Drive I stood trembling from the cold, considering my next move. Worse, I was envisioning wolves, though I was sure I'd hear them howling if they were in the area. At least I didn't have to deal with bears. They'd be in hibernation. I wished I was too. I decided to head for Highway 105. *If I make it far enough, I can go to Hudacek's house and use their phone*. I carefully began my hike forward. Walking on the hard, icy roadway seemed to help.

My initial terror began to ebb. *I just wish it wasn't so damn COLD!* I'd only gotten a few yards when I heard a car approaching from behind. I jumped the ditch at the side of the road and scrunched down in the snow. The car slowed. A spotlight weaved back and forth across the Drive in front of it. Elated at the thought of a squad car, I leapt up and ran forward frantically waving. The car slowly approached. The spotlight blinded me as the car came to a stop. I ran around to the passenger side. The door flew open. In the sickly glow of the ceiling light sat the DJ, leering at me like a gargoyle. I cursed myself for not having noticed the spotlight on his Pontiac when he

picked me up, stood gaping at him in disbelief, my mind churning out my choices. They seemed pretty slim.

The DJ beckoned with his flaccid, swine-like hand. "Don't be an asshole. You'll freeze to death out there. At least sit inside for a while and warm yourself."

I felt surges of warm air wafting around me, drawing me forward. *A couple minutes won't hurt.* "All right, all right," I snapped. "Just don't get the idea you're going to screw me." I cautiously slid onto the passenger seat.

"Here's your fags," he said, handing over my cigarette case. "You took off without them."

I quickly pulled open the case and took out a Pall Mall. He proffered the hot lighter. My hand trembled as I leaned over and lit up.

"Close the door before we both freeze. I won't try anything." Slamming the door, I smoked in silence, wondered why he didn't drive off. "You know, I'm not that bad a guy." His voice, the voice I'd fallen for, sounded too slick and smooth, now. "All I want is a little fun." I hated it when they tried to pull their nice guy tactics. "What'll it take for you to change your mind?"

"I'm not going to," I said, trying as hard as I could to make it sound final.

"Ah come on, Fran, be reasonable. I'm not your regular one-night stand. We could have some good times together. I'd even take you dancing, or out to dinner."

"Oh yah, like tonight?" I snapped, though I was vaguely pleased that he used my name. I thought he'd forgotten it.

"I'm sorry about that. I couldn't help myself –you looked so damn pretty when you came bouncing out of your house tonight."

"Cut the crap. You figured I was easy. For your information I don't screw EVERYONE I meet."

"I'm sure you don't. Obviously, you're smart and attractive. I don't know many girls like you." His resonant voice had begun to sound whiny.

"Bullshit! You're just like all the rest of the guys I know. Over-sexed and stupid!"

"Okay then," he grumbled, sounding hurt. He pulled a bill from his jacket pocket.

"Here's a fiver, will that be enough?"

"No way! I'm not a whore!"

"How about ten?"

"I *said* no." I took a side-long glance at him. He was fumbling in his pocket again.

"I've got a twenty here."

I was getting sick of his voice, felt myself weaken. We'd probably be sitting here all night until he got his way. Ma's nylons needed to be replaced and I didn't have any money.

"Well... okay... but make it fast." I grabbed the bill and stuffed it in my purse on the floor.

"Pull down your pants."

In a flash he had unbuttoned his fly and lunged at me, giving me barely time to turn toward him. He yanked my skirt to my chin. I raised up, wriggled the silky step-ins down to my knees. Not fast enough. I felt his sweaty hand rip them away. *Oh shit! How am I going to explain this to Day?* Angered, I swore I was not going to cooperate any further. I lay back zombie-like and stared at the ceiling.

He began pumping away like a pile driver. Closing my eyes, I let my thoughts drift to Mike Janicovich. I quickly erased the vision, not wanting to excite myself. Instead, I began formulating the conversation I'd have with Mike when he got back from Pennsylvania.

The DJ began to gasp and groan. I hoped he'd drop dead of a heart attack. *The fat bastard.* Suddenly he heaved himself off me. "I gotta take a leak," he said, grunting as he wedged his huge, repulsive frame out from behind the steering wheel.

I felt his sticky warm fluid against my leg while he was outside, yanked my babushka off my head and wiped the mess away. *Men are such pigs*, I thought. Lighting another Pall Mall, I felt nothing but unbridled relief. The Pontiac sagged pitifully toward the driver's seat as the DJ got back in. Leaning toward me, he reached down to my purse.

"I've got the case here," I said, extending the Pall Malls to him.

"I don't want a fucking fag, I want my twenty."

Incensed, I shrieked "ASSHOLE! You're nothing but a two-bit jerk."

"And you're the worst piece of ass I've ever had." He turned on the ignition and gunned the motor all the way to the highway.

"Like you're the lover of the century? At least you could pay me for my ripped underwear."

He pulled the Pontiac over to the side of the highway, dug in his

suit pocket and threw two singles at me. "That should do it," he said, then took off again at breakneck speed.

I glanced at the dashboard clock. It was just past eight-thirty. "Drop me at the corner. I don't want to be seen with you."

The car screeched to a halt at Central and Oakes. "Get out bitch!"

Standing alone under the street light, I watched the Pontiac tail lights disappear down the street, heard the radio blare, "Unforgettable... that's what you are."

The noise of crunching snow from my cumbersome, booted stride, echoed across the silent night. I trudged two blocks east to Tower Avenue. My breath exploded in billows on the icy air, quickly floating away like a silent prayer. I stopped across from the lit up Standard gas station. Staring at the low, long building until my eyes stung, as if by magic, Mike materialized in a misty, luminous light. He beckoned me to join him. The fantasy evoked an instant image of his precious, sinewy body –the fabulous body I'd fallen in love with. ◆

The Cadet

The flower of our young manhood. –Sophocles.

Decembⁿer, with its ice storms and frigid temperatures, was as paralyzing as the despair that consumed me. I was relieved that dance classes were over for the holidays. Mrs. Sterling had driven me crazy with her constant concern over my mood swings. Christmas vacation would soon release me from the torture of my dull, day-to-day labors at Central, as well.

Our first semester grades were out. I was disappointed with mine. The grades reflected the negligence that had replaced my resolve to succeed. I hadn't finished my sports mural in time for Miss Rehnstrand's art show, resulting in a C. I didn't give a hoot about biology, but my D grade brought a dark void, as it culminated in the loss of my friendship with Mr. Gradin. And though I got B's in both history and language arts, I was sure Mr. Crowley, my history teacher, didn't know who I was. He probably gave me someone else's grade. I'd breezed through language arts with Mr. Jay, though my essay output had drastically declined. He was always enthralled with everything I wrote. I got a B in commercial art, with Mr. Yaworski. I did manage to finish my soap carving, spurred by the idea of giving it to Ma as a Christmas gift.

I was completely bored with my girlfriends as well. I'd lost interest in discussing any of my winter adventures with Marie and Isobel, or anyone else. The Duluth DJ disaster brought the awareness that some things were better kept to myself. It would have been impossible to embroider that tale enough to make me come out looking good anyway.

Bobbie Klenke and I drifted apart, ever since she noticed that Jill Rochet was gaining ground with me. Jill was a tenacious opponent. I failed her exhausting inquisition about my true love, Mike Janicovich. I couldn't find a strong enough argument to deflect her painful observations of, "If the guy truly loved you, he wouldn't have abandoned you right before Christmas," or, "He probably didn't want to buy you a gift." I concluded that Jill was right. Her determination and constant bom-

bardment to urge me into the arms of Harold, her cadet brother, were wearing me down. Finally, I caved in. *What's the difference*, I thought. *One idiot guy is as bad as the next.*

Harold Rochet stood waiting on our snow-covered, front porch, stomping his feet and shivering. An ungodly, howling wind had sprung up. It took me a while to answer the door, as I'd mistaken Harold's pounding for the inevitable rattle and groan that assaulted our clapboard duplex every winter. In any case, I'd had my ear tuned for the blast of a car horn. I unhooked the heavy storm door, clinging to it like a raft in the middle of an ocean. I knew if I let loose, the wind would whip the door back and break another of its glass panes. I hollered into the night, "Where the hell's your car!?" A blast of cold air blew snow into my eyes and open mouth.

Harold shouted back, "I haven't got a car! Let me in!" His high-pitched voice sounded girlish and stupid.

Oh shit, I thought. I inched forward and let him squeeze past me into the cold hallway. *Now he'll see what a pig sty we live in.* I hadn't cleaned house for over a month.

Ma's voice suddenly sang out, "Bring your date in, Fran. I'd like to meet him!"

I bounded ahead of Harold into the living room, expecting the worst. Ma stood smiling at us, in front of the Isinglass heater. She'd combed back her scraggly hair and donned a fresh, clean apron. I noted the dining room lights were out, making it impossible for any-one to see the mess through the darkness there. Grateful for that, my eyes scanned the parlor. Ma must have whirlwinded her way through. The sofa bed was closed up, Grandma's rocker positioned closer to the dining room entryway. The library table in the corner was cleared of clutter, the ancient stained-glass, bronze lamp glowed with three new light bulbs. The floor lamp next to the rocker cast a brighter light than usual, too. It's rays were reflected in the closed, newly dusted piano alongside. Ma directed Harold to the rocker. *A smart move*, I thought. *Now he can't see behind him.*

Harold strode forward like he was on review, bringing to mind a bantam rooster in heat. "Excuse me," he mumbled as he crossed in front of me. For an instant I thought he was going to salute. He sank into the rocker, immediately straightening his back and placed his feet –encased in shiny, black patent leather shoes– flat on the floor in front of him. They were dripping wet. Taking off his gray hat, he turned it

over and put his matching gloves inside, placing both on the floor. The hat reminded me of those worn by the Salvation Army Captains who rang bells over their red kettles in front of Roth Brothers every Christmas. Except that the Army hats were dark blue. "This is a cozy spot," Harold said, in an inflectionless voice.

"Let me take your trench coat," Ma said. Harold jumped up, his halibut-hued face coloring. I realized then that his height wasn't the biggest disappointment, though he was one head shorter than me. He seemed a spiritless person, dutiful and automated to follow a straight course. It was the self-same trap I'd almost fallen into. I glanced at his gray, wool uniform. The top appeared to be a tunic with a black, four inch wide stripe down the front and around each long sleeved cuff. I wondered where the buttons were. *Surely he didn't pull the tunic down over his head, like women did?* His perfectly creased trousers had the same stripe alongside the outer pant legs. Ma's words burst through my thoughts, "Aren't you going to finish getting ready, Fran?"

For a moment I panicked, knowing I couldn't put the lights on in the dining room and sit at Ma's vanity. "I'll just be a second," I said. Grabbing my shoulder bag off the couch I thundered out of the room, up the front stairs to the bathroom. There I leaned into the cracked mirror and fluffed powder from Ma's compact onto my face. A slash of fire engine red lipstick was the only other makeup I applied. I had no desire to impress Harold. I decided to change my long skirt, too. In my room I found my chocolate-brown corduroys lying in a heap on the floor. I pulled off my skirt. Throwing it aside, I shook out the corduroys and yanked them up my legs.

Moments later, as I approached the downstairs parlor door, I could hear Ma's voice droning on and on. Every once in awhile Harold responded, "Yes, Ma'am," or "No, Ma'am." His responses sounded dull and flat.

I burst into the room. Harold jumped to his feet like he'd been called into action. "I'll grab my coat, then we can leave," I said.

Ma stood up and helped Harold into his trench coat. "Too bad Fran's sister and brother aren't home. They would have loved to meet you." I wondered at the tone of Ma's voice, wondered if I'd detected a false note.

Harold turned, looked up at Ma and shook her hand. "It's a pleasure meeting you, Ma'am," he said in his monotone voice. Ma blushed.

Harold and I trudged the two blocks east to Sixtieth Street. After an initial struggle of who was going to hold on to who, Harold's

gloved hand clutched my upper arm like a vise. We bent into the howling wind. Mists of ghostly snow swirled around us. I'd opted to wear my glasses, not caring what Harold thought of their ugly, brown frames. I squinted through the fogged, wet lenses as I blindly stumbled along. Harold was slipping and sliding on the icy roadway next to me. I prayed he wouldn't fall. I was sure if he did, he'd pull me down with him. Once we got to the bus stop we stood clutching ourselves, with our backs to the wind. I suddenly wondered if I was supposed to pay my own fare, or if he was going to.

By the time the bus approached, my mind had switched to another worry. *Geez, I hope Lefty's not working.* Like us, the vehicle was covered in a layer snow, partially concealing its ugly ivory and burnt orange hue. Harold guided me forward, then stepped aside to let me board. I was relieved to see that old Lefty wasn't driving. I turned to Harold as he sprinted up the steps. "I can use my school pass," I said.

"Not necessary," Harold replied in his clipped, monotone voice. He dropped exact change into the coin box. The money slid down a metal shoot. The driver flipped a lever alongside the box, activating the coin counter. Determined not to sit too close to Harold, I rushed to the rear of the bus and positioned myself in the exact middle of the long, five-passenger seat. Harold stood brushing clumps of snow off his trench coat. I removed my mittens, pulled a Kleenex from my purse and wiped away the water spots on my glasses.

"Which movie are we going to?" I asked.

Harold, finished with his snow-brushing, straightened in his seat. "There's a double-feature at the People's Theater."

I turned my head and looked at his pallid face. It was then I noticed his entire forehead was covered with mini-blackheads. *Yuk*, I thought, *This kid's still in puberty.* "The People's? Have you ever been there?"

"Well, no. But I like Westerns. <u>Rio Grand</u>, with John Wayne is playing. He's my favorite actor." His empty tone of voice belied any enthusiasm a normal person would show.

Ah geez, what a creep. Composing myself I said, "I don't know how to tell you, but that theater is kind of... well, it's a dump. Kids just go there to make out." Did I detect a gleam in Harold's placid eyes?

"Is that so bad?" he asked, sounding like a juvenile.

"YES!" I spouted, my raised voice drawing the attention of the six or seven passengers scattered on the seats in front of us. I was relieved none of them were school mates. In a calm, low voice I said, "I don't see

the point of paying good money to see a movie if you're not going to watch it." I glanced at Harold's face again. He looked insipid and stiff.

"Of course you're right," he said. His phony smile revealed the braces on his large teeth. "What do you want to see?"

"All About Eve. It's playing at the Palace.[26] With Bette Davis. She's my favorite." I was elated to see how easy it was to get my way. *He is SUCH a pushover*, I thought.

At our stop in front of the Palace, I bounded off the bus. Harold lurched off behind me, falling against my back. "For Pete's SAKE!" I blurted.

The brilliant-white theater marquee lights chased each other round and round like carrousel horses. Ten-inch-tall black letters, spelled out ALL ABOUT EVE. The heat from the light bulbs felt warm on my face. I suddenly felt a lot better. I'd often dreamed of a stage career, imagined I'd just stepped out of a long black limousine, with crowds of people waving and shouting my name.

Coming back down to earth, I glanced at the clock inside the cashier's cage. I noted we had ten minutes before the main feature. Harold waved the ten dollar bill he'd pulled from his coat pocket at the cashier. The gum-chewing woman quickly slid back the block of wood that covered the crescent shaped opening in front of her. Just as Harold slid the bill into the opening, a gust of wind whipped it out of the cashier's hand. She slid off her elevated stool and retrieved it from the floor. Glowering, she snapped, "Ain't you got any singles!?"

"No, Ma'am," Harold mumbled. "Sorry."

The cashier harumphed loudly. She unlocked a drawer behind her with a small key attached to a cord. I noted her orange-painted finger-nails. She slowly counted out the change and tore off two, pale blue tick-ets that popped out of a bobbin-like hole in front of her. "Don't let those bills fly off," she snapped, then quickly slid the wood back across the opening. Harold stuffed his change in his pocket and touched my elbow. I shook his hand away. Inside, the overwhelming, heavenly aroma of fresh buttered popcorn filled my nostrils. An elderly, blue and gold uni-formed gentleman waved us over. Harold handed him our tickets. The old guy tore them in half and gave the stubs to Harold.

"I'm going to the restroom," I said. "Get me a large popcorn. And some Milk Duds." I turned from my date and rushed over the plush, flo-ral carpeting through two swathed, heavy velvet drapes. Inside a cubicle in the washroom I sat on my coat and waited. I'd decided not to take any

chances, not wanting any of my high school friends to see me with Harold. After I was sure ten minutes had passed, I sauntered out.

Harold stood like a post, his trench coat slung over an arm, a box of popcorn in each hand. He was staring up at the gilded molding along the huge ceiling above us. If he wasn't so short, he could have been mistaken for a military statue. For an instant I felt terribly sorry for him. I approached, searching for soothing words. "Sorry, Harold," I said, in the warmest tone of voice I could muster. "I didn't mean to take so long."

A half-startled wariness crossed his puny face. "That's okay. We only missed the cartoons." At the door to the theater he turned and looked at me. His timid eyes seemed watery, with absolutely no expression in them. "May I take your coat?" He asked.

"I'll take it off," I said. "You've got your hands full."

The main floor of the Palace was vast and enchanting, with its art deco ornamentation, gold-leaf wall sconces and heavy stage draperies. And though the Beacon Theater was just as magnificent, that theater had lost some of its glamour for me. I'd danced on the stage at the Beacon during one or two recitals and was familiar with the backstage clutter and dinginess. I loved being transported away from my day-to-day struggles in a setting where, the minute you took your seat, you entered a world of unending glamour.

Harold stumbled behind me down the aisle to the center of the theater. The March of Time news story on Korea that I'd seen last month, was reeling across the screen. Looking around in the dim light, I chose an unoccupied row and sidled to the very middle. I sank onto the plush, horsehair seat and scrunched down as far as possible, hoping no one from Central was present. After the news was over, the house lights came up. A transparent, gold-colored curtain slid across the screen. Seconds later, the credits for All About Eve began rolling. The gauzy curtain slid back. The house lights dimmed. Harold handed me a box of popcorn, accidentally knocking the box against my chair arm. Several greasy kernels scattered onto my lap. I brushed them onto the floor. "Thanks a lot," I said, not looking at him.

The movie told a brilliant, cutting story of theater life, with Bette Davis as Margo Channing, an aging Broadway star, who takes an outwardly naive fan under her wing, only to discover the waif is scheming to take her throne. The name Margo Channing was the first thing that captivated me. All through the feature I contemplated names for myself –Francine Channing ...Francine Lansing ...Felicia Fairbanks.

Soon I felt I was Margo. I saw myself sauntering across the stage, advancing with one shoulder raised, hips undulating, a jeweled cigarette holder gracefully held between my long, thin fingers.

I was the worldly, exploited, long-suffering heroine surrounded by fools and hangers-on who constantly insinuated themselves into my life. Margo's brilliant quips of "Fasten your seat belts, it's going to be a bumpy night," and "Everybody has a heart –except for some people" –were things I could say if given half the chance. It dawned on me that, like Margo, I was a survivor and one day I would renew myself, too. Still, I couldn't keep from sobbing. For both of us. As soon as the movie ended, I jumped up and quickly squeezed past Harold, whispering, "I gotta go to the restroom." In a cubicle there, I sat unrolling gobs of toilet paper and blowing my nose until it hurt.

Minutes later I rambled through the deserted lobby to the street. Harold stood under the darkened marquee, waiting. He looked desolate and uneasy. His breath came out in puffs, like he was smoking, though I was sure he'd never condone that bad habit. The thought made me wish I had brought my pack of cigarettes with me.

It had stopped snowing. The wind had died down, too, barely stirring the blanket of snow that layered the sidewalks. The street lights reflected on the crusted cement, like sparkling diamonds. Most of the theater patrons were already halfway down the block ahead of us, heading to their cars or to the bus stops. Harold's braces gleamed in the dim light. "Would you like to go for coffee... or something?" he asked, sounding listless and hesitant.

"What time is it?" I asked, practicing a sophisticated, low tone of voice.

"Almost ten," Harold said. "What's open?"

"Not much, really," I said, pronouncing the word, RE-al-ly. Suddenly I remembered the Hotel Superior[27] at Belknap and Tower. "We could go to the Hotel Superior. But... it's rah-ther expensive." I glanced at Harold. His small eyes seemed to brighten.

"A hotel?" He'd stopped at the intersection as a car turned in front of him. Putting his arm out as if to hold me back, he accidentally smacked me in the chest. "Oh geez," he said, his voice catching.

"For Pete's sake! The COFFEE SHOP, I meant. What IS your problem?" My vocal chords had begun to ache from the strain of my newly acquired accent.

"Sorry," Harold mumbled. We sauntered south on Tower, evading a few shop keepers who were shoveling snow off their walks. "How far is it?"

"Just four blocks or so," I said.

Harold pulled his trench coat collar up over his ears and stuffed his hands into his pockets. His action brought the realization that though the wind had died down, it was bitterly cold. "Let's walk a little faster," I said and rushed ahead of him.

We hustled along to the Belknap intersection. It's stoplight flashing, first yellow, then red, seemed unusually brilliant in the darkness of the night. When it turned green, Harold looked left and right, then touched my elbow and guided me across the street. Light glowed invitingly through the oval windows of the hotel lobby. I hurried through the heavy door with it's port-hole window. Heat blasted around me, causing my glasses to fog. I yanked them off and stuffed them in my coat pocket. Harold trailed behind as I sashayed into the huge dining room. No one was sitting at any of the dozen or so round, white-clothed tables. Candles, flickering in their round, glass globes evoked a movieset feeling in me. I imagined myself as Margo, promenading across the room, dragging a fox boa behind me. I continued through to the coffee shop. There was one customer at the counter, his head bent over a steaming cup.

"Let's sit in a booth," I said, sliding into the one closest to the door. The leather seats were a cheerful, yellow and beige stripes. A waitress appeared from nowhere.

"Hello kids," she said as she lay two huge, plastic-encased menus in front of us. "What'll you have? Coffee or soda?"

"Two coffees," Harold mumbled.

As the waitress hurried off, I leaned toward Harold. "Maybe I don't want coffee," I snapped.

"I... thought... you were cold." A hurt look crossed Harold's small, pinched face, making me immediately ashamed.

"You're right," I said. "I am kind of chilled." I opened the menu and scanned the options, thinking, *OhmyGod, these prices are pretty steep.* "I'm not very hungry. I guess I ate too much popcorn."

Harold was still looking at the menu. "How's their pie?" he asked.

"Ahh... pretty good," I said. I didn't want to admit I'd never been in the cafe before.

The waitress returned. "Two apple pies. With ice cream," Harold said, his voice sounding strong and authoritative. She smiled as he handed the menus back to her.

"Thank you. Sir."

I glanced at Harold again, concluded that he maybe was used to

giving orders to subordinates. I couldn't find a clue in his pale, simpering gaze. *Maybe I'm being too mean, I thought.* "So, Harold. What's it like at the academy?"

"It's fun," he said, his voice flat and joyless sounding. I wondered what in the world he would define as fun.

"Are there any girls at the school?"

"Oh no," he said, looking as if he were perking up. "It's strictly male. We're training for military careers." Harold was definitely enlivened.

"Like, you mean the infantry? Or... something?" *Do I CARE?* I thought.

Harold's laugh, though high-pitched and girlish, was welcome. I felt myself relax. "We're going to be officers. Well, after college."

"RE-ally? Where does a person learn THAT?"

"West Point," he said, sounding proud. I had the feeling I should know what West Point was.

"That IS impressive," I said, "Then you'll have the girls swarming around you. They love college guys. And uniforms." Harold smiled. I began to wonder if I had misjudged him.

Just then the waitress appeared with our order. The pie was warm, the vanilla ice cream melting in dollops over it. "Hmmm. This looks really good," I said. "Thanks, Harold."

"You're welcome," he said, then, looking like a shy grade schooler, "Ah, Frances... could... could I... ah... ask you something really personal?" His face became more ashen than ever. Pearls of sweat gathered on his upper lip.

"Sure!" I said, wiping a trickle of ice cream off my chin with the yellow linen napkin.

"Ah... have you... ah... ever had sexual intercourse?" He slid his stubby-fingered hand across his lips.

I sputtered, quickly leaning forward as a gob of pie fell off my fork back onto my plate. I briefly wondered if I should be honest, decided, *why not?* "Sure have," I blurted, "Lots of times. Haven't you?"

Harold lowered his voice. "I *want* to. But my girlfriend's afraid." He sighed and blinked his eyes.

"SO! You do have a girlfriend. Good for you," I said, suddenly feeling like Margo Channing, advising her understudy. "Tell her it's nothing to be afraid of. In fact, it's really wonderful." I caught myself. "I mean, when you're in love."

"I've heard that," Harold mumbled. "But... I don't really know how to start."

"You start by kissing. Obviously." I took a sip of coffee. Harold's eyes had begun to brighten. "Not just lip kissing. You put your tongue in her mouth. And move it around. Slowly. It's called French kissing."

"What if she won't open her mouth?" Harold's words were rushed, like if he didn't hurry he'd lose his nerve.

"She will. Trust me." I finished off the last of my pie, pushed the plate to the side of the table. Harold hadn't finished his. He'd lain his fork down as I spoke. "Are you going to finish that pie?" I asked. He nodded his head no, then slid the plate over to me.

"You sure know a lot," Harold said. His braced, smile didn't seem as ugly to me anymore. "So... after I French kiss her, then what do I do?"

"Well, you could kiss her on her ears or her neck. Girls like that." I was feeling really warm, slipped my heavy coat off and draped it over my shoulders. A scene from All About Eve with Margo in a long velvet cape appeared in my head. "Then... well, when all the kissing is going on, you should be... well... feeling her up."

"Feeling her up?" Harold looked confused.

"You know, feeling her... a... titties." I was definitely warming to the subject. "By then you'll both be ready."

"What do you mean?" Harold leaned forward, his eyes all squished up, looking confused.

"Oh Harold," I said. "I don't want to say it. Just believe me. You'll know what to do." I was feeling uneasy. "Can't you ask your father anything?"

"God, no." Harold sank back in the booth as if defeated. "He'd shit if he knew I was even thinking about sex." Harold's eyes glistened, like he was going to cry.

I reached over and patted his hand. It felt clammy and cold. "Don't worry Harold. Everything works out in the end." I couldn't believe I was parroting the words my mother always said. It seemed to help him, though.

"Have you got a steady boyfriend?" Harold asked.

"I wish," I said, then corrected myself, "I'm pretty sure I will be going steady after the holidays." An image of Mike Janicovich immediately filled my head. Before I knew it I was telling Harold all about him, from our first attraction, to our passionate coupling inside the Chevy at Glen's

Fair Game

Standard Service Station. Harold seemed awed by my revelations.

"Wow," he said. "That's real love."

"You're right about that," I sighed. I was Margo Channing again. "Love is SO cruel. But remember, everyone has a heart –except for some people."

"I felt bad coming here for Christmas," Harold said. "I didn't want to leave Sheila. She's my girlfriend." *Mike did the same thing to me.* The thought brought pity for Harold's dilemma. He hesitated for a moment, then continued, "Please don't tell my sister, Jill."

In my best Bette Davis voice, I said, "My lips are sealed." Then, "You know what? If I was you, I'd go back to New York as soon as I could. I'll bet Sheila would welcome you with open arms!" I immediately imagined Mike standing on the Great Northern Depot platform. He waves at me. I rush forward and fall into his arms.

"You think?" Harold's sickly, pale face lit up. "You know, I might just DO that!" He waved over the waitress and handed her a five dollar bill. "Keep the change!" he said.

The waitress looked at the bill. She smiled broadly and said, "Well, thank you! And, Merry Christmas!"

After we left the coffee shop, we jaywalked across the deserted main drag. Block on block of dim, yellow light from the poles positioned at every corner, cast dull shadows on the arctic-like scene. As we stood waiting for my bus, I said to Harold, "The Billings Park bus comes first. Why don't you go ahead? Mine'll be here in less than five minutes. There's no reason for you to drag yourself out to South End."

"You don't mind?"

I nodded my head, no. "You've already proved to me that you're a gentleman."

Harold put out his hand, then, as if he'd just remembered something, he leaned forward and kissed my cheek. "You're so kind," he said.

After Harold boarded the Billings Park bus and waved from inside, I felt my eyes fill. I wiped the tears away with my mittened hand, thinking how nice my dreaded date had turned out. Things seemed cheerier than they'd been for a long time. Still, I was conscious of a dull throb of grief. The uneasiness without a name that I often felt, returned. ◆

26 - The Palace Theater, 1102-04 Tower Avenue.
27 - Hotel Superior, 1510 Tower Avenue.

Repentance

That vague kind of penitence which holidays awaken in us.
—Dickens

I was grateful when school let out for the holidays. Jill wasn't speaking to me, after Harold took my advice and returned to Poughkeepsie. "GEEZ!" she screamed, "You ruined Christmas for our whole family!"

Though her words cut deep, I responded in a flurry of spite. "Some family! You don't even talk about SEX!"

Jill blurted, "You are SICK!"

Bobbie and Avis, standing nearby, doubled over in laughter as Jill stomped off. "Piss on her," Bobbie said. "Now we can be friends again."

I felt my face grow hot as I screamed, "Shut up, SHUT UP!" and took off in the opposite direction of Jill, rushing through the Christmas decorated halls of Central. Shaking with hostility, I vowed I'd never get friendly with any of my high school peers again.

Christmas at our house duplicated the year before. Except this year Ma refused to accept any Salvation Army basket. "I detest handouts," she said. Somehow or other, she managed to come up with presents for us three kids and serve the ritual lutefisk on Christmas Eve. We three provided token gifts for each other —purchases from Mae Stewart's Variety Store[28] and Woolworth's Five and Dime,[29] where Day had gotten a part-time job.

I suspected Ma paid for the things Howard bought —a celluloid mirror, brush and comb each for Day and me, mine in pink, hers in ivory. I hated pink. Day got me the latest in hair ornaments —five plastic-coiled headbands in black, white, green, red and blue. I got her two silky neck scarves and Howard a pair of mittens, which on opening he said, "Geez, I wanted leather gloves!" Ma's contributions were new boots for one and all and a book for each of us. I got her a pair of red plaid woolen gloves. I loved plaid and knew she wouldn't object to me borrowing them from time to time.

Fair Game

I wasn't surprised that Ma insisted we spend Christmas Day at father's sister's house. Aunt Etta and Uncle Arlo lived in Billings Park. We hadn't gone to Aunt Etta's last year, the only time we'd bypassed that traditional visit since Grandma Larsen died. Ma hastily warned, "Don't mention we're going to Aunt Mattie's on New Year's Day." It was the first time we'd ever been invited to a holiday get-together with father's other sister, Aunt Mattie and Uncle Russ. We knew Aunt Etta would be offended to learn of our disloyalty. A deep river of enmity ran rampant between Etta and Mattie. We didn't want to hurt Aunt Etta's feelings.

Howard and Day were especially glum. Neither of them enjoyed social gatherings. Aunt Etta's usual houseful of guests petered down to just her, Uncle Arlo, and us. Auntie reported that Grandma O., her mother, was at Grand Aunt Hettie's, in Sandstone, Minnesota. "I don't know why! They've never been that close," Aunt Etta snapped. Etta's daughter, cousin Brenda and her son-in-law Wally, were absent as well. That surprised me. Aunt Etta shifted her corpulent body in her chair, "They're invited to the Haugen's," she said, her voice sounding sarcastic.

Ma was impressed. "Really? You know Brenda's in-laws are prominent Superiorites, of Norse descent. They're lovely people. She's lucky to have gotten into that family." Aunt Etta's scowl clued me to the fact that, by inferring the Haugens were better than Auntie's family, Ma had unwittingly committed a social blunder.

We three were in Aunt Etta's bright kitchen. The luscious aroma of the roasting turkey in Auntie's massive, cast iron stove filled the air. I was peeling potatoes, a task I absolutely abhorred. Ma was cautiously opening a can of cream-style corn with Auntie's old, rusted can opener. Aunt Etta's huge frame was wedged in a chair between the kitchen table and the pantry door. The folds of flab under her upper arms were shaking like jello as she whacked at a yam with a potato peeler. She momentarily stopped her task to scowl at Ma. "Good God, Marie," she spouted, "Let me open the corn. You can do the yams."

Two red dots grew on Ma's high cheekbones. "I'm fine," she said.

Compelled to intervene, I jumped into the conversation. "Your new curtains are beautiful, Auntie." Etta's broad, sweaty face filled with light, her open smile revealing a missing front tooth. "I love this kitchen. It's so roomy and sunny. Yellow is my favorite color." I touched Ma's foot with mine under the table, afraid she'd remind me

that my favorite color was actually red. "Who painted for you?"

Etta laid down her paring knife. She looked at the ceiling, her hooded eyes slowly moving down the walls. "Brenda and Wally did it. I thought the enamel wouldn't work well, but I like it now. Next thing I'm going to get is a new sink."

I gazed at the old-fashioned contrivance on the back wall beyond Aunt Etta. "It's not so bad," I said, though I'd learned from experience that it was highly inconvenient, due to the fact there was no drain board.

"I want one of those new ones with the cabinet underneath," Auntie said. "Then I'll have more storage space."

Ma snapped, "You've got the whole pantry." I frowned at her, hopeful she'd get the message that she should be more tactful.

Auntie ignored the remark. "There's so many dishes and stuff in the pantry. And no room left for wash stuff."

Ma piped in again, "You've got that broom closet."

I curled my lips in a sneer, afraid Aunt Etta would burst into a tantrum and said, "Geez Ma, just because you don't need more space doesn't mean other people can't have more."

Ma raised her eyebrows and sighed. "You're right. I guess I'm just not much for keeping up with the Joneses."

Aunt Etta snorted. "Huh! You worry more about neighbors than anyone I know!"

Just then Day burst into the kitchen. "What time are we eating?" she asked.

Auntie exploded, "For God's sake, Marie, don't you feed your kids?"

That was how the whole day went –Ma and Etta haranguing each other, even though their friendship dated back to before Ma had married my dad, Etta's brother. Day, as usual, kept speaking out of turn. Luckily she remembered to keep her mouth shut about our date at Aunt Mattie's. For that I was grateful. I was grateful for my twin Howie and Uncle Arlo's reticence, too. Neither of them contributed a word all day. It was a relief to me when we left early in the evening. On the bus ride home I told Ma I was going to get off and go to the 58th Street Cafe.

"We'll have none of that on Christmas Day," she ordered. I was sure Ma's new found strength was just retribution for my disloyalty to her at Aunt Etta's. I didn't care anyway, knowing that, soon, a new opportunity for fun was fast approaching.

Aunt Mattie's daughter, Polly, and her husband, Lance, had invited all of us to their South End house for New Year's Eve. We'd attend-

ed their wedding reception last August, where I had become reac-
quainted with our cousins.

Polly's older sister Tess and I had become especially chummy
four years earlier, after she married. Tess and her husband Rocky lived
in a converted box car on Aunt Mattie's back lot in Billings Park. I'd
spent time there with Tess. I never forgot their adorable love nest.
Long and narrow, it housed everything anyone could need. The apart-
ment sized refrigerator, stove and sink were alcoved at one end, a
small kitchen table and two chairs opposite. Most of the space was
filled with bedroom furniture –a dresser and an enormous double bed.
I'd been amazed how anyone could have such a gigantic place to sleep
and had pined for a bed just like their's.

A blond beauty queen, Tess had met Rocky through my father.
They'd been WW II Army buddies. Rocky was the spitting image of
Sterling Hayden, one of my favorite actors. To me Rocky and Tess were
the epitome of married bliss. Whenever I visited, Tess took me into her
confidence, telling me how wonderful marriage was. "It's heaven," she
said. "Especially the sex." I craved information. From Tess I learned,
"Pointed breasts are out, the natural look in." I knew she would know as
she pored over movie and love magazines, like <u>True Confessions,</u> daily.
We'd lay on our stomachs across the huge double bed and flip through
magazines while eating chocolates.

When Rocky came home from work, I'd immediately jump up
and leave. I was sure they were addicted to daily sex. That thought
always made my heart race. I prayed that someday, when I got mar-
ried, things would be just as rosy for me. I seldom saw much of them
now, but knew Rocky and Tess had a two-year-old daugher. Anxious
to restock my limited reserve of marriage lore, I was looking forward
to getting as chummy with Polly as I'd been with Tess.

Polly was twenty-four and not quite as outgoing as Tess. She was
short, had auburn hair and a stocky frame. She reminded me a lot of my
sister, though I thought Polly was cuter. Her round face dimpled when she
smiled, bringing to mind a Tri-State Fair Kupie doll. The day Polly called
and invited us for New Year's Eve, I blurted, "We're dying to see your new
house!"

When I told Ma, she said, "For Pete's sake. I'm not going. She's
probably just having young people over."

"Well, I'm going. Someone has to be civil in this family!" I was
thrilled to be included.

"That's fine with me," Ma said, ignoring my animosity. "Just don't paint yourself up like a floozy."

In spite of cousin Tess's advice, I wore my pointy bra under a tight, black sweater. With it, I chose Day's red plaid, pleated skirt, bought on layaway at Roth's with her Woolworth's earnings. My sister fierily objected, "GOD! She's always borrowing my best clothes!"

Ma interceded with soothing words, "Now Day, you don't want to go, so Fran's got to make a good impression. For all of us."

"You always stick up for her!" Day screamed. "I hope she makes an ASS of herself!" She wasn't far off the mark.

I rushed through the snow-caked streets of South End, my heavy, new stadium boots feeling as if they weighed a ton. My feet slid back and forth inside Ma's too-large, black pumps, jammed in the boots. They felt icy cold, making me wish I'd worn bobbysox, instead of Ma's nylons. Swirls of snow whipped around me, the wind sending frigid whiffs of air up under my skirt. The bare spaces between my garters and my panties were beginning to numb. I pulled Ma's red wool coat tightly around me, stuffed my mittened hands in the pockets. Though I'd objected at first, as I didn't want to mess my hair, I was glad Ma insisted I wear my wool babushka.

After fighting the wind and dizzying snow, I was relieved to finally reach Polly's small box-like house, nine blocks away. Bright lights glowed through the front window's drawn shades. The entryway was decorated with a string of multicolored Christmas bulbs. I banged on the door as hard as I could with my fist, causing the huge cedar wreath there to fall. I quickly retrieved it and hung it back on its nail just before the door flew open.

Cousin Polly, looking annoyed, asked, "Why didn't you ring the doorbell?"

"Didn't see it," I said, feeling stupid.

Peering behind me, she ushered me inside, "Where's the rest of you guys?"

"They can't come," I said, unable to think up a fast enough excuse before she shut the door behind me.

"That's too bad." Polly sounded disappointed. I noticed she had on scruffy old slippers and a loose, cotton smock. Her hair hadn't even been combed. There was a square of newspapers spread on the highly polished hardwood floor, alongside the door. I quickly pulled off my boots. Ma's pumps came off with them.

"I guess I don't need the shoes," I said.

Polly hunched her shoulders. "You can put them on if you want."

I pulled the shoes out of the boots and slipped into them. I realized too late that I stood towering an inch above my cousin. It made me feel like a clodhopper.

"Give me your coat." Slipping it off, I handed it over. Polly turned and left me standing alone. I wasn't sure what to do next. No one else was in sight. I noted the new furniture –a tweed couch and chair, blond coffee and end tables. The end tables held ceramic, turquoise lamps with square, matching shades. A huge, mod, ceramic ashtray sat in the middle of the coffee table. I wondered if I'd be allowed to smoke. There was little else in the room except for a console television opposite and a huge Christmas tree in a corner, brimming with opened presents underneath. I silently cursed myself for not bringing a gift.

After what seemed an eternity, Polly shuffled back into the room. She had combed her hair and changed into a low-cut, silky green dress that clung to her ample hips. "Come on," she said. "I'll show you the rest of the house." She seemed shy and uncomfortable as she led me through a tiny dining room that housed matching blond table, chairs and a sideboard. Everything smelled too clean, like a furniture showroom. "We're still in the process of buying stuff," my cousin said. "Hopefully, we'll get new drapes soon. And get our pictures up."

Off the dining room was a small kitchen with built-in cabinets and a huge, chrome dinette set. To me it was the warmest room in the box-like house. I complimented Polly on the room, thought, *Geez, this place isn't half as cozy as cousin Tess's love nest.* "Do you want to see the bedroom?" Polly asked. I was sure she didn't want me to, wondered why she wasn't more enthusiastic. *A new husband, a new house. I'd be ecstatic.*

"That's okay. Just tell me where the bathroom is." She pointed to one of two closed doors down a small hallway off the kitchen. "Where's your Lance?" I asked, not sure if it was a proper question and feeling uncomfortable using his name.

"He went to get more beer. Do you want one?" She opened the refrigerator door and extracted a bottle of Northern. Pulling an opener from a drawer, she uncapped it.

"I don't want any," I said.

Polly hunched her shoulders. "Okay," she said and a took a long gulp.

Suddenly the door bell clanged. Polly seemed relieved. "That's probably the rest of the gang."

Repentance

"Who all's coming?" I asked.

"Tess and Rocky, and Brenda and Wally." Polly dashed back the way we had come. I was surprised that Aunt Etta's daughter and son-in-law were invited, guessed that they hadn't told Auntie.

I made my way to the bathroom. There I leaned into the cabinet mirror above the marble, pedestaled sink. My face looked too pale, what with the subdued make-up Ma had insisted I wear. I pulled open the medicine cabinet door and guiltily surveyed its contents, afraid I'd find something indecent there. It overflowed with shaving equipment, aspirin, Vicks, hair tonic, deodorant and Vaseline. *No makeup. Damn*! Carefully closing the door, I looked around me.

The room was decorated entirely in pink –pink curtains, pink rug and commode cover, pink shower curtains. Even the water tank had a pink chenille cover. Polly's cosmetic bag sat on top of the tank. I quickly unzipped it and pulled out a tube of lipstick, slashed the ruby-red hue across my lips. Digging deeper, I extracted two bobby pins and a brush. Pulling the brush through my shoulder length hair, I quickly knotted the strands into a bun and secured it at the nape of my neck. I could hear laughter and loud talking beyond the bathroom door.

Carefully returning everything to Polly's cosmetic bag, I took a quick peek behind the shower curtain, curious, as I didn't know anyone who had a shower. The first thing that caught my eye was a bar of soap embedded with a long rope, hanging from the shower head. I felt my face heat, wondered what in the world anyone would use that gadget for.

Suddenly someone banged on the door. I heard Cousin Brenda's shrill voice,

"Wha'dya doin' in there Frannie?" She sounded tipsy. I burst through the door, slamming it shut behind me.

Cousin Brenda threw her arm around me, causing the glass of beer in her free hand to slop onto Day's new skirt. "Oh my God!" she shrieked, "Now look what I've done." She began slapping at the dampness with her cocktail napkin.

Cousin Tess was just coming through the kitchen door. "Geez, Brenda," she said, "Take it easy on the beer." I noted Tess's bright red, full skirted frock, noted she had put on weight. Her pendulous breasts looked enormous. *Geez*, I thought, *The natural look doesn't do her any favors*. I wondered if she even had a bra on. Tess's stiff, wavy blond hair seemed brighter than usual. I guessed she'd just had it done as the strands glistened like shellac, and the fumes from her hair spray wafted around us

when she neared. Tess rolled her eyes as our gaze met. "Come on, Fran... we're in the kitchen."

Brenda clutched my arm as we followed Tess. Polly sat at the kitchen table, chug-a-lugging another bottle of beer. "Want one?" she asked, nodding toward the huge refrigerator behind her.

"I don't think we should give her beer," Tess said, sounding snippy. "She's underage, you know." I was surprised by her hostility. She used to be so much fun.

Brenda plopped down alongside Polly. "Oh for God's sake! Just because you're a teetotaler doesn't mean everyone is!" She offered me a cigarette from her pack of Pall Malls. Her hand shook as she lit a match. I leaned toward her, held her hand steady and lit up.

Tess scowled. "She shouldn't smoke either."

Polly snapped at her sister, "You're as bad as Russ!" Brenda giggled. A bit taken aback at Polly calling her dad by his first name, I thought, *Geez, she's not as shy as I thought.*

Tess's face was blazing. "Come on Fran," she said, "Let's go in the living room. With the guys." My hesitation seemed to aggravate her even more. "Oh for Pete's sake," she steamed and stomped out of the room.

I sank onto a chair opposite Polly and Brenda. Polly immediately jumped up and got me a bottle of beer and a glass. "You don't get as drunk if you use a glass."

"Yah," Brenda chimed in, her words slurring, "Look at me, I'm sober." My two cousins giggled again.

I carefully poured the gold colored liquid into the glass in front of me. The foam quickly rose. Brenda shrieked, "Put your finger on the rim so it doesn't overflow!" I followed her instruction, was amazed that it worked.

Raising my glass I mumbled, "Happy New Year" and took a small sip, like I'd remembered Margo Channing doing in the movie All About Eve, except Margo drank champagne. The sharp, bitter flavor momentarily made my eyes water. Brenda and Polly didn't seem to be paying any attention to me. Their voices had lowered. As they sat whispering, I stared at them, wondering at the fact the three of us were related. We sure didn't look alike.

Brenda was an unstylish, bony woman, who looked older than her twenty-six years. I guessed it was because she wore little makeup and was flat-chested. I was sure she took after her father's side of the family as all the Oliphant women were ripe bodied and buxom. Her black,

long-sleeved dress did little to enhance her pale, slightly pock-marked face. There was something terribly plastic looking about Brenda. Even her hair was pale and unfashionable.

When she first got out of high school Brenda sang alto in the Rex Trio on KDAL in Duluth. The Rex Beer company was their sponsor. Later she scandalized Aunt Etta by working as a bar maid at Virginia's Tavern.[30] I never could picture Brenda in either role. Recent family gossip disclosed that since her marriage four years ago, she was trying desperately to get pregnant. There had even been a suggestion that Brenda and her husband were in counseling due to Wally's affair with a teenage, grocery checkout girl. Aunt Etta was deeply wounded when Wally revealed to her that Brenda had told the therapist she'd been molested as a child. I had tried to pry the details from Ma, but she said, "Nice people don't talk about those kinds of things." And though I wanted to feel sorry for Brenda, I never could, due to her caustic, snappish ways. My appraisal was suddenly interrupted by Polly.

"Oh my GOD!" she shrieked. "I forgot the snacks." She jumped from her chair and rushed to the refrigerator. "Quick," she said. "Give me a hand."

Brenda took the two trays from her. "Where do you want these?" she asked, stumbling as she came past me.

"On the dining room table. Quick! Before Tess gets her ass in a sling."

I accepted the third tray and followed Brenda. In the dining room we lay the trays on the table. "Come and get it!" Brenda hollered. Polly was right behind her with a fourth tray.

"Get the lights, Frannie," Polly said. I fumbled along the wall. "By the kitchen!" she yelled. I flipped up the switch. The small room flooded with light from the square fixture in the middle of the ceiling.

Cousin Tess was already standing over the table. "Where are the plates?" she snapped. "God, Polly, sober up!"

Polly, looking flushed, hurried back to the kitchen, returning with a stack of small red paper plates and napkins. "Okay Miss smart ass, dig in!"

Tess began loading down her plate. All the while I was trying to figure out what the sticks of celery were filled with. "What's this?" I asked.

"Peanut butter," Polly replied. "It's healthy."

Brenda piped up, "I hate peanut butter. What's in the dip?" She spooned a glob of the pink concoction onto her plate.

"Shrimp dip," Polly said. "And over there is spinach." Both dips were in silver colored bowls in the middle of two of the trays. "There's egg salad and tuna salad sandwiches over there," she added, pointing at the last two trays piled high with her open-faced creations. I carefully took a sample of everything. Polly's face whitened. "Oh geez... the potato chips!" She rushed from the room, returning with a bag of chips. She giggled as she quickly piled them around the dips on their separate platters. "Oopsadaisy! Your hostess is a bit tipsy!"

Her sister Tess snorted, "You're drunk!" She turned to me, "Come on. Let's sit in the living room."

About to join her, I glanced at Polly. She wrinkled her nose and nodded no. "You'll have more fun with us. In the kitchen," Polly said. She and Brenda laughed as they filed ahead of me. Just then I felt someone grab me from behind. It was Wally. His arms grasped me around the waist.

I yelled, "Let go or I'll drop everything!"

Brenda's husband loosened his grip. "Boy, you're sure blossoming nice," he said.

Brenda turned and scowled at him. "Shut up! She's family for God's sake!"

I wasn't sure how to react. I didn't know Wally very well, but felt flattered by his attention. I turned, looked at him and smiled. He had a hammy face, all pink and shiny. His pale pig-like eyes were magnified by small eyeglasses. His shoulders were slightly rounded. I detected a paunch under the plaid flannel shirt tucked in his wool trousers. "Geez," he said, blushing, "I'm only trying to be nice."

Cousin Rocky sauntered into the room behind Wally. I felt the irises in my eyes expand. He was a real dream boat, with his hard jaw and tendoned neck. Tall, slim and suave, my heart skipped a beat when he winked at me with his quick, gray-green eyes. "How's my favorite cousin?" His wide smile warmed me.

"I'm okay," I said, feeling heat rise up my neck.

"You're more than okay in my book," he responded. He wore a woolly pullover with dark slacks that reminded me of an artist and emphasized his blondness. I leaned back against the kitchen door frame as he moved closer, afraid I'd faint from excitement. "I like your sweater," he said, his eyes focusing on my breasts.

Just then Tess appeared behind him. She slapped his shoulder, "That's enough of that." Locking her arm in his, Tess pulled him toward the living room.

Repentance

Brenda was shrieking from the kitchen, "Come on Frannie! I poured you another beer!"

I smiled wanly at Rocky. "See ya later." Cousin Lance pushed past me into the kitchen without speaking. He was handsome too, but had a drab personality. A moody man, he didn't acknowledge my presence. I took my seat across from Polly. She was looking up at her husband, grinning like a sick cow.

"For God's sake," Lance spouted, "It took you long enough to put out the snacks. At this rate we'll be here all night."

"I'm sorry," she said. "I forgot about the food. What difference does it make what time people eat anyway?" She popped a potato chip into her mouth and began chomping away on it. I was surprised at their hostility, thought all newlyweds were deliriously happy.

Lance's face darkened. "Everyone's half soused already!"

Polly wrinkled her nose at him. "So? Isn't that what we DO at parties?"

Lance thundered out of the room. Polly stuck her tongue out at his back and burst into laughter. Feeling slightly giddy, I laughed too. Brenda had lowered her head to her crossed arms. Now her head bobbed up. "What did I miss?" she spouted, looking like a startled chicken. Polly and I hooted.

A sudden wave of nausea brought me to my feet. I rushed into the bathroom, slamming the door behind me. Falling to my knees, I leaned my head over the commode. Vomit spewed across the toilet seat. I heard my moans from far away... "*ohmygod, ohmygod...*" then everything went black.

The next thing I knew I was stretched out on the bathroom floor. Fuzzy looking faces began materializing. I heard voices through the fog. "Better take her to the hospital!" "No way!" "We'll have to sober her up!" "Put the coffee on!"

The fog slowly lifted. There, standing crowded around me were Tess and Brenda and Wally and Rocky. As I opened my eyes, Tess said, "Fran. Are you okay???"

"Wha... what happened?" I tried to get up, felt another wave of nausea and sank back onto the floor.

"We'll have to get her home." Rocky's voice sounded warm and caring.

"NOooooo," I moaned. "Ma'll kill me..."

I heard Tess say, "Help me get her up," just before everything went black again.

Fair Game

When I came to I was lying on a bed. A vanity lamp glowed from across the room. I slowly lowered one foot at a time to the floor. The waves of nausea had dulled, though, when I tried to get up the room started spinning. I lay back down, heard the door creak open. "Fran... are you awake?" It was Tess.

"Ah... yah," I muttered. "But my head's killing me."

"Polly made some coffee. I'll help get you into the kitchen." I raised myself up off the bed. Tess put an arm around my waist and guided me into the kitchen. There I sat surrounded by my cousins. They looked disheveled and groggy.

"Wha... what time is it?" I asked.

"Twelve-thirty," Lance piped up, sounding disgusted.

"Oh shit," I said... "I missed New Year's." A wave of nervous laughter filled the room.

"We've got to get you sober enough to take you home," Tess said. She handed me my jacket and babushka. "I'll walk with you outside for a while." The girls huddled around me, helping me into my coat. "Get her boots, Rocky." Seconds later he was shoving them over Ma's pumps. He and Tess, standing on either side of me, pulled me up from my chair.

Outside, the wind had settled down, but the air was icy cold. A milky glow seemed to have settled over the white, silent landscape. The sky was awash with twinkling stars. As I leaned against Tess I gazed up at them. The words to an old nursery rhyme filled my head —*Star bright/star light/I wish I may/I wish I might/get the wish/I wish tonight.*

Shaking away the words I thought, *Wishing gets you nowhere.* I was stumbling alongside Tess as she walked me back and forth in the alley behind Polly's house. All of a sudden I realized she was talking to me.

"They're all worried that Russ will find out about this," Tess said. "He's dead set against drinking."

I mumbled. "I won't tell Uncle Russ nothing." My mind was whirring with the thought I'd missed the celebration. I felt weighed down in a terrible sadness. "I... I'm no damn good."

Tess stopped and looked at me. "Don't say that. Everyone gets drunk once in their life."

"I don't mean this." I felt my eyes fill. Suddenly the tears gushed. "I'm... I'm such a slut."

"You are NOT!" Tess said.

"Yes I am! You don't know the half of it!" I was remembering my little red book, remembering all the names there.

196

Repentance

"Oh Fran, don't be silly. Everyone knows you're okay."

"No I'm NOT!" I blurted. "I've had sex! I'm not a virgin anymore." My voice sounded too loud. "I'm a slut!" I was about to blurt out details when I realized Tess had stiffened. I was sure I had shocked her beyond belief.

"That's no big deal. I'm sure you're in love. Aren't you?" she asked.

I sensed that love made all the difference in the world in Tess's book. "Ah... yah," I mumbled. My head was still spinning, causing confusion to reign. I wasn't sure now who it was that I loved. *Was it Bud? Or was it Mike? Or someone else*? I shook the haze away. "I... a... I'm going steady, but he's kind of old."

I could feel Tess's body relax as she clutched my arm, turned me once again and marched me back down the alley. "How old IS he?"

I racked my brain trying to remember. "Ummm I think he's twenty-four." *It's Bud! HE's my one and only.* I felt somehow relieved that I'd remembered that. "We met last year. At a football game."

"He's not married is he?"

"Ah... no. No... he's just such a sweet guy, though." I began sobbing again. "Maybe we will marry some day." My head was clearing fast. I felt the weight lift from my mind, felt relieved that I hadn't revealed everything about my sexual fiascoes. I was pretty sure none of my cousins would understand. *Better watch this confessing stuff.*

Back in the house, everyone looked disheveled and tired, but relieved at my recovery.

Tess commanded, "Don't any one DARE tell Russ what happened. You know how he feels about drinking." She frowned at me. "And smoking, by the way. You can tell your ma you got sick from the shrimp dip."

Polly spouted, "Sure! Blame everything on me!"

"Better than having Russ find out," Tess snapped.

It felt good to be in league with my cousins. The real test, though, would come the next day at Aunt Mattie's. I hoped against hope we all would pass with flying colors. ◆

28 - 5809 Tower Avenue, Mae Stewart's Variety Shop.
29 - F.W. Woolworth, 1201 Tower Avenue.
30 - 6419 Tower Avenue, Virginia's Tavern.

The Tie That Binds

*Every man sees in his relatives, and especially in his cousins,
a series of grotesque caricatures of himself.* –H.L. Mencken

The next afternoon, at Aunt Mattie and Uncle Russ's New Year's Day get-together, I learned first-hand why cousin Tess was so worried about upsetting her father, Uncle Russ. It was more than I wanted to know.

We guests milled around Aunt Mattie's dining room table, waiting to be told where to sit. "Watch out for Russ... and Rocky," Cousin Brenda stage-whispered as she clutched my upper arm. I looked at her pasty face, wondered at the fact she used such pale lipstick. Suddenly it dawned on me that she'd said something.

"WHAT?" I spouted, not sure if I had heard right or if the pounding hammer in my head from last night's beer binge had caused permanent damage to my ears. Howie and Day and Ma, and my cousins Tess, Rocky and Wally, all turned to look at me. I smiled wanly. "Sorry," I said. "I thought I heard voices." I looked at Brenda. Her face was blank, though I detected a slight nod of warning to clam up.

Aunt Mattie sashayed into the room carrying a platter of turkey. She set the serving dish down in the middle of the table. "Come on Russ!" She yelled, "Soup's on!" Mattie waved at the ten places set around the extended table. "Sit anywhere you want." Then she nodded toward the end of the table. "Except in Russ's chair."

I shook Brenda's hand away and plopped onto the first chair I saw. Brenda said, "Why don't you sit on the other side of me?" Before I could answer, Tess had sunk onto the seat and motioned to her husband Rocky to take the chair on the other side of her.

Mattie sat at the foot of the table next to Rocky. The rest of the crowd, Howie, Day, Ma and Wally, sat opposite Tess, Brenda, and me, waiting for Uncle Russ. He dragged himself at a snail's pace into the room. I detected a smug half-smile cross his face, as if he was enjoying our agony at having to wait for him. Pulling out the heavy oak chair, he sank into it. *Finally!* I thought, wondering at the hush that

had fallen. *Maybe he's going to pray.* I never heard of any of my relatives saying grace, though.

Uncle Russ was about five foot five and had a chunky body. A two-inch roll of fat hung over the waistband of the dark pants he wore. His stiff, gray cotton shirt was open at the collar, revealing a white undershirt. I suspected he had on his work clothes. His graying hair was extremely short, emphasizing jug ears and a doughy complexion. Uncle Russ's eyes were his most distinctive feature. One eye was China blue, the other one white, due to an industrial accident he'd suffered at Stott Briquet Company where he worked. A piece of metal had imbedded there. I avoided looking into his bad eye, as I was sure it had been replaced by an opaque marble. "Throw some turkey on my plate," he bellowed, stretching forward, plate in hand.

Aunt Mattie looked hot and flustered. She stabbed a huge chunk of white meat and deposited it on Russ's plate. "Okay, she said, looking round the table. "Start passing."

Cousin Rocky picked up the mashed potatoes and silently globbed a spoonful onto his plate, passing the serving bowl on. Soon everyone had helped themselves to the feast –turkey, mashed potatoes, gravy, rutabagas, and jellied cranberries.

An uncomfortable silence settled over the table again. Ma piped up, "Where're Polly and Lance?"

Mattie nervously looked around the table. "They went to Polly's in-laws." I suspected they were hung over, like me. I wished I could have stayed home, too.

Uncle Russ scowled. "Who the hell would want to drive out in the country in this weather?"

Ma wouldn't let loose. "Oh, it's a beautiful day," she said, "A little cold, maybe, but the sun's bright." I knew she thought she was doing her part at relieving the palpable tension in the room. I also knew it wasn't helping me a bit. *I should be genial, like Ma*, I thought. I couldn't think of anything to say, and was afraid I'd make an ass of myself. The throbbing inside my head increased.

Suddenly, I jerked in my chair. I felt Russ's knee rub up against mine. I shifted closer to Brenda, not sure if I imagined the action, or if we were jammed so close it was unintended. Uncle Russ's knee found mine again. This time the rubbing was in earnest, and there was no room left to maneuver further away. I gave his foot a kick and frowned at him.

He turned and smiled. His teeth were gray and stubby. "You look awful grownup, compared to your twin. How old are you two?"

I took a deep breath, forcing myself not to spout, *What the hell do you think you're doing!* I heard myself answer him in a dull monotone, "We're going to be sixteen in March." I glanced at Howie. He had his head down, and was shoveling food into his mouth. My sister was poking her fork into a piece of turkey.

"Did ya hear that, Mattie?" Uncle Russ spouted. "Marie's kids are almost grown up and that asshole brother of your's can't even come over and see how good they look."

Mattie's berry-brown face blanched. "I didn't invite him," she snapped. "I didn't want Marie to be uncomfortable.

Ma chimed in, "That wouldn't bother me."

Russ slammed his hand on the table. The glass of water next to it spilled. Wally reached over and moved the glass. Russ ignored the action. "Divorce is the ruination of society," he spouted. "Once a person marries, they should face the music and stay married."

I glanced at Ma. The two red dots that always grew on her cheekbones when she was angered were spreading. "Sometimes there's no other choice. Some men just can't settle down," Ma said.

"That sounds like a damn Oliphant excuse. The Oliphant men are the worst philanderers on God's earth!" His flashing blue eye settled on Mattie, as if in challenge. "And that includes the old man!"

Aunt Mattie frowned at him. "Can it," she said. "Let's try to have peace and quiet. For once."

My gaze had circled the table during Uncle Russ's tirade. I was positive cousins Rocky and Wally looked guilty. Rocky's eyes wavered as my glance fell on them. Wally was staring at his plate.

Russ's face seemed to expand like a balloon about to burst. "Don't back-talk me, woman," he said. "You're lucky you got a steady man. How the hell a husband can wander beats me. Hard work and soberness keeps you on the straight and narrow. Get me a toothpick."

Mattie momentarily left the room. She returned with a small shotglass filled with toothpicks. "Pass this down to Uncle Russ," she said, handing the glass to Howie. He dutifully passed it on. Everyone had finished eating. We sat silently waiting. I looked up at the ceiling, thinking, *What if it crashed. Right now.* "I'll start clearing the table," Aunt Mattie said, breaking the silence.

Brenda slowly rose. "I'll help." The two women gathered a few

dirty dishes and left the room.

I edged away from the table, wanting to scream, *Get me out of here!* "I'll help too," I said.

Russ's paw-like hand shot out and grabbed my wrist. "Sit down," he ordered."You're a guest here."

"Ouch," I sputtered and pulled my hand back, kicking his foot again.

Ma, ever the diplomat, changed the subject. "Mattie sure has done a nice job redecorating, hasn't she, Fran?"

I smiled broadly, feeling as if my face would crack. "Yah. I like the wallpaper in here." Obediently turning my head to look behind me, I felt a stab of pain in my neck. *Geez, my whole body is sore. I'll NEVER touch beer again.* The pastel plaid was ugly as far as I was concerned, but knew I was supposed to be agreeable. "It's a lovely color," I said. Aunt Mattie DID have an eye for nice things. I especially liked the three flower prints on the wall above a long clock shelf that housed knickknacks and three or four books.

Uncle Russ, stabbing at his teeth with a toothpick, pushed his chair back from the table. Rocky, Ma, Howie, Day, Wally, and I seemed to lurch at the movement. "It better look good," Russ snapped. "It cost an arm and a leg." He stuck the toothpick in the side of his mouth, got up, and strolled through the arched entryway into the living room. There he sank onto Mattie's new floral couch. He patted his hand on the seat next to his. "Come sit next to me Fran," he said. *Geez,* I thought, *why doesn't he give it up!*

Just then Annie, Tess and Rocky's two-year-old, came stumbling out of the bedroom off the dining room. All blond, cute and chubby, she rubbed her eyes with her little fists, looked around, and spied Russ. "Gampa! Gampa!" she gurgled, and ran into the living room, throwing herself onto his lap. Russ's puckish lips broke into a wide smile.

"Here's my little darlin,'" he said. "All rested and frisky."

"What's fisky?" Annie asked. We all laughed at her cuteness. Pushing back my chair, I sauntered into the living room. Judging from his conduct with his granddaughter, I figured maybe Uncle Russ would behave himself. I sank onto the couch next to him. He threw his right arm behind me, over the back of the couch.

I heard Brenda call Wally from the kitchen, "Come and take the garbage out, then we've got to get going. My ma's expecting us!"

Wally, looking embarrassed, rose from the dining room table. "The boss calls. I guess I'll see you all when I see you." He waved as he left the room.

Rocky, Ma, Howie, and Day got up and joined us in the living room. Rocky sank onto the couch on my other side. I could feel his hot thigh next to mine. I inched closer to Uncle Russ, who lowered his arm around my shoulders and squeezed me. "This is your cousin Frannie," he said to Annie.

"Fannie," she said, her face beaming.

I leaned toward her and tickled her under the chin. I felt Russ's hand slide down my back, felt his fingers inch closer to my breast. I jumped up. "Gotta pee!" I shrieked.

"Oh Fran," Ma said. "Don't talk like that." She was sitting on an armchair, next to the couch. Howard kneeled like an alter boy beside her on the floor, Day on the other side. They both looked like shiny-faced juveniles. Especially my sister. She'd refused to wear nylons, sat with her perfectly folded-down bobbysox over shiny loafers, her legs daintily crossed at the ankles. The sight of the three of them made me feel like an outcast. "And straighten your skirt while you're in the bathroom, Ma said. "It's all crooked."

I pulled at the waistband of Day's gray and yellow plaid skirt and turned it. "It's too damn big," I said.

Day spouted, "If you'd wear your own things maybe they'd fit!"

Ma shushed her. "Let's not get into that, here."

I rushed through the dining room, retrieving my shoulder bag from the back of a chair where I'd hung it. In Mattie's small bathroom off the kitchen, I took a comb out of my bag and pulled it through my hair. My face looked sickly white. Applying a thick layer of my fire-engine red lipstick, I exited the bathroom and stood looking at Aunt Mattie. "Can I help?"

Aunt Mattie was wiping off the kitchen table. "We're all through here, now."

"Did Wally and Brenda leave?" I asked.

"Yah, they were anxious to get over to Etta's. Let's go in the other room. Tess wants to take some pictures."

In the living room I saw that Tess had taken Rocky's place on the couch. "Where's Rocky?" I asked.

"He went to get the camera. It's back at our house." I remembered then that they were still living in their converted box car on the back lot. "I saved your place," Tess said, patting the spot between her and Russ.

I squeezed into the space. Russ immediately threw his arm onto the back of the couch behind me again. Howard was showing little

Annie how to pump her new spinning top. "Fasser! Fasser," Annie shrieked. I was surprised at his patience with her. He actually seemed to be enjoying himself. Day looked glum. Her elbow rested on the armchair where Ma sat.

Ma was chattering full force. "I don't know about that, Russ," she was saying.

Oh Geez, I thought, *I hope she's not going to argue him into the ground.*

Uncle Russ seemed amused by her feistiness. "I'm not against ballet dancing," he said. "I'm talking about all those sick dances the teens do now. They're forever rubbing against each other."

I wondered what the difference was between rubbing against each other while dancing, as opposed to him rubbing his damn knee against mine under the table.

"It's disgusting," Russ spouted. "Leads to all kinds of trouble. Same with smoking and drinking. The government should crack down harder on stuff."

"There are laws," Ma countered. "Seems to me I read in the Telegram about all kinds of people getting arrested."

"Ach," Russ continued. "I'm talking about banning smoking and drinking."

"Oh for Pete's sake," Ma said. "That didn't work during Prohibition. People still got their booze."

Russ scowled and looked over at Mattie, who was in the dining room, folding up the tablecloth. "When are we getting some pie!?" he spouted.

"Soon as Rocky comes back and takes the pictures." I admired my Aunt's patience with Uncle Russ. She treated him like a son instead of a husband. He was just five years older than Mattie, but seemed ancient in comparison. She'd been sixteen, he twenty-one when they married. I once heard Aunt Mattie say of her youthful marriage, "I wasn't pregnant, either!"

Aunt Mattie was so different than Aunt Etta. For one thing, she was a lot thinner, though her hips were pretty wide. Like her sister, she had her father's eyes –large, pale orbs flecked with green. Her face was a perfect oblong, with small ears and a slightly hooked nose. Ma always said the Oliphants had Roman noses. Mattie wore her auburn hair in French braids that, to me, made her look sophisticated. I was hoping to have her do mine the same way, once my hair got longer. I

liked the way she dressed, too. Usually she wore trim little suits with matching pillbox hats and spiffy shoes. Today Mattie had on a sea-green, short sleeved dress with small, round buttons all the way down the front to the hem. A matching shiny belt emphasized a smallish waist. The full skirted dress flounced around her when she moved. I often thought that Aunt Mattie dressed more fashionably than her daughter Tess.

Tess had taken to wearing crispy cotton house-dresses since putting on weight. I had to admit she had nice legs, though. They were long and thin. The high wedgies she wore emphasized their curves. I felt Tess shift her full body on the couch next to me. "Here comes Rocky," she said, then hollered at him, "See if you can get all of us in the pictures, Rocky!" She waved her mother into the room, "Ma! Sit on the floor by Annie."

The picture session ended quickly. Afterwards we regrouped around the dining room table for Aunt Mattie's delicious pumpkin and mincemeat pies. It was amazing to me that both she and Aunt Etta were good bakers. Maybe it was a family trait. I hoped that one day I'd be just as good at baking pies as they were.

The evening was winding down when Ma, looking sleepy, said, "I think it's time we leave."

"I'll get the car." Rocky rose from the dining table.

"I'll take them home," Uncle Russ spouted. Everyone looked surprised as usually Uncle Russ turned in early. And though I sensed Rocky was about to object, he backed down when he looked at his mother-in-law Mattie.

A broad smile had crossed her face. "Now that's more like it," she said to her husband. "I knew you could be civil if you wanted to." Russ actually chuckled.

Russ's old Ford was parked in front of their cozy, one-story house. Ma, Howie, Day, and I, after donning our heavy winter coats and boots, lumbered behind Russ to the vehicle. He wore an ugly mackintosh coat and a stupid-looking hunter's hat with the earflaps down.

"You and Marie in front," Uncle Russ said, motioning to us. "Day and Howard in back."

I tumbled in ahead of Ma. The old car was ice cold. Russ turned on the ignition and put the floor shift into gear, smacking my leg in the process. "Oops," he said plopping his fat hand on my knee and squeezing it. I sidled closer to Ma. All the way to South End Uncle

Russ spewed out his litany against women working, against smoking and drinking, and against divorce. Ma was silent. I didn't realize she'd dozed off until we got to our house.

Howie opened the passenger door and pulled at her arm, "Wake up, Ma!"

Ma shook her head. "Oh dear," she said, "I guess I'm worn out." She slid from the car and without waiting for me, filed behind Howard and Day into our clapboard duplex. I was about to jump out when I felt Russ's iron grip on my arm.

He pulled me back, lunged at me and planted an open-mouthed kiss on my lips. His face looked sweaty and his good eye was bulging. "Meet me sometime."

I pulled away from him and yelled, "NO WAY!" Beating a quick retreat into the house, I thundered up to my hideaway on the second floor, thinking, *GEEZ! I need someone to protect me from these idiots!*" A niggling guilt descended, *Maybe I'm at fault.* I half-heartedly vowed to find that special protector. Meantime, another lustful relative was waiting in the wings ready to pounce. ◆

Nailing Anything that Moves

Nonconformity and lust stalking hand in hand through the country, wasting and ravaging. –Evelyn Waugh

Uncle Gradie was an enigma. For years I heard wild stories about my father's brother. When I was six I learned that Uncle Gradie was stationed at Hickam Field, Pearl Harbor. He "miraculously" survived the treacherous attack on December 7, 1941. I often repeated and embellished the story to my school friends, ever eager for their approval. During the 1940s being related to a war hero was as awe-inspiring as being in the presence of General Douglas MacArthur.

In later years, his sister, Aunt Etta, claimed Gradie was passed out from a three-day binge and slept through all the harrowing events of Pearl Harbor. But that was Uncle Gradie –tough, wild, and free-wheeling. My siblings and I never even saw him when he was on leave in Superior. Uncle Gradie spent his time boozing in the local bars and hobnobbing with his boyhood cohorts, who, Ma once said, "Were the terror of Billings Park in their youth." She also said, "All the men on your father's side were raucous louts when they were young. They stole car tires and hub caps. Your dad and Gradie both served time for stealing." Ma's words brought a nebulous anger in me for her disloyalty to the clan, though Aunt Mattie often stated, "Gradie likes the ladies." Laughing, she added, "He'll nail anything that moves."

Ma said Uncle Frank and my dad, Damer, were wild men as well, but it was Uncle Gradie who came to be known as the rascal of the family. Rumor had it that he was the love child of his mother, who'd had an affair with a street car conductor. That confusing piece of family gossip convinced me Uncle Gradie wasn't an Oliphant, so really wasn't a relative. I reasoned that it was perfectly okay for me to be attracted to him.

As I got older, his designation as the black sheep of the family made his appeal even stronger. I was convinced we had a lot in common.

During visits to Aunt Etta's, when she lived in South End, I gazed at Uncle Gradie's handsome image in the large framed picture of him on her sideboard. His awesome good looks took my breath away. Broad shouldered and lean, Uncle Gradie's square jaw and cocky, lop-sided grin brought a tingle in the pit of my stomach. His deep-set, small eyes seemed to follow my every move. I'd study them for some hint of meaning, but only found a peculiar glint that I interpreted as humor. The deep laugh lines that coursed his face were fascinating, too.

Uncle Gradie had a straight, classic nose, unlike any of his siblings. His nostrils were flared. If I stared at his image long enough, they seemed to emit little puffs of steam. Snapshots sent from various parts of the world always found him slouched against a jeep or other Army vehicle. He'd be leaning back, his six-foot-frame and long legs stretched out, his hat askew, giving the appearance of a man without a care in the world. I imagined him raising the flag at Iwo Jima, hitting the beach on D-day, machine gun rattling, or in the cockpit of a P-38 diving toward a Japanese aircraft carrier, guns ablaze. Gradie was my all-time WW II hero.

Snippets of news filtered down to my young ears throughout the war. Uncle Gradie getting promoted. Uncle Gradie getting demoted. Uncle Gradie breaking military law and being thrown in the brig. Uncle Gradie transferred to another base. Uncle Gradie transferred to Germany after the war ended. By then he'd made Master Sergeant.

In the Spring of 1951 at age thirty-eight, Uncle Gradie brought home his German war bride Greta, for a month-long visit. His sisters were ecstatic, sure he would settle down now. I was a little worried, hearing from Ma that his sisters said Greta wouldn't let Uncle Gradie out of her sight. A vague daydream of meeting him somewhere alone, had begun to formulate in my head. My resolution to start a clean slate fell away.

During the last week of their visit, my mother and we kids were invited to Aunt Etta's to meet Uncle Gradie and his new bride. That news sent me into a tailspin of anticipation, pushing out all memory of my run-ins with other male relatives. The thought of meeting Uncle Gradie brought a warm tingle inside me. On the designated day, Ma came down with a migraine, insisted I go alone. Neither Howard nor Day had any desire to accompany me.

Fair Game

As always, when those rare family affairs included us, I paid particular attention to my appearance. I knew Ma was judged by her children's behavior. Any infraction on my part would reflect poorly on her.

I chose my favorite skin-tight black pullover though, as I'd blossomed to a thirty-six B bra. I was proud of my bursting bosoms, fully aware of the attention they gleaned in that heavily-wired and pointed harness. To compliment the sweater, I chose Day's blue/green plaid skirt, a near replica of the family tartan. It descended to my calves. Not too short, not too long. I selected the silver cross that I'd gotten from my grandmother as my only adornment. That should save Ma's reputation, I reasoned. Brown loafers and green bobbysox completed the ensemble. What relative wouldn't be proud to have such a fine specimen of girlhood carrying their genes?

My shoulder length hair was a problem. I couldn't put it in an upsweep, as that would suggest a false sophistication my relatives abhorred. Pulling it back in a chignon would bring the same result. I fluffed it out with a brush, the brown lustrous curls a perfect frame for my freckle-dusted face. Ma's pale rose lipstick produced the effect I was striving for –a suggestion of virginal innocence combined with robust youth.

All the way on the bus from Sixtieth and Tower to Twenty-eighth and Tower, the scenario of my visit played across my consciousness. I pictured my entrance into Auntie's bright kitchen. On sunny days the glossy-yellow walls reflected the light through curtainless, double windows. My eyes always stung from the glare. I once asked Auntie why she didn't hang curtains. She said, "Who's going to look in? There's not a soul around for miles." That was true. She and Uncle Arlo had purposely moved from South End to, "be out away from things." The only view from those windows was the constant coupling and uncoupling of engines and boxcars in the Great Northern Railroad Yards across the street. There were two tiers of glass shelves over-loaded with mini-cacti and small house plants across the entire window expanse. None, however, hampered the view.

I pictured Auntie in her favorite spot at the maple kitchen table. It had four plastic-padded chairs and a matching, flowered oilcloth covering. I could see her huge, coal-burning, black and chrome cook stove opposite the table. I knew it would be weighted down with cast-iron kettles steaming fantastic aromas into the house air. Uncle Arlo shook out the ashes from coal residue every morning, careful not to

spill any on Auntie's geometric patterned linoleum. In winter he carried the overflowing coal bucket outside, and strew the ashes onto icy sidewalks.

By the time I descended the bus and walked the half-mile to Elmira Street, I was sweaty and flushed with anticipation. I burst into Aunt Etta's kitchen with the bubbly, "Hi," I'd practiced during my long trek.

Auntie was carefully icing cupcakes spread on the table in front of her. The other end of the table held her best Noritaki "Belle Rose" china stacked in readiness. I was sure cousin Brenda had spent most of the morning sudsing the set in Auntie's inconvenient, enamel sink. There was no drain board, so as soon as a piece was rinsed it immediately had to be wiped dry with one of Auntie's flour-sack dish towels. We all detested that tedious job.

Seeing Auntie there at her post, I was immediately put at ease by her broad smile, sans one front tooth. I hugged her around her neck and kissed her full, warm cheek.

It would have been impossible to get my arms around her huge frame. It overflowed the sides of the chair she occupied. Thin, wan, Cousin Brenda, exited the pantry across from us. She had been partially obscured by Auntie's huge new refrigerator. That brilliant white appliance extended a few inches across the pantry door. Auntie could barely wedge herself through the space when she needed access. Cousin Brenda put down a pumpkin pie, wiped her hands on her apron and said. "How's it going Fran?" It was as if we'd just spoken moments earlier, when in fact it was two months since I'd last seen her.

"Just fine. How 'bout you guys?" I hugged my cousin, felt her body stiffen in my embrace.

Cousin Brenda picked up a stack of dinner plates and headed into the dining room. "We're okay," she said. "Wally's in the living room. Go say hi."

Oh shit, I thought. I'd forgotten about her husband. In my mind he was a creep. I remembered how he liked to grab me and pull me onto his lap. One or another of his fleshy hands always got too damn close to my breasts for comfort. Wally was a plumpish, balding man with thick glasses, who had the misplaced idea that he was attractive to females. Before I could offer to help in the kitchen, I heard his raucous howl from the other room. "Is that my favorite cousin? Come on and let me see how juicy you've gotten."

Fair Game

I blushed in mortification as I made my way into the dining room behind Cousin Brenda. Grandma O. sat across from the isinglas heater in Auntie's platform rocker with its Italian tapestry upholstery and matching stool. She was busily tatting a large round doily. A Pall Mall hung from the side of her mouth. She looked up and smiled. A long ash fell onto her sagging bosom. Grandma brushed it away, shook out her tatting and leaned down to crush the butt into an ashtray on the floor. "Good to see you," she said, then resumed tatting.

Bespeckled Wally, ever the creep, was beyond the columned oak archway in the living room. He was slumped on the mohair Tuxedo sofa with its tatted doilies on the arms and back. The sofa sagged from his weight. Next to Wally sat an unfamiliar woman, her hands demurely folded in her lap. Stopping by the rocker, I cautiously leaned down to kiss my grandma. Too late. Wally bounded from the sofa and caught me from behind, his massive arms squeezing my waist. He dragged me backward across the living room carpet, pulled me into his lap, and sank onto the scratchy-to-the-touch sofa. He reeked of Old Spice aftershave. I felt his fingers nipping me just below my breast.

"Stop that!," I hissed, then quickly grimaced. The woman next to us was watching. A shocked look of disgust briefly registered on her bland, round face. I pulled myself up, pressed my skirt into place. "Hi," I said, "I'm Fran. Damer's daughter."

The woman's clouded face cleared and she smiled. "I'm your Aunt Greta." I liked the lilt of her deep voice with its exotic accent. I shook her extended hand. It was icy cold. She looked old and a bit dried out, but I detected the beauty she must have had at one time. Her short dark hair was tightly curled, giving an old-world effect to her manner.

Wally interrupted my train of thought. "Getting yourself in any trouble these days?" For an instant I searched my mind. *Maybe he'd heard something. Maybe the family was aware of some of the scrapes I'd perpetrated.* I brushed the thought aside. Impossible. I changed the subject.

"Where's Uncle Gradie and Uncle Arlo?" I'd not seen Aunt Etta's husband Arlo, in his sofa-matched chair in front of the TV. I felt relieved that neither of those uncles had seen Wally's disgusting actions.

"They're out in the shed. Arlo's showing Gradie some of his wood-carvings."

"He taught Duncan how to make a bird-house," Aunt Greta said. For a moment I forgot that Duncan was Gradie's formal name. No one in the family ever called him that. An uncomfortable silence descended. Greta stood up. "I guess I'd best help the ladies." I noted that she was quite tall. Her pear-shaped body line ended in thick, shapeless legs. Not wanting to be left alone with Wally, I moved into the dining room. I would have helped in the kitchen, but knew Auntie and Cousin Brenda preferred getting things together by themselves. Brenda had finished setting the huge oak, lace covered table. She was bending down taking out eight wine glasses from Auntie's ancient sideboard that fronted a lace curtained window. I wondered why Wally didn't grab her from behind. Aunt Greta took the glasses and set them to the right of each plate. Both women exited to the kitchen

I sat on the footstool at Grandma O's feet. "Do you think she'd be shocked if I smoked?"

"Don't worry about it," Grandma said. "Kids in Europe are smoking by the age of twelve. Anyway, nobody cares." She folded up her tatting, deposited it in a cloth bag at her feet. Pulling out a Pall Mall from the pack on her lap, she lit up and offered me one. As always, I was struck by the dignity of her face, its soft but strong square chin, her large eyes behind wire-rimmed glasses. Her neatly waved gray hair capped a perfectly oval skull. She was a poet and exuded quiet intelligence.

"I've got my own," I said, knowing Grandma was living frugally on her small Social Security check. We lapsed into silence as we puffed away. The smoke floated aimlessly around us in ghostly, hazy layers of white.

"How's school? Grandma asked.

"Okay." I racked my brain for positive news on that front, found none.

"How's your mother?" The cultured tone of her voice always disarmed me, but I held my ground.

"She's okay." Wanting to get away from that touchy subject, too, I lunged into dance class news. "I got the solo part in Swan Lake. The recital's in June. I quit baton lessons when I was a freshman. It got too cold to march outside with the school band."

"I imagine so," Grandma said. I could tell she wasn't paying much attention. Grandma knew little of my talent, never attended recitals. She glanced over her shoulder. "Where'd Wally go?"

"Upstairs. Probably to the bathroom," I said. The tone of Grandma's voice had given me the notion she didn't much like repulsive Wally. I wondered what she thought of Greta. "Do you like Uncle Gradie's wife?"

"She's all right. Keeps him in line." Grandma chuckled at her own words. "I just wonder for how long." A little shock of recognition at what Ma called, the Oliphant meanness, had filtered down through Grandma's words to my ears. I felt an urge to egg her on.

I lowered my voice to a conspiratorial whisper. "You don't think it'll last, do you," I said, trying not to sound hopeful

"Oh, it'll last all right. She's got money and Gradie doesn't." Grandma smiled knowingly at me. "Gradie has a way with women. Like his dad." Her words disconcerted me. I wondered if she meant his real father. Before I could respond I heard the back door bang open. Uncle Gradie bounded into the room. Uncle Arlo, a bent, gray wisp of a man, hobbled behind him. He leaned on his cane and coughed heavily. I felt my mouth gape open, my breath catch. Uncle Gradie stopped in his tracks.

"Holy shit!" he barked. "This can't be Damer's kid? Is that Day?"

I felt my voice quaver in response. "No. I'm Fran, one of the twins." I fought the overpowering sensation of raw desire that welled up at the sight of the handsome, giant Gradie. Shaken, I was afraid to stand-up, afraid I'd lunge at him like a love-sick imbecile. I hugged my knees, trying to hide myself. I could feel my face heat, could feel a droplet of sweat gather in the crevice between my breasts. I wondered if I would faint.

"Get up," Gradie ordered. "Let's have a look at you." I slowly rose, balanced myself with my right hand on Aunt Etta's long shelf of African violets under the wall of windows alongside me. I put my other hand on the dining room table to steady myself. A wine glass rattled against a plate. Greta, who must have entered during my flush of confusion, rearranged the china. "My God," Gradie boomed, "June is busting out all over." I felt his dark eyes on my breasts, heard Greta hiss something in German, ending with what sounded like "ach!" Gradie winked at me and moved into the living room. Uncle Arlo, whose snail's progress had been blocked by Gradie, shuffled forward. I gave him a quick kiss on his withered cheek.

"How 'ya feeling?" I asked.

"So-so," he said, immediately going into convulsed coughing. My heart always went out to Uncle Arlo. I knew his decline was the result

of being gassed on a WWI battlefield. I held him by the elbow and guided him to his chair in the living room.

Gradie motioned from the couch, patted the space next to him. Cousin Wally, thundering down the stairs from the second floor, sank onto the couch just as Gradie pulled his hand away. Gradie smiled silently across the room at me. His devil-may-care lopsided grin made my heart skip a beat. I smiled back. In that instant I detected a glint of unabashed desire in Gradie's eyes. Just then Aunt Etta called us to dinner. Wally jumped up and rushed to the table. I helped Uncle Arlo from his chair, felt Gradie's hand brush my bottom. It felt like an electric shock. I stifled my shriek as he pulled his hand away.

Aunt Etta directed us to our seats around the over-laden dinner table. Gradie had the place of honor at the head of the table, Auntie Etta was at the foot. I was assigned a chair between Aunt Greta and Cousin Wally. Greta insisted we exchange places. That put me next to Gradie. She squeezed my arm affectionately as I sat down. I sensed Aunt Greta had realized the distaste I had at Wally's earlier, disgusting action.

Cousin Brenda, across from me, began passing platters of food. She sat next to her dad, Uncle Arlo and next to him, was Grandma O. Gradie lifted his wine glass and boomed, "What the hell is this piss? You know I want beer." Aunt Greta snapped something at him in German. "Okay, okay," he said. "Here's to Etta!" We raised our glasses and mumbled our appreciation. I'd never had wine before. It felt deliciously snappy as it coursed through me, leaving a soft warmth inside.

Conversation burst all around me, everyone shouting praises at Aunt Etta as they shoveled roast beef, mashed potatoes, and creamed peas off their plates into their mouths.

Grandma O. launched the subject of poetry, leaving the rest of us behind with her quotations from Robert Burns in the Scot's dialect she always assumed when reciting his odes. She got especially carried away with Aunt Etta's favorite poem, A Red, Red Rose: "O, my luve's like a red, red rose/That's newly sprung in June/O, my luve's like the melodie/That's sweetly played in tune." There were four verses. The third one caught my ear: "Till a' the seas gang dry, my dear/And the rocks melt wi' the sun/And I will luve thee still, my dear/While the sands o'life shall run." I thought, *I wish someone would love me like that*!

After Grandma finished her recitation, Wally blasted off on the aggravations of his job as a manager at the Farmer's Co-op. He said

they'd soon be relocating in Oregon, and, "Thank Christ we'll be getting out of this depressed area." I glanced at Cousin Brenda, knew full well she would hate to leave.

Gradie sputtered his future plans on locating in Oregon when he retired. I was relieved no one asked anything about Ma. Gradie refilled my wine glass. I gulped it in a flash. I felt something on my ankle. I looked over at Gradie. Realizing that it was his foot, I felt giddy. He winked. Heat rose up my neck.

"Don't give her any more wine," Aunt Etta snapped. "She'll get sick."

I was feeling a bit groggy, but smiled and said, "That's all right." My words sounded slurred. Everyone hooted. From the corner of my eye, I saw that Gradie had dropped his napkin and was rummaging his hand under the table cloth. I felt his hand touch my knee and squeeze so hard I almost jumped. He retrieved the napkin and laughed aloud. "I'm not used to all this fancy crap." He gulped down his third glass of wine.

Aunt Greta snapped at him in German again. She turned to Etta and began chatting about cooking. Cousin Brenda and Uncle Arlo were silent. They shared reticent, withdrawn natures.

Once the first round of dishes were cleared, we all had a piece of Etta's pumpkin pie. Soon everyone left the table, lolled in chairs and on the sofa. I sat in a cracked leather lounge chair alongside Cousin Wally. I was glad I couldn't see his pasty face. Gradie was stretched out on the sofa, emitting little snorts of air with each deep breath. Uncle Arlo had retreated to his cot in the den just beyond the living room.

A small table was there, pushed against the wall under the piano window. It held Uncle Arlo's cribbage board and a deck of cards. Except for me and Grandma, the women were in the kitchen washing dishes and picking up. Grandma was back in her spot, slowly rocking and puffing a Pall Mall.

I could hear Aunt Greta in the distance traipsing back and forth, restacking Aunt Etta's best china in the sideboard. Suddenly she called out to Gradie, "Why don't you show Fran the birdhouse you made?"

He signaled me with a nod of his head, sprung up and grabbed my arm.

"I'd like to see Uncle Arlo's stuff, too," I said. Uncle Arlo shifted on his cot. Its springs creaked as he attempted to rise. I went into the den and pulled him to his feet.

"Thanks," he said. "You go ahead, I'll catch up." Wally got to his feet too, started for the kitchen. Cousin Brenda, with towel in hand,

was wiping a china bowl as she came into the dining room. "You're not going anywhere," she said. "Get the garbage together. You can at least do that much." Wally sank back into his chair.

Gradie and I went out the back door into the dark night. He grabbed my wrist and pulled me forward, "Hurry up before Arlo gets here." Pushing open the shed door, he pulled the cord to a bare light bulb. Glancing out the one front window facing the house, he pinned me against the closed door. With one hand at the nape of my neck and the other pulling up my skirt, he pressed his hard mouth against mine. I closed my eyes, let my body relax. His free hand was inside my panties. A wave of warmth flooded my body. "Do you like that?" I moved my head yes. His tongue was in my mouth, circling my teeth. As suddenly as he had begun, he stopped. "Here's Arlo," he said. I stepped back. Gradie opened the shed door.

It felt as if I was in a dream. I watched some girl named Fran look at Gradie's birdhouse. She admired Uncle Arlo's wood carvings, displayed on shelves around the room. Time slowed. What seemed like hours later, we returned to the house together. Cousins Brenda and Wally had left. I hadn't even heard their car.

"I've got to get the bus," I said.

Gradie exploded. "No way! I'll drop you off. After I take your grandma home."

As I was about to follow Gradie and Grandma out of the house, I felt Greta's hand on my arm. "Fran," she said, "Don't let him stop anywhere for beer."

After Grandma was safely in her apartment at Twelfth and Banks, Gradie gunned the motor and tore Uncle Arlo's pickup truck two blocks over to Winter Street. There he made a screeching wide turn west to Billings Park. Just past the second set of tracks he parked alongside the road and shut off the headlights. In the dim glow from a nearby streetlight, I looked at Gradie's handsome face, imagined him in full uniform instead of his rumpled blue shirt and slacks. "We gotta make this quick," he said. "The Frau gets antsy when I'm gone too long."

I pulled up my skirt, wriggled off my panties. "Not that fast," he said. He skillfully drew up my sweater and with one hand unhooked my bra. His warm lips on my breast set my body aflame. I wriggled down under him, ran my fingers through his head of thinning hair. He reached for my hand, pulled it down to his crotch. "Is it hard enough for you?"

I mumbled, "I guess so." *Geez, they always want you to touch it. I felt myself shudder. What if he turns the lights on and I have to look at it!* I pulled away.

Gradie whispered, "You ready?"

I nodded yes. I was drifting again, transported on the rapture of the moment. Gradie was breathing hard. He tugged at his pants zipper. His entry was rough. I flinched from a flash of pain. "Too much for you?" he muttered. I didn't want him to stop, shook my head no. He lunged on, his strokes harried. I chewed on my lip to keep from crying out in pain. His breath quickened and before I knew it, it was over. I felt cheated and saddened. My WW II hero was no different than any other guy.

I pulled up my panties, hooked my bra and straightened my skirt. Gradie was already zipping his pants, his foot on the gas peddle. We took off in a cloud of cinders. In the silence I thought about my red book in the Folger's coffee can. I decided when I got home I'd record Uncle Gradie's name, then burn the book. The only words my uncle uttered on the long drive home were, "Don't ever tell anyone about this, else I'll be in deep shit." I promised I wouldn't.

I didn't burn my book. I just couldn't part with it. Instead, I vowed I'd find a steady boyfriend. I reasoned that would be the right time to burn the book. Then I could start a clean slate. Meanwhile, an astounding piece of news filtered down to me. Mike Janicovich was back in town! At long last things were looking up. ◆

Winner's Circle

Success is a rare paint, hides all ugliness.
–Sir John Suckling

Though I avoided Roberta (Bobbie) Klenke as much as possible in school, it was inevitable that I'd run into her on the South Superior bus. On the ride home one afternoon, she hollered, "Hey Fran! Did yah hear Pirkovich is back working at the Standard station?"

Bobbie's words confirmed the rumor I'd heard a couple days earlier. "I doubt if he's working," I snapped. "He's probably hanging out there with his friend." I couldn't bring myself to say Mike, afraid Bobbie would detect the excitement I felt at the thought of seeing him again. In any case, there were too many teens surrounding us who'd be listening in. We were pressed together on the crowded vehicle like teaspoons in a drawer. I shouldered my way through the mob. Face to face with Bobbie, I lowered my voice. "Should we check it out?"

"Sure!" I could tell Bobbie was eager to reconnect with me.

I leaned closer, "Let's just walk by. Across the street. I don't want those guys to think we're interested."

Bobbie's smile widened. "Great," she said. "We can get off on Sixtieth and walk over to Central Avenue."

Moments later we were sauntering south on Tower. The last spring snow had melted in the warmth of the April day. A dazzling white blur from the sinking sun reflected on the swanlike clouds above. A few crocuses had poked up alongside the Larson house on the corner. I felt blissfully happy, fully alive. Our pace slowed as we neared Tower and Central.

Bobbie stopped. "Now what?" she asked.

I glanced across the street. The yellow Standard Gas station looked deserted. A car pulled in next to the gas pumps. I clutched Bobbie's arm and waited. Mike strode out of the station, his indolent tomcat grace bringing a catch to my throat. Before I could think I screeched, "MIKE!"

217

He stopped in his tracks, looked at us for a second, then strolled over to the car that had pulled up. I couldn't believe he was ignoring me. I watched him pump gas into the car tank, watched him slowly hook the long nozzled contraption back alongside the pump when he finished. He moved to the front of the car, cleaned the windshield and collected the money the driver handed over. Before I could decide what to do next, he went back into the station. The door closed behind him. "Jerk!" I sputtered.

Bobbie touched my arm. "Don't feel bad. He's a clod. Like Pirkovich. Geez, they're nothing but a bunch of ignorant Bohunks!"

I pulled a Kleenex from my coat pocket and snorted into it. "You're just trying to make me feel better. I'm okay."

"Do you want to go over there?" Bobbie stood staring at me as if afraid to move.

"NO! I don't give a shit if I EVER see him again. I'm going home." I turned and headed back toward Sixtieth.

I heard Bobbie yell, "See yah tomorrow?"

"I don't know! I'll see." As soon as I got to the corner I rushed into Sather's Grocery Store,[31] anxious to slow down and think this latest setback out. Digging in my pocket, I found a nickel and bought myself a Mounds candy bar.

Outside I stood savoring the rich chocolate-covered coconut, my mind in a turmoil of indecision and worry. *Should I go see him now? Should I just call him? What if he won't talk to me? What if he gets mad?* My waves of doubt prompted an image of a bouncing yo-yo. *My whole life's a damn yo-yo. One minute up, the next minute down.* I made a split-second decision. *I'll go right over there and talk to him. It couldn't hurt.* Crumpling up the Mounds wrapper, I threw it in the gutter and rushed across Tower Avenue. A car screeched to a halt alongside me. The driver shrieked, "Watch where the hell you're going." His voice barely registered on my consciousness. I plunged ahead, afraid if I slowed I would change my mind.

At the station I burst through the front door. Mike was at his desk, on the phone. His boisterous laughter stopped, as if a valve in his chest had shut off. He lowered his voice, "I'll call you back." He slammed the phone into its receiver. "What do you want?"

Without thinking I burst out, "You! I want you!" I felt a pang of shock inside from my boldness. I looked at his handsome dark face. A loose thatch of curls from his gorgeous hair fell onto his forehead. I

remembered running my hands through those thick locks, remembered our passionate encounter in the Chevy. A tingling delight coursed through me as I met his flinty gaze head on. All the while I stood frozen, afraid any movement would turn him away forever.

Mike rose from the chair. He moved casually toward me. "Took you long enough to decide that." I felt a shudder of joy at the sight of his long legs. A shadowy ironic sneer hovered on his lips. "I've been back for four months," Mike stood in front of me, his body taut, his hands on his hips. Suddenly he swept me into his arms, smothered my mouth with his warm lips. I felt a wild surge of pleasure. Disengaging himself, he stood back, held me out away from him like he was examining me for... what? ...damage?

I felt myself tremble. "I didn't KNOW you were back. Why didn't you call?" My words sounded muffled.

"I don't make phone calls. You could have called ME." Mike hugged me and lowered his lips to mine again. There was passion in his kiss, but anger, too.

Anger rose inside me. I pulled away from him, shrieked, "I called for two months! Your boss threatened to call the cops!"

Mike chuckled, a low rumbling sound, that set my body aflame. "Yah. You really aggravated him." He pulled me to him. His hard body brought shivers of electricity inside me. "Too bad, too. Now we won't be able to screw in the garage. We'll have to go to Greenwood."

Oh shit. Not a cemetery. Not with him. "Couldn't we like, go to a motel... or something?" My words sounded more like a plea, than a suggestion.

"I can't afford *that*," Mike said. "Besides, we'd need luggage... and everything."

He was right. I'd heard of a young honeymoon couple being turned away when they didn't have luggage or have their marriage license with them. "What about... your place?" I was hoping against hope that he lived alone.

Mike burst out, "MY place? I... a... I live at home." Though he sounded shocked, I detected something else in his voice. Was it... deceit?

I felt a sudden eruption of spite. "It's that damn Pirkovich, isn't it? You're afraid of what he will think." I turned away and headed for the door. Mike rushed behind me, pulled me back.

"He's nobody. Just a dumb kid. His family's my... *our* neighbors." Mike embraced me again. His rough, aggressive kiss held me captive. I

surrendered to the crush of feelings that drew us together. The memory of our love-making opened in front me, as if a curtain had fallen away.

I murmured, "Oh... I guess the cemetery's okay."

And so our romance moved along. Three times a week after he closed the station Mike and I met at nine o'clock. We drove out to Greenwood Cemetery and parked by the Soldier's Circle. And though all our couplings were uncomfortably consummated on the back seat of his 1950 Packard, our love-making was as erotic as ever. All Mike had to do was move against me and the sparks of arousal fanned into leaping flames. The surging physical excitement seemed to increase with each encounter. One night I was sure he howled in ecstasy.

I was momentarily startled as the cemetery was spooky enough without me envisioning werewolves. I dared not open my eyes, squeezed them tight, my ears alert for any additional outburst. Except for Mike's heavy breathing, the night was silent. Inwardly I felt flattered that I could elicit so much ardor from my one and only. It happened again the next night. When the third howl of passion erupted I reached up and twined my arms around Mike's neck and squeezed hard. Summoning my sexiest deep-throated voice I whispered, "I LOVE you my darling!"

"JESUS!" He shrieked. "Not so tight. I got a toothache!"

I stroked his cheek bone. "My poor baby," I cooed, eliciting the identical howl that had first scared the wits out of me.

In any case, I was grateful to have found a settled romance. I'd at long last gained entry into the winner's circle of steady couples. Still, a niggling doubt that there was more to going steady than having sex, descended.

One day I decided it was time to test Mike's love. My decision was prompted by a conversation with my grade school nemesis, Doris Raleigh. Though we never were in any classes together in high school, whenever we met in Central's hallways, or on the bus to South End, we chatted and updated each other on our activities.

Doris had adjusted well to high school. She wore the latest fashions, enjoyed sports, and had been inducted into the ultimate social club, the Boosters. Though painfully skinny, Doris's fashionable clothes hid the sharp edges of her frame. She had lightened her short hair and always had it done up in a flattering style. Her plain face was highlighted with subdued shades of makeup, too. I suspected her sister, Vivien, was her mentor in that area. Vivien was the spitting image

of Elizabeth Taylor. It was rumored she had studied modeling in New York City one summer.

In grade school I was deadly jealous of Doris's intelligence. Yet I never denied the scholarly talent she was noted for. She was a two time high school honor roll student. I was sure she would continue that record through the rest of our tenancy at Central. The day I ran into Doris, she was coming out of the administration office holding a sheaf of papers. "Hey Frannie!" she yelled. "What's up?" Her crooked, puffy lips curled into a broad smile. I noted she was wearing braces, marveled at the thought of someone going to the trouble of straightening their teeth.

I raised my voice above the din of banging locker doors and boisterous chatter, "I'm doing great!"

Doris fell in beside me as we strolled down the hall. "Don't see you much, anymore. I miss our little gabfests. Like when we were at Bryant."

"I'm kind of busy. With my dancing." I suddenly felt compelled to brag about Mike. "Oh yah," I said, forcing a nonchalance into my voice that I didn't feel. "I'm going steady."

Doris's eyelashes, rimmed in a flattering shade of brown, fluttered. "WHAT?" she spouted. "How come I haven't heard the news?"

I felt amused and somewhat smug, at her reaction. "He's not in high school. He works."

"Wow! An older guy. Lucky you!" Doris edged closer to me. Shifting her papers under her left arm, she linked the right one in mine and lowered her voice. "Is he sexy?"

I rearranged my lips into a grin. "Of course. I wouldn't pick anyone who wasn't."

"Who is he?" Doris pursed her fat lips and squinted her eyes. It was a sly look that I remembered she took on when she was about to hatch some mischief.

Bracing myself, I thought, *She'd be mean enough to put the make on him.* "Just a guy I met at the Standard station in South End," *Huh! Mike wouldn't look at her twice.*

Doris's face cleared. "Isn't that where Curly Pirkovich works? I know Curly. Real well. He's a character." I felt myself stiffen as she lowered her voice, "Why don't you invite your boyfriend to the sock hop on Friday?" Her pronunciation of boyfriend sounded sarcastic. "I'm pretty sure Curly's going to be there."

Bitch, I thought. "I might just do that." I was already hatching my plan of action. First though, something occurred to me, "Have you got

a date for the dance?" I asked.

I detected a pinkish hue cross Doris's face. "No. Me and a bunch of the girls go alone. Like Pirkovich. It's more fun."

The very next night I cautiously broached the subject with Mike. "I heard Curly's going to the sock hop at Central on Friday. Maybe we should go."

"To a DANCE? I don't know any of those teenage dances." He pulled me on top of him. I snuggled my head up under his chin. "Watch the jaw. I still got a toothache."

"They play lots of slow dances. You can waltz, can't you?" I shifted my body off his, sat on the edge of the back seat. "Geez, we don't go ANYwhere together." My voice broke, though I forced back the tears.

Mike sat up. "You're not going to cry are you? I can't stand to see anyone cry." He was rubbing his broad hand down the side of his jaw, looking pained.

Aggravated, I snapped, "I don't cry! I just don't see why we can't go. It's not like there wouldn't be anyone there for you to talk to."

Mike's hand slid over his mouth. I could barely hear him talk. "Jesus, you got any aspirin? This toothache's a killer."

I decided to put my plan on hold. "Why don't you take a little nap? Maybe you'll feel better." I crawled over the top of the front seat, locked the car doors and waited for him to wake up. Scrunching down, I tried not to look out into the mist that shrouded the cemetery like grandma's hand-tatted shawl. I'd never before had the opportunity to look outside. *Why was it so misty?* Then I realized the windows were steamed up. Reaching out, I wiped away the obscuring fog. Sweeping my eyes over the dark cemetery, in my mind I formulated the words I was sure would persuade Mike to go to the sock hop.

The night deepened. Suddenly, out of the corner of my eye, I thought I detected movement. A rush of dread ran through me. My heart thumped against my rib cage as I slowly turned my head, sure I would see a sight from hell. Peering beyond the low circle of white veteran's headstones, I detected a monstrous figure standing there. A streak of lightening abruptly cracked the sky apart, revealing a towering fir tree. I hugged my arms around myself, felt a chill descend. Thunder clapped above us. Rain burst against the car windows in sheets.

Mike jerked awake as another streak of lightning ripped across the sky. "What the hell?" He jumped out of the back seat into the night. Leaning over, I pushed down the locked door handle to let him in. In the

short time he was outside his shirt was soaked. It clung to his muscular chest. "Damn!" he spouted as he slid into the driver's seat and turned on the ignition. In the dimness I could see his jaw was swollen.

"Are you okay?" I asked, thinking, *I wish he'd go to a damn dentist.*

"I'm okay," he mumbled as he slammed his foot on the gas pedal. The car burst out of the cemetery onto Highway 35.

Once we were headed back to South End, I set out my plan. "You know," I said, "There's a mattress in the shed behind my house. My Ma let a neighbor store it there." The truth was I'd seen my brother and his cohorts drag the mangy mattress into our shed from the empty lot across the alley.

"Really?" I could tell from his voice that Mike's interest was piqued. "Maybe we could haul it into the back of the car," he said.

"That's not what I meant." *Geez*, I thought, *do I have to draw him a picture*!? "I was thinking we could sneak into the shed some night. But it would have to be late. Like at eleven, or midnight."

Mike frowned. "What the hell would we do until then?"

"We could go to that sock hop. We wouldn't get out of there before eleven."

A lovely, sleepy-cat smile spread across his lips. "I don't know... Maybe."

I hastily added. "You don't get off until nine. We'd only have to be at the dance for a couple hours."

"I'm not going to dress up!" he spouted. "I hate dressing up."

"It's real informal," I said, my voice sounding hurried and bubbly. "You don't need to wear a tie or anything like that." The thought of showing off my handsome catch to my high school peers was boggling my mind. *Geez, I'll be the talk of Central!*

Mike put out his arm. I snuggled against him. "I guess we could go," he said.

I flung my arms around his neck and squeezed him tight. Momentarily taken aback, Mike let go of the steering wheel. The car skidded on the slippery highway.

Mike yelled, "Watch it ! We don't wanna end up dead!"

An instant vision formed of me in an open coffin in a funeral home with no visitors in sight. Little did I know that by the end of the sock hop dance, I'd be wishing I was dead. ◆

31 - Charlotte Sather, 5927 Tower Avenue.

Hopping and Bopping!

Music, when soft voices die,
Vibrates in the memory. –Shelley

I was sure Mike would be the most handsome guy at the sock hop. To me he looked like Errol Flynn in his white, open-at-the-neck shirt and tight, shiny-black slacks. His curly chest hairs peeked out from the top button of the shirt. His brawny arms were visible beneath rolled up shirt sleeves. His thick curly hair was heavily doused with hair oil, leaving a glossy sheen. To me Mike oozed sex appeal.

With Ma's help, I'd talked Day into lending me her latest Roth Brother's purchase –a bright red ballerina skirt and white, short-sleeved cotton blouse. There were red embroidered tulips on the front two pockets of the blouse. The blooms centered right over my breasts. I folded down my brand new pair of bobbysox twice, the final fold just touching the tops of my old wedgies. I wasn't at all worried about the scruffy shoes, knowing I'd take them off once we got to the dance. I completed the ensemble with a red neckscarf. New, beige pancake makeup and a subdued shade of red lipstick produced a shiny, healthy look that I knew was appropriate, but didn't like. What with my curly short hair, I was sure I resembled little orphan Annie.

The dance was well underway by the time Mike and I arrived. Music wafted across the parking lot as we walked hand in hand to the gymnasium. Inside, we were immersed in a world of dim light and the sounds of the rhythmic, syncopated music of Frankie Cox Jr's combo. The hall was decorated with layer on layer of purple and white crepe paper, twisted and crisscrossed beneath the high ceiling. Pink spot-lights roved slowly over the crowded dance floor, where couples were swaying to the strains of The Tennessee Waltz. It gave the impression of an intimate lounge and made me feel dreamy and sentimental.

I pulled off my wedgies, dropped them alongside the wall. "Quick, Mike. Take off your shoes!"

"What?" Mike looked around. "Geez," he said. "I was wondering what sock hop meant. Now I know." He smiled and slipped off his

loafers, set them alongside mine. Drawing me into his arms, we sidled into the flowing crowd of dancers.

Wow, I thought. *He's not only sexy, he's a great dancer!* Mike pulled me close. I lowered my head onto his chest. I could hear the heavy beat of his heart. I raised my face; he brushed my lips with his. I glanced around, hoping everyone was watching. All the couples were tightly embraced, oblivious to anything around them. As with me, I was sure the dance was a fountain of happiness for them. The dance number wound to a close. Everyone stood back, clapping and whistling in appreciation of the great music.

Frankie gave a little nod of his head and snapped his fingers three times. The band immediately struck up Nat King Cole's latest hit, <u>Too Young</u>. I could hear little gasps of pleasure from the girls crowded around us on the dance floor. Their partners swept them back into their embrace and glided them along. Mike and I joined the stream. We circled the long dance hall, weaving and swaying adroitly through the crowd.

I glanced around me. *God, these dances aren't as bad as I thought.* It was then I noticed that practically every girl in my line of vision had on an angora, shortsleeved sweater with a little strand of pearls at the neck. Their dates wore practically identical short-sleeved sports-shirts and corduroy pants. *Damn!* I thought, *Doris could have told me what everyone was wearing. She was up to no good.* I felt myself stiffen in Mike's embrace.

"What's wrong?" He stopped for a second. A couple of dancers plowed into us. "Sorry," Mike said and swung me along again. "Is something wrong?" he asked.

Quickly composing myself I said, "Nothing. It's just... well, I was thinking this is kind of juvenile. I mean, this sock hop thing? Don't you think?"

"Hell, no," Mike spouted. "I'm having a damn good time!" We moved along again, Mike mouthing the words softly in my ear, *"They say that we're too young. Too young to fall in love."* Our eyes met. I forced a look of rapture into mine. Mike closed his eyes and continued, *"They say that love's a word... a word we only heard and can't begin to know the meaning of."*

All the while I scanned the dance floor to be sure Doris wasn't amongst the dancers. Most of the couples were long-time steadies like Priscilla Anderson and John Keller; Jean Christopherson and Fuzzy Rich;

Fair Game

Janice Hammer and Jerry LaGesse; Karen Hill and George Hanson; Jeannie Johnson and Bill Downs Jr; Jaci Little and Bud Preston; Lois Paul and Oogie Sather; Julia Ross and Bill Thompson; Donna Sands and Ron Walker. As Mike guided me past the refreshment stand I saw Doris. She stood amongst a crowd of girls sipping punch. She waved and hollered, "Hey, Fee Fee! Over here!" *Bitch* I thought, tripping. Mike stopped. I grabbed his hand and picked up the beat, shuffling quickly past Doris.

"You leading now?" Mike laughed. The music ended. Loud clapping and whistling filled the hall again. Frankie and his combo immediately launched into *Because Of You*, the song that had come to my mind the first night I met Mike. I fell back into his arms, let him guide me around the dance floor. *I'll be damned if I'll let that bitch ruin MY night*, I thought.

After the set ended I grasped Mike's hand and led him to a seat at the darkest end of the gym, not wanting to draw attention to our unfashionable clothing. Sitting there on the wooden folding chairs, I prayed Doris wouldn't find us. All the seats alongside the wall were filled. Several couples stood in groups, chatting. I was relieved they partially obscured us from view. Mike held my hand. I felt him squeeze it as he turned and said, "I'm gonna go find the men's room." I was dying to go to the girl's room and upgrade my makeup, but was afraid I'd run into Doris. I watched Mike stroll across the hall. I was sure every girl in the place was ogling him, green with envy.

I looked alongside me. A couple chairs down sat some South End girls. As I acknowledged their waves, Doris appeared from nowhere. *Oh shit. She's heading this way.* Four or five of her hangers-on were straggling along a few steps behind her, like ducklings. As she advanced, I noted two little bumps protruding from Doris's angora sweater. I was sure she had on falsies. She strolled over. "Hey, Fee Fee. I saw your guy. What a dreamboat!" A flicker of a sneer crossed her full lips. "I love your outfit!

I stood and faced her. "Listen, Doris," I said, sounding serious. "I'd appreciate it if you'd stop calling me Fee Fee. I don't like that name."

Doris's face clouded. I wondered if she was faking the hurt look that momentarily appeared there. "Geez, Frannie," she said, "I didn't know that. I thought it was your official nickname. Everyone I know calls you Fee Fee."

"Well, you can tell them to knock it off." My raised voice attracted the attention of some of the South End girls. I recognized Anita and Marie, cousins of my old friend Bella. Anita's best friend Inez, was

there too. Inez, pronounced her name *Iniss*, which Doris said was pretense. Kind-hearted and smart, Inez had been extremely popular at Bryant Grade School. She seemed a lot less visible in high school. I noticed neither she nor the other South End girls wore angora sweaters. Anita got up and moved toward me. Doris's friends fell in behind her. "Is she giving you a hard time?" Anita asked, glaring at Doris. "Watch what you say to Frannie. She's my friend."

Doris blanched, looking fearful. "We were just discussing her nickname. How do you feel about Feef, Frannie?" She looked at me, her wavering smile like a plea for approval.

I instantly felt a generosity of spirit toward my old grade-school nemesis, sure we could at long last, bury the hatchet. "That's not bad," I said, and smiled.

Doris smiled too. The tension in the air vanished. Anita, Inez and Marie crowded around Doris and me, chattering like a flock of parakeets. I felt swept up in giddiness, completely forgetting where I was.

"What's going on?" I heard my date's deep, resonant voice. My mind suddenly went blank. The crowd of girls stepped back and, as if awestruck, stared open-mouthed at him.

Doris was the first to find her voice. She raised her eyebrows. "Well Feef," she said, "Are you going to introduce us?"

My mind reeled and raced through the alphabet, searching for a clue... A... B...C... D... E... F... G... *Geez, why doesn't he help me.* H... I... J... K...

"Hey MIKE! What the hell are YOU doing here?" It was the first time since I met Curly Pirkovich that I was glad to see him. Mike and the girls turned as Curly lunged into our midst.

"This is my date, Mike Janicovich," I said. No one was listening.

They were all laughing and joking with Curly, who, finally acknowledging me, said, "You're some babe. I never thought I'd see the day Mike would show up at a school dance."

Just then Frankie Cox Jr. announced, "Girl's choice!" The trio struck up a fast jitterbug. The girls milling around Mike squealed in delight and rushed off to grab partners. Several of the females paired up. *I wouldn't be caught dead dancing with a girl*, I thought. Just then Doris grabbed Curly and, though he protested, she dragged him onto the dance floor.

Mike, laughing, sank onto the chair next to me. "That Curly's a hoot. He can't dance worth shit and there he is making a fool of himself. I told you he was just a dumb kid." I was relieved Mike didn't

make any remarks about me forgetting his name. We held hands through the set of three fast numbers. When Frankie announced the last dance, <u>Goodnight Irene</u>, Mike and I waltzed around the floor in a tight embrace. I was in heaven.

After the dance ended, I was surprised that Mike and I were once again surrounded by admiring girls. I felt a pang of distrust as Doris shrieked, "We're all going to Chef's. Why don't you guys join us?"

I was pretty sure Doris hadn't invited my South End friends. Besides, I didn't trust her. Without looking at Mike, I said, "We're going out to Oliver."

As we left the gymnasium I noted the huge round clock above the exit. It was eleven-thirty. *Perfect*, I thought. In Mike's Packard, before I could say a thing, he scowled and said, "How come you lied to your girlfriend? We could've gone to Chef's. Sounded like fun."

"WHAT?" I snapped. "She's NOT my girlfriend." I felt my face heat, angered at the thought of how much he'd enjoyed himself while I stewed in agony all night. Dark thoughts of Mike flirting with Doris filled my head. "I didn't like it when you flirted with Doris."

Mike sputtered, "Flirted? Are you crazy? I'm not interested in that ugly stick!"

I couldn't stop fuming. "It sounded like you'd rather sit around gabbing with her than screw me!"

Mike's face lightened. "Oh Geez," he said. "I forgot about the shed." Embracing me, he trailed a path along the side of my cheek with his tongue, then French kissed me. I shifted closer to him.

The kiss over, Mike put the car in motion. We headed to South End. I leaned against him. He threw his right arm over my shoulder and squeezed me tight. I looked up at his dreamy eyes. "When we get out to my house, park a block over on Butler. To be sure no one sees your car."

I picked the intersection of Butler and Sixtieth as there were no houses nearby. No chance of nosy neighbors. The Great Northern railroad tracks were one block west of the spot, a huge vacant field one block east. It was a desolate dark area, that, as children, we avoided. After Mike shut off the engine of the Packard, we were plunged into darkness. "Christ," he said. "This is spookier than Greenwood."

Outside the car I took Mike's hand and led him through a winding path that cut through the tall dry grass of the empty lot behind our duplex. Guided by the dim streetlight two doors down from the building, I quickly made out the ramshackle shed. I whispered. "Light a

match." I wanted to be sure we didn't accidentally crawl into our land-lord's side of the shack. The glow from the match seemed dazzling. "This is it!" I said, quickly blowing out the light. I pulled on the low, square coal-chute window. It creaked open. "I'll go first," I said. "Give me a hand." Mike held my arm as I hoisted my right leg into the space. I could feel the lumpy coal briquettes under my wedgies. As I lunged through the window several of the briquettes rolled out from under my feet. "DAMN!" I shrieked as I fell onto the hillock of briquettes.

"You all right?" Mike stage-whispered.

"Yah," I said, cursing under my breath. "Wait up." I fumbled along the rough inner walls of the coal shack. I could see dim streams of light through the chinks in the wood at the front of the shed. Pressing my face against one of the wider cracks, I realized the glow was from a bare light bulb on the downstairs landing in the back apart-ment facing the coal shed. I remembered that our landlord always left that bulb burning. Moving along I located the mattress. It was propped across the small front window. I was disappointed to discover it was a single. Stretching my arms, I grasped either side of the mattress, swung it out and let it drop. I minced toward the open coal chute win-dow, carefully avoiding the mounds of coal that I'd sent spewing across the shack's dirt floor. "Come on!" I whispered.

Mike adroitly made a hand-leap through the open window. Stumbling across the heaps of coal, he bent down, his arms sweeping the space in a circle around himself. "Where is it!?"

"Over here." I grasped his hand and led him to the side of the shed where the mattress had landed. Kneeling, I tugged on Mike's hand. He lowered himself beside me.

"Jesus," he said. "The damn thing's kind of small, isn't it?"

"It's a single," I said, worried over the disappointment I'd detect-ed in his voice.

"It's more like a kid's mattress." He sounded cranky. "Stinks, too. Of piss."

I shushed him. "Just... don't worry about it, it's better than the back seat of your car." I stretched out across the mattress. My feet overlapped its lower edge.

Mike lowered his voice. "Barely," he said. "I ain't taking my clothes off. That's for sure." He slid his hands down the length of my skirt. Clutching the hem, he pulled it up. "Take off your panties." His voice was impatient. "I'm gonna make this quick." He pulled down

the zipper on his slacks and mounted me.

The muscles of my thighs and belly flexed rhythmically as I responded to the power of Mike's surging passion. The piston driving strength of his body once again possessed mine. But this time it was over in seconds.

"I'll make it up to you next time," Mike said. "Let's get out of this rat hole." He pulled me up off the mattress and kissed me. As always his lips were warm and demanding. "Come on," he said, leading me across the mounds of coal and back out the chute window.

I momentarily leaned against the shed. Mike pressed against me. "We could just as well of done it standing right here," I said.

He kissed me hard, "I'd better go now."

I clung to Mike, not wanting him to leave. He pulled away. "Gotta go..."

I watched him disappear through the tall grass on his way back to his Packard then bolted toward the front of our house. Just as I reached the back lean-to, I heard Ma. "What were you DOING back there," she demanded, flinging open the rickety door. "Get IN here!"

I brushed past her into the darkened kitchen. "Don't turn on the lights," I said.

"WHY? Is something wrong?" She sounded hysterical. Before I could stop her Ma rushed to the switch next to the dining room door and flipped it on. "OH MY GOD!" she shrieked. "You're FILTHY dirty! What is all that black stuff on Day's clothes?"

"Soot," I mumbled.

"SOOT! Where WERE you?" A light seemed to go on in her eyes. "Oh for PETE's sake. Not in the coal bin!" She sank to a kitchen chair and covered her eyes with her hands.

"Geez, Ma, don't worry about it. I'm sure it'll all wash out. It's cotton." I brushed my hands across the front of Day's white blouse. The action left two dark smudges. *Oh shit. I'd better wash my hands.*

Ma shrieked, "I am not talking about the CLOTHES! Are you insane? Oh Lord... the neighbors..." Her sad, languid eyes locked on mine. I turned away. "Is this what going steady is all about?"

Her words cut deep. "He took me to a DANCE, you know. It's not like... not like I can't be nice. In return." I grabbed the teakettle off the two burner gas stove and filled it with water. Slamming it on the range, I lit the gas with a farmer's match and sank in a chair across from Ma.

"Oh Lord." Her words sounded like a moan. Shaking her head

back and forth, she continued. "You don't have to do that just because someone's nice to you."

I didn't want her to comfort me. An ancient buried memory blossomed in my head. Without thinking I burst out, "YOU used to! With father! I remember going with you to his apartment. He gave me a cream-puff. Then you and him went in the other room." My gaze wavered. In a flash I felt as if I'd slapped my mother's face.

"I only did it to get the money he owed for you kids." Ma's voice broke. "You don't have to do anything so disgusting. You're better than any filthy guy."

I jumped up shrieking. "Mike is NOT filthy. He's my steady! I LOVE him!"

Ma sighed. Slowly shaking her head, she let out a little moan. "Lord help us." She got up and grabbed the whistling tea kettle with a ratty pot holder. Taking it over to the sink, she poured the boiling water into our orange, enamel wash basin and refilled the kettle. "Just clean yourself up and get to bed. You can leave Day's things on the chair. I'll take care of them." She turned and left me to my sponge bath.

Later, in my upstairs hideaway, as I mulled over my confrontation with Ma, I remembered Mike's car skidding on Highway 35 a few nights earlier. *Maybe I'd be better off dead. Then Ma would be sorry.* I shuddered at the recall of my funeral vision, the one where nobody showed up. *She should talk. She's no better than me. She can't even keep a man. At least I've got a steady boyfriend.* ◆

Wooing

If I am not worth the wooing, I surely am not worth the winning. –Longfellow

In spite of Ma's disapproval of Mike, in my inmost heart, I harbored the belief that one day we would marry. In addition to our three-nights-a-week couplings, Mike added something new. He began escorting me to events like the Shrine Circus and the Home Show, held in the Duluth Armory.[32] We went to movies at the Palace and Beacon theaters in Superior and the Norshor [33] in Duluth. Once Mike took me fishing at the Gordon Flowage, though I sat on the lake side, daydreaming.

Curly tagged along on every date. I became less and less agitated with Mike's friend, though I resented the fact that, after those threesomes, they dropped me home first. Once when Curly disappeared into the men's room, I said, "Why don't we dump him and go out to the cemetery?"

"Geez," Mike said. "You're getting to be a raving sex maniac. We can't be alone all the time." Fearful at the thought of losing him, I backed off.

Still, I glowed in the light of our growing involvement. Just being in Mike's presence stirred a hunger that I needed to quell. It was as if his handsome face was carved on my heart. I couldn't suppress an increasing agitation that something was terribly wrong with our romance, though.

For one thing, Mike never took me to Oliver, never suggested I meet his family. And though I didn't dare bring him to my house, I began suspecting Mike was hiding something. My mind buzzed with suspicion *–He's ashamed of me. He's married. He's got another girlfriend.*

Mike had absolutely no interest in my life away from him, either. When I brought up the subject of school, sounding resentful, he said, "I never went to high school. I had to get out and make a living." I could understand him not wanting to hear about my petty school problems, but couldn't understand why he wasn't interested in my dance activities.

232

Wooing

"That's kid's stuff," he said. "After high school you probably won't even think about it anymore." Over Ma's volatile objection, I gave him an enlarged, color-tinted photo of me posed in my Swan Lake costume. "Geez," Mike said, "That costume is awful skimpy on top."

One late Saturday morning, after I finished teaching my toddler dance class and left Braman's Music Studios, Mike's 1950 Packard was parked in front. He was alone. A jolt of desire coursed through me. Bounding into the car I threw myself at him and with all the passion I could muster, gave him a white-hot kiss. I felt him tense up as he gripped my wrists and pushed me away. "Watch it. There's people around."

I slid away from him, feeling crushed. "Geez," I said, "It's just that I'm so glad to see you." The tremors of jubilation inside me died.

Mike reached over and squeezed my hand. "There's a time and place for everything," he said. He pulled the car away from the curb and made a U-turn in the middle of Tower Avenue. "I thought you'd like to take a little ride. Down to Shell Lake." An indescribable softness had crept into his voice.

I felt a blush of pleasure. "What's in Shell Lake," I asked, sidling close against him.

He lowered his right arm and drew me close. "I got a cousin there. He owns a jewelry store." Mike smiled with warm spontaneity.

A great exhilaration filled my chest. *OhmyGod, ohmyGod! He's going to buy me an engagement ring! Ha! That's why Curly's not along.* I cautiously asked the question that was burning my tongue, "What are we going to do there?"

Mike stopped the car at the intersection of Belknap and Highway Two for a red light. He looked over at me, causing a quiver of delight at the sight of his dark, smoldering eyes. "We'll have lunch on the way. In Shell Lake I'm going to take a look at my cousin's truck. See if it needs a tune-up." Mike set the Packard back in motion.

My heart sank a fraction. *Maybe he ISN'T going to buy me a ring. Maybe I'm imagining things.*

I heard his voice from far away, "First we'll take a spin out Moccasin Mike Road." He stepped on the gas. The car sped out of Superior. In seconds we were bouncing along the rutted roadway that led to Wisconsin Point. An electric silence descended between us.

I savored the rapture that filled me at the realization we were going to make love. I envisioned us naked on the beach sands, hoped

he'd brought a blanket. Sunlight dappled the overhanging tree leaves. Everything was pristine and sunny, the horizon cloudless. The intriguing combination of brisk wind and warm sun brought a feeling of complete exhilaration and hopefulness inside me. I burst into song –"Because of you there's a song in my heart. Because of you the sun will shine... the moon and stars will say you're mine... forever, and never to part..."

Mike playfully waved his hand in front of his face. "Maybe you should be studying singing, instead of dancing," he laughed, then squeezed my knee. I pulled his hand to my lips and kissed it. Mike turned the Packard off the road into an overgrown copse of trees and bushes. "This looks good," he said, shutting off the car motor. "Let's check out the beach."

Strolling hand in hand along the shore of Lake Superior, I was struck by the soothing effect the lapping waves evoked in me. "Let's take off our shoes and go wading," I said.

Mike momentarily stopped. "I don't think so. The water's always so damn cold." He moved ahead, pulling me along.

The beach was strewn with driftwood in every form and shape imaginable. I stopped and picked up an especially large, gnarled piece. "I think I'll take this home," I said. "As a memento of the day."

Mike tugged my hand. "It's just a hunk of wood. Let's go in the bushes. In case someone shows up."

Hugging the driftwood, my eyes scanned the deserted horizon. "I don't see anyone." My vision of love-making on the beach was instantly replaced by the dream of us on a moss-covered forest floor.

At the car Mike pulled two Army blankets out of the back seat. "One for underneath, and one for on top," he said, chuckling. "I wouldn't want anyone to catch us bare-assed naked out here." I blanched from his crude words, though, when his eyes met mine, they filled me with desire.

Between the rough blankets I reveled in his nakedness as we surrendered to our overheated senses. Without a thought, words burst from my mouth, "Let's make a baby." I felt Mike falter. Molding myself against his tautness, I opened my body to him. With a fevered groan Mike suddenly jerked inside me. His deep gasp sounded like a deflating balloon.

I heard Mike mutter, "Don't ever talk about babies again." I lay dazed and motionless under him. He rolled off me, wrapped the top

blanket around his body and disappeared into the bushes.

I got up and scrambled to the Packard, retrieved my clothes and hastily dressed. All the while uneasiness, spiced with irritation, grew inside me. *Geez*, I thought. *He didn't have to be so huffy.* A suspicion I sometimes harbored blossomed in my mind. *I probably can't have a baby anyway. With my record I should have gotten P.G. by now.* The thought left a dull ache inside. *I hope he doesn't find out. Every guy wants kids when they marry.*

Back on the highway the car sped along. I wondered at the silence between us. Glancing at his handsome face, I hesitantly asked, "A penny for your thoughts?"

Shifting in the driver's seat, he put out his arm. I slid closer. "I was thinking how sexy you are," he said. Squeezing me, he continued. "I like it that you're so... easy."

I straightened my back. "EASY!? What do you mean by THAT!?"

Mike laughed. "I guess I meant relaxed. You're so... relaxed and... affectionate."

I responded in a soft voice, "That's because I love you." He looked into the far distance, but didn't speak. *Why can't he SAY it*, I thought. Doubt filled my head again. *Maybe he's not going to buy me a ring.* A heavy, sodden listlessness swayed in my mind as the car slowed through Hawthorne. "Where are we stopping to eat?" I asked.

"Probably at Solon. We can grab a bite at Prevost's."

I was relieved to hear him speak. His deep sexy voice was comforting. I leaned back, stretched out my arms. "How long does it take to get to Shell Lake?"

"A little over two hours from Superior. It's about seventy-two miles."

Just north of Solon on Highway 53, Smithy's Restaurant came into view. I'd heard that the well-known establishment was only open for dinner and had real good food. Pointing at the site, I said, "Maybe we can have supper there. On our way back."

Mike sputtered, "Geez, do you think I'm made of money?"

Our stop at Prevost's in Solon was hurried. Mike kept checking his watch through our quick lunch of hamburgers and fries. "We're not making very good time," he said. "I'll have to step on it. Else we'll be hitting too much traffic on the way back."

I felt as if I'd been slapped in the face. Searching for a neutral subject and finding none, I lapsed into silence. The Packard sped through

Gordon and Minong. A short distance beyond Spooner, Mike turned the Packard off the highway at a sign that read, "Welcome To Shell Lake. Population 1,016."

It was a typical small town, filled with tree lined streets, white houses and picket fences. The downtown was just two blocks long with one gas station, a cafe, the Farmer's Co-op, a post office and a bank. Three or four other wood-framed buildings dotted the landscape. In the distance I could see two church spires. Mike pulled the car into a parallel parking spot between a beat-up Studebaker and a grimy pickup truck. "This is it," he said.

I looked out the window, saw the sign on a small shop right in front of us, Serdich Jewelry and Watch Repairs. Inside, there was no one in sight. Mike shouted something in a foreign tongue that sounded like, "Yahoo!" The curtains over a door at the back of the store parted. A giant of a man stood silhouetted there. Mike yelled, "Hey you old Bohunk!" Rushing forward, he embraced the man. Mike's arms barely reached around the massive man's frame. As I stood gawking, they kissed each other's cheeks.

Embarrassed, I glanced around the shop. There were two long counters, one off to my right and a smaller one in front of the two men at the back of the shop. To my left were shelf on shelf of knickknacks –glass animals, ceramic bowls, china cups... all dust catchers... things Ma liked. I moved closer to the longest counter. My eyes immediately focused on the trays of engagement and wedding rings nestled in a separate space –in slots of deep-blue velvet on tiered surfaces. I leaned closer. An especially beautiful pear shaped diamond ring caught my eye. *Wow*, I thought. *Wouldn't THAT make Ma's eyes pop*! I was imagining it on my left hand, imagining the envy it would generate amongst my high school peers, too. I felt Mike's arm on my shoulder gently tugging. I turned.

Mike's cousin stood smiling like a giant Buddha, his ham-like hand extended. I put out my hand and smiled. He immediately yanked me forward against his barrel chest, laughing and talking in an unintelligible language as he squeezed me. "MIKE!" I shrieked, "He'll break my ribs! Tell him to stop!"

Laughing, Mike said. "Okay Yakob! Enough!" The two men hooted together as I stood breathing deep trying to catch my breath. "He likes you," Mike said, looking pleased.

"I guess." My words sounded breathy. "Doesn't he speak English?"

Mike had his arm around my waist, "Not much," he said.

"How can he run a business if he can't speak English?" I was smiling and nodding at Yakob, trying to relay a sense of geniality minus the alarm I'd felt at his enthusiasm.

He kept looking me up and down and repeating, "Nice. Veddy NICE!"

Mike said something I couldn't understand. They both laughed uproariously. I was beginning to get annoyed, when Mike said, "He's married. His wife speaks good English." I relaxed a little and looked at Yakob.

His bull-like head was capped with thick, black curly hair, just like Mike's. He had a long nose and a thick patch of scraggly mustache over his upper lip. The lower lip was full and pouty. His dark eyes were partially obscured by bushy eyebrows. Still, I could tell they were vivid, questioning eyes.

Yakob's body was squat and square, though not fleshy. He looked like a man who could lift a ton of bricks. His biceps, revealed through a short sleeved, white shirt, were immense. When he talked he gestured dramatically with his beefy hands. There was a vivacious quickness in his every movement. He seemed to be questioning Mike about me, babbling in his foreign tongue and glancing at me every once in a while.

"What's he saying?" I snapped.

Mike put up his hand as if to silence me. "He's just asking questions. About you. How we met. Stuff like that."

I wasn't sure I liked being talked about. "Where's his wife?" I asked, sounding peevish. I was anxious to meet her and maybe find out something about Mike's family.

"She's in Ashland. At a dealer's show, or something." Mike turned from me and launched another rush of alien gibberish.

I strolled back to the counter, leaned down to look at the diamond ring I'd admired. Yacob came bounding around the counter. "I show!" he said sounding excited. He opened the case with a key on a long cord attached to his belt loop. Sliding the glass door back he took the ring out of its niche. Grabbing my left hand, he carefully slipped the diamond on my ring finger.

Feeling flushed at his action, I brandished my hand to watch the light catch the facets of the gorgeous stone. Mike stood silent and glum, then hastily shook his head in a nearly imperceptible no. I slipped the ring off and handed it back to Yacob. A look of complete dejection filled his eyes. I prayed it wasn't reflected in mine. Quelling

the lump I felt rising in my throat, I touched Yacob's hand. Nodding, I said, "VERY nice!" It seemed to help, though he immediately moved to another case that held row on row of miniature knickknacks. Yacob waved his hand over the display. "You take."

I looked at Mike. "Pick something for yourself," he said, looking uncomfortable.

I reexamined the contents on the shelf. My eye settled on a miniature box, hoping it was something Mike could afford. The trinket was gold-colored and heart shaped. In it's upper left corner was a microscopic, enameled red heart. I pointed at it and said. "That one."

Yakob took the novelty box out, pulled open a drawer and extracted some tissue paper. Carefully wrapping the box he handed it over. "From Mike," he said.

I looked up at Mike. He lowered his sensuous lips to mine and kissed me, bringing an instant shriek of delight from Yacob. Yacob danced and hollared, "From me!" He handed over another small, tissue wrapped package. I unwound the paper. Nestled inside was a tiny, handblown glass frog. Leaning over the counter, I kissed Yacob's cheek. He smiled broadly, touching the spot, then rolled his eyes at the ceiling.

"How CUTE!" I said, looking at Mike. "It'll be perfect on my driftwood."

Mike frowned, "That ratty piece of wood?"

"YES! I can sand it and varnish it and it'll look gorgeous."

Mike laughed and looked at Yakob, then launched into another foreign-tongued barrage. I was sure he was teasing, as, half-way through the conversation Yakob smiled and said. "Funny womans."

Just then a customer walked into the store. Yakob greeted her with an expansive smile and slowly asked, "I can help you?"

Mike took my arm and guided me outside. "You wait in the car or take a little stroll. I've gotta go out back and check Yacob's truck.

Strolling down Shell Lake's main street, I thought, *Be sensible. We've only been going steady for two months.* I was sure that in the very near future Mike would get me a ring. He'd bought me a gift after all. And I'd met a relative. *I know things are going to be perfect for us.*

Finished with my stroll, I sidled into Mike's Packard and rolled down the passenger window. The sun had begun its descent in the west. The layers of thin clouds that began to form were tinted in pink, against the perfectly blue patches of sky. I was reminded of baby blankets. *Pink for girls, blue for boys*, I thought. My daydream burst as Mike and

Wooing

Yacob came bounding through the jewelry store door.

My eyes locked on Mike's supple, athletic body. "Everything's taken care of," he said. Embracing Yacob, they kissed cheeks. Yakob charged to the car, grabbed my hand through the open window. Before I could protest, he planted a wet kiss there. I felt myself blush in pleasure. "Veddy soft," he said, then followed Mike around the car to the driver's seat, bursting into his unintelligible chatter. The men embraced again. Mike jumped into the car. As we pulled away from the curb, Yacob stood waving both arms above him like a cheerleader at a football game.

On the way back to Superior, I asked Mike, "What language were you and Yacob speaking?"

"Serbian." I detected irritation in his voice.

"So he's from Serbia?" I asked, warming to the idea of getting information about Mike's family.

"There's no Serbia anymore. Since the war. It's Yugoslavia." Mike shifted in his seat, put out his arm. I nestled close against him.

"Isn't that Marshal Tito's country? The dictator?"

Mike seemed to explode. "You don't know nothing! Tito's a great man!"

I felt shriveled, cautiously added, "He's real handsome, that Tito. You and Yakob are, too." My words seemed to calm Mike. He brushed his hand across the top of my head, as I continued. "Are your parents in this country?"

"Of course!" Mike pulled away from me.

"Do they speak English?" I asked, pulling on his arm in an attempt to get him to put it around my shoulders again.

Mike shook my hand off. "Don't ask stupid questions," he barked. "You know, sometimes you just talk too much."

The irritation in his voice alarmed me. I lowered my head onto his broad shoulder and closed my eyes. Dozing off and on all the way back to Superior, I forced my mind into blankness. I didn't want the niggling worry over Mike's outbursts to grow. By the time we got to my house, he seemed okay again. We hugged and kissed warmly.

"By the way, he said, "I can't see you Wednesday, but I'll pick you up Thursday night downtown. After your dance class."

In spite of a slight pin-prick of misgiving, I felt a terrible cloud lift. I was certain we were back on track. I ran into the house with my driftwood under my arm and my two little packages clutched in my hand. As expected, Ma stood in the middle of the living room glaring.

Fair Game

"Where have you been!?" she shouted.

"Just out with Mike." I said, forcing nonchalance into my voice. "We took a little ride out to Wisconsin Point and then drove down to Shell Lake."

Ma wagged her head back and forth, then let out a long sigh as if in defeat. "You know," she said. "I've resigned myself to your going steady, but I really would appreciate it if you'd call and let me know where you're at once in a while."

"I guess I could do that," I said as I handed Ma the driftwood I'd found on Wisconsin Point.

A vague pleasure briefly crossed Ma's face. "This is a nice piece," she said, turning it around in her hands, then depositing it on a near-by chair. "I remember when I was young and used to stroll the beach down at the point."

Before she could launch one of her long, drawn-out stories I said, "Close your eyes, I've got something that goes with it." I put one of the small packages into her cupped hands.

Opening her eyes, she quickly pulled away the tissue paper and held the glass frog between her fingers. "How sweet! Where did you get him?"

"Mike bought it at his cousin's jewelry store. In Shell Lake." Her happiness was bringing a warm glow inside me. "He got me something, too!"

Ma's face clouded. "Not an engagement ring, I hope."

I felt myself flush. "NO! I never expected THAT." I unwrapped my treasure, "Look," I said, "It's a little love box."

Ma picked up my heart-shaped trinket. Suddenly, she burst into lilting laugher. "For Pete's sake," she said, "What do you need a pill box for!"

I snatched the box away from her. "I don't care! I LOVE it!" Turning, I thundered upstairs to my hideaway, thinking, *I KNOW he's going to buy me a ring. I just KNOW it!*

Once again my heart ruled my head. This time the consequences would prove catastrophic. ◆

32 - 1301 London Road, The Armory.
33 - 211 E. Superior Street, Norshor Theater.

Fair Game

Justice is blind, he knows nobody. –Dryden

On Thursday night, in the middle of my ballet class, the Braman's receptionist came downstairs. I held up my hand in signal for Mrs. Davis to stop her piano pounding. Walking to the young woman, I asked, "What is it?"

"Telephone call," she said. "Mike."

"Now!?" A mix of exhilaration and disquiet filled my mind. *I wonder what's wrong? He's never once telephoned me since we met.* "Is he on the phone?

"No," she said and handed me a piece of paper. "He left a message."

I read her printed note: *8:15 p.m. –Mike called. Tell Frances I'll pick her up at nine.*

I managed to finish out the hour without a hitch. Quickly changing to my ballerina skirt and pullover sweater, I threw my dance gear in my red hat box. Rushing to the small office just beyond the studio expanse, I tucked the box under Mae's desk and locked the door behind me. It was a routine I followed every Thursday night, knowing I wouldn't need my dance equipment. I seldom practiced between my Thursday night and Saturday morning sessions.

Charging up the stairs two at a time with my shoulder bag banging against my hip, I burst out of Braman's front door onto Tower Avenue. Dusk covered the downtown buildings with a purple haze. A hard wind swept debris along the deserted street. A puff of air blew up under my skirt. I felt a sudden chill. Mike's car wasn't parked in front of Braman's. *Geez, where is he? I really could use a ride now.*

I made my way along the front of the building to the parking lot entry. Suddenly a car horn blasted out of the dimness back there. I cursed myself for not wearing my glasses. Frantically digging in my shoulder bag, before I could retrieve my glasses, I heard the car door open. The faint ceiling light illuminated two figures. One of them jumped out of the passenger side. I squinted into the dark, thinking, *Oh shit, he's got that damn Curly with*! I hurried to the car. With ter-

rible suddenness I realized it wasn't Curly at all. "Who are you!?" I
spouted. In a flash the guy's hand shot out. I felt his vise-like grip on
my wrist.

"Shut up and get in!" I could smell the rancid stench of his
whiskey breath, vaguely wondered why in the world Mike would be
involved with such a disgusting character. I lowered myself onto the
car seat. Before I could even settle in the guy pushed his bulky body
against mine. Slamming the door, he shouted, "Got her! Let's hit the
road!" He and the driver burst into raucous laughter. I listened with a
vague sense of unreality, realizing I wasn't in Mike's car at all.

Slowly turning my head, I looked at the driver. *I think I know this
guy.* A mental picture of him instantly appeared in my mind. It was the
self-same picture I'd seen in the Evening Telegram. A heavy-boned
and rakishly good-looking man, he'd been accused of rape. I felt a ter-
ror run through me as he met my gaze. His eyes were small and pig-
gish looking, like black holes in a pale face.

His thick lips curled into a sneer. "What the fuck are you gawking
at? Haven't you ever seen a good-looking guy before?" He burst into
coarse laughter as his foot hit the gas pedal. The car roared out of the
lot, pebbles and dust scattering in its wake as it turned south.

His buddy spouted. "She only screws pimply jocks, from what I
hear." They both hooted.

Suddenly the driver's name popped into my head. *Mike Wittens.* I
remembered, then, that the girl he was accused of raping was from
Central, remembered my own doubt when I realized who she was... a
fat, plain-faced, almost ugly girl. I remembered the question that had
immediately popped into my mind, at the time –*Why would a good-
looking guy like Wittens even look at her*? She had been raked over the
coals, her reputation ruined forever. Wittens had gotten off. The girl
disappeared from Central. Rumor had it that she was pregnant and had
concocted the whole story. I fervently wished I was somewhere else.

My thoughts were interrupted by Wittens's harsh bark, "Don't be
hogging that whiskey! Pass me the bottle." The guy on my right hand-
ed over the half pint. Wittens took a swig and returned it to his buddy.

My eyes focused on the label, "Old Crow." Then slowly, as if
afraid my voice would break, I said, "You'd better take me home."
Hearing myself speak seemed to bring some strength inside, though
my hands felt cold and clammy and my nerve endings hung like
thread outside my skin. "You could get in a lot of trouble if you don't."

The car jolted forward as the driver slammed his foot hard on the gas pedal again. At the same time he boomed, "SHUT UP!" and struck me in the mouth with the back of his hand. A short, vicious blow, it brought stinging tears to my eyes. My head erupted in blinding white pain. "I don't wanna hear one fucking word from your fucking mouth!"

His buddy giggled. "Yah. We don't like smart-mouthed sluts."

I forced back the tears, took a deep breath. I couldn't breath out. There was no air inside me. It felt as if I was trapped in a bottomless cave. Like a ping-pong in my head, wild images bounced back and forth. I was being stabbed to death. I was being dragged naked by my hair and tossed in a river. I was being burned in a pile of dead leaves. Silently commanding myself, *STOP IT*, I shook away the images.

I resolved to escape the first chance I got. Looking warily from one to the other of my captors, I was sure Witten's buddy was pretty drunk already. He was plump with a blotchy face and droopy red eyelids, like he hadn't had enough sleep. I was sure it wouldn't be difficult to deal with him if I could get him alone. *Maybe... I could trick them somehow. I could hide or... run.* I looked out, trying to determine where we were as the car tore through the night. *It's so dark... so forever.* The car's headlights swept over the white and black highway sign at Tower and Central. We veered west so fast I was thrown toward the dashboard. Wittens arm shot out, pushing me back. We were nearing the cemetery turnoff on 105. I felt a hazy relief. I could still walk home from here.

But the car sped on past the turnoff, past the turnoff to Billings Drive and the turnoff to Calvary Cemetery. We were going further and further away from home. Further and further away from any hope of finding my way back.

Five miles beyond Superior the blazing lights of Oliver came into view. I prayed they'd stop for more liquor, or gas, though I wasn't sure what I could do. An alarm bell went off in my head. *What will Mike think? How can I explain how I got here?* I immediately felt guilty and scrunched down in the seat. *He'll never believe you.* Guilt flooded the back of my mind. *Why did you get in the car? You had it coming. It's your own fault.*

I heard Wittens's words through the fog that was clouding my thoughts. "We got enough booze?"

"Sure do!" his companion answered. His words were slurred, "We could make it all the way to North Dakota if we wanted to!" Spittles of saliva slid from the corner of his flaccid lips.

OhmyGod, OhmyGod. He's crazy drunk. I'll be lucky to ever get home.

The car thundered onto the long, wooden bridge over the St. Louis River. We were leaving Wisconsin, entering Minnesota. I tried to envision a map of the area in my head. Nothing materialized. I cursed myself for my stupidity. As we wobbled and jerked over the wooden planks of the ancient structure, I half wished we would crash through to the black waters below. It seemed a lesser disaster than the one I was sure awaited me.

But we didn't crash. Once we entered Minnesota, Wittens swerved the vehicle off the highway onto a tree-wooded bluff. He shut off the car lights. Blackness enveloped us. "Give me the booze, Izzie," he said.

I filed his friend's name in my head. *Maybe... If I remember. Maybe I can tell someone. Who though? No one's going to believe this. I can't believe it myself.*

I felt Izzie's hand brush against my chest as he handed the booze over. I flinched, resenting his familiarity.

"What'sa matter? No one every grab your tits before," Izzie hooted, then every obscenity I'd ever heard rang from his mouth. "Ya see bitch! Ya see!" he shrieked, "I know how to put fuckers down too!"

Wittens intervened. "Calm down Izzie. You'll wake up the whole damn state." He took a swig of whiskey, then lay the bottle on the dashboard. Opening the car door, he grabbed my wrist. "Come on," he said. "Action time!"

It felt as if my feet were dragging across dry clay. An odd, blue crystal light somewhere way in the back of my brain began to grow. I heard my shaky words... "I... please. Please don't hurt me."

"How the hell can I hurt you? You're not a fucking virgin!" He pushed me into the back seat. "Just don't give me any shit!" he said.

I felt everything go silent inside me as I lay back and waited. Without ceremony Wittens pulled my skirt up over my head and jerked down my panties. I felt relieved that he didn't make me strip. I could hear him unbuckle his belt. The sound of his pants zipper lowering echoed onto the silence. Snarling, "Let's do it bitch," he threw himself over me and forced himself inside. I suddenly felt very far away. I knew he was pumping roughly inside me, but I couldn't feel anything. My senses were numb. I was just hanging on.

Moments seemed to drag into hours when I suddenly realized the pumping had stopped. "Get out!" he screamed. "Get the fuck out you fat slut!"

This is it, I thought. *They're going to leave me here. Leave me in this God forsaken wilderness.* I wasn't that lucky. He pushed me back across the hood of the car and pulled up my skirt. Once again he roughly entered me. My back ached from the position. I clenched my fists and looked up at the sky. The navy blue darkness was sprinkled with fuzzy stars. The sky seemed to lighten as clouds skudded across the expanse. The wind had died. The world seemed to stand still. I felt shivers inside, wondered if my teeth were chattering. Suddenly I detected movement out of the corner of my eye.

Izzie's words were warped with whiskey, "Fucking shit!" he yelled. "Hurry up. I got a hard on."

"Shut up!" Wittens snarled. "I got first dibs and I ain't done." He stopped then and pushed me along, back into the car. "Lay back and put your fat legs up on the front seat."

I felt as if I had to hold close to myself and not let go. I hugged myself and slowly entered the back seat. Wittens pushed me back and ordered me to slide further down. My rear end was on the edge of the back seat, my legs stretched wide across the front seats. He mounted me again. It felt as if there was no more air in the car as he pumped away. I closed my ears to the terrible noises that his actions generated.

Izzie opened the back door. "When the hell are you going to finish. I'm sick of sloppy seconds!"

Wittens crawled off me. "Okay asshole," he said. "See if you can do any better."

Izzie wasn't as rough, but the waves of whiskey fumes were making me nauseous.

I tried to discipline my voice, tried to take control. "Could you... please... could you please not breathe in my face?"

Izzie turned his head and put his face to my chest. His movements slowed. I suddenly realized he was dozing, letting out little snorts of air. I carefully slid out from under him. He fell forward onto the back seat and immediately curled up in the corner.

I pulled myself into a fetal position opposite him, feeling as if I was in the bottom of a cold, deep well. My back ached, my arms were stiff, every muscle in my body seemed on fire. I wondered if this was how whores felt after a trick. *You ARE a whore*, I thought. Overwhelmed with helplessness, my mind filled with accusations. *Why didn't you resist? They didn't have a gun. Or a knife. You didn't bleed. You survived. You had it coming.*

245

Fair Game

My thoughts were interrupted by Witten's snores coming from the front seat. For a second I was tempted to jump from the car and run for my life. I looked into the darkness. A confusing rush of anticipation and dread whirled inside me. Maybe something worse would happen. I felt an obsessive sense of everything going wrong. *Why take another chance. Maybe these guys will be okay now that they got what they wanted.*

I crawled out of the back of the car and slid onto the front seat. My nose was running. I wiped it with the back of my hand. My whole face felt burnt like it had been rubbed with sandpaper. Gently shaking Wittens arm I leaned to his face and whispered, "It's kind of late. Could we go now?"

He woke with a start. "What the fuck!?" He squinted at my face. "Geez, you are one ugly bitch!"

I sagged back against the passenger door. Huddling there I felt like a little kid pretending to be grown up. My voice wavered, "It's late. I want to go home. Please?"

Wittens straightened in his seat. "Stop that fucking whining. I'M the one who decides when the hell you can go." He turned on the ignition.

The sound of the motor... of movement made my heart skip a beat. *Thank you, Jesus*, I thought.

"IZZIE!" Wittens yelled. "Get your ass up front!"

I could hear his buddy mumbling in the back seat. "Where... where the hell ARE we?" He exited the car and pushed against me into the front seat. "Oh yah," he laughed. "We was banging the bitch!"

Though my feelings were paralyzed I felt panic rise inside me again. My antennae had picked up an increase in tension.

Wittens U-turned the car back to Oliver. "It's only three a.m. We can still knock off another piece."

I squirmed and fidgeted, felt wet stickiness on the underside of my skirt. I wondered where my panties were. My bobby socks were missing, too. My feet felt like blocks of stone. *Why would they want my socks?* Another wave of panic passed through me. *Where's my shoes? Where's my purse?* I carefully moved my bare foot in front of me on the floor of the car. I felt my purse and shoes, kicked them up under the dashboard. I was imagining my escape, praying we'd be closer to town this time. *But where can I run? Who will help me?*

I looked out the window as the car barreled through Oliver. The tavern lights were still blazing. I imagined Mike sitting at a bar there,

sick with worry. Maybe drinking himself into a stupor. *Oh God. Please make everything okay!*

Moments later the car veered onto Billings Drive and stopped right off the entryway. "We'll knock off a quickie, then dump the slut."

Izzie hooted. "I get first dibs this time!" He leered at me. "I'm gonna screw your brains out." He nodded toward the back seat. "Get your ass ready!"

In the back seat I lay zombie-like and closed my eyes. Izzie cursed and shrieked like a banshee. My mind drifted in and out of the terrible reality of the situation. *Hold on*, I thought. *It'll be over soon.* Second thoughts snuck in. *Don't ever tell a soul. No one will believe you.*

What seemed like hours later, after Wittens took another turn, I stood leaning against the car, shaking. I was afraid my knees would give out before I could get back in the front seat. My shoulders ached, my arms and legs were stiff. My eyes stung so bad I could barely keep them open. There was no way I would be able to run. I lowered myself onto the front seat, feeling as if I were reentering a burning building I'd just escaped.

Wittens started the car and turned onto Highway 105. "Where do ya wanna get out? At the police station?" His cruel laughter rang in my ears.

My words were hardly audible even to myself. "By the depot. In South End," I didn't want them to know where I lived.

At the designated spot I reached down, slipped on my shoes and grabbed my purse. I exited the car stiffly in slow motion, like a wild animal freed from a cage.

Wittens yelled "You asked for it!"

Izzie's words quickly followed, "Once a slut always a slut!"

Feeling sluggish and disoriented, I minced my way along the rail-road tracks. I couldn't feel them, but knew my feet were moving because I could hear rocks crunching with each step I took. At Sixtieth Street I paused. Confusion descended. Which way home? Off in the distance past a vacant lot, I saw the fuzzy outline of our coal shed, just visible beneath the dim street light in the alley. I moved slowly ahead, through a path that seemed vaguely familiar. Was it just last week that I'd walked here after the sock hop? I paused next to the coal shed. A terrible chill descended. Was someone following me?

I bolted into our back yard, threw myself against the door. My sobs burst like the howl of a wolf as I crashed into the kitchen. There at our

round wood table sat Ma and Howard. I saw in their eyes that they did-
n't understand what was happening. Neither of them spoke. I paused in
my mad dash and screamed, "I'm NOT GOING TO SCHOOL!" My
mother took on the wounded look I hated. "AND DON'T ANYONE
STAY HOME WITH ME! I DON'T WANT TO SEE ANYONE!
EVER!

With that I rushed through the darkened front room up the stairs
to the second floor. In my hideaway I barricaded the door with the
chair and fell exhausted onto my mattress. I tried to stop crying, but
the whirring accusations in my head kept generating new waves of
grief. *You let it happen. You got in the car. You didn't fight back. You
asked for it.*

Soon there were no tears left. I screamed at the walls of my room
until I heard Ma banging on the door. "FRAN! You'll wake the neigh-
bors! Open the door. I want to talk to you! Mike's been calling all
night."

"I DON'T WANT TO TALK TO ANYONE! EVER!" I pulled
myself into a ball, feeling sore and filthy dirty. Drifting into sleep I
dreamed I was being chased naked through the black night. Panting
and crying I hid in a hollow tree trunk in front of Bryant Grade
School. Without warning I was grabbed by the hair and yanked from
my hiding place.

Meantime, I would have to face the nightmare of telling Mike. I
prayed he would believe me. ◆

Hanging On

Delay of Justice is injustice. —Landot

In my upstairs hideaway I awoke unsure of where I was. I had been drifting in and out of sleep in a gray blur. It was a fitful sleep filled with dark images. Now I remembered what I had prayed to forget. I had done something really wrong. I forced that horror from my head, forced the tears back. I didn't want to cry anymore, didn't want to think.

Weariness descended like a shroud. The hours dragged on. Gradually I moved my body... stretched my legs, turned my ankles in mini-circles, checking to see that I was still in one piece. Raising my arms I spread my fingers and studied my hands. It was as if I was no longer the person I once was. My senses stirred. I noticed my dirty feet, my ballerina skirt –wrinkled and stained, my sweater –stretched and twisted across my chest. I listened to the silence of the house. Sluggishly, I willed myself up off my mattress.

In the hallway downstairs, I looked out the window. The streets were empty; *everyone must be at work or at school.* In the dim kitchen I turned on the ceiling light and checked the grimy-faced wall clock. Just 2 p.m. There was a note on the table. I picked it up and read: *Dear Fran: I called school and Mrs. Sterling. Told them you have the flu. I hope you feel better. Love, Ma.* I swallowed hard, forced back the tears.

My eyes scanned the kitchen expanse. Though I was sure everything was different, nothing had changed. I noticed our huge copper wash vat on the stove, filled with water. I lit the gas under the enormous receptacle. In our lean-to shed off the kitchen, I dragged our galvanized-steel bathtub into the middle of the kitchen floor.

Rummaging in Ma's closet I found her chenille robe, stripped and pulled the robe tight around my naked body. My dirty clothes were heaped on the floor. Carefully, as if extracting a sliver with tweezers, I picked them up one by one and deposited them in the trash can under the kitchen sink. I vowed to burn them the first chance I got.

When the water was hot enough, I scooped it pan by pan into the bathtub until it was filled. Slumping down into its warmth, I closed my eyes and scrubbed every inch of my body with a rough washcloth. Then, quickly, as if rising from a caldron of hot tar, I hopped out of the tub and wrapped myself in Ma's robe. At the sink I bent down and shampooed my hair with a fresh pot of water. Suddenly the phone rang. It made me nauseous with quick fear. I stood frozen, rivulets of water trailed down my neck onto the collar of Ma's robe. *Maybe it's Mike*, I thought. *I don't care. I don't want to talk to anyone.* The ringing continued. Grabbing a towel I covered my head and ran upstairs.

In my hideaway I huddled on my mattress, pulled the blankets up to my chin. I willed myself to sleep, but sleep wouldn't come. One thought alone kept repeating itself. *You HAVE to call him.* In slow motion, as if under water, I returned to the kitchen. Sitting at the table, I stared at the shelf alongside the kitchen window where our black dial phone sat. The seconds ticked away. Moving to the phone, I gingerly dialed the Standard station. Glen answered.

I heard with amazement the words coming out of my own mouth, "Could I, ah ah... could I speak to Mike?"

I heard Glen call Mike, heard Mike's deep voice in the background, "Ask who it is."

"It's your girlfriend," Glen laughed.

Mike's voice raised. "Tell that damn bitch to drop dead!"

Glen sounded embarrassed. "I guess he doesn't want to talk to you."

A terrible anger rose in my throat like bile. I heard myself scream, "Tell him I want my damn picture back!"

With a sick stomach I heard Mike's raised voice, "I tore it up and threw it in the outhouse. Its buried in shit by now!"

I slammed down the receiver, staggered to a kitchen chair and sank onto it. The drowning sensation that was threatening to engulf me suddenly passed. Rage burst without warning. "Bastard!" I yelled. "He wouldn't even let me explain! Damn men! I hate them! I HATE them all!" My words brought a strange calmness within me. Returning to my room I crawled into bed and dozed off. It wasn't long before my nightmare unfolded again. Shivering naked in the hollow of a tree someone was yanking me by my hair. This time I felt a hand on my shoulder, too. I shrieked myself awake.

Ma was standing over me looking pale and anxious. "Are you... okay?"

With one foot still in my dream, I stared blankly up at her. I felt my voice raise anxiously, as though my mother were a stranger. "Wha... what do you WANT?!"

"I thought maybe you'd like something to eat. It's after six." Ma clenched her hands together in front of her and pressed them against her mouth, as if kissing them.

"NOTHING! I don't want a thing. Just leave me in peace!"

I saw the hurt in Ma's eyes, but didn't make an effort to comfort her. *Where's my comfort?* I thought. She turned and silently left the room. My disposition sank to swamp bottom level.

Weepy days and endless nights of bad dreams dragged on. I knew I was moving through the hours like some kind of zombie, every thought about the future on hold. Days passed by in a dismal fog. I lay on my mattress smoking and filling up ashtrays all day. I didn't have the strength to change anything or to get up or to scream or to act. I didn't want to go out. I hardly ate, began losing weight and feeling weak.

I didn't want to talk to Ma. I kept repeating, "I don't have anything to say." The few sentences I uttered had long pauses in them. I knew Ma didn't want to know what had happened. And then one morning I awoke thinking, *I am SICK of this!*

Though I was afraid to go back to school, unsure of how I was supposed to act, I went. There were only three weeks left before classes would be over. For that I was grateful. The week I was away had little effect on my grades. I'd stopped doing my homework long ago. I knew my C average would carry me through. I kept to myself, avoided old friends, didn't look anyone in the eyes. I was afraid they would realize there was something different about me. Everyday except Thursday, I went straight home from school. My dance activities seemed to buoy me up. It was a safe world, where I could always shine. And then on the third day of the second week back at school, another jolt to the shaky order of my life arose.

Mr. Gradin had just called roll in homeroom when all eyes focused on the opened door to our classroom. There stood Miss Lemon, the Dean of Girls. Smiling broadly she said, "Excuse the interruption. I'd like to speak to Frances Oliphant. In the hallway."

My mind froze. A calm inevitability that I was doomed to disaster descended. I carefully made my way out of the room. Miss Lemon's face was expressionless. She placed her hand on my arm. I shook it away. "What's the matter?" I asked.

"Don't be alarmed," she said. I detected apprehension in her voice, like she was afraid I was going to attack her or take off running. "We want to check you out." I breathed a bit easier, remembering Ma had reported that I'd had the flu. It made sense that they would want to be sure I was okay now. Still, a niggling question hovered in my mind. *Why would they send the Dean of Girls to get me?*

My question was clearly answered when we reached 304, the hospital room. There inside the door stood the Superior policewoman, together with one male patrol officer and the city nurse. Miss Stromlind immediately took charge. "We're here to examine you. We have a report that you've got a venereal disease."

I felt the color drain from my face, felt my knees shake. I momentarily leaned against Miss Lemon. She gently guided me to a chair. Sinking onto it, I heard my voice from far away. "Who told you that?"

Before anyone could answer, Miss Lemon spoke in a powerful voice. "I see no reason why this police officer has to be in the room."

Miss Stromlind nodded at the man. He turned and left. Her steeled-eyed gaze met mine. "We're not allowed to reveal any information on who's involved. It's confidential." She looked at the city nurse. "Get on with it," she said.

Miss Lemon pursed her lips. "I think maybe the nurse and I can handle this without your help," she said. "Why don't you wait outside?"

Miss Stromlind glowered and looked at the nurse. "Is that all right with you?"

The nurse was a heavy-set, plain faced woman whose graying hair was pulled back in a bun. She tugged at the hem of her dark-blue uniform jacket. "I'm sure we'll do fine." I detected sarcasm in her response.

Miss Stromlind stopped by the door. "I'll be just outside if you need me."

The Dean of Girls looked at me. "Have you ever had a vaginal exam, Frances?"

I cleared my throat, not sure I could speak. "No," I mumbled.

Miss Lemon's large, dark eyes momentarily reflected pity. She looked at the nurse, nodding her head back and forth as if reluctant to be a participant. "Would you explain the procedure, please?"

The nurse spoke in a no-nonsense tone of voice. "We're going to have you remove your panties and lay back up here," she said, pointing at a high, narrow table. She walked over to it, put her hand on the metal devices at the end of the table. "We call these stirrups," she said.

"You put your feet in them and lay back so we can examine you inside."

Miss Lemon nudged me forward. "It's pretty painless, if you relax," she said. "I'm sure the nurse doesn't expect you to take anything else off, or remove your shoes." She glanced at the nurse, who smiled. "Isn't that so?"

"No problem," the nurse responded. "I'll be as gentle as I can."

During their conversation I was overwhelmed with thoughts of drowning. I willed myself to float on the current. Mechanically, I removed my panties, slid back onto the high table and hoisted up my skirt. The nurse lay a cool sheet across my bare, lower half. She gently placed my left foot in a stirrup, then repeated the action with the right one.

"Relax and scoot down. I'm going to insert a device inside your vagina now." She raised the tool for me to see. It looked like an enormous flat-billed Platypus. "We call it a Speculum. It's made of steel, so it'll be a little cold at first."

I flinched as the icy contraption slid inside me. Closing my eyes I took myself away, focused on the thought that school would soon be out and I wouldn't have to come back to Central for three months. I heard the nurse again.

"Now I'm going to extract some tissue. Breathe deep and relax."

I took a quick breath, was sure I could feel movement high in the recesses of my body. I envisioned a long-handled scissors snipping off a piece of my heart. I opened my eyes. Miss Lemon stood alongside the table, her hand on my arm.

"That's all there is to it, Frances," she said. "I'll write out a pass to get you into your next class." She helped me off the table.

The nurse pulled back the sheets and dumped them in a bin near the door. "Before you put your panties back on, I'm going to give you a shot of penicillin. As a precaution." I didn't dare ask as a precaution against what. I lay on my stomach across the leather pad that covered the table. I felt a quick sting as she inserted the needle in my left hip, then just as quickly pulled it out. "That should do it," she said.

Miss Lemon added, "We won't speak of this to your mother unless the results are positive." I had no idea what in the world she was talking about and didn't care.

The nurse, through with her tasks, opened the door. Miss Stromlind briskly stomped into the room. "I'll be in touch, Frances," she said, sounding threatening.

Miss Lemon interceded. "I don't see why. This matter is in the hands of the Health Department now."

"The girl is out of control!" Miss Stromlind spouted.

"I'm sure that's something we can handle here," Miss Lemon said. "Right now I think we'll let Frances leave."

I plodded zombie-like down the steps from the third floor, heading for my locker on the first floor. All the while I felt a strange sensation in my left hip, like it was growing. Just off the second floor landing I rushed into the girl's bathroom there. Lifting my skirt I examined my hip. It was covered with a red rash and was swollen twice it's normal size. *Oh my God*, I thought. *I must be allergic to Penicillin. Maybe I'll die.* The thought brought a strange calm. It was as if dying was the logical conclusion to the direction my fragmented life was taking.

Just then the door opened. In walked Doris Raleigh. I dropped my skirt and leaned into the sink. Turning on the tap, I noisily splashed water over my face.

"Feef!" Doris shrieked. "You alright?"

I rose from the sink, pulled a paper towel from the dispenser on the wall. Dabbing at my face I looked Doris straight in the eye. "I had the flu. The nurse just checked me out. I'm okay. Now."

Doris's carefully tweezed eyebrows rose. "I didn't know we had a nurse here at Central."

"She's the city nurse. I guess they were afraid I'd spread my germs all over Superior." I forced a wry smile across my lips. The action made my face hurt.

Doris laughed. I could tell from the look in her pale eyes that she'd bought my story. "Say," she said, "I was sorry to hear you broke up with that dreamboat, Mike."

I was surprised at the strength in my voice. "Who the hell told you THAT!?"

Doris's face paled. " Geez, I didn't know it was a secret. Sorry." The iris's of her eyes expanded. "Curly said your boyfriend's dating his mother. They might get married."

I threw my hands across the low sink, leaned down as if to vomit and closed my eyes. *The bastard*! Still I felt compelled to ask the question I didn't want an answer to."Did Curly say how long they've been involved?"

"Since before Christmas," Doris said, "He must be some kind of

Hanging On

freak. Dating a woman old enough to be his mother." I knew it was her way of comforting me, but wished she would shut up.

I pushed myself away from the sink, thinking, *He's been stringing me along the whole time.* "Men are assholes! Always were, always will be!"

Doris hooted. "You are a riot, Feef! Hold up while I take a leak." Seconds later, exiting the toilet cubicle, she washed and dried her hands, then looped her arm in mine. We sauntered down the empty hallway back toward our classrooms. "So," she said, "What's on your agenda this summer. Hopping the hunks?"

I stiffened. "Actually," I said. "I'm going to summer school. At Duluth Central." I didn't tell her it was because I'd gotten an F in biology. Before she could comment I added, "What'll you be doing?"

"Hopefully I'll find a job. Gotta save up for college, you know." Her full uneven lips broke into a wide smile as she disengaged herself and moved away from me. "Hope we get to see each other once in a while." Halfway down the hall she turned. "Keep me posted on your love-life!"

Bitch, I thought, as I waved back. *You've got it made in the shade.*

Little did I know that my impending summer school venture would put me back on track, on a train to nowhere. ◆

A Liberal Education

Experience bought by pain, teaches. –Anonymous

To me the Twin Ports of Duluth, Minnesota and Superior, Wisconsin, were as different as night and day. Duluth oozed elegance. Superior I now saw as a dismal, soul-stifling town. And though I hated the thought of being in school for six weeks, I welcomed the change of scene.

Escaping from Ma was appealing as well. I was sure if I were in her presence daily, she would weasel information from me that I didn't want to share. I'd been lucky that she never learned of the vaginal exam. And though nothing came of it, I knew she would have been incensed enough to raise hell with everyone who had been a party to my disgrace. That would have broken the whole story open and left me more of an outcast than I already felt I was.

I'd been to Duluth many times with Ma over the years, but this time I would be strictly on my own. Still, I didn't expect a completely problem-free transition. I was sure, with my track record, some kind of disaster was waiting in the wings. The first promptly arose the weekend before my classes were due to begin. The Duluth/Superior bus drivers went on strike.

"I guess I won't be able to go, now," I told Ma, sounding hopeful.

I could see Ma bristle, knew that I wasn't going to get off the hook so easily. "I'm sure Lois Paul's dad will give you a ride. He drives to his office in Duluth every day."

And so it was that I found myself seated in Miss Nethercott's English Composition Class at Duluth Central High School[34] on a Monday in June. Sitting across from me was Marvel Waring. On hearing her glamorous name, I was swept away with awe-filled movie images of Betty Grable and Lana Turner all rolled into one. A well-developed blond, Marvel exuded personality and verve. There was a cool sophistication in her manner as well, especially toward our three male classmates, who all but drooled in her presence. I appreciated her detachment, as I had no desire to deal with the juvenile histrionics I'd

endured the last two years at Superior Central. To me all males were threats to my well being. Marvel's presence made my resolve to ignore them easier to carry out.

Our teacher, Miss Nethercott, was a formidable, tall and bony woman. Her short gray hair was carefully finger-waved from her high forehead to the nape of her spindly neck. Except for a dusting of powder, she wore no makeup. Her long sleeved, high-necked print dresses skirted her calves and were accompanied by no-nonsense oxford shoes. During our first class Miss Nethercott set down strict rules of, no gum-chewing, no talking unless called on, and no tardiness. In her high pitched, authoritative voice she stated, "All assignments WILL be handed in on time. No exceptions." I welcomed Miss Nethercott's unbending temperament, and set myself on a straight and narrow course to excellence.

During our first ten minute break, Marvel invited me to join her outside for a cigarette. Our three classroom compatriots shuffled along out of the building behind us. Marvel turned and in a stone-cold tone of voice said, "This is a strictly non-male meeting of the minds. You guys find somewhere else to hang out." They stopped in their tracks and, with flushed faces, ambled away.

I stifled an urge to laugh out loud. It was amazing to me that Marvel could put down guys without having to curse or threaten bodily harm. We two girls found a spot on a stone parapet just below the third level of steps that rose up from First Street. There we sat smoking and looking out on the fantastic vista of steep hills below us. The downtown buildings of Duluth were bathed in sunshine. In the distance, the waters of Lake Superior reflected the glowing sun. Light beams danced off the whitecaps of the endless inland lake. On the horizon I could just make out an ore boat moving slowly toward the Duluth entry. I breathed deep, exhaled a ring of cigarette smoke. "Geez, Duluth is SO beautiful. I wish I lived here."

Marvel, in her light breathy voice said, "It's a burg like any other small town. I'm going to New York City after high school."

Her words opened whole movie scenes in my mind's eye. I saw Marvel's star-studded life as a famous aviator, a world-renowned opera star, or a glamorous fashion model. "You'd make a fabulous model," I said. "They've got schools in New York City for that, I think. Or a stage actress."

"No can do," Marvel replied. "My boobs are too big." Her lilting

laughter filled me with joy. "Anyway, I'm going to be a writer."

I was totally amazed, had never heard of anyone contemplating becoming a writer. "Can you study for that?" I asked.

"Not really. I did sign up for this class with Neathercott for that reason, though. She's the best when it comes to creative writing. Actually, to be a writer you've got to LIVE. You've got to EXPERIENCE everything." Marvel's enormous brown eyes took on a faraway look. Pursing her ruby-red lips, she held her Pall Mall between her index finger and thumb, sucked a deep drag and exhaled like she was blowing out a candle.

Wow, I thought. *She's not only gorgeous, she's brilliant*! I felt my face heat as I hesitantly asked my next question, sure Marvel would think it was the dumbest one she'd ever heard. "You... don't... think a person can experience life here? I mean, in Duluth?"

Marvel sighed deeply, stretched her arms and extended her long shapely legs out in front of her, like she'd just gotten out of bed. "Of course," she said. "But after a while you get a bit jaded." I made a mental note to look up *jaded* in my Webster's pocket dictionary. Marvel continued, "Like the bars here," she said, "I used to hit all of them. Then I discovered Kytos. Kytos is a microcosm of life. You can find all kinds of characters there. It's like... like a gathering of Damon Runyon types."

Before I'd even added *microcosm* to my invisible dictionary check list, I blurted, "I LOVE Damon Runyon."

Marvel beamed. "I just KNEW you were a reader," she said. "You know, reading is the first step to becoming a writer." She turned and looked me straight in the eyes. Her porcelain white face seemed to glow in the sun like the statue of Venus that I'd seen in an art book at Superior Central. Studying my face Marvel added, "You kind of look like Bette Davis. I ADORED her in <u>All About Eve.</u>" *God*, I thought, *Marvel would be a perfect friend.*

The first week in class Miss Nethercott concentrated on Grammar. We spent endless hours studying sentence structure. Marvel was a whiz at dissecting the complicated aspects of that task. Just seeing Marvel standing at the blackboard, chalk held between her delicate long fingers with their bright red nails, filled me with pride. I was sure I'd be one lucky girl if I were ever able to claim her as my number one friend. She evoked complete devotion in me. Her graceful posture and cool, fawn-like beauty, in any other girl would have sparked waves of

unadulterated, green-eyed jealousy. Instead I could not believe my good luck at having found her. Better still, she was a fantastic mentor.

Every day during our cigarette break, Marvel helped me go over my notes, patiently pointing out my errors and explaining the ins and outs of the parts of speech and other necessary writing mechanics. Best of all, after school, we reconvened at a little coffee shop at Eleven Lake Avenue, just doors up from Superior Street, Duluth's main drag. That came about due to the fact I had two hours to kill before I had to meet Mr. Paul at his office[35] for my ride home.

The first time we descended the two steps inside the entrance, Marvel said, "You'll LOVE this cafe. It's SO European." The small expanse housed five wrought iron tables covered with red and white tablecloths. Each held red, pineapple shaped candleholders encased in criss crossed webbing. To me they looked more Hawaiian than European. Below the long windows, with their white lace curtains that fronted Lake Avenue, were two small, red vinyl booths. Checkered table cloths graced the tables there, as well. Marvel glided into the first booth. "This is my spot," she said. "Sometimes I come here to write. When it's too wild at home."

My ears immediately perked up. "Wild?" I asked. Then quickly blurted, "I'm sorry, I didn't mean to sound nosy."

"Don't worry about it," she said. "It's not a problem per se. My parents are very social..."

Just then an apron-clad elderly man appeared. "Marvel! How are you!?" He was short and fleshy with gray hair and a full, matching mustache. There was a deep scar on the left cheekbone of his dark, hawkish face. The sight of him filled my head with images of Hessian cavalrymen. In a booming deep voice he commanded, "Today you must eat!"

Marvel's wise dark eyes sparkled. "This is Max, my favorite innkeeper," she said. Then she nodded her head at me. "Max, meet my best friend, Fran. We're going to summer school up the hill together."

Max gave a little click of his heels and bowed. "Charmed, I'm sure," he said. I was just recovering from the joy of Marvel's intro-duction when he reached down, lifted my hand from the table and kissed it. I felt my face heat, felt a wave of panic rise inside me. I quickly pulled my hand from his grasp. "Ah no, my wee sparrow," he said in a fawning voice, "I meant no harm." He turned and kissed Marvel's extended hand then.

Marvel raised her shoulders in a little shrug. "European men always kiss women's hands," she said. "It doesn't mean a thing." She looked at Max, assuming a cool, sultry pose. It instantly occured to me that it was a tactic she used in dealing with males. "We want coffee. Nothing else, understand? The figure, you know." Marvel straightened her back and placed her hands on her full bosom.

Max beamed. "Yes, yes... I understand American women. Always worried about the body." He pursed his lips and retreated, uttering little tsk-tsks of disappointment.

Marvel leaned forward. I tried not to stare at her impressive cleavage, revealed beneath the white cotton blouse she wore. "What was I saying before we were rudely interrupted?" She laughed then, a deep, honest laugh, good-natured and sincere. "Oh yes. About my family." She lit a cigarette. I studied every detailed movement –the pursing of her lips, the flick of her wrist as she pulled the cigarette away and blew out the smoke. "They're extremely social. If they're not giving parties, they're at them."

"Wow," I said. "That sounds so... so... elegant."

"Some of them are," Marvel said. "But it gets to be a terrible pall in the end. Sometimes I just have to go off by myself. They don't mind."

"What do they do? I mean, for a living?" I felt heat rising on my face again, afraid I'd made a terrible social blunder.

"Dad's a lawyer, Mom's on all kinds of Boards. They're very liberal and pretty much let me do my own thing."

I immediately envied that aspect of Marvel's life, though I couldn't imagine how I'd ever manage on my own. "No sisters or brothers?"

"Nope. I like cats, though." She laughed again. "Not that we have any. Too much trouble. I spend most of my time alone or with my boyfriend Tony."

I felt a strange disappointment at the thought of Marvel having a steady, even though at one time it had been a prime objective of mine. No more. Not since the terrible evil I'd endured less than a month earlier. "How did you meet?" I asked, not caring what her answer would be.

"He was a bartender at one of my parent's parties. He works at Kytos." Marvel looked around, like she had misplaced something. "MAX!" she hollered. "Where's our coffee!?" She knit her perfectly arched eyebrows. "I detest inferior service."

From beyond the double doors to what I assumed was the kitchen, I heard Max boom, "I'm fixing a special pot for you. I'll be right

along." Seconds later he appeared with a silver tray and matching coffee pot. "This," he said, "is for my special customers. He took two delicate cups and saucers off the tray and set them in front of us. After he poured the coffee, he spooned whipped cream into our cups from a small container alongside the pot. "This is how we serve coffee in Vienna." Max stood back and bowed.

"Excellent!" Marvel said as Max retreated. She looked at me, her huge brown eyes glistening. "I just adore elegance," she drawled. "I don't mean ostentation, either. I mean refinement and taste. It transforms life into poetry. Don't you agree?"

I nodded my head, feeling slightly nervous using such dainty china. "I guess," I mumbled, fully aware that Marvel was putting on airs. I'd decided early in our friendship that her affectations were just another fascinating aspect of her personality. Meanwhile, I racked my brain for a new topic of conversation. My eyes wandered to the windows above us. I was fascinated by the fact we were just below ground level. Suddenly a question popped into my head. "Don't you have any problems getting into Kytos?"

"Never. I go when Tony's on duty." A secretive smile softened her full lips. "Or, I dress accordingly," she said. I could tell she had noted my quizzical look. "You know... like with spikes and lots of makeup. I'll take you there after summer school is out."

The thought of accompanying Marvel to Kytos buoyed my spirits. I welcomed every day of school, welcomed the homework and mostly, welcomed the joy of being in Marvel's presence. With her help, my essays improved. And though she always garnered A's for her work, I was more than satisfied with my B's.

Our daily break sessions and visits to the coffee shop expanded to jaunts up Superior Street, where we window shopped and daydreamed about the future. Marvel, on learning of my dance interests said, "Just imagine us —me a famous writer, you a famous ballerina. We'll live together in Greenwich Village. In New York. We'll have tons of adventures!" Her words made my head spin with possibilities. Still, a niggling doubt kept me from fully sharing Marvel's optimism. Especially when she brought up the subject of sex.

We were entrenched in a booth at Snyder's Drugstore[36] sucking on straws inserted in our root beer floats. Marvel was surrounded by the purchases she'd made at Glass Block.[37] I was still feeling dizzy from the fast paced shopping spree I'd accompanied her on. Much to my

amazement Marvel charged a complete outfit, including a white eyelet dress, lingerie, white high-heeled wedgies and matching purse. On questioning her on how in the world she could do that, she said, "I have my own account." She went on with killing casualness. "My folks want me to look good. And Tony loves me in white. Says it makes me look virginal." Her full-lipped smile temporarily calmed me. "So," she said, "What are we going to do to sex you up?"

I panicked. "I'll do fine," I said. "My Ma's got some nice dressy clothes." I was sure I sounded snappish.

Marvel pursed her lips. I felt cooled by her obvious disapproval. "I suppose it will do," she said.

Feeling slightly miffed I blurted, "Why do we have to look sexy?"

Marvel lit a cigarette, dragging on it as though she were sucking in oxygen. She turned her head and blew out the smoke. "Not necessarily sexy," she said. "Mature. Anyway, do you have a problem with sex? Surely you're not a virgin?"

I breathed deep, tried hard to control my voice. "NO! It's just... just that I'm choosy."

Marvel's full-throated laughter cleared the tension I'd felt building. "Of COURSE you are. I'm with you," she said. "As far as I'm concerned, I'd rather give it away than have someone take it, though."

Her statement filled me with momentary panic. I wondered if she could tell I'd been raped. I glanced at her face. The same far away look that always filled her large brown eyes when she spoke of becoming a writer, had returned. Feeling relieved, I asked, "Do they hit on the girls that hang out at Kytos a lot?"

Marvel laughed. "Actually," she said. "There aren't many females that even hang out there. You'll have the pick of the crop." She instantly added, "Three more days and we'll be able to check it out!"

I stifled the nervous tension that rose inside me. Torn between the fear of a sexual encounter and the anticipation of launching a thrilling new adventure, I hoped against hope that everything would work out.

The last day of summer school quickly dawned. In preparation for my trip to Kytos, I took special care with my appearance. I asked Ma to let me wear her two-pieced seersucker suit. I didn't dare ask for any dressier outfit. "We're having a little graduation party after class," I explained.

Ma promptly agreed and charitably offered up her best necklace, bracelet and earring set as the perfect accessories. I polished her white

pumps and scrubbed one of her matching leather clutch purses. In the purse I deposited all my make-up, unwilling to deal with any objections from Ma to what I was sure she'd insist was "painting yourself up like a floozy." I covered my face with a light dusting of powder and twisted my hair into a bun at the nape of my neck. Ma supplied me with a huge red-flower hair-comb and inserted it just above the bun. "You look so... mature," Ma said, eyes misting. *Great*, I thought, *That's exactly what I want.* I left for school feeling as if I was on cloud nine.

In class I was further buoyed by the astounding news that I'd earned an A for the course. Miss Nethercott added, "I am pleased as punch with Marvel and Frances. It's been a joy to see them evolve into such excellent writers. One has a firm grasp of the figurative language, essential for great writing. The other has keen insight. Her ability to stick to the point is remarkable, as well."

Though unsure of which of the two of us fit which description, I felt as if I were walking on air. I was stunned by the fact Miss Nethercott had placed me on the same level of excellence as Marvel. Outside class my friend hugged me and exclaimed, "I am SO proud of you!"

I felt myself stiffen in Marvel's embrace. I pulled away, quickly said, "Thanks to you."

Looking a bit giddy, Marvel looped her arm in mine as we walked. "Now," she said, "Let's get our makeup on. Then we'll go celebrate. At Kytos."

I felt a sudden unknown dread. "I... a... I'm not sure I should go. I can't drink. Mr. Paul will smell my breath when he takes me home."

Marvel halted and looked me full in the face. "Geez, Fran," she said. "Don't tell me you're pooping out. No one said you had to drink." Her face clouded like she was going to cry. "Friends don't let friends down," she added.

In spite of my nervous anxiety, I gave in, thinking, *What the hell's the difference? It'll be a change of scene.*

Our pilgrimage to Kytos Bar turned out to be more than just a change of scene. It was my introduction to the seamy side of Duluth's skid row. ◆

34 - Lake Avenue and 2nd Street, Duluth Central H.S.
35 - Minneapolis, St. Paul & Saulte Ste Marie RR, 602 W. Superior Street.
36 - Snyder's Drug Store Inc., 109 W. Superior Street.
37 - 118 -132 W. Superior Street; Duluth, The Glass Block.

Dead Ends

Every sweet has its sour; every evil its good.
–Emerson

I was never fearful when I strolled the lower end of Superior Street. On our frequent bus trips to Duluth ma always cautioned, "If you ever come over here alone, don't get off the bus before the Glass Block. It's too dangerous. Especially for women." I knew she thought Mr. Paul dropped me right in front of Duluth Central. I never told her anything different.

I strolled up Superior Street each morning from Mr. Paul's office to Lake Avenue on my way to class. At that hour the denizens of Duluth's skid row were already settled in bars or fast asleep in cheap lodgings. The area was dotted with many seedy establishments like The Lenox Hotel[8] and The Fifth Avenue[9] Hotel. Their customers were transient seamen and railroad workers.

By late afternoon, on my trek back through the area to meet Mr. Paul, things were a lot different. I steeled myself against the odors and sights, stared straight ahead and quickened my pace. Most of the riffraff had surfaced, like angleworms after a rain storm. Some were drunk, slogging along, mumbling to themselves. One or two slouched in doorways, or leaned against the dingy approach to the Greyhound Depot.[10] Others grasped wine jugs or held out their hands asking, "Got any change?"

With Marvel along, it was an entirely different jaunt. She bubbled with friendliness, called out names, smiled blithely like each derelict were a long-lost friend. After every encounter, she turned to me and said, "That's "Whitie, he used to be a boxer;" or, "There's Buzz across the street. He's mental." She stopped once to speak to a dirty, disheveled female, "How ya doing Flossie?"

The woman's cracked-lip smile filled her wrinkled face. "I get by," she said, cackling like a hen laying an egg. Marvel pulled a dollar bill from her purse, folded it and slipped it into Flossie's grimy hand. The woman bobbed her head up and down, exclaiming over and over, "You're a dear." After we left her Marvel said, "Flossie used to

264

be a stripper and a prostitute. Boy, has she got the stories!"

I was immediately compelled to ask, "Aren't you afraid of these people?"

Marvel laughed. "They've just had bad breaks. It could happen to any of us." Her kindness consoled me. It was yet another amazing aspect of my friend's personality. With a graceful toss of her head and in her best poetic drawl, Marvel went on, "Who knows what karma awaits us? Anyway, walking up and down the street talking to prostitutes is better than being one."

"Karma?" I asked. We were at the corner of Fourth Avenue West, waiting for the light to change.

Marvel looked at me, sunlight reflected in her eyes. "Fate... fortune... destiny. You know."

I blurted, "You mean the ups and downs of life?"

Marvel burst out, "Exactly! You are SO good at getting to the basics." We made our way toward the other side of the street.

An unkempt, long haired man was heading in the opposite direction. His short sleeved print shirt was stained, his rumpled trousers tied with a piece of rope.

"Stinky!" Marvel exclaimed smiling broadly, "I thought you were in St. Paul!"

The man stopped in the middle of the roadway. He had a drinker's veined face.

The smoke from the cigarette in one side of his mouth curled up, clouding his eyes. "It's a dead-end town," he said, wheezing as he spoke in a high-pitched tone of voice. "Couldn't take it."

Marvel squeezed his arm. "You're better off in Duluth. With your friends."

The driver of a chrome-finned, black Buick turning into the intersection, stuck his head out the window and hollered, "Move it you good-for-nothing wino!"

Stinky raised his middle finger at the man and moved on.

"Dumb fucker," Marvel said as we skipped up onto the curb. "Come on. Kytos is kitty-corner from the depot.[11] In the Fifth Avenue Hotel building. Let's go down this way." Nodding her head toward Michigan Street, we descended the sloping pavement and turned west.

I had never been below Superior Street. It felt as if we were entering a dark, dank tunnel. The tall buildings on the main drag cut off most of the light. Railroad tracks traversed the other side of Michigan Street,

from Garfield Avenue and beyond, in the west. Behind the Union Depot the tracks thickened and branched into a vast maze. It was the same to the east, past Lake Avenue.

A dingy, noisy area, it looked doubly menacing due to the unsightly back ends of the towering Superior Street buildings. Much of the brick and mortar on those buildings was chipped and unpainted. All had rusted fire escapes clinging against them, like giant praying mantises.

If Marvel hadn't grabbed my arm I would have walked right by Kytos. The nondescript entrance was level with the street. In the middle of the enormous planked door was a small, diamond-shaped window. Marvel peered through the sooty opening. "Good," she said. "Tony's working." She grasped the cast iron door handle and pulled hard. The door groaned open.

The putrid odor of stale beer and urine assaulted my nostrils the minute we stepped across the threshold. I followed behind Marvel into the dark recesses of the saloon. Western music blasted my eardrums. Hank Williams Sr.'s *Hey Good Lookin'* blared out of the huge jukebox at the end of the room. The music brought to mind my brother. Hank was Howard's favorite hillbilly singer. I instantly felt a pinprick of guilt at being in Kytos.

Before I could dwell on the thought, Marvel pulled a chair out from a square, wood table and waved at the one opposite. "Sit down, Fran," she ordered. Puzzled by the hard tone of Marvel's voice, I sank onto the chair. Peering into the smoke filled dive, uneasiness settled inside me.

Marvel turned side-saddle, crossed one long bare leg over the other and edged her skirt up to her knee. Her whole demeanor seemed to change, like she'd shed one skin and slid into another. I felt a chill, realizing how dazzling she looked. Pulling her Pall Malls from her handbag, Marvel gracefully held a cigarette between her slender fingers.

As if from nowhere, a dark and oily-haired man appeared. In one movement he flipped open a steel lighter and ignited the flame. The glow reflected in Marvel's shiny eyes. She leaned forward, clasped his hand between hers and lit up. Blowing out the smoke, she turned up her face. The man kissed her cheek and smiled. "This is Tony. My beloved," Marvel drawled. "Tony, this is Fran, my best friend. From school."

"Ah yes." Tony said. "I've heard SO much about you." The guy was gorgeous, there was no other word for it. His honey colored skin glistened with sweat.

I felt a catch in my throat as I smiled. "Nice to meet you." I was

sure my words sounded prudish. My eyes wavered as Tony's veiled, smoldering gaze met mine. I was sure I saw something flicker far back in those eyes.

Marvel ordered two Cokes. "It's much too early for anything stronger, darling," she said, extending the 'r' in darling. There was a saccharine edge to her voice that I'd never heard before. As Tony headed back to the long bar that spanned the entire length of the narrow room, liquid laughter bubbled from Marvel's lips. "Isn't he exquisite?" She sighed deeply, as if in the throes of rapture.

Though I fully agreed with Marvel, I felt a strange embarrassment that Tony's physical bearing had stirred something inside me that I'd thought was dead. "He's... a... he seems like a nice guy," I said.

On Tony's return with the Cokes, I took a second look at him. The tight black T-shirt and slacks that he had on under a long bar apron noticeably outlined his bulging muscles. I was immediately reminded of my lost love, Mike. Tony set the Cokes down and pulled up a chair. "It's not too busy right now." He drew Marvel into his arms. I felt my body stiffen as Tony's mouth moved over Marvel's in a fervent kiss.

I looked away. The three men sitting at the bar were hunched over their glasses of beer, staring into the dregs as if hypnotized. I glanced behind me. The two tables there were empty, as were the four tables situated between us and the jukebox. Rising slowly, I coughed. Marvel and Tony momentarily stopped their kissing match. "Ah... ah, where's the toilet?" Tony nodded toward the back of the room, then pulled Marvel onto his lap. He began moving his hand up her thigh. I sprinted away.

Inside the minuscule bathroom, I leaned over the small sink. The porcelain was cracked and a trail of rust had formed under the dripping hot water tap. Peering into the filthy, locker sized mirror above the sink, I automatically pulled my lipstick from my purse and slashed the fire engine red hue across my mouth. Leaning into the glass I realized the pancake makeup I'd applied in spatula thick strokes looked orange in the florescent light.

Geez, I thought, *you look like a slut*. I unraveled a long wad of toilet paper and wiped off as much of the makeup as I could, then fluffed loose powder from my compact over my face. Sinking onto the toilet seat I silently imagined the time ticking away. After what I estimated as fifteen minutes, I exited the washroom.

I noticed that a couple of the tables closest to the juke-box were

now occupied. Two sinister looking men were at one table clasping beer bottles in their hands. They were staring at a lone woman who sat at the opposite table. Her bearing was as subtle and sensuous as her mouth. Deep auburn hair shone bronze against her pale, elongated face. She smiled as I walked by and said, "How's it going?"

I nodded and smiled back. "So-so," I said. Approaching Marvel's table, I noted that she and Tony had their heads close together, whispering like conniving teenagers. I sank onto my chair. Tony jumped up and headed back to the bar. "Gotta make some money," he said, winking at Marvel. He cocked his head toward me. "Don't forget to ask her."

Marvel put up her hand as if to silence him, then turned and looked at me. She lowered her eyelids like she didn't want anyone to see inside her eyes. "So," Marvel said. "How do you like Kytos so far?"

"It's... okay," I said. "But, ahh... I think I should be going pretty soon. Mr. Paul is very punctual." I was afraid to make eye contact with Marvel, felt as if we had hit a snag in our friendship.

Marvel seemed oblivious to my frame of mind. She leaned close. "I was wondering, Fran. Do you know what *menáge á trois*, is?"

Disconcerted by the foreign sounding phrase I blurted, "Geez, Marvel. I don't know half the words you use. Most of the time I've got to look them up in the dictionary."

Marvel broke into husky laughter. "You are TOO much! Me and Tony were thinking we'd like to try it."

"Try what?" I asked. "I wish you'd stick to the point."

Marvel repeated the foreign phrase. "It's like, three people sharing sex."

I felt myself panic, thought, *OhmyGod! I don't even like to see ONE person naked, let alone THREE!* Desperately trying to control my voice, I said, "I don't THINK so, Marvel. That sounds weird."

My friend suddenly pushed angry words across to me. "Loosen up. I can't IMAGINE what your problem is. Unless you're a Lesbian! ARE you?"

The sickening sensation of my life plunging downward returned. I carefully enunciated my reply, "What... the... hell... is a lesbian?"

Marvel's beautiful porcelain face broke into a deep scowl. "It's two women having sex. You'd probably like it." Her face lightened as she put out her hand and touched mine. "I'm not adverse to the pleasures of Sappho." A sly, roguish look filled her dark eyes. "Do you know what Ausonius said about Sappho?"

I shook her hand off mine, "Shut up. You're making me crazy with all

those foreign words!" My outburst didn't do a bit of good.

Marvel launched the sonorous tone of voice she assumed when reciting poetry: "*She jerks, she sucks, she futters by every orifice, that she may not leave anything untried and so have lived in vain!*"

I heard myself shriek, "Geez! That is SO sick!" All at once I was aware that the jukebox was silent. The eyes of the other patrons focused on us.

Marvel smirked. "This is good," she said, sounding glib. "This is how stories are born."

I felt myself explode, "Oh for Pete's sake! Knock off the airs for once in your life." Instantly shocked by my outburst, I jumped up and ran from the tavern, trying hard to control the tears I felt welling inside me.

At the corner, waiting for the light to change, I heard someone yell, "Hold up!" I turned my head. The auburn haired woman who'd been sitting near the jukebox was loping down the street behind me. I noted that she looked younger than I'd first thought.

Gasping for breath, she asked, "Aren't you Frannie Oliphant?"

I peered into her face. She had high strong cheekbones and a bright look of eagerness mixed with boldness. "Do I know you?"

The point of her tongue slowly moistened her under lip. "You used to hang out with Tonya Westman. At Superior Central."

I racked my brain for a clue, found none.

"I'm Vernetta Kopelek. Vernie. I work at Cornwall. With your brother. I got laid off last week."

The mention of Howard softened my mood. "Do you live in Superior?"

"Naw. I'm shacking up with my boyfriend Bubba. In Duluth. My folks threw me out. I'd graduated this year, but fuck it, high school's the pits."

I looked at Vernie again. Dark circles underlined her close-set eyes. Still, there was something exotic about her. I guessed she was a Bohunk. Like Mike. Just then I heard the Duluth Central bell chimes strike four. "I've gotta run," I said. "My ride home's waiting."

Vernie edged closer. "Bubba'll give you a ride. He gets off in an hour."

I shook my head no and continued walking. "That's okay. Mr. Paul's probably waiting right now."

Vernie's broad forehead creased. "Too bad," she said. "Those guys sitting across from me got lotsa money. They're Canadian seamen and love to party. They'd probably pay for a few good laughs."

Geez, I thought, a*nother sex freak*! "I don't go for that weird threesome stuff." I quickened my pace as we neared the side entrance to the Fifth Avenue Hotel.

Vernie puckered her lips in a tight rosette and whistled. "Geez... don't tell me. Marvel tried to get you in bed with her and Tony. She tries that with everyone."

I stopped in my tracks. "Just leave me alone," I said. "I'm not interested in ANY guys right now."

Vernie hunched her shoulders. They seemed too broad for her long-waisted body. "I can wait," she said. "I'll catch you some other time." With that she strolled back toward Kytos. There was a stalking, purposeful intent in her long-legged gait. It was a seductive stride with enough hip sway to pull her full skirt in alternate directions. I noted her perfectly shaped calves and slim ankles, felt an instant sting of envy.

I rushed up to Superior Street, felt energized by the bustling throngs of people and moving traffic. It seemed like a brighter, safer world than the one I had just escaped.

Sprinting to Mr. Paul's office, a wave of relief overcame me at the realization I was heading home at long last. I forced all thoughts of Marvel and Tony and Vernie and Kytos, out of my head. ◆

38 - Lenox Hotel, 601 W. Superior Street.
39 - Fifth Avenue Hotel, 502-506 W. Superior Street & 9 S. 5th Avenue West.

Sidetracked

Bear ye one another's burdens. –Bible

My summer school class had consumed half my vacation. Compared to what went before, the remaining free days seemed destined to dullness. Ma and I were on good terms. She was sure I was settling down. I seldom ventured out at night, never neglected to tell her where I was going.

I spent hours in my hideaway reading. The days and nights were long and unspeakably lonely. Often I daydreamed about my earlier escapades and, in a perverse way, missed them. A hidden world was emerging inside me where I absorbed the things I'd heard and seen.

I saw my life as a journey without rhyme or reason and with many changes of direction. That discovery left an uneasiness that I couldn't define. *Maybe I was doomed to disaster. Maybe nothing will ever turn out right. Maybe I don't deserve better.* Still I harbored hope, clinging to Ma's favorite phrase, "Things always work out in the end." Then, all of a sudden, I got sidetracked. Vernie Kopelek re-entered my life.

It was noon on a Saturday in August. I was in the kitchen. The coffee was ready in anticipation of Ma's return home for lunch from her dog-sitting job at Wagnell's. She was right on time, instantly lowered herself to a kitchen chair and put the long, white-papered package she was carrying on the table in front of her. "I bought some wine bread at Lange's Bakery."[42] It was my favorite dessert.

I leaned over and hugged Ma. "Let's not eat all of it this time," I laughed. "Howie and Day'll have a fit if we do." My brother had gone over to Cornwall[43] to collect his paycheck. My sister was downtown shopping.

Just then the back door flew open. In walked Howie. Right behind him was Vernie Kopelek. My brother's face beamed, his lop-sided grin filling his boyish face. "I ran into a friend of yours at Cornwall," he said, sounding as if he'd found a chest of diamonds. "She sands the TV cabinets that I put together."

Vernie sauntered in behind him. "Hi!" she said, smiling. "I got called back to work. Just picked up my first check for the week." A

271

vision of Jane Russell in The Outlaw, instantly popped into my head. Like that busty Hollywood sexpot, Vernie had dark hair and a sensuous mouth. Her hair was covered with a red bandanna. A fallen ringlet threw her forehead in shadow.

Vernie's camellia-like complexion was highlighted by the thread of her scarlet lips. Her long sleeved, white shirt was tied at the waist, the sleeves rolled up to her elbows. The tight, red pedal pushers she wore emphasized her long, lithe body. Fire engine red toenails peeked out of her open-toed sandals. I felt a pang of envy as I noted her slim ankles and shapely calves. I looked at Ma, sensed her disapproval.

Though alarmed, I knew my mother would, if nothing else, be polite. I hurriedly introduced my flashy friend, "Ma, this is Vernie Kopelek. I met her in Duluth."

Ma looked confused. "Ah... happy to meet you," she said. Then, as if recovering her senses, "She isn't the writer you told me about, is she?"

I felt a stab of disgust at Ma's reaction, remembering the way she judged people by outer appearance. It was a trait that seemed at odds with her kind nature.

Before I could respond, Vernie chimed in, "No way! You must be thinking of Marvel. The weirdo." Vernie's hard solid laugh pierced the silence that had descended.

Endless sounds filled my head...voices, murmurs, whispers. I shook them away, attempted to cover my tracks. "I met Vernie at the coffee shop where Marvel and I hung out after school." Scowling at my new-found friend I nodded my head in warning.

In a flash Vernie picked up on my lie. "Oh yah... I love my coffee." She ambled to the kitchen table, pulled out a chair and sat down. Ma quickly went to the sink, washed out a cup and poured her some coffee. Vernie continued, "Anyway, it's a pleasure meeting you, Mrs. Oliphant. I've heard SO much about you." I couldn't help but admire my friend's artfulness. In spite of the fact I'd never mentioned my mother, here was Vernie fawning her way into Ma's life. Still, it would take a lot more than charm to win my mother over.

Ma's soulful eyes gleamed with curiosity. "Are you from Superior?" she asked.

Vernie crossed her shapely legs, pulled a pack of cigarettes from her peddle pusher pocket and lit up. All the while I was sure I could see the wheels behind her close set, dark eyes turning. "I used to live here." She pulled smoke up through her nostrils. "Now I live in Duluth."

I thought, *Oh God, Ma's not going to let that pass.*

Sure enough, before I could intercede, Ma launched her cross-examination. "Where in Superior?" she asked.

Vernie smiled broadly. I suspected she was using the same tactics she used to charm men. I doubted if they'd work with Ma. "My folks live on Elm. Near the Gas Works Plant.[44] Where all the Polacks live."

Ma pressed on. "Are your parents from Poland?"

I was tempted to shout, "What the hell does THAT have to do with anything," but restrained myself. I knew Ma's line of thinking. She prided herself on her open-mindedness, yet at times her sympathies seemed limited when it came to ethnic groups and religion. It was one of the confusing aspects of Ma's personality that I'd been mulling over in my room lately. Though she always insisted we be kind to everyone, at times her words seemed hypocritical. Sometimes she criticized people with comments like, "They're not Lutherans," or, "Those people are noted for their ignorance." Vernie was fortunate. Ma had a special affinity for any immigrant experience, having gone through that upheaval herself.

Vernie pressed on oblivious to Ma's ill will, "My folks are Czechs. My old man left Czechoslovakia before the war. He sent for the old lady after he'd been here a while." I felt a sudden admiration for her candor.

Vernie's words brought a far-away look to Ma's soulful eyes. "You know," she said, "Young people today have NO idea how difficult it was for their parents." She sighed heavily. "To leave the country of your birth and travel thousands of miles to a strange land. THAT'S tragic."

Vernie's deep-throated chuckle filled the room. "Yah," she said. "Everyone came over on different ships, but we're all in the same boat."

Howard, who had been hovering behind Vernie, hooted. "That's a good one," he said, dispelling the tension I'd felt rising around us.

Ma unwrapped the winebread. "Howie, get a knife and some dessert plates." It was her way of disciplining my brother for his brashness. Her efforts were wasted on him. Anxious no doubt to make a good impression on Vernie he rushed to the pantry, returning with the plates and knife. "You forgot the napkins." Ma said. "They're in the sideboard drawer. In the dining room." Just as he headed toward the door my sister appeared. Howard stuck his tongue out at her as he squeezed past to complete his chore.

Day looked disheveled and overheated. "Sure!" she spouted. "You guys always have treats when I'M not here!" Noticing Vernie sitting between me and Ma, her face flushed. "I know you," she blurted. "You hang around with that creepy Bubba."

Howard shoved back past our sister and hissed, "Shut up, lard ass." He took the last chair around the kitchen table next to Vernie.

Looking cool and relaxed Vernie said, "So Maizie. Do you still hang around with that creepy Sondra Brunette?"

Howard hooted again. "I guess she fixed you," he said. "That's what you get for opening your big mouth."

Day glowered at him. "I'm going outside seeing as how this is a private party." She stomped away from us.

Ma jumped up and hurried out of the kitchen behind Day.

"Good," Howard said. "Now there'll be more wine bread for us."

Vernie leaned toward me. "Do you think your Ma will let you help me get some of my stuff out of my folk's house? They don't know about Bubba, so he can't do it."

I really didn't want to go with Vernie, was afraid of the temptations. Still, I felt sure a battle would break out if she stayed in our house much longer. "I don't have any money." My voice sounded pitiful.

"No problem," Vernie said. "I got paid today."

I left the room to go look for Ma. She and Day were sitting on the front porch, deep in conversation. "I'm going downtown with Vernie," I said. "I'll be back early."

I could tell Ma wasn't happy with the turn of events, but was relieved that Vernie was leaving. "Call me and let me know where you are," she said.

Vernie and I headed to Sixtieth and Tower. Her long-legged trot made it difficult for me to keep up. "Take it easy," I hollered. "The bus won't be coming for a while."

My friend laughed. "We're not taking no damn bus. I'll have Bubba pick us up." With that Vernie sprinted into Sather's Grocery. A minute later she exited. "I called Bubba. He's going to meet us at that little park on Fifty-eighth Street."

When he pulled up in his car twenty minutes later, I got a glimpse of Vernie's boyfriend. It was enough for me to wonder what she saw in him. He was a wiry little twerp with a pock-marked face that looked like a wedge of Swiss cheese. When Vernie introduced me, he grunted and immediately looked away. I wondered at his grim, distant per-

sonality. Not wanting to pass judgment on him like Ma would have done, I forced my distaste away. Maybe he was a man Vernie could mother and boss around. I noted that she immediately gave him orders as we settled on the front seat and we headed downtown. "When you get to the place, park at the corner. Me and Fran'll grab the stuff while you wait in the car."

Bubba grunted, "Okay. I'll keep the motor running."

An alarm bell went off in my head. *Maybe we aren't going to Vernie's house at all. Maybe we're going to rob a bank.* My panic diminished as we barreled up Tower Avenue and turned east onto Belknap Street. At the intersection of Elm, Bubba turned the car north. Row on row of identical neat houses stretched along both sides of the route. I marveled that anyone could find their own house. The car slowed, like we were sightseeing. Four blocks down Bubba pulled over to the curb.

Vernie nudged me. "Get out." She turned to Bubba. "We'll be back in a jiffy." With that she bounded out behind me. "Let's get this over with." We walked one block further, then turned into a cottage that looked exactly like all the others we'd passed. There was a hemp doormat on the front stoop. Vernie bent down, lifted the mat, picked up a key and unlocked the door. She handed the key to me. "Put it back," she said. I dutifully followed her order.

The front door opened into a small, sparkling clean living room. I was surprised to see what a nice place Vernie had been reared in. Compared to our house it was a temple of elegance. A mohair, three-cushioned sofa was perfectly spaced below the front picture window. Its dark, wine hue matched the huge flowers in the pleated chintz drapes. Sunlight reflected off a heavy oak coffee table in front of the sofa. There were two lounge chairs opposite, on either side of the arched doorway that led to the dining room beyond. The matching oak table, sideboard and china closet there looked gigantic.

A statue of the Virgin Mary graced the sideboard. Her cupped hands held a votive candle that glowed red in its holder. On the wall above was a small replica of Jesus nailed to the cross. I looked away, noted that everything in both rooms gleamed. The heavy odor of furniture polish filled my nostrils. I was sure there wasn't a fleck of dust anywhere. "Your Ma sure keeps this place spotless," I said.

Vernie put her finger to her lips and whispered, "The damn woman's paranoid. She spends her whole life cleaning." With that my friend crept towards the back of the house. I started to follow her. "You

stay here. If the old lady comes, don't worry. She barely speaks English." She nodded toward the sofa. "Sit down. I'll be right back."

I cautiously sank onto the edge of the sofa. The house was silent. I felt myself shiver. Seconds passed and then I heard a key turn in the front door lock. *OhmyGod*, I thought, *now what?* I jumped to my feet.

A tall, slightly bent woman stood leaning back against the door. Seeing me she let out a blood-curdling scream, like she'd seen a ghost. Her face was devoid of color, her small eyes flashed. Foreign words spewed from her small mouth. I wondered what language she was speaking, knew for sure it wasn't Norwegian. I stood up, was about to speak, when the bag of groceries in her arms crashed to the floor. The woman kept crossing herself. Rushing forward, I began picking up the canned goods and vegetables that lay strewn across the carpet. The woman shrieked, "VERNETTA!?"

Vernie sauntered into the room carrying two battered suitcases. "Oh shit," she said, "It's the old lady," then yelled something foreign. The woman shrieked back harsh, indiscernible words. Vernie burst into raucous laughter. "My ma says you look like the devil."

Bristling, I spouted, "I do NOT!"

Vernie pursed her lips, "Don't worry about it. She thinks all my friends are devils." She put down the suitcases and walked over to her mother, pushed her away from the door and pulled it open. Her mother slammed the door shut. Vernie's face turned crimson with rage. "Get the fuck AWAY, you bitch!" I couldn't believe my ears, never heard anyone speak to their mother like that. The two women began grappling each other, like they were in mortal combat. "Get the bags!" Vernie hollered. She yanked open the door again and wedged her foot in front of it.

I tried picking up the suitcases, but they were too heavy to manage. Pulling on the handles, I dragged them forward and shoved past Vernie. All the while her mother was yelling, "War! War! War!" I felt a pang of compassion, thinking she'd lost her senses. Maybe this trauma had sparked memories of wartime in Czechoslovakia.

By the time I got to the curb in front of the house, I was sweating with exertion. I knew I'd never make it to the corner. I stood out in the street and waved Bubba forward, The car screeched to a halt in front of me. "Help me with these damn suitcases," I hollered.

Bubba tumbled out of the driver's seat and came around the car. He was a whole head shorter than me and worse, smelled of sweat. As

he threw the bags in the back I pulled open the passenger door. Turning I yelled, "VERNIE! Hurry up!"

She came tearing out of the house. The sleeve of her blouse was torn, her bandanna missing. "Christ!" she said. "That old bitch is tougher than I thought."

Vernie's mother appeared on the doorstep. "War! War!" she shrieked, shaking her fist. We all lurched into the car. In a flash we were on our way.

Feeling relieved at having escaped without a scratch, I asked the question that hovered on my lips, "How come she kept hollering war? Was your Ma in a concentration camp or something?"

Vernie and Bubba burst into explosive laughter. "It's her God-damn accent, you idiot," Vernie said. "She was yelling whore."

My friend's sharp words brought an uneasiness inside me. I felt panic set in. As the car headed west I suddenly remembered that they lived in Duluth. More than anything else, I wanted to go home. "Drop me downtown." My voice sounding shaky. "I can't go to Duluth without calling my Ma."

I detected an edge to Vernie's voice. "We're not going to Duluth. We're going to Bubba's sister's. She's letting us stay at her place for a while." Vernie lit a cigarette, handed the pack to me. I pulled one out and lit it with the match she offered. Her hand was shaking. "Bubba'll give you a ride home," she said

"NO WAY!" her boyfriend snarled. "I'll get Sorry to take her home."

I wasn't sure I'd heard right. "Sorry? Is that someone's name?"

Vernie chuckled. "It's Bubba's brother-in-law. His name is Harvey, but everyone calls him Sorry.

The thought of getting in a car with a stranger alarmed me. "I probably should take the bus," I said.

Vernie spouted, "Don't get your ass in an uproar. Sorry's harm-less. You'll see."

I already had seen more than I'd wanted to, wondered what in the world was in store for us at Bubba's sister's house ◆

42 - Lange's Bakery and Cafe, 5807 Tower Avenue.
43 - A TV cabinet making factory, junction of the Great Northern & Northern Pacific and North 62nd St.
44 - 11 E. 2nd Street, Gas Plant Works.

Indefinable Desire

Desire hath no rest. —R. Burton

Iknew little of the residential pockets that surrounded Superior's Tower Avenue business district. That part of town always struck me as exciting and affluent. Vernie's parent's home confirmed my suspicion that all downtown residents were better off than we lowly South Superiorites. I was amazed that, though the houses along Butler Avenue between Eighteenth and Nineteenth Streets were larger, they were seedier than the ones on Elm. Two story edifices, most were wood-framed and in need of a paint job. Still, they looked a cut above the dilapidated duplex I lived in.

There were several half-clothed young children playing in the street. Water gushed from an open fire hydrant. The front yards of the weathered houses were filled with numerous broken toys and bicycles. Patches of property in front of each house were devoid of grass, worn down to hard clay, just like ours in South End.

Bubba parked the car behind one of the houses. I could see the Billings Park viaduct two blocks south. An open field behind the building fronted the railroad tracks. It occurred to me that this was the neighborhood where my sister's girlfriends, Sondra Brunette and Nellie Jano lived. I hoped they wouldn't see me and blab to Day.

Vernie poked me in the ribs, "Out," she said. "We'll drop my stuff off, then we're going to Kytos."

I nervously exited the car and waited for her. All the while I searched my mind for an excuse to escape. "I can't go tonight," I said. "I gotta baby-sit."

Vernie's harsh laugh burst out. "Who invited you?"

I suspected the sudden change in my friend's disposition had something to do with Bubba's family. I vowed to watch for other changes. *Hells bells*, I thought, *it's not like we're bosom buddies!*

Bubba and Vernie headed through the back door into the house. He carried both her suitcases. As soon as I stepped over the threshold behind them, I felt a blast of hot air. Bubba hollered, "Jesus Christ! She's at it again. Baking bread on the hottest day of the year!"

Before my eyes adjusted from the bright sunlight outside I heard a high-pitched voice, "Shut up! It's my house and I'll do what the hell I want!"

Ah Geez, I thought, *Another bunch of screaming fruit cakes*. I heard someone else's shrill voice from the side of the room. "You shut up! I already got one headache."

I looked around. The kitchen was remarkably spacious. A round table with eight chairs commanded the middle of the room. A gas range and refrigerator were side-by-side, opposite the door. The west wall was filled with cabinets and an enclosed sink. A rocker in front of the sink was occupied by an older woman. To the east, an arched entryway lead out of the kitchen.

Another, younger woman, was standing near the stove. Wisps of her untamed dark hair clung to her round face like ringlets on a Kewpie doll. There was a film of sweat on her red face. She wore a sleeveless cotton shift, unbuttoned to her bosom. Pendulous breasts hung free beneath the faded, flimsy cloth. Bare-legged, her feet were encased in pink mules. "Take those damn suitcases upstairs," she snapped. Bubba pushed past her into the other room.

The woman in the rocker had shoulder-length black hair that was parted in the middle. The roots were chalk-white. She looked as bad tempered as Bubba. A cigarette dangled from the side of her mouth. The smoke curled around her flaccid neck. In her hand she held a glass of dark liquid. Wire-rimmed glasses magnified her pale eyes. She hollered at Bubba's back, "And don't think you're getting MY room! You guys take the attic."

Vernie pulled out a kitchen chair, sat down and lit a cigarette. She nodded her head toward the women at the sink. "This is Bubba's sister, Myra. That's his ma, Sophie, in the rocker."

I smiled at them feeling as if my face would crack. "Nice to meet you," I said. Neither of them responded.

Myra moved to the table and sat opposite Vernie. I cautiously sank into the chair next to my friend. Myra took a cigarette from Vernie's pack on the table and lit up. "So. How long will you two be staying?" Her voice sounded harsh.

I looked at Vernie. A red circle began forming on her high cheekbones. I was flabbergasted to realize she was actually embarrassed. In a soft, low voice she said, "Just a week or so."

"Good," Myra answered She leaned back in her chair, waved her

hand in front of her face. "It's a pain in the ass trying to juggle this family around." Her bead-like eyes seemed to refocus as she looked at me. "So, who are you?"

I felt my face flush. "Fran. I just came along to help Vernie get her stuff from her ma's."

Myra's laugh was more like a whinny. "Thank God for that. I don't have room for any more freeloaders. Do you want something to drink?"

I shook my head, mumbled, "No thanks." I was beginning to feel miffed that Vernie wasn't adding anything to the conversation. Deciding to do my part, I asked, "How many kids have you got?"

Myra's full face softened. "Three boys. They're outside playing."

Sophie piped up from the sidelines. "Three devils. Spoiled rotten." I looked at Myra's mother. She wasn't like any grandmother I'd ever seen. Her withered face was covered with a thick layer of pancake makeup. Her rose-colored lipstick was crooked, making her lips look deformed. There was a trace of a mustache above her mouth. She wore shorts and a sleeveless, peasant blouse. Her legs were long, the thighs flabby and filled with dark bruises. Bare feet were crossed over each other, revealing filthy-dirty soles. Suddenly a smile filled her face. Her teeth were misshapen and yellow. "You gotta a boyfriend?" she asked. I nodded no. She looked at Myra. "Why don't you fix her up with your brother-in-law. It's about time the idiot got lucky. He's too moody for his own good."

Heat rose up my neck. Before I could answer, Myra snapped. "Just shut up else I'll put you back on the street where you belong."

The old woman struggled to her feet. She wasn't as tall as I'd first thought, due to her hunched back. Her upper arms were as flabby as her thighs. I felt repulsed at the sight of the patch of hair under her arm as she raised it and slapped Myra across the back of her head. "Show some respect," she snapped. Moving to the refrigerator, she added ice to the glass in her hand. "Where'd you hide the booze?"

Myra picked up Vernie's pack of cigarettes and threw them at her mother. The pack bounced off the woman's shoulder. "You drank it all. You want more, you gotta buy it yourself!"

All the while I was edging off my chair, sure a battle royal was about to explode. I wanted to be ready to run.

Just then the back door banged open and the fattest man I'd ever seen waddled in. He was even fatter than Aunt Etta. His short sleeved nylon shirt clung to his barrel chest, revealing dark nipples and a patch

of hair. Surprisingly, his oval face looked silky and delicate. The most striking feature were his large, timid eyes. Smoky-blue, they were rimmed with thick, sooty lashes. His glance filled me with an indefinable burst of desire. I looked away just as Myra's mother spouted, "Sorry! Do me a favor. Go pick up a bottle of bourbon. I'll pay you later."

Myra shrieked, "Don't you dare! You'll never see the money."

Without a word Sorry squeezed past Myra's mother and went into the other room.

She frowned at her daughter, then looked at me. "Don't EVER have kids," she said. "They grow up and shit on you." She walked back to her rocker and sank into it.

Myra rolled her eyes. "Listen to her. Like SHE'S the innocent one." She got up and went to the stove. She extracted a perfect loaf of bread from the oven with two pot holders and dumped it on a wire rack in the middle of the table.

Vernie spoke up. "Geez that bread smells good. You sure are a great baker."

Myra humphed. "No credit to HER," she said nodding her head toward her mother. "She never was around long enough to teach me a thing."

Myra's mother began rocking faster in her chair. Her scowling face took on the appearance of a collapsed Halloween pumpkin. "Just SHUT UP you thankless bitch," she yelled.

In a flash Myra grabbed the loaf of bread and threw it with all her might. It missed her mother and hit the side of the sink beyond. Vernie's face turned white. I looked down at the table, took a deep breath. Rising, I carefully moved toward the other room. Mother and daughter were screaming obscenities at each other at the top of their lungs. I picked up speed, barely saw Sorry spread out on a low-slung sofa as I hurried through to the front door.

"Where you going?" he asked. His voice was deep and incredibly melodic.

"I gotta catch the bus," I said. "My ma will be pissed if I don't get home soon."

Sorry grunted to his feet. "I'll get the car."

"You don't have to do that," I said. "I live all the way out in South End."

"I want to," he replied. "I'll bring the car round to the front."

I felt a wave of pleasure, wasn't sure if it was from Sorry's offer or relief at getting away. "Okay," I said. The weakness of my response surprised me. Myra and her mother were still screeching in the background. All of a sudden I heard the sound of breaking glass. Sure the battle would spread, I bolted out the front door. As I stood waiting for Sorry at the corner, I thought of how quiet my family was in comparison to Myra's and Vernie's. We sure weren't perfect, but, I concluded, we weren't half as bad as I'd imagined.

When Sorry pulled up I gasped in pleasure at the sight of his immense, finned convertible. The top was down, white vinyl seats gleamed in the sunshine. I slid onto the passenger seat, pulled the door shut and glanced at Sorry. His sultry good looks seemed enhanced by the bright sunlight. I noted his slick black hair, his neatly trimmed sideburns. And though the flab on his thick neck was still there, it didn't seem as repulsive as I'd first thought. I felt like a small girl in the presence of her over-sized dad. A tranquil bliss rose in me.

Sorry smiled with warm spontaneity. "You had lunch?" he asked.

I barely heard his words, was envisioning his lips on mine. I'd noted their fullness, imagined they'd be soft and moist. "Ah... lunch? No... I guess not." I couldn't remember, what with all the excitement.

"Let's take a spin out to the Park. They got good hot-dogs at the pavilion there."

Billings Park was bustling with picnickers. The wide lawn that stretched out in front of the pavilion was over-run with screaming children. All the picnic tables were filled. Women were spreading table clothes, emptying picnic baskets, waving away flies. A few men stood over the stone grills that dotted the area, hot dogs and hamburgers roasted on them. Smoke billowed up from them. The aroma of cooking meat filled my nostrils and brought a pang of hunger.

Sorry pulled over to the curb alongside the pavilion. "You want beer or pop?" he asked.

"Pop will be fine, orange, if they've got it." I purposely looked away, not wanting to see Sorry's waddling stride, not wanting to dispel the new image I'd formed of him in my mind as a muscle-bound Adonis.

Moments later we were settled at a picnic table on the first point overlooking St. Louis Bay. A slight breeze had come up, cooling the air. The sun was making it's slow descent opposite us. Sorry had already eaten five hot-dogs. I'd had two.

"Should I go get a couple more?" he asked, sounding hopeful. He took a swig of beer from the bottle in his hand. "I didn't have breakfast."

"Not for me," I said, forcing the sweetest smile I could summon. "But you go ahead and eat as much as you want."

While he plodded back to the pavilion I thought about all the other times I'd been in the park. I remembered Frankie Hoolihan and our coupling just down the hill from where I sat, remembered our frightful adventure near Girl Scout point. Visions of the night Madeline, Ella and I'd been picked up by the police with Madeline's Duluth friends, played across my mind. I could see Madeline walking toward me in the parking lot from the very spot where I was sitting. I wondered if those days were over for me, wondered if I'd ever find a guy who'd stick by me. My mind settled on Sorry.

Could he be the one? I remembered Harold, the cadet, remembered what a creep I'd thought he was, then how sweet he'd turned out to be. I felt my eyes fill, wiped at them with the back of my hand. I could see Sorry coming across the grass toward me. *What the hell*, I thought, a*t least he's easy-going and harmless.*

Sorry and I moved to a bench overlooking the Bay. There, as he sat eating three more hot-dogs, I smoked and watched the sun sink lower on the horizon. Shafts of orange light cast willowy shadows on the lapping waters below. An incredible calm settled inside me. I convinced myself that Sorry would be the perfect boyfriend. "You sure are a sweet guy, compared to your relatives," I said.

Sorry's words, muffled by the food he was chewing, were barely audible. "They're not MY relatives," he said. "Myra's married to my brother. He runs a hamburger joint."

I racked my brain trying to think who his brother could be. It finally dawned on me. "Oh! You mean Buzz? He's a sweetheart. Just like you."

Sorry didn't seem to hear me. "Myra's good hearted, but her relatives are a bunch of assholes."

I was surprised to hear Sorry swear. For some reason I'd thought he'd be too shy. Maybe I'd been mistaken about his nature. I'd learned the hard way about people. They change like Marvel and Vernie. Even the love of my life, Mike Janicovich, had changed overnight after my rape.

Sorry continued. "Myra's mother is a whore."

The word bounced off my head like an errant rubber ball. It occurred to me that Vernie's mother had repeated the same word over

and over. Hearing it now grated my nerves. "Don't call people names," I snapped. "That's not very nice."

Sorry laughed. It was a deep, pleasant sound that echoed across the water. "I'm not calling her names. She IS a whore. That's what she does."

I shook my head in disbelief. "You mean... like... she sells herself?"

"Yah. She's been a prostitute for years. She says she's retired, but no one believes her. She still disappears for weeks at a time. Myra takes her in whenever she comes crawling back."

I couldn't believe my ears. I'd never heard of a grandmother having sex. "Maybe she can't help it," I said. I was thinking of my own wayward days, thinking how I'd sometimes felt obsessed with sex. Like when I'd been with Mike. All of a sudden a terrible thought occured to me, *Geez, I hope I don't end up being a whore!*

I heard Sorry's voice from far away. "We'd better go. It's getting dark."

Back at the car I sat silently as Sorry pulled up the convertible top and secured it.

"We'll take the Drive out to South End," he said. I hardly heard him.

Halfway along the road, Sorry pulled the car into an opening alongside the route. After he shut off the car engine he leaned over to kiss me. I barely responded. "You okay?" he asked. "We don't have to do anything if you don't want to."

"I'm sorry, Sorry," I said, stifling a giggle.. "I was thinking too much." I turned my face to him. "You can kiss me anytime you want." His lips were as smooth and damp as I'd imagined. When he moved toward me I relaxed and let him feel my breasts. His movements were awkward and hesitant. Still, they elicited a spark of desire inside me that I had thought was dead. All the while Sorry panted like an overheated polar bear.

"Oh... Frances," he said. "You wanna do it?"

"Sure," I said. "Why not?"

We moved to the back seat. Sorry's love making was less than thrilling but, gratefully, was over in seconds. After we'd finished and were heading east on Highway 105 to my house, he said, "I really like you. A lot. Would you go out with me again? Say in about a week?"

I felt a catch in my throat, like a rock had lodged there. Swallowing hard, I said, "I'll... have to... think about it." I felt puzzled at how garbled my words sounded. I knew my mouth was moving, but the words seemed to be coming from somewhere else, as if manipu-

lated by a ventriloquist. Wrestling away the sensation, I went on, "I'm not as nice as you think." A kaleidoscope of my failed romances flashed inside my head. "You could do a lot better."

Sorry reached out and stroked my cheek with his strong, hairy fingers. "You can't be all that bad," he said.

I felt tears well inside, forced them back. "Well, if you feel that way about it, I guess it'll be okay." I was convincing myself that Sorry was exactly what I needed –a nice guy with a low sexual appetite,. *Only time will tell,* I thought. ◆

Advising and Sympathizing

He had only one vanity; he thought he could give
advice better than any other person. —Mark Twain

In September I was back in school, raring to go. Once again I
vowed to toe the mark and do my very best. It was a pledge I made
every first semester of every school year. Until this, my junior
year, they were all broken promises. I ached to take my rightful place
at the top of Central's list of exceptional students. This year I was pos-
itive I would succeed.

Thanks to my summer school mentor Miss Nethercott, and my
friendship with Marvel, I set my course on a writing career. I signed
up for Mrs. Betty Jones's journalism class.

The school newspaper, The Devil's Pi, was published bi-monthly
during the school year in the printing department of Central. In 1951
the editorial staff included Co-Editors-in-Chief Sharon Kossoff and
Geraldine Walt, both seniors. They topped the full staff from News
Editor down to Typists. There was a business and mechanical staff,
too. The majority of the reporters were juniors, like myself: Richard
Allen, Bonita Andrews, Bruce Bakke, Marion Balow, Jeanne
Beaulieu, George Berg, Burnell Berling, Connie Carlson, Betty
Chapman, Marjorie Compton, Beverly DeRoo, Robert Eaton, Joan
Eckerman, Emelie Gradin, Betty Johnson, Virgina Hill, Elizabeth
Kaner, Helen Kersten, Doris Lido, Henry Logee, Dianne McGillis,
Judy Niemi, Tom Nolan, Brenda Nollet, Beverly Olson, Diane
Peterson, Don Sauve, Arlene Somerville and William York.

The Devil's Pi advisor, Mrs. Jones, was an empathetic and talent-
ed mentor. I sealed her favor after our very first assignment. Each
reporter had to prepare a three hundred word, or less, sample of our
writing style. It didn't hurt that Ma lent a hand. She gave me some

baby pictures of Mrs. Jones' late husband, who Ma had baby-sat as a youth.

Knowing human interest stories were favorites of our advisor, I settled on an article about the small school bus that transported Oliver students to Central. I figured it would be a good way to find out what was happening with Oliver resident Mike Janicovich, my lost love. I was still seeing Sorry off and on, but yearned for a more exciting boyfriend, like Mike had been. For my article I interviewed all the students who rode the Oliver bus and the driver, Andy Rep. The news from Andy was not encouraging. Mike and Curly Pircovich's mother were engaged.

Mrs. Jones told me that my essay would appear on the front page of the Pi's first issue and would have my by-line. She added, "It's extremely unusual for a reporter to get their first assignment by-lined." My article appeared on September 27th, 1951:

<div align="center">

Yellow "Crackerbox" Transports Students[45]

by Frances Oliphant

</div>

Have you seen it? Maybe you've heard it! Well, don't miss it! What am I talking about? The little yellow crackerbox, of course. It's the only one of its kind and holds exactly eight double seats, not including the driver's place of honor in front.

Why not hop on your bicycle and roll down to the Oliver Village Hall? If you make it by eight a.m. you will get an excellent peek at the crackerbox free of charge. The Village Hall is where this little bus has its home. The Village of Oliver pays for the upkeep of the bus; therefore, the school children ride without charge.

Andy Rep is the driver and has been for the past year. He thinks the children are "okay," except occasionally when someone gets out of hand. This doesn't happen very often because if it did the culprit would have to get out and find some other means of transportation.

The day the paper was distributed, I stood in line with a mob of other students, eagerly waiting to hand over ten cents. After obtaining my copy, awed by the sight of my name in print, I read and reread the story. All around me I heard comments like, "Did you read *Tossed*

About by Sharon and Gerry? and, "Did you see the article on the foot-ball team?" and, "Check out the *Senior Snaps* column. They've got a dreamy picture of Lenni Kangas." When my writing success didn't grant me notoriety, my dismay was agonizing. Worse still, all the names of the Oliver bus riders had been slashed from my article. That left me a social outcast with that crowd and cut off all access to news on the Mike Janicovich front.

I would have to find another path to the winner's circle of high school notables. I found my niche in Miss Eleanor Guse's Physical Education hour.

The first day of class I successfully evaded Miss Guse's eye by donning our required short, green step-in uniform and rushing out of the locker room before anyone else. I hurried up to Miss Guse and gave her my name. As soon as she checked me off her roster, I asked to be excused to go to the bathroom. When the rabble of giggling girls headed for the gym I stayed behind. By the time everyone returned, I was already dressed. I wouldn't be caught dead in the dreaded com-munal shower. Never a sports enthusiast, I followed the same routine daily and hid in the locker room waiting for the class to end.

One day as I sat cross-legged on the floor reading my English assignment, in walked Delia Foss. Her face was blotched, eyes damp.

I jumped to my feet, afraid she'd realize what I'd been up to and report me to Miss Guse. I knew Delia was a goodie-two-shoes and popular amongst our peers. I couldn't help but feel sorry for her though and spouted, "What's wrong with YOU?"

Delia gave out a little whimper, like a kitten wanting milk, and, in a low voice, said, "I'm feeling kind of sick." Before I could respond she rushed past me and disappeared behind the washroom door. I could hear her vomiting.

Geez, I thought, *I 'spose I should go see what's wrong.* Hesitant, I crept into the stark, six-stall room. Delia was wiping her face with a paper towel. "You okay?" I asked.

Delia burst into tears and blurted, "I... I don't know... maybe... maybe I'm pregnant."

I couldn't believe my ears. Delia having SEX? It was unheard of, impossible. Though I knew she was going steady, I could not imagine top-notch students like her and her boyfriend even touching each other. "Naw. I doubt that," I said, forcing my voice to sound mature and compassionate. "You have to do it to get pregnant, you know."

Advising and Sympathizing

I could tell by the look in Delia's bright little eyes that she saw something different about me that she'd never noticed before. Her voice lowered, "Promise you won't ever, ever EVER breathe a word of this to anyone?" Twisting her hands together, she fidgeted like a nervous cat.

I put my finger to my mouth, "My lips are sealed." Trying desperately not to appear too inquisitive and trying to calm Delia at the same time, I softened my tone of voice, "Come on, let's go in the locker room."

We settled on a wooden bench along the wall. Turning to Delia I quietly asked, "Did he put his thing inside you?"

Delia's square little face reddened. Beads of sweat gathered just below the hairline on her clear, high forehead. I couldn't believe this pretty, green-eyed girl would know anything about sex. Her response confirmed my suspicions. "Thing?" she asked. Her perfectly arched, brown eyebrows rose.

I suddenly remembered the long-ago conversation I'd had with my old friend Bella about horses doing "it." I decided on a different approach. "You were kissing, right?" Delia nodded yes. "Then he was kind of... feeling you? On your breasts?" She nodded again. "Did you take off your panties?"

Delia clutched herself and leaned forward. "Oh no! He just laid on top of me."

I restrained myself from blurting, "For Pete's sake, did he put it in or not!" Instead I touched her arm. "He probably just put it on your leg."

Though she looked relieved, I could tell Delia still wasn't convinced. "But I FELT something."

OhmyGod, I thought *Now what do I say?* Remembering another long-ago conversation, this time with Tonya, I said, "Did it hurt?" Delia shook her head no. "Did you bleed?"

My new friend's face reddened again. "No!" A look of confusion passed across her small-featured face. "You mean when you have sex you bleed?"

I forced back a giggle. "Most girls do, the first time."

Delia breathed a deep sigh. "You mean I'm not pregnant!?"

I forced a reassuring grin. "I'm pretty sure you're not. But from now on be more careful."

Delia's smile filled her face, revealing two deep-set dimples. "I'll NEVER let him do that again," she said. "At least not until we're married."

Her words brought relief, mixed with a strange sadness inside me. "That's the spirit," I said, thinking, *geez, I sound just like Ma.*

Fair Game

The next day in gym class Delia rushed up to me and whispered, "I got my period. You were right. I'm not pregnant."

Delia spread the word that I was a well-informed and trusted confidant. Thanks to her I earned the unofficial and dubious title of Sex Advisor to our little band of gym pupils. At first, some of the girls thought I was too free and easy, and were jealous. I ignored their comments of, "A nice girl doesn't go jumping from bed to bed," or, "You sound like a bitch in heat." But, they kept coming to me. I was too good a source of information.

More often than not, they stood on the fringe of my circle of fans, the pupils of their eyes expanded, their hands nervously held over their tight little mouths, as if afraid they'd shriek with pleasure. Most thought I was just a girl who failed to conform to the idea of normal behavior. My edict that, "I'm not a one-man woman, never have been, never will be," was good enough for them.

I regaled the group before and after gym class with the adventures on the Military Road with Bella, to the last, less than satisfactory couplings with Sorry, careful not to mention names. I was always the star –always the triumphant party in each and every encounter. I evaded any mention of my rape, my vaginal exam, or any other adversity I'd suffered. There was no doubt in my mind that I was protecting my disciples from needless details. I was sure none of them would ever come close to experiencing that kind of bad luck.

One day I revealed that I was keeping track of each and every one of my conquests. "There's sixty-seven names in my little red book," I proudly proclaimed. My acolytes oohed and ahhed, egging me on. "And," I said, "I'm sure I'll make one-hundred by graduation day."

Delia beamed in admiration. "You are SUCH a vamp!" she said.

The trouble was, I was no longer a vamp. With Sorry I'd settled for someone less than thrilling. I yearned for more love-of-my-life encounters. Surprisingly, I found one through a contact in Journalism class.

I was keeping up my reporter duties, slavishly hoping for another by-line that never came. Most assignments were supplying dates of school activities, for the paper's Comin' Up or Jot Down columns. Occasionally editors Sharon and Gerry printed some of the tidbits of gossip I gleaned in Central's hallways. That kind of news was never by-lined. I saw that practice as elitist, hateful, and unfair.

I was especially livid with envy when grade school friend Anita

Arneson got a by-line. Her interview with movie star John Derrick, who was in town promoting his latest motion picture release, <u>Saturday's Hero</u>, was a front page story.[16] The editors even ran an Evening Telegram picture of the event. Everyone in school buzzed with excitement at Anita's good luck. I managed to hide my feelings by profusely complimenting her on her work. Anita was, after all, a good friend and recently had become a source of some alarming information.

Anita and I took to sharing our adventures every day in Mrs. Jones's classroom. One Monday morning Anita said, "You should go to the dances at Woodmen's.[47] Me and Marie and Inez went last Friday night and had a ball."

"Do you go with them every Friday night?" I asked.

"No. Mostly I go with Marie. Or Jamie Marco."

I remembered that Jamie was a senior. I was impressed. "Oh," I said. "I didn't know you were friendly with her!"

"Not anymore," Anita said, lowering her voice. A conspiratorial glimmer had crossed her huge brown eyes. I knew immediately that she was going to tell me something scandalous. "Thanks to Jamie I almost got raped," Anita said.

"WHAT!?" I spouted, immediately on alert. Maybe Anita was the person I could finally share my own horrific experience with.

"Jamie and me were waiting for the bus to go home and this guy offered us a lift. Normally I wouldn't go, but it was cold and Jamie was all hot to trot."

Anita pushed her curly, shoulder-length, dark hair back, then combed through it with her fingers. "He was really cute, you know." I was, as always, aware of the vivacious quickness in her every movement. Ever since grade school I'd noted how boys were drawn to her sultry good looks. She was tall and curvy, had full lips and deep-set candid eyes. She reminded me a lot of Vernie, but had a classier look to her, like a hothouse flower. She was quick-witted, too; her words often razor sharp and caustic. I was glad she considered me her friend. "We went up to The Labor Temple[48]," Anita continued. "They're open later than Woodmen's and serve booze."

I was amazed how open Anita was. She'd never spoken about drinking before. "Didn't they want some identification?" I asked.

"Naw. We looked pretty spiffy," Anita said. "After a few beers things got out of after we met this dreamy guy."

I was dying for details. "Did you both dance with him?" I asked.

Anita burst into bubbling laughter. "Not at the same time," she said. "Jamie was all over the guy. You know, rubbing up against him. Stuff like that."

I wondered if she'd done the same thing. I knew if it was me telling the story, I'd probably blame my girlfriend, too.

"When we left with him, he tore out Billings Drive and pulled a knife on us."

"Oh Geez!" I shrieked, drawing the attention of our fellow students.

She barked at them, "Mind your own business," then lowered her voice, looking smug that she'd shocked me. "He said, 'which one of you two am I going to rape tonight?' I almost shit. Then he told us to get our asses in the back seat. Jamie was moaning all over the place. By the time we moved to the back, I'd come to my senses and said, 'I got my period.'"

I felt instant admiration for Anita's quick-wittedness, wished I had been as sharp on the uptake. "What happened then?" I asked, my voice sounding breathy.

"He pushed Jamie down on my lap and raped her."

"OhmyGod! What did you do?" I asked.

"What the hell could I do? Anyway, it was her own fault, acting like a whore. She asked for it."

Anita's opinion stunned me and left a sinking feeling deep inside. I realized there was no way I could ever tell her or anyone else about my rape. I vowed to bury the memory forever. A rush of queasy panic welled up. I quickly changed the subject. "So," I said. "How do you and Marie and Inez get to Woodmen's? Isn't it way out in Allouez?"

"Yah," she said. "We gotta take two busses, which is a pain." Her eyes lit up again. "One night though, we got a ride with a cop."

I heard her voice from far away, "Really?" I said, not paying much attention as I desperately fought to quell my uneasiness.

"Rob Porter. Now THERE'S a good-looking guy."

The name rang a bell. Searching my mind, I finally remembered. He was one of the squadman who'd picked up Madeline and Ella and me in Billings Park the summer before last.

Anita went on, "When I told my mom about Rob giving us a ride, she threw a fit. She said, 'Don't ever get in a car with that Casanova again!'"

I instantly filed that juicy piece of information in the back of my mind.

Meanwhile, school dragged on through fall into winter. I completed two more big journalism assignments, neither of which brought me a by-line. I'd learned to make things easy for myself by doing interviews with people who weren't amongst the in-crowd.

When I did an article on The American Legion Citizenship Award recipients, I purposely left out my nemesis, Doris Raleigh, who had wrested that honor from me three years earlier. Instead I featured Betty Jantzen, Eugene Sands, and Gary Sterling. I liked the defiant, in-your-face feeling I got from featuring less visible students. It gave me a sense of control and held back the insecurity I felt at not being amongst the chosen few.

My article on current songs of the day was an example of the tactics I used to make myself feel better. Only one of the interviewees was a hotshot. I picked her because she was from South End. Several of the rest of those mentioned dropped out of school before graduation.

Students Name Favorite Songs[49]

"Music hath charms to soothe the savage breast," but have you heard *Come on-a My House; Sick, Sober and Sorry; I Wanna Play House With You; Jezebel, Knock-kneed Suzy;* or *Cherokee Boogie;* only to mention a few? My, how soft and soothing? Ah well, they're great hits anyway, for the time being.

Of course, there are definitely soothing songs. Nancy Liljegren's favorite is *Because of You. Longing For You* is Alice Swonger's. Les Paul and Mary Ford's, *How High The Moon* is tops with Shirley Johnson and Nat King Cole's recording of *Too Young* is Georgia Verkeyn's and Maizie Oliphant's favorite.

Joyce Osacho likes *May The Good Lord Bless and Keep You*, while *Bali Hai* is favored by Brenda Trombley. *Again* is Bertha Brand's choice. *Waiting for the Sunrise*, Bonnie Andrews; *Hora Staccato*, Betty Kutzler's.

Generally speaking, you'll find be-bop, jazz, hillbilly-western, and popular songs the most requested by teenagers on radio programs. *Hey, Good Lookin'* is one that rates high with Flossie Bloomster and Adeline McDowell. Bob Lindner and Eileen North like the number *My Truly, Truly Fair*, and Lois Donnick said *Detour* is her favorite. Donna Olson enjoys *The Sunshine of*

Your Smile, while Josie Crusher chooses *Sweet Violets.*

There are many likes and dislikes in the field of music. If a survey was taken of every student at Central, one would certainly find a variety of music represented.

Self enmity was eating me up inside. It threatened to consume me. I began to believe the only thing that held it at bay was my dancing. Nothing could keep me from my classes at Braman's Music Studios. There I continued my starring roll as student and assistant teacher. I was sure the hope of one day taking over for Mrs. Sterling was the only thing that kept me from giving up. Often I thought, *Piss on it, I should just quit school.* An article, written by my friend Anita, summarized my dedication to the dance. The fleeting wink of fame that it brought me amongst my peers was gratifying, but was hardly enough to satisfy my unquenchable need for attention.

Fran Oliphant Tells How She Became Dancer[49]

Tap, ballet, toe and acrobatic dancing –these are Frances Oliphant's favorite pastimes. Frances always wanted to take up the different types of dancing. When she was 10-years-old, she finally convinced her mother to allow her to take up dancing lessons.

From then on, her mind was clearly set on becoming a teacher like her instructor, Mrs. Mae Sterling. For six years Frances has been taking lessons from Mrs. Sterling and although she now gives lessons herself, she still has a one hour lesson every Saturday. On Thursdays around 4:30 you can see Frannie trotting faithfully to Braman's music store to give her "dear little darlings" their one-half hour lessons. She has, at present time, around 25 pupils, whose ages start from three years. She teaches both boys and girls.

Her most exciting moments were the first day she started taking lessons, the first time she appeared at a recital, and the first day she was the teacher.

Frannie's favorite classical song to dance to is "*Waltz of the Flowers,*" by Tchaikowsky, and ranking high with her on the popular side are "Hawaiian War Chant," and "Slowpoke."

Among the gal's likes are, of course, dancing, collecting

post cards, any music, and journalism. Her only dislike is people who ask her questions.

"One day," Frannie related, "I was trying to explain to a little four-year old boy how to do a complete somersault. He just couldn't seem to get the hang of turning over, so I decided I had better demonstrate. Down on the floor I got, and, do you know what? I couldn't turn a somersault either."

It was quite an embarrassing lesson for her that day.

Another embarrassing lesson was waiting in the wings. His name was Rob Porter. ◆

45 - The Devil's Pi, Volume 30, Issue No. 5.
46 - October, 1951, Devil's Pi.
47 - Woodmen Hall, 3316 E. 3rd Street.
48 - 1001-11 Tower Avenue, The Labor Temple.
49 - Devil's Pi, October 1951.

Flatfoots and Hunyaks

He that is a master, must serve. —G. Herbert

Each school year I drew on new acquaintances –other outcasts attracted to my boisterousness. In the fall of 1951, in Miss Tetzler's homeroom,[51] Bertha Brand latched onto me. Like many who seemed desperate for a friend, she was overly shy. I enjoyed spending time in the Tower Avenue apartment she shared with her mother and younger sister, Melanie. Living on Superior's main drag was the ultimate residency, in my mind. There you were in the middle of things and had access to all the night-life a person could want. I took to visiting Bertha's after school once or twice a week.

The Brands lived in the front two rooms upstairs of Bridelle's House of Gifts,[52] in the New York building. Mrs. Brand was a short plumpish woman with a pixie-face and loose dentures. She wore Ben Franklin glasses that more often than not were perched halfway down her tiny nose. Her thinning black hair, though tightly permed, didn't always cover patches where her pale scalp showed through.

Like my mother, Mrs. Brand wasn't much of a housekeeper, but unlike Ma, she liked her beer. On occasion Bertha and I accompanied her to Kolanek's,[53] or the Labor Temple Bar.[54] Mrs. Brand's routine at both places was always the same. She dumped her change onto the small table we occupied and counted out coins for a round of tap beer. "I'll buy you each a glass, then we'll see if we can get some hunyak to buy a round." Mrs. Brand referred to all men as hunyaks. After a few sips of the frothy brew she got giggly and loud. Bertha would turn red with embarrassment and hiss, "MA! You're drunk!" or "Geez Ma, everyone's looking at us."

Every so often Mrs. Brand's ex-husband, a seaman on The William A. Irvin ore carrier, showed up. He and Bertha were the spitting image of each other. Both had flame-red hair, luminous brown eyes, and big noses. Mr. Brand was welcomed with open arms as he always came bearing gifts of food and money. He'd hand us girls a fistful of dollar bills and tell us to go to the movies. Bertha's sister Melanie always took off alone.

For that I was grateful, as her personality grated my nerves. A tall hefty girl with a pinched nose and close-set eyes, she reminded me a lot of my old friend Tonya Westman. Both were out-spoken, over-bearing, and difficult to impress. I knew if Melanie was around, it would be impossible for me to take charge. When Bertha and I returned from the movies, the Brands would be lolled across the couch, Mrs. Brand in a loosely tied house coat, Mr. Brand in his undershirt and baggy boxer shorts.

Sometimes Mr. Brand took us to Chef's Restaurant[55] for a full course dinner. I loved Chef's, with it's chrome fixtures and art-deco, recessed lighting. To me it was the epitome of elegance. Frequently our meals turned into spectacles of embarrassment for Bertha and me. Melanie loved to bait her parents with comments like, "You old farts look like idiots, kissing and carrying-on," or, "Jesus, can't you keep your hands to yourselves?"

Once, when Mr. Brand said, "Shut your fat mouth," Melanie sneered, "Geez Ma, can't you find a better hunyak than this old geezer?" I always excused myself right after the meal and bused home. I didn't want to hear what Melanie had to say about the sleeping arrangements.

One cold Friday night when Mr. Brand showed up again, I talked Bertha into going to the dance at Woodmen Hall.[56] It had occured to me that it was time to zero in on Rob Porter. Bertha was less than enthusiastic. "Geez," she said, "I can't even dance."

Slightly miffed at her mutiny, I snapped, "Who said you have to dance. We can just watch, you know." We caught the Itasca bus across the street from her apartment at 7:30 p.m. Looking up at the front windows of the Brand residence, I noticed the lights had gone out. As always, I felt a pang of embarrassment at the thought of Bertha's parents having sex. I was sure it was terribly sinful and unheard of at their age.

I was not impressed with Woodmen Hall. A low, square building, it looked like a shoe box. Inside the entryway was a wood table where a young man collected the dollar entry fee. There was a small bar there too, that stocked pop and snacks. Just beyond, the room deepened beneath a low ceiling to a raised bandstand at the far end. Dimly lit, there were a smattering of couples swirling around the dance floor. Most of the participants were girls dancing with each other. *Shit*, I thought, *this is the pits*. I recognized a group from Central gathered near the bandstand. They included Anita, Marie and Inez, from South End. Bertha and I hung our coats on the portable rack just inside the dance hall. The minute we turned around Anita waved us over.

She was holding a bottle of Coca-Cola, shrieked, "Did you see Rob out front?" I shook my head no. Anita shrugged her shoulders. "He must have took off on a call or something. He'll be back." With that she put her Coke bottle down on the bandstand, rushed across the hall and grabbed one of the guys sitting there. It was then I noticed that all the guys were lined across the wall opposite all the girls. Some looked drunk.

Questioning Inez, she said, "They go drink at the corner bar between sets." *Oh crap,* I thought, *grade-school stuff!*

Meanwhile, Bertha took a seat in the darkest corner of the hall. I reluctantly joined her. The band struck up The Beer Barrel Polka. Two other girls came over and took the vacated chairs alongside us. One was Maude Trimley, a senior at Central who lived outside South End near Greenwood Cemetery. "Hi Maude," I said, anxious to find someone who liked to talk more than the reticent Bertha. "It's kind of dead here."

Maude was tall and tomboyish, with a pock-marked face and a wild sense of humor. She hooted at my words. "Shit," she said, "It's been worse." Nodding to her friend, she continued, "This is Diane Koonia. She lives in South End. Goes to Cathedral."

Maude's friend Diane was short and fat. Her face was round and puffy. Her eyes seemed mere slits of light. Her permanently raised eyebrows left the impression of someone in constant expectation of being shocked. "Hi," she said. "Do you like to polka?"

I hunched my shoulders, "Yah, I guess."

With that Diane jumped up, "Come on!"

Maude shrieked, "Go get um!" Diane and I took off, bouncing around the floor like a couple of heifers.

"Geez! I squawked, "Not so fast," I was amazed at Diane's light-footedness.

"You're a pretty good dancer," Diane said. "We ought'a come out here alone. Maude doesn't like to dance, just bullshits with everyone."

I looked at Diane again. Her beady eyes were shiny, the folds of skin on her weak face bouncing to the beat. *No way in hell am I getting mixed up with HER*, I thought. By the end of the three-polka set I was gasping for breath and thoroughly fed up. I signaled to Bertha. "Let's blow this joint. "

Maude jumped up. "We're ready to go, too," She nodded toward Diane. "Come on."

Diane, looking disgusted, flounced ahead of us, her full skirt caught between her heavy legs. Maude laughed uproariously. "Geez Diane... you look like a puff-assed penguin.

The four of us gathered by the front door, pulling on our long winter coats and babushkas. The ticket collector asked, "You guys coming back?"

Maude shrieked, "Hell no. It's too F-ing dead tonight! We're going to the Labor Temple. Lots more action there!"

The guy flushed. "Well... if you're coming back, you need me to stamp your hands," he said.

"Piss off," Maude snapped. "Let's go! The bus'll be coming."

Outside, I looked up and down the street. "Maybe we could get a ride with someone."

"Shit," Maude said. "The guys don't start picking up girls until the dance is over. After they get good and drunk."

Just then a black and white squad car pulled up in front of the hall. The window rolled down. My heart skipped a beat at the sight of squadman Rob Porter.

I sauntered over to the car, purposely undulating my hips like I remembered Vernetta doing. In the most silver-tongued tone of voice that I could muster I asked, "You driving taxi tonight?" I felt a rush of delight at the realization he looked interested. I thought, *All right! I've still got the touch.*

A sly look briefly crossed Rob's dark, handsome features. "I don't usually take on a whole car load. Where's everyone going?"

I leaned against the side of the car, put my face up close to his. "Just downtown. They wanna go to the Labor Temple. I was thinking of someplace less public myself."

Rob's full, perfectly shaped lips broke into a smile that lit up his gorgeous face.

"Tell them to get in back. You sit up front with me."

I waved the girls over as I promenaded in front of the squad, feeling as if I were on stage and Rob was my audience of one. "Come on! He's going to drop you guys downtown!"

Maude and Diane loped over to the squad and jumped in the back seat. Bertha hesitated. "Geez," she said. "I don't think my ma would appreciate me coming home in a police car."

"Oh for Pete's sake," I spouted. "He'll drop you down the block." Already annoyed at her coolness to me and my friends, I felt relief at the thought of Bertha quitting school in January, when she turned sixteen.

Rob avoided the main streets during the drive downtown. All the while I was aware of the whispering of my three friends in the back seat, barely audible above the squawking police intercom. I ignored them, took quick glances at our handsome driver. He had a sensuous face, direct and challenging, with high, strong bones and large eyes. His jaw was clenched, making his cheek bones stand out. He'd removed his police hat. His black hair, drenched with hair-tonic, glistened in the dashboard light.

When Rob turned into the alley next to The Labor Temple, Maude spouted, "You'd better come too, Fran. I heard this flatfoot's a horny sucker." With that she jumped out of the car. Diane and Bertha tumbled out behind her.

Bertha slammed the back door. "Don't expect me to ever go to Woodmen's again!" With that she turned in the opposite direction of Maude and Diane. Waving back at them, she headed south on Tower Avenue. She shouted over her shoulder, ""I'm going home! I don't need no damn hunyaks!"

Rob turned down his intercom and stepped on the gas. "Jesus," he said, "You sure got a bunch of dumb ass friends." Soon the squad was tearing south on Hammond Avenue, behind Monty Allen's horse farm and the Tri-State Fairgrounds on our right, and the Superior Municipal Airport on our left. I was relieved that he didn't turn on the siren. "I gotta check out Bryant," he said. "Kids trying to break in or something."

By the time we reached our destination all was quiet. Rob parked the squad on Hughitt Avenue behind the school and shut off the headlights. As my eyes adjusted to the dim dashboard light, I saw Rob pulling off his coat, throwing it in the back seat. I suddenly thought, *God, I hope he doesn't take his clothes off. I wouldn't want to be caught naked in a squad car!*

I needn't have worried. Without ceremony Rob unhooked his nightstick and lay it across the top of the dashboard. I waited to see if he'd remove his holster and gun. He didn't. Instead, he lunged at me and pulled me close. Rob's full lips met mine. He stuck his wet tongue halfway down my throat. I struggled to keep from choking. At the same time I kept shifting under him, trying to dislodge the weight of his holster and gun from against my hip.

In seconds he had unzipped his pants and was ready for action. "Scoot down on the seat," he said. "We gotta make this fast." Our fran-

tic coupling was over in a flash. Memories of all my other unsatisfactory liaisons filled my head. Maybe guys were hunyaks, like Mrs. Brand said. Of one thing I was sure, looks didn't mean much when it came to performance.

After the ceremonial, "I gotta take a piss," and his return, Rob said, "You're some hot number." His words disconcerted me. I wondered what I'd done that was so spectacular. Before I could respond he went on, "I remember the night we picked you and your friends up in Billings Park. I remember thinking, 'Boy, I'd like to get in her pants."

Rob's words exhilarated me. *Geez, maybe I AM hot stuff.* The thought that someone as handsome as Rob could be attracted to me was almost too much for me to grasp. "You probably say that to all the girls," I said, thinking how feeble-minded a statement that was.

Rob's laugh was hard and solid. At first I thought I detected a sneer, but his words dispelled that thought. "I know lots of girls," he said. "But I don't think they're all hot, like you." With that he reached for his nightstick.

In the dim light I noticed that the long, firm piece of wood looked knotted and chipped. I ran my fingers over it. "Geez," I said, "This looks like it's seen lots of action. What're are all those marks?"

Rob laughed again as he turned the stick in his oversized hands. "These," he said, running the palm of his hand over the small indentations that looked like they'd been gnawed by beavers, "are all the married women I've screwed." Rotating the nightstick, he ran his index finger against even more little chinks. "And these," he said, "Are my favorites. High school girls."

I looked at Rob's face, trying to determine if he was kidding. He wasn't. I'd heard the rumors from Anita and tonight, from Maude. The only weak words I could muster were, "Aren't you engaged?"

A smart-ass grin filled Rob's face. "So?" he said as he reattached the nightstick to his belt. "I vowed to serve. And that's what I do."

I decided it was time to change the subject. I asked the question that was hovering in the back of my mind. "What's with the policewoman, Stromlind? Is she some kind of a tight-assed virgin?"

Rob's face darkened. "Ah... I don't like to talk about anyone on the force," he said, not sounding like he meant it. "Let's just say she's not a virgin." He smirked then and continued. "Just be careful if you have any more run-ins with her. She's tough."

Fair Game

Though Rob's warning was late in coming, it wouldn't be long before I'd be in Miss Stromlind's clutches again. First though, there were other debacles waiting. ◆

51 - Room 229, Central High.
52 - 1402 Tower Avenue, Bridelles House of Gifts.
53 - 1318 Tower Avenue, Kolanek's.
54 - Labor Temple - 1001-11 Tower Avenue.
55 - 1410 Tower Avenue, Chef's.
56 - 3316 E. 3rd Street, Woodmen Hall.

Lucking Out

Fortune is not satisfied with inflicting one calamity.
—Plubius

The winter holidays came sliding down over my world like an avalanche, threatening to bury me alive. I felt weary with a gloom that seemed intent on suffocating me. The annual trek to Aunt Etta and Uncle Arlo's at Christmas was the last straw. After a full day of inertia and boredom I felt I had to break free. When Diane Koonia called the next night and asked me to go with her to Woodmen Hall I jumped at the chance. "Meet you on the bus in an hour!" I shrieked.

Ma, who was sitting sipping her coffee in front of the open oven door, scowled. "You're not going to start chasing again, are you?"

I rushed past her. *Geez, the woman's getting worse than a prison matron.* My response was explosive. "I've got to get out of this dungeon. It's burying me alive!"

Any other time I would have laughed at Ma's mumbled retort, "Uff. You're so over-dramatic. Nothing's that bad."

I rushed upstairs to my hideaway, concentrated on getting ready and out as fast as possible. All the while I thought, *SHE doesn't care if she NEVER has any fun. Geez, I hope I don't ever get THAT bad.*

On the bus with Diane, I was surprised when she told me, "I lied. Woodmen's isn't open. I thought we could go to the Labor Temple instead. They're having their holiday dance. We can go to Woodmen's tomorrow night."

I was puzzled that a good Catholic high school senior like her would stoop to lying. "Why would you lie about that?" I looked at her, noted she didn't seem half as obnoxious as I first thought. Though Diane's big face was fleshy and her eyes barely visible through folds of fat, she had a smooth, clear complexion. There was an almost angelic quality to her looks.

Diane hunched her shoulders. "I don't know. I thought maybe you didn't like the Labor Temple dances. I've never seen you there."

I brought up the best good-natured smile I could summon. "Oh, I like them okay. The bar downstairs is where I usually hang out, though." I forced myself to sound worldly.

Diane sounded impressed. "Really?" she said. "I didn't think they let single women in. I've never been downstairs."

"Lots of women go there," I said. "My friend Bertha's mother is a regular. You just can't sit at the bar. That's reserved for men only. They got plenty of tables and booths, though."

Diane and I got off the bus at Broadway and Tower, crossing the street in a rush. We were intent on avoiding the slush that passing cars sprayed across the street as they tore by. Upstairs in the Labor Temple cloak room, we hung our heavy coats and removed our stadium boots. Diane had on a gorgeous green satin dress with matching spike pumps. The three-inch heels were slimming and emphasized her slender ankle bones.

Low cut in front, the dress enhanced her impressive bosom. I suddenly felt dumpy in my full black ballerina skirt and red pullover. Luckily I'd opted for nylons instead of bobbysox. I wished I'd borrowed Ma's pumps. My run-down loafers seemed juvenile next to Diane's fancy shoes.

After we paid the entry fee, we made our way through the vast lobby that surrounded the dance hall. Peeking in the first entrance, I noted that the dance floor was crowded with tightly embraced couples. The band was playing *Harbor Lights*. I said, "Looks like date night. Maybe we should go downstairs."

Diane snorted. "Geez, I was hoping we could get in a few polkas."

I was about to snarl at her when I caught a glimpse of Miss Stromlind. The police woman was fully uniformed, leaning against the cigarette machine across the hall. I clutched Diane's arm and gave it a little jerk. "Come on," I said, "Let's go dance this waltz." We momentarily struggled with each other, trying to decide who was going to lead. As soon as we got going the music stopped. "Let's find a chair," I said. We found two vacant seats alongside the back wall.

"What the hell brought that on?" Diane spouted.

"I saw that policewoman bitch over by the cigarette machine," I said. "What an idiot. Like any teenager's going to buy cigarettes right in front of her face and get arrested." Just then the band struck up, *The Beer Barrel Polka*.

Diane jumped to her feet. "This is more like it!" She grabbed me

around the waist, steered me out to dance. We thundered around the floor. All the while I was trying to focus on the few lone men who dotted the sidelines. All I could make out were blurred, whirling faces. Diane kept bubbling with gaiety. The fixed smile on her broad face seemed lit up from inside. Feeling lighthearted at the sight of her, I relaxed and let Diane whip me around faster and faster.

By the end of the dance I was elated and re-energized. The accordionist shouted, "Time for the *She's Too Fat Polka*! I glanced at Diane, concerned that maybe she'd be hurt. "You want to sit down?" I shouted. "I'm bushed."

"Hell no!" Diane grabbed my arm and led me off again, laughing and singing the words... "*OH! she's too fat, she's too fat, she's too fat for me*!!" Her jolly nature was a balm to my spirit.

After the third polka Diane and I sank onto our chairs in the corner by the door. "Whew, that was fun!" I gasped. "Time for a beer, though."

Diane's face clouded. "Aw geez, I'd like to get in a couple slow ones."

I restrained myself from saying I thought it was revolting for two females to waltz together. Instead, I said, "All right. But just one, okay?"

Diane nodded her consent. When the band launched *Moonlight And Roses*, she stood up. She held open her arms like I was supposed to fall into them.

I waved her back. "Not close, now," I said, carefully adjusting the distance between her and me so that no part of our bodies touched. We moved slowly along the fringes of the crowd. All the while I kept my feet flat on the floor, determined to act like I was not enjoying myself. Diane hissed, "Relax. You're moving like a cardboard dummy." When the dance ended she looked at me. "Let's just finish this set," she said.

"No way!" I spouted. "It's getting late and I want to go down to the bar." Diane hunched her shoulders in resignation and followed me out to the cloakroom. "Let's put on our boots and take our coats with," I said. In the vestibule on the first floor I could hear music and laughter from beyond the double doors that led to the bar. Feeling giddy with expectation I smiled at Diane, "Sounds like they're having a ball!"

Inside the bar we made our way through the crowd. All the tables and booths at the front were occupied. The barstools were all taken, too. The men there turned and gave us the once over as we passed. At

the far end of the room I spied a small table with two chairs in the corner under the red exit sign. I shrieked above the clamor, "Come on Diane! Here's a spot!" We threw our coats across the back of the chairs and sank onto them.

Before I could even light up a cigarette the waitress was standing over us. I recognized her from when I'd been in the bar with Mrs. Brand. She was short and fat and chewed gum like it was going out of style. "Where's your ma," she asked, her jaw not missing a beat as she chomped on her gum.

"She's not my ma. She's my girlfriend." The waitress hooted. "We'll have a couple bottles of Northern," I said. The woman waddled off. I looked at Diane. "I hope you got some money. I'm broke."

Diane dug in her coat pocket. "I got five dollars." She smoothed out the bill and lay it on the table.

I felt a whiff of cold air as the exit door behind us opened. Two tall guys bundled in Mackintosh jackets burst in. Both of them looked drunk. Catching my eye, the skinniest one blurted, "Hey, hey! Must be my lucky night!" He had an elongated, pale face with sharp, clear-cut features. Thick blond eyebrows accented his blue eyes, rimmed with the palest of full eyelashes. He immediately brought to my mind images of Alan Ladd, one of my favorite actors. "Mind if we join you?" he asked. I liked the coaxing timbre of his voice, though it sounded warped with whiskey.

I looked at Diane. An angelic little smile crossed her full face. She hunched her shoulders. "Fine with me, if they can find some chairs." With that the guys went over and huddled with the bartender. Moments later they'd commandeered two chairs from the back room.

"So," I said, forcing a casualness into my voice, "What's your name's?"

My guy immediately spouted, "Just call me Killer. And this is Maxon. Snatch Maxon." His buddy scowled at him. "Sorry," Killer said. "He prefers Maurice."

I was sure he was pulling my leg, but ignored his rowdiness. I liked his style, was sure he'd be a ton of fun. "This is Diane," I said, nodding at her. Maurice sidled closer. I noticed Diane didn't even flinch at his familiarity. It occurred to me then that maybe she was lots more fun than I'd first thought. Turning to Killer, I went on, "I'm Fran. We're from South End."

The waitress appeared with our beer. Diane handed her the five. The woman glared at the guys. "Don't tell me you're going to let her pay?"

With that Maurice dug in his pocket and handed her three singles. "Keep the change," he laughed. The waitress stuffed the bills in her apron pocket. "What da ya bums want?" she asked. Maurice and Killer ordered beer.

Three rounds later I began feeling light headed. Through the fog, I noticed that Maurice and Diane had edged closer to each other. He had his arm around her shoulder. They were deep in conversation. Killer and I were babbling on about joints we'd drank in, including Kytos Bar. I kept embroidering my saga until it sounded like I was a regular there. "That dump's dangerous," Killer said. "No place for a nice kid."

"I'm not a kid," I spouted. "I've been around the block."

Killer laughed. "Well," he said, "From what you've told me, you've been around it more than once. Come on. Let's go." He threw a five on the table. Outside, Diane and Maurice tumbled into the back seat, immediately falling into each others arms and kissing like they were starved.

When Killer pulled off Winter Street, behind a huge mound of snow, I was sure he'd be as aggressive as Maurice. Instead, sounding bored, he said, "Better keep the motor running, else we'll all freeze." Maurice and Diane were wrestling in the back seat. Little moans of pleasure burst from her lips every so often. "Geez," Killer said, "They're steaming up all the windows."

I was momentarily confused by his lack of enthusiasm. "Maybe we should be doing the same thing," I said. "You got a problem with that?"

Killer laughed, not sounding amused. "It's... well, it's just that you seem kind of familiar."

"Hells bells," I said, "You probably saw me at Kytos. Or some other bar."

Killer's forehead wrinkled, like he was deep in thought. "No. I don't think so. What's your last name?"

"Oliphant," I said.

His face cleared. "That sounds familiar. I used to have a paper boy working for me by that name. When I was in charge of distribution for the Tribune. Howie. Howie Oliphant. I must of met you when I'd go out to get the money he collected. So, he's your little brother?" He stretched and lay his arm around my shoulder.

"He's my twin," I blurted.

Killer jerked away from me. "What!? But... he's only... let's see. He can't be more than sixteen. You're SIXTEEN?! How the hell do you get away with drinking at your age?!"

I felt a wave of disgust at his shock. "No one ever asks me for I.D.," I said. "Anyway, what's the big deal?"

Killer started the car. "It is a big deal. Your mother and mine are old friends. They'd shit if they thought I tried anything with you!" With that he stepped on the gas. The car jolted forward.

From the back seat Maurice bellowed, "What the hell's going on!?"

Killer snarled over his shoulder, "We're taking these girls home." Out in South End Killer stopped the car a block from my house. "Get out here. I don't want your ma to see my car."

Miffed, I snapped, "She wouldn't know one damn car from another." I peered back at Diane, wanting to say something cutting for the benefit of Killer. "Let's go out to Woodmen's tomorrow night and find some real men." I slammed the door, thinking, *Brother! When the hell am I going to find a FUN guy.* It would take two more disasters before I would succeed. The first one unfolded the next night at Woodmen Hall.

Though I hated Woodmen's, I was desperate to try my luck out there one more time. Diane was more than happy to accompany me. I was sure she thought she'd run into Maurice again. "He was such a good kisser," she said.

The night duplicated my trip to Woodmen with Bertha, except that Diane met the man of her dreams. It happened during the third polka. We were bouncing past the entry door. There, a batch of new prospects were gathered. One of them broke away from the crowd and tapped me on the shoulder. I was about to turn and fall into his arms when he said, "Mind if I dance with your friend?" I barely had time to shake my head no, when he swept Diane away. They danced every number together for the rest of the evening.

Thoroughly disgusted, I spent my time bullshitting with Anita and her friends. They were especially hysterical over my updated report on my recent adventures with Rob Porter and Killer. They hooted noisily at every detail. When Anita said she thought Rob was on duty I sauntered to the lobby and looked out the door. His squad was parked in front. Grabbing my coat I had the door man stamp my hand, then I rushed out.

When I got to the squad I tried to pull open the door. It was locked. Rob leaned over and rolled down the window, nervously looking around. "I gotta take it easy," he said. "Someone reported me to

Chief Buchanan." The disappointment I felt must have shown in my face. "Not to worry, though, I'll meet you down the street. Under the railroad viaduct."

I peered into the darkness. A block away I saw the huge shadow of the structure Rob was talking about. Feeling strangely angered, I blurted, "You gotta be kidding!"

"Your loss," Rob said. With that he stepped on the gas and headed the squad out. I could hear the wheels screech as he tuned onto East Second Street.

I moved back toward the dance hall. Diane and her new friend were just exiting. "Where were you?" she shrieked.

"At the corner bar," I lied. "Where you guys going?"

Beaming, Diane looked up at her friend. "This is Chuckie. He's gonna take me home."

I looked up and down the deserted street. "Where's his car?"

Chuckie laughed, sounding like a robust moose. "Ain't got no car," he said. "We're taking the bus."

I thought I detected a southern accent. "Where you from?" I asked, as I started down the street to the bus stop. I'd given Chuckie a second look and wasn't impressed. He was tall and gangly, with a nondescript face and bushy, straw-colored hair. All I could think of was him and Diane together looking like Bud Abbot and Lou Costello.

"Iowa," Chuckie said, then turned to Diane. "You ready babe?" He put his arm out for her to grasp. It made me feel as if I'd been dismissed. Worse, on the South End bus on the way home, they pushed past me and took the last, long seat on the bus. There they immediately fell into each others arms and started necking. *Oh shit*, I thought, *Everyone's got a guy except me*! By the time I got home I vowed I'd find one, too.

The next night I called Bertha. Mrs. Brand told me she'd gotten a job in Brainard. "Damn," I said. "I wanted to meet her at the Labor Temple bar."

"I'll go with you," Mrs. Brand yelped, sounding like a giddy school girl.

Hell, better her than nobody, I thought. "Don't bring that damn Melanie with," I said and hung up the phone.

That evening Mrs. Brand and I were settled in a booth in the Labor Temple bar for less than ten minutes when two guys sent over bottles of beer. "Wow," Mrs. Brand said, "You sure attract hunyaks fast."

"Yah, but the trick is to keep them." I raised my bottle at the guys and waved them over. A rush of exhilaration swept over me. Both guys turned out to be lake carrier crewmen and brothers.

The older of the two looked gray and toughened, like a dry hide. Short and wiry, his bullet head was shaved and reflected the light from the lamp hanging over our booth. He sidled alongside Mrs. Brand. "I'm Evan. This is my little brother, Shawn. We're from Ohio."

I looked at Shawn. He was tall, lean and agile looking. His blond hair grew upward and outward in a great mass of curls. His facial features were slender and delicate. A deep cleft in his chin below his rosebud lips gave him an almost saintly aspect, like pictures I'd seen of St. Francis. His honey colored skin glistened in the light. His appearance infused new hope inside me, though it crossed my mind that he was almost too pretty to be a guy. I brushed the thought away and smiled my best come hither smile. "Don't be shy," I said. "I don't bite."

Shawn's face blazed. "I'm not shy," he said, though when he slid into the space next to me and his leg touched mine I could feel a tremor flutter through him.

I lay my hand on his thigh and squeezed it. "Relax. Have a drink."

Evan was chattering away in a high pitched, rapid voice, giving little opportunity for anyone else to contribute. When he started talking about their ship I leaned forward. "I thought all the ships had taken off already," I said.

Evan took a gulp of beer and shook his head. "We'll be the last one out."

Mrs. Brand popped into the conversation. "I know a guy who works on an ore boat. He's stuck in Ashtabula, Ohio."

Evan looked at his brother, as if expecting him to contribute to the conversation. Getting no response, he hunched his shoulders. "That's where we're from," he said. "We're on the lakes most of the year though. It's our second home. Right, Shawn?"

Shawn mumbled, "Yah. I... a... I think I'd better get back there now."

Damn, I thought. *This kid's a real dodo.* I was about to give up when Evan said, "I think we should take these ladies on board. Let them see our little cabin in the sky."

Mrs. Brand shrieked, "Jesus no! I don't wanna be out on the Big Lake now. It's too cold!" She kicked me and gave a little shake of her

head. I knew immediately that she was afraid some of her ex-husband's buddies would see her.

I kicked her back. "That sounds like fun! Me and Shawn can go if you guys don't want to." I glanced at Shawn. The iris's on his pale eyes expanded like he'd seen a ghost.

Evan smiled slyly. "You'd be game for that, wouldn't you Shawn?" His words sounded more than an order than a question. Taking out his wallet he extracted a twenty. He handed the bill to his brother. "Grab a cab and take Fran down for the grand tour. I'll meet up with you in an hour or so."

Shawn was silent all the way to the docks. I didn't care. I was excited at the prospect of boarding my very first oar carrier. As the cab approached Lake Superior near the railroad bridge to Duluth, I could see Shawn's ship. It loomed beside the Great Northern grain elevator like a hulking dragon. The cab moved slowly along the snow encrusted pier. I looked up at the three-story ship, imagined other ports it had called at over the years. The name on the side was HONEY HILL[57]. I made a little vow that someday I'd be off traveling the world myself. *Hell.* I thought, *If I'd have been a guy I'd have gone a long time ago.*

The cold night air seemed to seep right through me as I carefully followed Shawn to the ship. When he stopped and said, "You first," I almost lost my nerve. He was pointing at a steel ladder propped against the prow of the ship. Beneath it were chunks of broken lake ice, slowly bobbing up and down against the dock. Momentary panic filled me as I imagined myself falling headlong into the icy waters.

"I can't swim," I said.

Shawn chuckled nervously. "You're not going into the drink," he said. "Just hang on and don't look down."

I inched up the ladder, rung by narrow rung, clutching the side frame so tightly with my mittened hands that they felt crippled with pain. At the top I swung my leg over the side and jumped with a plop onto the deck, my knees buckling under me. It was then I became aware of the strange silence, broken by what sounded like heavy breathing. "What's that noise?" I asked.

"Just the engines idling," Shawn said.

"Sounds spooky to me." In my mind's eye I pictured a ghost ship, manned by zombies. "Where's everyone?"

Shawn touched my elbow. "They're in their bunks. Sleeping. Come on." He steered me down a narrow passage to the last door,

unlocked it and guided me over the steel threshold. The cabin was minuscule, with two bunk beds, a small desk and a chair. Shawn seemed in a big hurry, like he was afraid he'd lose his nerve. "The top bunk's mine. You get in while I go to the head." I heard the key turn in the lock outside.

I quickly took off my coat, boots and shoes. Fully clothed, I hoisted myself up the three rung ladder into the top bunk. Under the covers I pulled off my skirt and sweater. It felt like my entire body was covered with goose bumps from the cold. Pulling the rough sheet and blanket up to my chin, I shimmied underneath and waited. What seemed like hours later, I heard the key turn in the lock, heard Shawn enter the cabin.

Suddenly the dim ceiling light went out. I felt him crawl up into the bunk. He was buck naked and shaking. "You got your clothes off?" he asked. I mumbled, "yes," quickly slipped off my bra. I felt him fumbling under the covers, felt his hand on my breast. A deep gasp escaped his lips.

Without warning he fell forward on top of me. I waited for his next move. It didn't come. His full weight was crushing. I touched his shoulder and gave it a little shake. "Shawn! SHAWN!" His head bobbed sideways against my shoulder. *Geez*, I thought *He's dead! OhmyGod!* I shook him some more. He didn't respond. I inched my leg out from under him, hung it over the side of the bunk. I tried to slide out from under him. *Damn! I can't move.* Realizing I was pinned under him, I tried to keep calm. *What in the world can I do?* I didn't want to scream, didn't want to wake up the entire crew. I'd be in one hell of a mess if I did. Moments later I heard a key in the lock. The light from the hallway outside silhouetted Evan.

"Get IN here!" I stage-whispered. "Something's wrong with your brother!"

Evan turned on the light. His hard little face darkened as he approached the bunk. He stood on the desk chair, leaned over and began shaking Shawn.

"He's not dead is he?" I asked.

Evan laughed. "No. He's sleeping. What happened?"

I was not amused. "He must of passed out," I said. "What's his problem?"

"He's a virgin," Evan said. He was making choking sounds, trying to keep from laughing.

Lucking Out

"Oh for Pete's sake," I said. "Get him off me. I gotta get out of here!" I pushed on Shawn's chest while Evan pulled him up. Sliding out from under him, I backed down the bunk ladder, dragging my clothes along with me. Quickly dressing, I grabbed my coat and boots and stepped into the hallway and pulled them on.

Evan came out behind me. "I'll go with you and call a cab," he said. "I'm really sorry about this. I thought I was helping him out." He handed me a five dollar bill.

"Shit," I said. "You didn't do either one of us any favors." With that I stomped out to the deck and cautiously descended the ladder. Evan called a cab from the pay phone at the end of the pier, waited with me until it came. "Thanks for nothing," I said as I hopped into the cab.

All the way home I silently cursed my bad luck. *Geez. When am I ever going to get a guy again?* ◆

57 - Changed to the Paul H. Carnahan in 1961.

Unraveling

So quick bright things come to confusion.
–Shakespeare

For me 1952 dawned bleak and unexciting. I dragged through my high school classes barely aware of what was going on around me. A conviction that nothing ever was going to go right consumed me. My dance classes seemed endless and hum-drum, too. Then one day Mrs. Sterling made a proposal. She asked me if I would like to teach two dance classes in Iron River, Wisconsin. I jumped at the chance. Besides increasing my hourly pay to two dollars, she paid for my bus ticket. I was ecstatic at the prospect of being on my own.

Each Saturday at 8:30 a.m. for the next six weeks, I caught the Greyhound at the Hotel Superior[58] station. With my red vinyl hat box and ticket in hand, I boarded the bus for the thirty-two mile trip east on Highway Two. The bus was always filled with the voices of eager travelers, excitedly discussing their plans for their journey's end in places like Milwaukee, Wisconsin and Chicago, Illinois. The one hour and eleven minute ride filled my head with dreams of far away places. I often wished I could just stay on the bus.

My classes went well. The first one, where I taught ballet and tap, was for toddlers, aged three to five. The focus of the second, for older kids, was tap-dancing. I was especially pleased with the pianist, Phoebe Savage. She was the same age as me, had a mature presence and a great natural talent. A short, efficient girl, she had studied tap dancing with a local teacher and knew exactly what was required. She seldom used sheet music and best of all, was adept at improvising when I beat out the rhythms on my drum sticks.

Before and after class I took a counter seat in Vacha's, a local cafe and Greyhound stop. The peach toned and post-modern interior had a soothing effect on me. There I sipped coffee and puffed on Pall Malls, imagining I was impressing everyone who frequented that small town establishment. It was a homey place. Everyone knew everyone else. They were curious about strangers and soon after digesting all the

314

information I eagerly shared, treated me like one of their own. They were especially pleased when I disclosed I had relatives in town –cousins of my mother, and well-known Iron River denizens. I didn't bother telling them that I barely knew the Ingle family and hadn't visited them in six years, since I was ten years old. Things were going smoothly until one March day, the week before classes were due to end, everything began unraveling.

I'd forgotten to set the alarm clock and overslept. I told Ma, "I'll never get downtown in time to catch the bus. I'll call Phoebe and cancel."

Ma wouldn't hear of that. "You can make it," she said. "I'll phone the Greyhound and tell them to hold the bus."

As much as I hated the thought of being late, I knew Ma would not be satisfied until I was on my way. She put great stock in dependability.

By the time I descended the South End bus at Belknap and Tower, I was in a state of high agitation and embarrassment. The Greyhound was parked in front of the station, the motor running. As I approached I could see the passengers through the windows. They were straining their necks to see what important personage was responsible for delaying their journey. After I got my ticket and boarded, I could sense their hostility at the realization it was me, a nondescript teenager. I slunk on board, sank into the one empty seat on the filled-to-capacity bus. It was an aisle seat, next to a distinguished looking, silver-haired man. Red faced and sweating, I immediately dug a Pall Mall out of the pack in my purse.

The man next to me pulled a Zippo lighter from his pocket and offered a light. After I lit up he snapped the lighter shut and extended his hand. "I'm Michael Verich."

I shook his hand, abruptly realized I knew him. He was the Dean of Boys at Central High. "I'm Fran Oliphant."

"Do you attend Central?" he asked.

Aware that he didn't know me from Adam, I felt a sudden relief. "I'm a junior."

He gave a little shake of his head and tsk, tsked. "Too young to smoke," he said, then gazed out the window. "Looks like a storm brewing."

In my excitement, I hadn't noticed that it was a cloudy, socked-in day, with barely any light from the sky. By the time we reached the outskirts of Superior, fine prickly sleet began pelting the bus windows.

Mr. Verich and I chatted on. I learned he was going to Eau Claire, Wisconsin, for a regional Deans conference. He learned that I was a

dance teacher, liked my classes in high school well enough, hated sports, and had a sister who was going to graduate in June.

Thick swirls of snow were blowing across the icy highway by the time we reached Iron River. The big windshield wipers on the front windows couldn't seem to move fast enough to keep them cleared. The driver turned off Highway Two and pulled up one block south, across the street from Vacha's. "So long," I said to Mr. Verich. "See you at Central!" Moving to the front of the bus, I waited for the driver to open the door. Other passengers were starting to get up, too.

The driver rose from his elevated seat and announced, "We won't be stopping for coffee this morning. We have to make up the time we lost back in Superior." I was sure the scowl on his face was for my benefit. "Kindly remain in your seats while I unload the papers."

I knew the collective grumble of my fellow passengers was directed at me. Red faced and sheepish, I jumped down the two steps onto the snow-encrusted sidewalk. The driver hadn't bothered to put out the steel footstool for my descent, or take my arm in assistance like he usually did. He was hurriedly unloading bundles of newspapers and packages from the underbelly of the bus.

A hard, snow filled wind knifed my lungs and tingled my face as I rushed across the street and burst into Vachas. I sank onto my favorite stool at the end of the long counter alongside the cash register just inside the door. Most all of the seats were occupied. The booths opposite were filled with customers, as well. The waitress immediately appeared with a cup and a pot of steaming coffee. As she poured she said, "Any trouble on the highway? You guys were pretty late."

I glanced at the door. I could see the bundles of newspapers that the bus driver had stacked in the cafe entryway. I leaned forward to look out the front picture window. The driver was reboarding his bus. "Some idiot was late and they had to hold the bus," I said.

"Don't cha' just hate it when that happens?" I was relieved the waitress didn't wait for an answer. She moved back down the counter refilling cups as she went.

Fifteen minutes later I was in front of my toddler class in the Iron River high school gymnasium. In spite of the bad weather, all ten were present, their mothers settled on folding chairs nearby. My pianist Phoebe had shown up, too.

The second class was less conscientious. Half of them were missing. "Hell," Phoebe said, "It's not that bad out."

Unraveling

The last student straggled in, his coat and hat covered with snow. "It's getting awful scary out there," he said.

Phoebe, looking disgusted, snapped, "Oh for Pete's sake. It's winter. You should be used to this weather by now." With that she banged a chord on the upright piano in the corner, a signal for me to get on with it.

After the endless repetition of our Harrigan soft-shoe routine, it was almost one o'clock. "That's it!" I hollered. My students rushed for the cloakroom, pulled on their winter gear, slamming the door behind them as they left. I looked over at Phoebe. She was pulling down the piano cover. "Would you like a cup of coffee at Vacha's?" I asked.

Phoebe's small face was firmly set in deep thought. "Naw. I gotta get home. To help my ma." High cheekbones accentuated her dark eyes behind the frameless glasses she wore. They gave her an intelligent, interesting look.

It occurred to me that I didn't know much about Phoebe or her family. "Have you got sisters and brothers?"

Phoebe smiled in a controlled, unmirthful way. "Are you kidding? There's seven of us. And I'm the oldest."

I pulled her one dollar salary out of my purse and handed it over. "Geez," I said. "That's gotta be tough." We were donning our coats and boots. "There's only three of us in my family and things sometimes get pretty bleak. Money-wise, I mean."

"For us, too," Phoebe said. "The old man's a drunk. I had to quit tap-dancing lessons. Got the shoes though. My best ones." She laughed then, a smart-ass guffaw that warmed me. "Do you know," she continued, "I have to wear those damn shoes to high school. I sound like a clod-hopper walking on the hardwood floors."

I smiled in recognition of her humiliation. "That happened to me once," I said. "When I was a Girl Scout. I had to go to this woman's fancy house to have my picture taken for the paper as I'd sold the most cookies. She was head of the Scouts. The only decent shoes I had were my tap shoes. When I walked on her parquet floors, the clanking reverberated all through the house." Phoebe and I laughed together over our mutual disgrace.

Outside the wind propelled swirls of snow around us. "Geez," Phoebe hollered, "I hope you get home okay."

"Don't worry," I hollered back. "The Greyhound always gets through!"

Inside Vacha's I noted I was the lone customer. "Where is everyone?"

317

The waitress was picking bottles of catsup off the counter. "Big snowstorm blowing in. We're going to be closing in fifteen minutes." She brought me a cup of coffee, then, looking serious said, "The Greyhound's not coming. Highway's closed east of us, all the way to Ashland."

"Oh for Pete's sake!" I blurted. "How the hell am I going to get home!?"

The waitress patted my arm. "If I were you I'd call those relatives of yours."

"Can't," I lied. "They're away for the winter." There was no way in hell that I wanted to descend on perfect strangers. "Maybe there's someone in town heading to Superior?"

The woman hunched her shoulders. "I doubt that. You could check over at the Ideal Hotel on the corner."

I put a quarter on the counter and left. Struggling the one block over, the caterwauling wind seemed intent on shoving me back the way I'd come. When the elderly desk clerk inside the hotel lobby saw me, he flinched, "How in the world did you get through this mess?"

Ignoring his comment I sputtered, "Is there anybody here going to Superior?"

The clerk raised his bushy gray eyebrows. "There's a couple in the bar. Drinking." There was deep disapproval in his voice. He nodded to a door across the lobby. "In there. I expect it wouldn't hurt to ask."

As soon as I stepped over the bar threshold, loud shrieking bombarded my ears, "You don't know what the hell you're talking about!" followed by, "Me?! You're the dummy in this family!" The couple sat at a small table at the end of the room.

I gingerly approached them, noted the burly bartender off to my left drying glasses. "You old enough to drink?" he spouted.

The couple turned to look at me. "I'm not drinking," I said as I moved toward them. In their mid-thirties, both were clothed in heavy bibbed snowsuits and flannel shirts.

The woman had flowing blond hair. Her pristine-faced beauty was marred by a whiskey flush that coated her face. She smiled broadly. Her teeth were discolored and rotted. "Hey kid," she said. "Come join us!"

The man with her was dark haired and sullen looking. His eyes looked glazed and vacant. "What ya drinkin?" he asked.

The woman immediately spouted, "Didn't ya hear her? She's not drinking."

Turning to the bartender she hollered, "Bring the kid a Coca-Cola!"

I sat on the empty chair across the table from them. "I was... I was wondering if you guys are from Superior?"

The woman bellowed, "You got that right! I'm Claudia. This is my honey, Jeff. What's your name?"

"Fran. I'm from South End. I was supposed to catch the Greyhound, but it's stuck down the line."

Just then the bartender appeared with a tall glass of Coca-Cola. Setting it down, he said, "Normally I wouldn't even allow you in here, but it's slow today."

Jeff laughed. "Shit," he said. "This whole town's slow if you ask me!" He looked at Claudia. "I don't know why the hell you drug me here in the first place." He handed some change to the bartender.

Jeff's hostility emboldened me. In the snippiest voice I could muster I said, "They serve me in Superior all the time."

The bartender hooted. "Hell, that don't surprise me one bit. Superior's the least law-abiding city in the whole damn north woods!" He returned to his post, chuckling to himself.

Jeff grinned. "Don't let it get you down. He's nothing but a shit-ass redneck. They all are in this burg."

Claudia snapped, "Can it. We'll be leaving in half an hour. Let's try not to get into any trouble in the meantime."

An hour later Claudia and Jeff were finally ready to leave. I plodded behind them as they staggered to the hotel parking lot in back. Jeff spouted, "Holy shit! This is worse than a force-ten gale on Lake Superior!"

Claudia shrieked over the wind, "Ah, can it!" She turned her head and hollered at me. "The idiot worked one week on an ore boat. Now he talks like he's a veteran or something." She yelled at Jeff's back, "You're the one who wants to get back to Superior! If you want I'll drive."

Jeff stopped alongside an old heap and pulled open the rusted door. "No way in hell am I going to let you drive this baby!" Claudia tumbled into the front seat alongside him.

I was about to crawl in back when she spouted, "Get in front. The heater don't work." I threw my hat box in the back seat and slid in next to her.

By the time we'd sped out of town I was grateful that we three were huddled close against each other. The car was frigid, its windows coated

with frost. The windshield wipers barely kept the swirling snow off the glass. Balls of white spun toward us in a kaleidoscope effect as the car weaved west on Highway Two. Jeff hunched over the steering wheel peering through a quarter-sized, clear spot on the windshield. Claudia was fast asleep, snorting like a disgruntled sow.

I sat tense and rigid, thankful the highway was deserted. All the while I silently prayed, *God keep us in your care, every day, everywhere.*

Just past Poplar the snow began to diminish. A weak glow filled the highway ahead as the clouds began to clear. By the time we reached Superior the sun burst through. The banks of snow along our route sparkled in the sunlight. At Belknap and Tower Jeff asked, "Where you wanna get out?" He sounded sobered and glum.

I leaned forward, peered toward the Hotel Superior, thinking I'd be able to see the huge clock in the Greyhound depot. "What time is it?" I asked.

Jeff pulled back his coat sleeve and looked at his watch. "It's about three-forty."

I calculated that the South Superior bus would be passing the corner in twenty minutes. "You can drop me in front of the Board of Trade Building."[59]

As soon as I retrieved my hat box and got out of the car I felt a wave of relief, thinking, *Thank you Jesus for watching over me.* I was about to move up against the building to light a cigarette, when a sleek gray Pontiac pulled alongside. I leaned down and looked at the driver. It was Chris Barry, a 1950 Central graduate. A ripple of joy coursed through me. Dark and muscular, he'd been active in the Drama Club and was extremely popular with the girls. I jumped into the car and settled next to him. A broad smile filled his insolent, rakishly handsome face. "Changed your mind?" he asked as he pulled out onto Tower Avenue.

I shook my head in confusion. "What?"

He stopped at Twenty-first Street for a red light. Peering at me he said, "Shit, I thought you were Maizie."

"She's my sister," I snapped, thinking, *That little phony. Tries to make me think she's a virgin, then goes out with the wildest guy in town.*

Chris's face reddened. Spewing curses he hollered, "Get the hell out of my car. I don't mess with juveniles!"

Feeling heat on my face I sputtered, "Geez. At least you could drop me in South End. I don't want to get stuck out on this cold corner!"

Chris set the car back in motion. "I'll drop you at Fifty-eighth Street."

We were silent all along the route south on Tower Avenue. When I got out at the designated corner Chris yelled, "Don't tell your sister you got a ride with me!"

On the walk home up Fifty-eighth Street, I thought, *Damn, I've GOT to get to the bottom of this.* Though exhausted from my long day's ordeal, as soon as my sister came home from her job at Woolworth's I confronted her. "So Miss Prissy, what's this I hear about you and Chris Barry?"

My sister's face clouded. "What ARE you talking about. I wouldn't date that creep if you paid me!"

Confused but determined, I spouted, "HE told me you were in his car!"

Her pale freckled face cleared, "He didn't tell you I escaped his clutches, though did he."

I didn't want to believe her. "You're SO full of shit," I said.

"For your information I walked all the way from Enger Tower on Skyline Drive, to Superior Street and Garfield Avenue in Duluth, just to get away from that creep!" Her voice quavered.

Though I was sure she expected sympathy, I pressed on. "When the hell was THAT?! And how come I never heard about it?" All the while I was thinking that maybe she was a goodie-two-shoes. I'd never heard of anyone walking that far just to avoid having sex.

My sister's eyes filled with tears. "Way last year. When you were in summer school." She sniffled and continued. "What do you care? You never pay attention to anyone else's problems."

She had me there, though I refused to give in. "Can it," I said. "You are SUCH a bitch!"

Maizie screeched, "MA! Fran's swearing again." A little smirk crossed her lips.

Ma came rushing out of the kitchen. "Girls! Not so loud! The neighbors will hear you." Ma looked at me, her eyes clouding. "Frances, I wish you wouldn't use that foul language. It's so unladylike."

Her words enraged me. "What? And be like HER... a prissy cow who acts like a virgin but is really a WHORE!?"

Ma gasped. "FRANCES! Don't EVER call your sister a name like that. She's a good girl and should be treated with respect."

Detecting the smug look on my sister's face, I lashed out again, "For Pete's SAKE! Just because she's graduating this year everyone

treats her like a damn queen! Hells bells. She's a big phony!" I stomped out of the room, slammed the door behind me and rushed to my hideaway upstairs.

There, I swore that someday, somehow, I'd get even with my prissy sister. ◆

58 - 1508 Tower Avenue, Greyhound Station.
59 - 1507 Tower Avenue, Board of Trade.

Fair Plays

Live and let live is the rule of common. –L'Estrange

March stretched into May. I'd turned seventeen, was counting the days to the end of my junior year at Central. My sister Maizie turned nineteen on May twelfth. I was beside myself with envy at the thought of her escaping school a year ahead of me.

On the weekend of her birthday, the Superior Blues, the local Northern League baseball team, began their season. Maizie and her friends Sondra Brunette and Nellie Jano, took to attending the games at the Municipal baseball stadium. Sondra was graduating with Maizie. Nellie had dropped out the year before. I labeled them the vestal virgins and when Ma wasn't around, loved to shriek at my sister, "You and your friends might as well be nuns. You don't get none!"

I didn't attend my sister's graduation ceremony in June, couldn't bear seeing her in the spotlight. I did learn that the day after, Maizie and her friends got themselves in a mess of trouble. It all came to light when I ran into the kitchen to answer the phone one Monday morning. Though I didn't recognize the woman's voice, I felt my knees weaken when I heard her name. "This is Miss Stromlind," she said. "I'd like to speak to Mrs. Oliphant, please."

I dropped the receiver and without thinking, shrieked, "MA! It's that damn policewoman." I racked my brain wondering what in the world I'd done to draw Miss Stromlind's attention again.

My mother came rushing into the kitchen. Putting her finger to her lips, she shushed me. Her face darkened. "Have you been up to some mischief?"

Though I wasn't sure, I resented the question. "I haven't even been out in months!"

Ma picked up the dangling phone receiver. "This is Mrs. Oliphant. What's the problem?" She didn't speak for a long time after that. I imagined Miss Stromlind blathering on about some stupid little infraction of her hyper-strict moral code. *Maybe she'd seen me smoking somewhere, on a corner, waiting for a bus, or in a cafe chatting*

with friends. It would be just like her to make a big deal out of that.

All of a sudden my mother exploded. "Just one minute!" she said. "There certainly is no call for such an accusation! You don't even know the facts!" Ma was silent again, listening. I could see the little red spots expanding on her cheekbones. Her face paled as she lashed out again, "THAT is not your concern! I would think what people do in their own homes is THEIR business!" Silence again.

Ma's words confused me. *What was Miss Stromlind up to? Was she complaining that I smoked at home? Was she going to arrest Ma for allowing me to smoke?*

Ma beckoned me closer, put the receiver between us so we could both hear Miss Stromlind's raised voice. "Now, hold on Marie, don't get so upset. When you calm down, come in and see me at the station. We'll have a nice talk."

Ma spoke into the phone, "I may just DO that." She hung up and said, "The NERVE of that woman."

Still confused, I blurted, "What was that all about!?"

Ma took the coffee pot off the stove and filled it with water. "She claims your sister and her friends Sondra and Nellie, were drinking at Mrs. Brunette's." Ma's hand shook as she lowered the pot and lit the burner. "Last Saturday after they'd been to the movies in Duluth. Now she's calling us mothers and raising a fuss." She sank onto a chair at the kitchen table. I sat down across from her.

My mind reeled in relief that it was my sister and not me who the policewoman was concerned about. "Were they?" I asked, thinking, *The big phonies. They're not any better than me*! Still, I was a bit surprised that Nellie Jano was involved. I'd briefly hung out with her in school last year, was sure she'd be too chicken to take a drink.

Ma sighed. "Certainly not! Day told me all about it. Mrs. Brunette had a graduation party for Sondra and your sister. A spaghetti dinner." Ma's elbow was on the table. She lowered her head to her hand. "Day said Mrs. Brunette was drinking, but that the girls had pop. And I believe her."

To me the story sounded suspicious. "So. What's the big deal? Can't people do what they want in their own house?"

"That's what I want to know," Ma blurted. "Still... there were some fellows there."

"FELLOWS?" I shrieked, thinking, *This is getting very interesting.*

Ma scowled at me. "Just some young ballplayers." She lowered

her voice, "I'm sure that was Mrs. Brunette's idea. You know she's divorced." Ma's tone of voice sounded accusative.

I wondered what my mother was driving at, suddenly felt defensive. "So? You're divorced. What's that got to do with anything?"

"Mrs. Brunette likes young men around. I guess it makes her feel good, or something," Ma said. "I heard she's quite the butterfly."

I glared at my mother. *Oh for Pete's sake*, I thought, *There she goes again... suspecting the worst.* "That's her own damn business," I spouted.

Ma got up and retrieved the coffee pot. "Don't swear," she said. Pouring us each a cup, she returned the pot to the stove. "You're right, I suppose. But the woman shouldn't be drinking in front of young girls." She shook the thought away. "In any case, it isn't any of Miss Stromlind's business. When I go down to the station I'm going to tell her that."

Preoccupied as to what my sister had been up to, I thought, *Maybe Maizie's on to something.* It never occured to me that the ball players were fair game. At the same time I felt gleeful that it was her in trouble and not me. I was dying to get all the details, blurted, "Can I go with you to the station?"

Ma raised her eyebrows. "Maybe you should. It probably would be good to have a witness. I don't trust that Stromlind, that's for sure."

The next afternoon I accompanied my mother to the dreaded police station. The sight of the building prompted a shudder of uneasiness in me, recalling, as I did, my run-in with Stromlind. When we walked into her small office, the policewoman waved at one of two chairs in front of her desk and said, "Sit over there, Maizie."

Feeling indignant I spouted, "I'm NOT Maizie. I'm Fran."

Ma piped up, "That's a fine-how-do-you-do. You don't know one of my girls from the other."

Miss Stromlind blanched. "I beg your pardon. There certainly is a strong resemblance." All at once it occurred to me that the policewoman was disappointed it wasn't me in her clutches.

Ma settled into the oak chair next to me. "There certainly is not. Fran's sister is the spitting image of her father." She nodded toward me. "She resembles my side of the family." Ma's voice dripped with hostility. I knew immediately that we were in for a battle royal.

Miss Stromlind hesitantly broached the subject of the meeting. Leaning forward, she looked at Ma. "I understand your daughter Maizie

and her friends, attended a party where hard liquor was served."

"That is correct," Ma said, sounding as if she were parroting Miss Stromlind's priggish tone of voice. To me they both were acting like a couple self-righteous missionaries. "What is not correct is that the girls themselves were drinking. I believe that's what you inferred when you spoke to me on the phone."

Miss Stromlind sank back in her chair. Her cold eyes seemed to be focusing on the picture of J. Edgar Hoover that I remembered hung on the wall behind me. "How can you be sure they were *not* drinking." The policewoman's words were slow and carefully enunciated.

Ma straightened in her chair. "Because," she said, speaking just as precisely, "my daughter told me and my children don't lie." Ma glanced at me. I smiled at her in encouragement, felt heat rise on my neck. I hoped my uneasiness wouldn't remind Ma of her suspicions about me. I was sure she thought I sometimes had a fondness for bending the truth.

Ma frowned at Miss Stromlind, "How can you be so sure they were drinking? Did you raid the party? Or have a spy in their midst?"

Miss Stromlind readjusted herself, as if she were overheated. "I'm not at liberty to reveal our source of information."

"I'm sure you're not!" Ma spouted. "It's no doubt some over-zealous busy-body!" I was surprised at Ma's words, knowing how she always was so concerned over what our neighbors thought.

Miss Stromlind pressed on, ignoring Ma's outburst. "I don't think you are aware of all the facts. Mrs. Brunette invited the Superior Blues baseball team for dinner, too. She served them drinks."

Ma lurched forward and flattened her hands on Miss Stromlind's desk. "Can't Mrs. Brunette invite anyone she wants into her own home? And, I might add, I haven't heard of anyone pulling the mothers of those boys into the station for a lecture. Did you people pull them in?"

Mrs. Stromlind shook her head. "That wouldn't be possible. They're all from out of town." Pushing on, she said, "Mrs. Brunette was drinking martinis."

Ma edged back on her chair and pursed her lips. "You just don't get the point. In any case, the woman can certainly drink martinis or anything else, in her own house!"

The bickering between the two women began to bore me. Though I admired Ma for contradicting everything Miss Stromlind said, I

knew it was getting her nowhere. At some point in their ravings it again occurred to me that I'd never thought of baseball games as a place to meet guys. The more the two women went on, the more excited I got over the possibility of a new love. I silently vowed to check out the candidates the first chance I got.

Miss Stromlind leaned back, clasped the edge of her desk. The knuckles on her hands were white. "I'm sorry if I upset you, Marie. I thought it was in your best interest to know what kind of people your daughter is getting involved with."

Ma jumped up. "I don't think that you have the right to criticize what other people are doing! I also don't think you're the kind of person that should be advising young girls. Or anyone else, for that matter! The story around town is that you're having an affair with a married man. Everyone in Superior knows about him transporting girls from the cities to the Third Street brothels." With that Ma flounced out of the room.

I rushed behind her into the hallway. Without warning she halted so fast I plowed into her. "Sorry," Ma said. "I forgot something." She moved back through the open door to Miss Stromlind's office. "By the way, my friends are the only people who call me by my first name. To you I'm Mrs. Oliphant!"

On the street Ma said, "The nerve of that woman. I wasn't put on earth to criticize what someone else is doing and I don't think anyone else is either."

By July Ma would change her tune. It was the same month I launched my plan of action, by contacting Nellie Jano. Unlike Ma, after Nellie's mother was interviewed by Miss Stromlind, she had forbidden her daughter from associating with Sondra. Nellie, an avid baseball fan, missed attending the games and was overjoyed at the prospect of going with me.

The first game Nellie and I went to was the mid-season All Star Game.[60] We sat behind Maizie and Sondra in the first base bleachers. There, in the screaming crowd of local sports fans, the heady smell of popcorn and the vision of gorgeously fit players in tight pants, I went gaga over first baseman Ben Bobbitt.

Knowing little about the game and caring less, I concentrated on the object of my passion. Whenever he tagged a runner out, caught a fly ball, or scored a hit himself, I jumped from my seat and shrieked, "Atta boy, baby!" or "You got it, honey!"

My sister kept turning her head and scowling at me. Every once in a while she snapped, "Oh for Pete's sake! Do you have to make a spectacle of yourself!?" The fans around us laughed noisily in support of my actions. Then we all hollered, "Ben-EE! Ben-EE!"

All the while Nellie sat stiff and silent. I was sure she was embarrassed as well, but was too shy to say anything. She was a tall, flat-chested girl, with a somber look about her. Clusters of pimples regularly popped out on her oily skin. When she was still in high school her mess of dark kinky hair prompted her peers to call her Ragmop. I'd felt sorry about that and had gone to lunch with her at Cronstrom's a few times. Now I wondered if she was going to put a damper on my style. I needn't have worried.

During the third inning when the Blues were ahead by one run, Ben struck out. As he headed for the bench he raised his hat and waved at me. I jumped to my feet and screeched, "You're still hot in my book!" Everyone around me hollered, "Hot stuff! Hot stuff!" I blew him a kiss.

I thought Nellie's eyes would pop out of their sockets. "Wow!" she said. "You sure know how to pick'em!"

Feeling ecstatic, I leaned forward and asked Maizie and Sondra, "Where do the guys hang out after the games."

My sister snapped, "I have no idea!"

I looked at Sondra. She hunched her shoulders. Disgusted, I said to Nellie, "What's with those two... acting like they don't have the hots for any of the players?"

Nellie's narrow lips broke into a knowing smile. "They don't want to share, I guess." She lowered her voice, "Most of the guys eventually end up at The Capitol.[61]

An hour later Nellie and I were installed in one of the high-backed, oak booths in the Capitol. The huge restaurant was teeming with wall-to-wall baseball fans, yelling and laughing above the clamor of china and squawking waitresses. I noticed several Central girls, crowded six to seven in a booth. "Geez," I said to Nellie, "The competition's pretty stiff, I'd say."

"It's always like this," Nellie said. "Don't worry though, it peters out eventually." With that she waved over the waitress. "One hamburger with grilled onions and two Cokes." After the waitress left she said, "I'm really not hungry, but if we don't order something the owners will kick us out."

I leaned into the aisle, noted the two brothers who owned the restaurant. One of them was at his post behind the marble soda fountain. The other one was in the wood-encased cashier's cage, perched on a high stool. All the while their eyes darted back and forth, on guard no doubt for any hint of trouble. Both their wives and two gorgeous daughters were waiting on customers, rushing back and forth with plates of food and trays of Cokes.

It seemed hours before the ballplayers showed up. Nellie had finished her hamburger. Both of us were through with our Cokes. We switched to coffee and were puffing away on our cigarettes when one of the owners marched over. "You girls gonna sit here all night?"

I pursed my lips at him. "It's a free country isn't it?" I could tell he was taken aback by my snotty tone of voice. Just as he slunk away several young players burst through the front door.

The few fans still occupying booths around us let out a communal shout of welcome. All of a sudden I saw Ben. He stopped to chat with one of the waitresses. I felt a pang of jealously, was relieved when her father stepped over and said something. Ben's face reddened. He hurried toward the back of the restaurant, where his buddies had congregated in a booth right across from Nellie and me.

As soon as he settled in, I gave a little wave of my hand. Summoning up my most seductive tone of voice I said, "nice game Benny!"

His buddies hooted. "It's your favorite fan." Ben's lopsided grin filled me with longing.

And so it was that our flirtation soon moved on to a dingy room at the Saratoga Hotel.[62] Ben was a competent lover, willing to unleash his hunger and satisfy it. My need was more compelling. I yearned for a male friend. Being with Ben evoked memories of Mike and our night of nakedness at Glen's Standard Station. Nudity diluted the constraints I felt wrestling around fully clothed on car seats.

I was sure I now understood the aftermath of my time with Mike, too. I'd been too pushy. Guys didn't like that. I convinced myself that being friends with them was the answer. Live for the moment was my catchphrase regarding Ben. After all he was *someone* and I was nobody.

I was especially enthralled with his sinewy body. Ben was an Adonis, body-perfect and handsome. His chiseled face culminated in a lantern jaw that gave the impression he was confident and always in control. Nothing was further from the truth.

Fair Game

Stretching out side by side after our harried couplings, Ben talked on and on like a sotted teen about his love for the waitress. He wanted my advice on how to proceed. At first I felt sorry for him, remembering the times I'd been rejected. I told him he should call her. He was afraid her father would answer the phone. "Then call her when the old man's at work." Ben wasn't sure how he could accomplish that. "Go in the damn restaurant. If he's there, he's working." Ben then worried about the mother answering the phone. He wanted me to call.

Though I empathized with him, I prickled with jealousy. I could not believe that he would want a hard-to-get girl when a perfectly willing one was lying next to him. I promised to call, but didn't. I always told him she wasn't home or that no one answered the phone. It slowly occurred to me that Ben was just a small town guy who didn't know any more about girls than I knew about guys. Once when I'd had enough of his moping I snapped, "You sound like a broken record!" He blushed and tried to change the subject. It was pointless. He hadn't a single thought in his head except his love for the waitress and baseball. I wasn't interested in either subject. I kept vowing to dump him, but didn't. I was sure he would eventually tire of his torture and fall in love with me.

Our secret alliance dragged on. Whenever the ball team was in town, I'd meet Ben on the corner of Eleventh and Ogden. We stopped in murky little taverns for a couple of beers, then made our way down the back streets and over the Soo Line tracks to the Saratoga. After our two to three hour carnal romps, we'd leave the hotel separately.

I always departed first. I'd make my way to Broadway and Tower and wait for the South End bus. Then I watched as Ben loped south on the other side of the street. I knew he was heading for the Restaurant to get a glimpse of his true love.

Sometimes, after I got home, I'd retreat to my hideaway and rage over Ben's clodish behavior. At other times I felt gleeful that I had landed such a notable trophy. Thoughts of him constantly swirled in my head, leaving little room for anything else. One night after returning home from one of our trysts, I was dumbfounded by something my mother told me.

She was at her post in the kitchen, drinking coffee. Alarmed at the serious look in her sad eyes, I asked, "What's wrong now?"

My mother pulled up a deep sigh and, in a lowered voice said, "Did you know that your sister is dating a Negro ballplayer?"

All at once anger rose inside me. Overcome with confusion at my reaction, I blurted, "SO?"

Ma's eyes clouded. "I don't think you realize the seriousness of that kind of thing."

I felt a half-startled wariness, remembering Ma's constant admonitions, "Be kind to people," and, "Treat everyone with respect." I concluded that, as always, she was merely concerned with what people thought. "Why would I care who she goes with?" Something suddenly possessed me to divert Ma's concern. "I'm going with a ballplayer!"

My words didn't seem to phase Ma. "Is he Negro? she asked.

"No! He's from New Jersey. I suppose that's a no-no in your book too?"

Ma flushed. "Don't get sassy," she said. "Dating Negroes is very serious. It could bring a lot of trouble down on our heads."

"Oh for Pete's sake, you worry too much. I'm sure it's just a summer fling."

Ma's face clouded. "I don't think so. I had a little talk with your sister. She insists they're going to get married."

I was surprised that my mother had conferred with Maizie. "What did you say?"

"I told her the danger she was getting into. Told her that her friend could be lynched."

Ma's words brought uneasiness, spiced with irritation inside me. I wanted to lash out and condemn my sister, wanted to get even with her for all the aggravations I imagined she caused me. I had no idea what it was that held me back. I moved toward the dining room, intent on retreating to my hideaway upstairs. Pausing in the doorway, I said, "That's ridiculous! People don't do things like that up here."

I would soon learn how wrong I was. ◆

60 - July 16, 1952, Municipal Stadium, Superior, WI. The Superior Blues won the first half of the season, and the Northern League staged an All Star game between the Blues and the best players from the other seven teams in the league. The Blues won 8 to 6 - www.snake.net/nl/stats/all-star/1952.html.
61 - Capitol Candy & Tea Rooms Restaurant, 1114 Tower Avenue.
62 - 802-808 Tower Avenue, Saratoga Hotel.

Not Over By A Long Shot

A moment's insight is sometimes worth a life's experience. –Holmes

I tried to stay in bed as late as possible the morning after Ma's disclosure. I didn't want to hear any more about my sister's problems. Hoping Ma was gone, I descended the stairs. I could smell fresh-brewed coffee. Ma was at the kitchen table. I wondered if she'd sat there all night. *Damn,* I thought, *she's going to start on me.* Sure enough, as soon as I filled my cup and sank onto a chair, Ma brought up the subject again.

"Fran," she said. "I know you don't want to be bothered, but we have got to talk about this."

I rolled my eyes and lit a cigarette. "Okay. But make it fast. I'm going downtown to meet my boyfriend later." I waited for her to protest. She didn't.

Without ceremony she began, "You said last night that people up here didn't treat Negroes badly. You really don't know the half of it. In 1920,[63] a mob of Duluthians stormed the jail and hung three Negroes. They had been accused of raping a white girl. I was twenty-four, working as a bookkeeper at the Foot Room Shoe Store.[64] The worst thing was that the rape most likely never happened." Ma took a deep breath. "I remember how horrified I felt when I read the story. The Telegram had a picture of them hanging from a light pole on Superior Street."

I'd felt cold needles of anguish inside during Ma's narrative. Cautiously, I said, "That was a long time ago. I don't think anything like that could happen again. Not in Superior, anyway."

Ma shook her head. "Who knows? It seems to me things never change."

As much as I hated to broach the subject I plowed on. "That case in Duluth was about sex. As far as I know Day is still a virgin." I couldn't believe my own words. I'd even reverted back to my sister's family nickname. It was almost as if I were defending her. Still, a nervous unease filled me at bringing up the subject of sex.

Ma sighed. "I know," she said. "Day's basically a nice girl. She told me her friend is a strict Catholic. He's hasn't gotten fresh with her or anything." A wan smile crossed Ma's lips. "I never figured any of our people would marry a Catholic."

I thought, *At least she's not going to talk about sex.* I always felt uneasy when Ma discussed that subject. "So," I said, getting up, "I don't know what you're worried about. It's no big deal." I didn't care one way or another what my sister was doing or with whom. I suddenly felt positive Day wouldn't do it. At the same time I welcomed the thought of her getting married. I'd finally be rid of her.

Ma touched my arm. A pink flush gradually crept up her face. "Ah... there's something we want you to do."

My eyes left her face for a flutter of a moment. "We? Who are you talking about?"

"Miss Stromlind. She called me. Some concerned member of the Superior Blues Booster Club raised the alarm." Ma was beginning to look more and more embarrassed.

I sank back onto my chair, not feeling an ounce of sympathy at Ma's discomfort. "Raised the alarm?" I asked, "What alarm?"

Her languid eyes clouded. "Miss Stromlind said that they think some Negro player is taking advantage of young white girls."

I felt totally disgusted with the idea that Ma would fall into the policewoman's clutches. "Honestly," I said. "You're the one who told me Miss Stromlind can't be trusted. How do you know she's not lying?"

Ma hunched her shoulders in defeat. "It's just that... that... I don't want Day to get into trouble with the police."

I found it difficult to see Ma in league with the policewoman. "What does she expect you to do?"

Ma sighed again, annoying me no end. "Not me. You."

I shook my head in disbelief. "Me!?" All of a sudden a new thought crossed my mind. "Did she say she'd cancel out my police record if I cooperated?" I could tell by Ma's face I'd answered my own question. "That's blackmail!"

Ma raised her eyebrows. "That's one way of looking at it. On the other hand, it wouldn't hurt to have her on your side."

I hated to admit Ma was probably right. Still, it annoyed me. "Geez, all it was, was an underage drinking charge. And I wasn't even drinking that night!" My words were beginning to sound raw and very angry. "The damn record's supposed to be cleared when I turn eighteen, anyway."

Ma got up. "Must you swear?" She took the coffee pot off the stove and poured us another cup. "Look at it this way, it'll be a year sooner. Plus, it would be easy to confirm. Miss Stromlind will give us the exact date when she takes care of it. She promised."

I took a sip of the hot brew, lowered the cup and looked at my mother. "What do you guys want me to do? Spy on Day?"

Ma shook her head, "Not spy, she said. "Observe, is more appropriate. Miss Stromlind just wants you to go to the games and watch Day. Make sure she's never alone with any of the Negro players at any time. Oh yah, and find out what his name is."

The thought slowly sank in. Spying, was how I saw it. I wasn't adverse to the idea though. I had often dreamed of being a detective, or a secret agent. Alarm bells went off in my head. *Maybe word is out on my activities with Ben.* Ma was right. It wouldn't hurt to have Miss Stromlind on my side. Forcing myself not to sound too eager I said, "Oh all right, I'll give it a try."

The very same night I broached the subject with Ben. I figured I could get some information without putting forth too much effort. He was less than helpful. Lying naked next to me after our steamy coupling, all he wanted to do was talk about the waitress. Trying not to sound hostile I snapped, "Can't we talk about something else for a change? Like baseball, maybe? You never told me anything about the Negro players."

Ben's handsome face darkened. "What's to tell?" His voice sounded pouty, like I'd hurt his feelings. "There's three of them. Two from Cuba and one from the States." He rolled onto his side, his back to mine. "Why? You interested?" His muffled words sounded crude.

I turned onto my side, encircled his taut body with my arm. "Don't be silly," I said, forcing myself to sound light hearted, though his tone of voice irritated me. "I got you. Why would I want anyone else?"

Ben rolled back to face me. The piston driving strength of his body possessed mine again. Afterwards, as I snuggled against him, I pressed on. "Whose the guy my sister's dating?"

Ben exhaled, sounding weary. "Alberto Ibereco," he said. "A nice guy. And an A-one pitcher. The Chicago White Sox have their eye on him."

Feeling slightly confused I said, "I heard he screws anything that moves."

Ben hooted. "That's Giddy-up Grant. He's a whore master. Likes white meat."

I felt my face cloud, blurted, "Sometimes you talk like a pig!"

Ben laughed again. "Just telling the truth."

Anxious to get back on track, I changed my tactic. "So, what's with Maizie and this Alberto guy? They been dating for a long time?"

Ben raised his eyebrows. "I think so. Not that they go anywhere. They walk around at night a lot. Or sit on the steps in front of the YMCA."

"Why do they do that?" I asked.

Ben looked uneasy. "You know. People don't like seeing that sort of thing in public places. Your sister and her friends were banned from the Capitol for sitting with the Negro players." A light bulb abruptly went off in my head. That's why I've never seen them in the places I hang out. I felt myself explode, "What the hell kind of trouble is that?"

"You know. It's... well... it's just not done."

"Oh for Pete's sake! That is so stupid!"

Ben hunched his muscular shoulders. "That's how it is. Nothing much anyone can do about it."

I felt something inside burst. "Well, I think it's sick." With that I jumped out of bed and started dressing. "By the way," I said. "I'm gonna be kind of busy for a while. I won't be meeting you for a week or so."

Ben lay back on the bed, his arms behind his head. "Okay," he said. "Give me the high sign when you want me again."

Geez, what an idiot! I thought, not sure if I meant myself or him.

I resolved not to think about Ben. I would concentrate on the task at hand. And though I'd come up with Day's boyfriend's name, I hesitated passing it on to Ma. She would want to know how I'd gotten the information so fast. I called Nellie Jano and made a date to meet her at the Municipal ballpark the next night. It was the last home game before the team was scheduled to leave town for their Eau Claire Bears series.

Nellie and I took our usual places in the first base bleachers behind my sister and Sondra. I decided to behave myself and ignore Ben. I concentrated on watching Maizie. Before that night, I'd never noticed how engaged she was with everything Alberto did. When he struck out a batter she jumped to her feet, screeching and hollering. When a hitter connected with his amazing fast ball, my sister sank back, totally dejected. Every time Alberto headed for the bench, they waved back and forth. I glanced around me, trying to determine the crowd's reac-

tion. Most paid little attention. A few older people leaned together whispering and tut-tutting. All in all I concluded Maizie wasn't any worse than me. She was just in love. I could empathize with that.

Like all the revved up fans around us, Nellie and I cheered the home team on. We gobbled hot-dogs and popcorn, washing them down with orange soda-pop. During the seventh inning stretch some of the people in our row of seats left. They were immediately replaced by three Negro women. The women were well dressed and flawlessly made up. Their hairdos were so perfectly coifed I suspected they were wearing wigs. Especially the shortest one. Her hair was a brilliant shade of red.

A ripple of whispering exploded around us. I heard someone say, "Must be the ballplayer's wives." Another one responded, "Good. They got wives." Momentarily confused I thought, *Damn, I forgot to ask Ben if any of those guys were married.* I couldn't bear the thought of Maizie finding out. I'd often been a witness to her overwrought histrionics. Ma blamed them on my sister's inferiority complex. To me it seemed she could turn on the tears at the drop of a hat. *Geez, I hope everything works out for her.*

Soon I was wrapped up in the exciting game and forgot about my assignment. It was a closely-contested battle, as were all games between the Blues and their arch rivals, The Duluth Dukes. The Blues won three to two in the ninth inning.

Nellie got up to join the mob heading for the exits. I clutched her arm, "Let's wait for Maizie and Sondra." When my sister and her friend headed out, Nellie and I tagged behind them. They slowed as they exited the stadium, like they were looking for someone. My antennae went up, my body tensed. The three young Negro women I'd noted earlier were standing on the curb in front of a Saratoga cab. "Girls!" they yelled, "Over here." Maizie and Sondra hesitated, looked back at Nellie and me.

"Do you know those women?" my sister asked.

I hunched my shoulders. They were sitting next to us, that's all I know."

The red head hollered, "Maizie! Come here, I got a message for you."

My sister nodded to Sondra. They both walked over to the cab. Deep in conversation, suddenly Maizie turned. "You guys want to go with? We're going to their hotel. For Cokes."

I looked at Nellie. "You wanna come?" I asked.

Nellie's dark face paled. "I don't think so. I'm not supposed to go anywhere with Sondra."

Briefly hesitant myself, I hollered at Maizie, "Are there going to be guys there?"

"No way," she hollered back.

Nellie said, "I'm going to get the bus. I'll talk to you tomorrow." With that she sprinted north, toward the bus stop.

I sauntered over to the cab. "Where you staying?"

The redhead said, "The Saratoga Hotel. At Eighth and Tower."

I was briefly mystified. "You know that's a dump, don't you?" "You should be staying at the Androy." I refrained from mentioning how I knew.

The three women burst into silvery laughter. First to recover, the redhead said, "Are you kidding? They wouldn't let us in their damn lobby, let alone one of their precious rooms,"

Suddenly puzzled as to why the ballplayers couldn't find better housing for their wives, I said, "I thought all the guys stayed there."

My sister piped up. "The white ones, maybe. Geez, you don't know nothing. The Negroes stay at the YMCA."

Before I could sort out that confusing piece of information the cab driver spouted, "You females going to stand there all night? I gotta get rolling."

The redhead got in the front. Sondra and Maizie and the other two women squeezed in back. My sister said, "You can sit on my lap." I rolled my eyes thinking, *This is disgusting*. I was beginning to get fed up with my role as snitch.

The room the women were staying in at the Saratoga was quite large. Still, it was just as grimy and sparse as the ones Ben and I had occupied. There was a huge, frayed looking couch and a double bed. The rest of the heavy furniture was chipped and ugly. My sister and Sondra settled on the couch next to one of the Negro women. I perched on the edge of the bed with the other two.

Our hostesses, who had given us money to buy pop at the restaurant in the building, were animated conversationalists. They laughed a lot and were so bubbly I couldn't help but enjoy myself. All the while I was wondering how I dared bring up the subject of their marriages. I sure didn't want to put a damper on the party.

The women began passing around bottles of Coca-Cola. Without warning, the door suddenly shook with loud banging. I jumped to my feet. "That better not be any guys," I spouted, looking at the rest of the group. They all seemed stunned.

337

Before anyone could move someone on the other side of the door yelled, "Police! Open up!" No one moved. The door crashed open. Three huge police officers burst into the room. One rushed into the bathroom, another one opened the closet door. The third officer yelled, "Where are they!?"

The redhead stepped forward, "Who you looking for?" she asked.

"Shut up!" The officer motioned toward me, Maizie and Sondra. "You girls come with us. We're going for a ride." We obediently filed out. Two squad cars were parked in front of the hotel. A scruffy group of North End winos and derelicts had gathered. When they saw us, a ripple of laughter passed through the group. I didn't see anything funny about the situation.

Miss Stromlind was waiting for us at the dreaded station. Sure her methods hadn't changed, I sauntered ahead of her and my sister. Entering the room Ma and I had occupied just days earlier, I switched on the light. I could hear Miss Stromlind outside ordering someone to take Sondra home in a squad. "Her father'll straighten that one out," she said. Then she directed my sister to the room next door. Settling into one of the chairs in front of the policewoman's desk, I steeled myself. I knew I was in for a long and hostile confrontation. Almost immediately I heard my sister's horrendous sobs. *There she blows!* I thought.

It wasn't long before I heard my sister's raised voice, "I have never had sex!" I got up and moved closer to the wall, leaned my ear against it. I recognized Miss Stromlind's voice, but couldn't make out her words. Maizie's were loud and clear. "I'm not saying another word!" The policewoman spoke again. My sister shrieked, "No! You can't do that! No one examines me. You better let me call my mother!" Her screeching suddenly stopped. It was replaced by heart wrenching sobs.

Minutes later I heard the door slam. I rushed back to my chair, sank into it. Miss Stromlind blasted into the office. Taking the seat opposite me behind the desk, she adjusted her suit jacket and folded her hands in front of her. I wondered which of her tactics she was going to assume. Friend or foe? A forced smile crossed her narrow lips. *Ha*, I thought, *friend.*

Raising her eyebrows as if in expectation, the policewoman said, "So Frances, what have you got to tell me?" All the while I could hear Maizie. Her sobs had lessened, but were still audible. I began to feel angered that Miss Stromlind didn't acknowledge them.

It occurred to me then that no matter how much the policewoman

tried, she could never be compassionate. Hunching my shoulders, I forced confusion into my response. "There's nothing to tell. My sister never met up with her friend."

Miss Stromlind closed her eyes as if in defeat. "You were supposed to get his name."

"I forgot," I said. "I did what you wanted, though. I went to the game and watched them. They waved at each other a couple times, but they didn't meet afterwards."

I figured it was time for Miss Stromlind to slam her hands on her desk. I wasn't disappointed, didn't even flinch at the sound. "You went to a hotel room with those women! What was that all about!?"

"They invited us," I said. "I didn't see anything wrong with that. They're baseball player's wives."

Miss Stromlind's laughter was raw and humorless. I straightened in my chair. "Wives? They aren't anyone's wives. They're whores! Prostitutes from Duluth! Friends of your sister's boyfriend."

I feigned surprise, though her words disarmed me. "So, you already know the boyfriend's name, then?"

Miss Stromlind ignored my sarcasm and raised her voice, "Giddy Grant. We know all about him. He no doubt planned on taking advantage of you girls."

I tried not to show the relief I felt. She was so far off track. I avoided contact with Miss Stromlind's cold eyes, looked up at the ceiling. "I don't know where you got that from. He wasn't even there. Unless your cops blew it and showed up too soon?" The tick of the pendulum clock above Miss Stromlind's desk mimicked the heavy beat of my heart. My eyes met her steel gaze. She leaned toward me. "All bets are off," she said. With that she picked up the receiver on the black phone and dialed a number. "Get Masterson to drive these Oliphant delinquents home." She slammed down the receiver and looked at me. "This isn't over by a long shot."

Maizie and I sat side by side in the back seat of police officer Ray Masterson's squad. She raved and sobbed and occasionally under her breath, hissed, "Damn bigots!"

I felt no compulsion to comfort her. I was contemplating my short career as a snitch. The more I thought about the mess I was ensnared in, the angrier I got. I was sure it wasn't my fault. I wanted to blame my sister, but in some perverse way, pitied her. Still, she had tricked me into going to the Saratoga. The thought pissed me off. I leaned toward

her and whispered. "What did that woman tell you?"

My sister's tear-splotched face darkened. "What woman?"

I hissed louder, "The damn women who invited us to the hotel!"

Maizie's face cleared. "Oh, that. She said Alberto wants me to meet him in Eau Claire." Her face screwed up and she began sobbing again.

My sister's words inflamed me. *Geez, those women must have thought we were awful stupid.* My anger rose. I was sick of everyone –the policewoman, my sister, her friends and my mother. After all, she was the one who talked me into getting involved.

Before the squad came to a halt, Maizie jumped out and ran up the stairs to our house, slamming the door behind her. I felt grateful knowing Ma was at a Legion Auxiliary meeting. As I got out of the car and headed for the house, Masterson sauntered behind me. On the porch I turned to close the door. He put his foot in it. "Tell your sister if we ever catch her with her boyfriend, we'll have a bucket of tar and feathers ready."

Something inside me gave way. I pushed the door wide open, then pulled it toward me with all the force I could muster. The door slammed against the policeman's foot. He yelped and jerked back. Reaching for his night stick, he hollered, "Son of a bitch!" I quickly slammed the door shut and locked it. Masterson began banging on the door and ordering me to open up. It was then I saw my brother standing in the hallway. He was in his faded pajamas, his face ashen. "What the hell's going on!?"

I hissed, "Don't open the door." We stood in silence until Masterson stopped yelling. We heard the screeching wheels of his squad as it careened down Sixtieth Street.

I could hear Maizie's sobs again. "What's wrong with her?" my brother asked.

Unable to bear any more hysteria, I snapped, "Can it!" I thundered up the stairs to my hideaway. There I burst in fury and cursed the world... the police, Miss Stromlind, my sister, my mother and finally, myself.

Miss Stromlind was right. This was one mess that wasn't over by a long shot. ◆

63 - On the evening of June 15, 1920 a crowd of 5,000 to 10,000 men, women, and children stormed the jail in Duluth and hanged three young black males who had been accused of raping a white girl. - (The Lynching in Duluth by Michael W. Fedo).
64 - 1315 Tower Avenue, Footroom Shoe Store.

Cross Questions and Crooked Answers

She was born to make chaos cosmic. —Beerbohm

Discord continued to be the normal state of affairs in our house for the remainder of the summer of 1952. The day after our run-in with the policewoman, my sister's trials magnified. She took off on the morning Great Northern train to Eau Claire.

My brother sounded the alarm. From the bottom of the stairs, he yelled, "Fran! Ma wants you!"

Quickly dressing, I descended to the kitchen. I knew Ma was agitated as she hadn't made coffee. Howie was at the stove, about to add grounds in the enamel pot. I snatched the canister from his hands, "I'll do it!" I snapped, then lowered the flame on the burner. One by one I measured out eight tablespoons of aromatic grounds and deposited them into the boiling water. Each little movement felt wooden and labored. After adding a handful of crushed egg shells, I turned to leave the room.

I heard Ma's stringent voice. "Where do you think you're going?!"

Trying hard not to sound snappish I said, "Just upstairs. Until the coffee's done."

Howard immediately piped up. "You always chicken out after you screw up!"

I rushed at him. He retreated behind Ma's chair, his fisted hands in front of his face in a boxer's pose. His lopsided grin was galling. I screeched, "You don't know your ass from a hole in the ground! Ma! Why is he here anyway? He should be at work."

Before she could respond Howard spouted, "Because, she asked me!"

I looked at Ma. Her languid, sad eyes clouded. "We're a family. When things happen we've got to work them out together."

"Since when!?" My words sounded harsh, but I didn't care. "None of you give a shit when I have problems!"

Howard's shrill cackle broke loose. "That's because you're always in trouble. Who can keep up?"

Ma jumped from her chair. "Shut up you two!" Quickly composing herself, she looked at Howard. "The coffee's done. You can pour it." He slunk past me like he was afraid I'd bop him one.

Ma's outburst had chilled me. After she sat back down, I nervously sank onto the chair opposite her. Howard filled the three cups that were on the table. I passed one to Ma. My brother took his and moved to the chair next to her. Ma's words were slow and measured, "I got two phone calls this morning. One was from Woolworth's. They said Day didn't show up for work. I had to tell them she was sick. Do you know where she is?"

The solemn tone of Ma's voice was a wake up call for me. I knew it would be pointless to lie. This time. "I think she went to Eau Claire. To see Alfredo."

Howard spouted, "Geez. What an idiot!"

Ma shushed him. "Why would she do that?"

I hunched my shoulders, decided to get the worst over. I would have to tell Ma about our misadventure with Miss Stromlind eventually. "Probably to warn him about what happened last night," I said.

Ma's face darkened, her forehead creased. "I hope they didn't elope."

Howard spouted the words that were on the tip of my tongue, "At least we'd be rid of her!"

Ma sighed. Sounding grim again, she looked at me, "I want you to call Sondra and find out what's going on."

"Geez! Why do I have to do everything!?" Knowing my protest was useless, I glared at Howard. "At least get rid of him. All he does is snicker in the background."

Ma looked at my brother. "You can go now. And don't repeat anything you've heard here."

Howard headed toward the dining room. Stopping in the doorway he said, "Everyone in South End probably knows already." He rushed out. I heard the front door slam behind him.

Ma lifted her hand and pulled it across her eyes. "Oh Lord," she said, "What have I done to deserve this?"

I got up and crossed the room to the phone. Picking up the receiver, I dialed Sondra's number. Her mother answered, "Hello. Brunette residence."

"May I please speak to Sondra," I asked, shifting from one foot to another.

"She's down in Eau Claire. Who am I speaking to?"

"Frances Oliphant. Maizie's sister." Sondra's mother immediately lowered her voice and asked to speak to Ma. I put my hand over the receiver, "She wants to talk to you."

Ma shook her head. "Uff," she said. "Do I have to?"

I felt my lips curl in a sneer. "You'd better if you want to find out anything."

She laboriously pushed herself up out of her chair. Taking the phone, Ma said, "Mrs. Brunette? I guess it's time we had a little talk."

I retreated to the living room, sank onto Ma's rocker and closed my eyes, thought, *when in the world is this all going to end!?* More than anything else I wanted to run away. I vowed as soon as I graduated I'd escape –away from Ma, away from everything.

Moments later Ma called me back into the kitchen. She was in her chair again, looking ashen. "Mrs. Brunette said Day's friend put a deposit on an engagement ring."

I sat down. "How does she know that?"

"Sondra's father owns a jewelry store. He told her."

A memory inside me ruffled. I'd once been so sure I was getting a ring. "Is the ring still there?"

"Yah... oh, I see, "Ma said. "Then they're not eloping. Maybe."

I summoned up my most comforting tone of voice, "I don't think so. What else did she say?"

"Not much. Only that she thinks I should sue the police department."

"What! Where are you supposed to get money for that!?" All I could think of was that this mess was getting worse by the minute. I got up and retrieved the coffee pot, poured us two more cups.

Ma's face had reddened at my words. "I... don't know what to do. It just makes me so mad that your father found out."

Afraid I'd drop the coffee pot, I lowered it to the table. "You did-n't tell me!"

"That was the second phone call. I didn't want to say anything in front of Howard. Who drove you home from the police station?"

I suddenly realized who the cop was. I felt my heart pound in my chest. Taking a deep breath, I sank to my chair. "It was that Masterson. Father's friend. The same one who told him about me getting picked up for drinking."

"Bastard!" Ma spouted.

Though shocked at her swearing I went on. "What did Damer say?"

"He said it was you. Said you were having a baby. A Negro."

I felt something sink inside me. "Oh for Pete's sake! I get blamed for everything! That sonofabitch cop's no angel. He tried to kiss me. That time we got picked up for drinking. When he drove me home."

Ma's face paled. "I suppose your Aunt Etta got hold of that. It galls me that she doesn't tell me anything. I could have nipped it in the bud right then and there."

I shook my head. "What could you do? When you went to court the judge didn't even want to be bothered with the case. All he did was lecture Damer."

Ma snapped, "I'd have told the judge! Would have got him to speak to the Chief! They would have gotten rid of Masterson."

I shook my head. "I don't think so. Those guys all stick together. Forget it. I don't give a shit what people say about me. Or think, for that matter."

The day after Maizie got back from Eau Claire, she was fired from her job at Woolworth's. Ma told all about it. "They sent a patrol car to the store to bring her in. That was all the management had to see. At police headquarters they tried to get her to say she'd slept with Alfredo. She refused. Thank God they let her call me. Miss Stromlind backed off after I threatened a lawsuit."

It was a Friday morning when Ma told me the story. "When did all that happen?" I spouted.

"Yesterday. You were at the movies," Ma said. "I don't know where else. You didn't get home until late."

I didn't give Ma the chance to cross-examine me. "Oh yah, I went out with Nellie," I lied. "I thought maybe she knew something." The truth was that I'd met Ben at the Saratoga. Reminding Ma that it was time for her to go to her dog-sitting job, I retreated to my room.

I had in fact questioned Ben about the situation. He said, "They told Alfredo not to hang-out with your sister. Else he'd lose his chance with the White Sox." Ben told me Alfredo was drinking heavily. "I think he's finished. They'll ship him off to Iowa. I wouldn't be surprised if he goes back to Cuba eventually."

Things went from bad to worse for my sister. Alfredo stopped seeing her. She spent hours on end in bed, sobbing and screaming accusations like, "Those damn cops terrorized him," or, "They told him they'd

344

hang him!" Once, she wailed, "I'll die if I never see him again." At times I thought she would lose her mind. Other times I just wanted her to shut up. If Ma tried to comfort her Maizie screeched, "Leave me alone!"

Toward the end of August things settled down. Neither my sister nor I went to any more ball games. She got a job at Western Electric in Duluth. I seldom saw her. I was preparing for my final year at Central High. Meantime, I lost Ben. He didn't even say goodbye.

Nellie telephoned to give me the news. "Your boyfriend was rushed to the hospital after the game last night," she said. "His appendix burst."

I instantly felt compelled to comfort Ben. The next morning I bused to St. Mary's Hospital[65] in Duluth. After getting Ben's room number, I stopped in the gift shop and bought him an Almond Joy candy bar. Nearing his room my resolve wavered. *Maybe he's not alone.* I walked by the room and glanced in. I felt myself blanch at what I saw.

Sitting on the edge of the bed holding Ben's hand, was the waitress. They were bubbling with laughter. Feeling a terrible disquiet rise inside my chest, I hurried back down the hall and left the building. Just as I approached the corner of Fifth Avenue East, my bus shot by. *The hell with it,* I thought. *I'll walk.* On the way down the four blocks to Superior Street I stuffed half of the Almond Joy into my mouth. My heart was thundering inside my chest. I breathed deep and tried to swallow. The candy lodged in my throat. Gagging, I spit it out.

I wasn't sure if I was gagging on the candy or my failure with Benny. ◆

65 - 407 E. 3rd Street; Duluth, MN, St. Mary's Hospital.

ALL THE WRONG FACES

You need someone to love while you're looking for someone to love. –Shelagh Delaney

In a daze, I found myself standing outside the Coney Island.[66] I was ablaze with spite. Entering the restaurant my mind whirred with thoughts of revenge. I'd call Ben and tell him off. No. I'd call her and reveal our trysts at the Saratoga. I gobbled down three coneys. Afterwards I felt worse. A terrible burning filled my throat. I waved the waitress over and ordered a Coke. "I need to belch," I said. "This damn food gives me heart burn."

The woman was tall, dark and painfully slim. "That's no wonder," she said. "You eat too fast. What you need is a beer." She laughed and went to get my Coke.

Her words had planted a seed of an idea inside my head. *After all I've been through, I deserve a little fun.* As soon as I finished my Coke I took off down Superior Street. I'd decided it was time to revisit Kytos Bar.

The long walk was invigorating. I marveled at the crowds on Duluth's main drag. Dazzled by the high buildings and bustling activity, it seemed to me that the Duluth citizenry were a lot more light-hearted than their counterparts in Superior. I envisioned myself living in this stimulating metropolis. Even as I traversed the seamy blocks of Skid Row, my spirits soared. The scenes that had once scared me, now felt familiar and completely unthreatening.

On Michigan Street, when I entered Kytos, it was as if I'd come home. The dim dive was bustling with noise and activity. Derelict bar patrons sat slunk over their glasses of beer as if they'd been frozen in time. All the small tables were filled.

Before my eyes adjusted from the bright sunlight outside I heard my name called from two different sections of the room. I recognized both voices. One was Marvel, the other one Vernetta. Before I could decide which to go to, Vernetta appeared. She put her hand on my arm. "Come on! I'm sitting back by the jukebox."

As we passed her table, Marvel jumped up. Grabbing me by the

wrist, she yanked me toward her.

Vernetta halted. "Let go of her you dike!"

Marvel, who just last summer had fascinated me with her personality and verve, was a different person. Her blond hair was mangy, with one-inch dark roots. She was a lot heftier than I remembered. She wore a loose-fitting, long cotton shift that was wrinkled and spotted. Silence momentarily settled in the room. Marvel hollered, "Back off, bitch!" Her once light, breathy voice was hoarse and tinged with whiskey.

Vernetta stepped in front of me. With both hands she pinned Marvel against the wall. Putting her face close up to Marvel's, she said, "You gonna behave? I'd hate to have to slap you silly."

Marvel whined, "Ah Geez, Vernie, I ain't gonna do anything."

Vernetta led her to her chair. "Sit! And keep your big mouth shut."

Marvel sank down next to her companion, an obese, middle-aged woman. The room once again filled with the clamor of raucous voices and clinking glasses.

On our way to Vernetta's table I said, "I thought Marvel would be in New York City by now. What happened?"

I was tagging behind Vernetta as she weaved her way through the crowded, narrow room. Over her shoulder she said, "Her boyfriend Tony dumped her. Took off for Italy. She's been a basket case ever since." Vernetta's laugh was humorless. "Booze. Sex. Drugs. You know the routine."

Vernetta's words rattled me. "That's dumb," I said. "Guys aren't worth that kind of trouble."

My friend stopped at the last table in the long room. There, before my very eyes sat Sophie, Vernetta's boyfriend's mother. Vernie pulled out a chair and sat down. "You remember Sophie don't you?"

I lowered myself next to her, felt myself tense at the sight of the woman. She looked as disheveled and evil as the first time we'd met in Myra's kitchen in Superior. Summoning up my friendliest tone of voice I said, "How ya doin?"

"Whoever I can," Sophie cackled. Waving over the bartender she ordered a round of beers.

"I'll get my own," I said. "I got a couple of bucks."

Sophie's laugh was galling. "You could have a lot more. If you're interested."

Vernie looked embarrassed. "Geez. Take it easy. She's just a kid."

I burst out, "I am not! It's just that... I don't like to ask anyone for money. They'll think I'm a whore or something."

Sophie's homely, veined face darkened. "I didn't say anything about whoring did I? I'm talking about hustling drinks, for God's sake."

I glanced at Vernetta. She seemed to have drifted away from us. I noted she still looked exotic. Her full, red lips were as sensuous as I remembered; her eyes, pools of unfathomable darkness. "What 'cha thinking about?" I asked.

"Bubba. I'm supposed to meet him at Tony's Cabaret.[67] In Superior. We're going to move my stuff."

Oh damn, I thought. *Not that again!* "Where you moving now?" I asked.

Sophie piped up. "She's gonna bunk with me for a while. Upstairs at the Fifth Avenue Hotel. My smart-ass daughter kicked us out." With that she burst into high-pitched cackles again. "Her loss," she said.

Vernetta excused herself to go to the bathroom. Sophie immediately clutched my arm. "Listen," she said. "If you go with her to Superior be sure she don't pick up with anyone but Bubba."

Oh geez, I thought. *Another job for the bumbling snitch.* Something occurred to me. *There sure are a lot of people in the world who don't trust each other.* "I wasn't planning on going to any more bars." I shook her hand off mine.

Sophie scowled. "Loosen up," she said. "Life's a bowl of cherries." Her grating laughter boomed above the noisy room.

Vernetta strolled back to our table. Her undulating hips drew lustful glances from the guys at the tables around us. "What's so funny?" she asked.

Sophie waved her hand as if fending off a swarm of pesky mosquitoes. "I was telling Frannie about the Kyto parties." She leaned toward me. Whiffs of garlic fumes filled the space between us. "The New Year's Eve party is a real blast."

Vernetta spouted, "That's four months down the road. Who knows if any of us'll still be around." She rolled her eyes. "Listen Sophie," Vernetta said. "I'm gonna go. Bubba'll wonder what's going on. Give me some scratch for a cab."

Sophie retrieved an enormous purse from the floor. Plopping it on the table she dug inside, extracted a five dollar bill. "Keep the change," she said. She pulled out a key from her blouse pocket. "You'll need this to get in the room. Don't lose it."

Vernetta took the five and the key, then waved over the bartender.

"Call me a cab." She glanced at me. "You're welcome to ride along."

Though I didn't even have a buzz on, there was no way I wanted to be left alone with Sophie. I was afraid that maybe Marvel would get out of hand, too.

During the cab ride to Superior, Vernetta said, "Don't tell Sophie, but me and Bubba split." With that she clammed up and stared out the window. I didn't dare ask for any details, didn't want to know any. It seemed to me every girl I ever knew was losing her lover, including me. When the vehicle pulled up in front of Tony's, Vernetta asked, "Do you wanna come in?" She sounded like she didn't care one way or another.

Afraid I'd get stuck with the cab fare I said, "Sure!"

Inside Tony's Cabaret, Vernetta marched straight through to the immense dance hall beyond the bar. The room was long and wide. At the back was a wrought-iron railing. Farther on was an elevated, deserted bandstand. Both sides of the room housed high-backed, wooden booths. I could just make out three guys sitting in the furthest booth to our right.

Vernetta headed straight for it. Her whole demeanor brightened, from the swing of her hips to the bounce in her step. "Hi guys!" she sang out as she reached her destination. By the time I caught up to her, Vernetta had slid in next to a light haired, good-looking guy. I stopped in my tracks. It was Killer, the guy I'd met in the Labor Temple bar with Diane Koonia. The one who had dumped us. Sitting across from him was Maurice, the guy Diane had romped with in the back seat of Killer's car. The third guy was a stranger. I didn't wait for introductions, turned and headed for the door.

Before I got there, Maurice caught up to me. "What's the problem?" he asked. He was much taller than I remembered, with broad shoulders and smoldering dark eyes. As soon as he looked in my face I knew he recognized me. "Oh," he said. "Afraid Killer's going to remember who you are?"

I nodded yes. "I should get home. I'm not used to drinking during the day."

Maurice hollered over his shoulder, "Be right back!" He guided me by the elbow out of the bar onto Third Street. "I'll give you a ride," he said. He headed for an old clunker parked in front. I slid onto the passenger seat, felt relief at the thought of escaping what I was sure would have been an embarrassing scene.

On our way south on Tower Avenue Maurice seemed intent on finding out about Vernetta, like how long I'd known her, if she was engaged, and where she lived. *A clod*, I thought, *Just like Ben. Talking*

about another women when he's with me. Still, I couldn't get something Diane had said about Maurice out of my mind. "He is such a good kisser." *Maybe I'm being too hasty.* "So," I asked, "What do you do for a living?"

Maurice said, "Not much. I'm going to college. On the GI bill. Studying Psychology." I was impressed. "Got some health problems, though. Ulcers. Which reminds me, I'm out of milk." He pulled the car over at Nineteenth and Tower, across from the Nottingham Apartments.[68] Bounding out, he crossed the street to the small grocery store[69] on the main floor. My heart skipped a beat at the sight of his easy stride. He moved with the hard grace of someone who had total control of himself. Back in the car he opened the milk carton and gulped down the liquid like he was dying of thirst. Wiping his mouth with the back of his hand he said, "It's hell when I drink."

Smiling the most comforting smile I could muster I said, "Maybe we could get together sometime?"

"Sure," Maurice said, sounding enthusiastic. "Write down your phone number. I'm going out of town tomorrow, but I'll call you when I get back."

Though his words raised my spirits, I hesitated getting my hopes up. School was looming just around the corner. I was amazed I had made it to my senior year. Maybe Ma's endless litany, "Everything works out in the end," was true. I had my doubts. ◆

66 - 107 E. Superior Street; Duluth, MN, Coney Island.
67 - 1710 N. 3rd Street, Tony's Cabaret, Superior, WI.
68 - 1719 N. 19th Street Nottingham Apartments, Superior, WI.
69 - Nottingham Cash Market, 1828 Tower Avenue (David Kaner, Owner).

Remote Possibilities and Last Chances

The only certainty is that nothing is certain.
–Pliny the Elder

I entered my final year in high school with apprehension. The memory of past failures kept me from wrapping myself in confidence.

The remote possibility that I might achieve some semblance of renown led me to sign up for Mr. Maves' Forensics Squad. I set my sights on the team's annual public speaking contest in Hurley, Wisconsin. My former Radio Commission advisor treated me with friendly support. Mr. Maves was a man of extreme patience. His unthreatening demeanor and complete lack of sex appeal kept my unruly emotions at bay. His dry sense of humor wasn't much to my liking though. I preferred more straight-forward gaiety. Luckily, my three other teachers possessed abundant gaiety. They were all men.

Mr. Hennessy, Mr. Moe, and Mr. Zieman were popular with all their students. There was a certain comforting sameness in their manner. Besides their zany bent, they were optimistic and supportive. My fifth male mentor was another story.

An unrelenting autocrat, Mr. Heinz Lepke hadn't an ounce of humor in him. He was an exchange teacher from Leipzig, Germany. Due to his appearance, I was sure he'd been a storm trooper in WW II. He had a military bearing and a scar on his left cheekbone. Mr. Lepke often pointed out his hometown of Leipzig on the wall map in our classroom. His nose inches from the map, he scrunched up his fierce eyes as if the spot would vanish if he didn't zero in on it. Leipzig was now on the other side of the Iron Curtain. I was sure if he'd stayed there he'd have been shot by a Russian firing squad. The very first day in class Mr. Lepke commanded, "Neffer raise your hund. Vhen I vish I vill call on you." Though I loved his subject of English Literature, I

quaked in fear of him catching my eye. My stomach was in constant flux during his lectures.

One day I was sure I'd explode if I didn't get to the washroom immediately. I raised my hand. As each second passed, the turmoil in my lower regions elevated. Mr. Lepke ignored me. Time stood still as he strutted back and forth reading from our textbook. After what seemed an eternity he said, "Vhat iss it!?" My face aflame, I jumped to my feet. Unable to speak, I grimaced and put my hand on my stomach. Before he could respond, I bolted from the room. The next day he ordered me to stand up. Glowering, he said, "Do not effer disrupt this class again!" He might just as well have added, "Or else I vill ship you to the Russian front!"

Mr. Hennessy, my General Science teacher, was short, dark-haired and gentle. His thick eyebrows and drooping eyelids shadowed his strikingly bright eyes. He had a slender nose and waffly, pale skin. His timorous deep voice put everyone at ease. Once when we girls were giggling and talking a bit too much, he wanted to know what all the chatter was about. I blurted, "We were just saying what a cutie you are." Mr. Hennessy blushed. I was sure he was flattered though, as his mouth broke into a wide grin, revealing his slightly gapped front teeth. I often daydreamed what a nice father he would be.

To me Mr. Moe looked like a cherub. Like Mr. Hennessy, he was short, but a lot stouter. He taught Girl's Household Physics. His small eyes sparkled with merriment. He had a receding hairline, pudgy nose and sagging jowls. Mr. Moe shamelessly indulged my speaking talents. I was always the first to be called on when oral reports were due. Most all my presentations, whether on Roper ranges or the art of changing a light bulb, were full of double entendres. Mr. Moe once commented, "Frances sure adds a lot of spice to fourth hour." And even though I never quite got the hang of wiring lamps or refinishing furniture, he appointed me class foreman. My main task was scouring the sink in the broom closet. For that he gave me profuse praise, "I don't know WHAT that sink will look like after you graduate."

Mr. Zieman was every girl's dream-boat. His first name was Orlyn and he didn't object to any of his students calling him Ozzie. I often fantasized about being in bed with him. He was tall and had a crew cut similar to movie-idol, Aldo Ray. Unlike Aldo, Ozzie's hair was dark. He wasn't as muscular either, but was tall and slim. He had heavy eyebrows and an enticing mouth. It took all my willpower to control myself from going on the offensive.

What restrained me was Ozzie's subject, Problems Of Democracy. I found "Probs" fascinating, even when it only required reading newspapers. When we moved on to psychology, I was hell-bent on learning all I could on that topic. Somewhere inside me I carried the guilt that it was my fault our family life was so chaotic. I was sure I'd find all the answers in Ozzie's class. Then too, it wouldn't hurt to hone up on the subject. Psychology was my new friend Maurice's college major.

I spent hours memorizing complicated psychological terms: compensation, externalization, reinforcement, sublimation. The defense mechanisms were next: repression, projection, fixation, regression. The closer I got to the truth, that maybe I was insane, the more I rejected it. I couldn't possibly be denying reality. I decided Maurice would be a better counselor. I couldn't wait to show off my wisdom in the field of psychology, either.

My affection for Maurice grew slowly. Two days after we met I got a bulky letter from him postmarked Minneapolis, Minnesota. When I tore open the envelope I gasped in pleasure at the pair of red rhinestone earrings that fell out. Yanking out his note, I read: *I found these in the back seat of my car. Some chick must of left them. See you in a couple days. Maurice.*

It was a week before Maurice finally did call. He said he'd pick me up at nine p.m. I felt like protesting, but was too anxious to find out if he really was a good kisser. When I headed for the door Ma yelled, "For Pete's sake! Where in the world do your friends take you at this hour of the night?"

I ran out, hollering over my shoulder, "It's Friday night for God's sake!"

Maurice looked as brooding and sexy as I remembered him. "What say we drive around for awhile?" he asked. At Third and Tower he said, "Ha! There's Pete Dubchek going into the Douglas.[70] Yell 'Hey Snatch!' then duck down." I did as I was told.

Maurice laughed hysterically, like a teen who'd just seen his first naked woman. "Dubchek's going to be raving about that forever," he said.

Geez I thought, *he's kind of juvenile for his age.*

After traversing downtown Superior several times in Maurice's car he pulled up to the Nottingham Cash Market. I ran in and got him his quart of milk. Then we headed out Highway Two to Wisconsin Point.

After we parked at the end of the Moccasin Mike road, I opened the door. "Jesus!" Maurice hissed. "Keep it locked. We might have to take off in a hurry."

Confused and disappointed I blurted, "What's with you? There aren't any cops around."

Maurice was gulping down milk. Wiping his mouth, he said, "You never know if there are any weirdos around."

His words alarmed me. *Maybe someone's after him. Maybe he's married.* I vowed not to think about either possibility. "So, Maurice," I said, "Do you want to get in back?"

He laughed then. "Listen Fran, my name's really Ronny. But don't ever use that name around anyone. Okay?"

Though puzzled at his penchant for secrecy, I said, "Sure. Makes me no never mind."

He moved against me, fanning the sparks of arousal. "We'll do it up front," he said, matter-of-factly. I could feel my body glow as our lips met. His kiss was heated and demanding. A sweet throbbing filled me inside. I shifted closer to him. I felt his hands on my panties. Rising up, I let him slip them off. Our coupling left me spellbound with new and compelling sensations. They were over before I could fully savor them. When Ronny jumped out of the car to relieve himself I thought, *Damn, he's not any different than the other guys I know.*

By the time he returned I decided to explore another aspect of his personality. I broached the subject of psychology. "We're into psychological defense mechanisms in Probs class." I lit a Pall Mall, handed him the pack.

Ronny took a cigarette. "I shouldn't be smoking. Stirs up the acids in my stomach." He lit up anyway. "So, you need help?"

"Not really," I replied. "It just seems like... well, like some of those fit me. You know, like I'm denying reality or something." I felt myself run out of words.

Ronny insisted there was nothing wrong with me. "Environment and circumstances make us what we are," he said. "High school doesn't have anything to do with anything, anyway," he continued. "You going to college?"

The thought had never crossed my mind. "Naw. Got no money."

"What are you going to do?" he asked.

Though flattered at his interest, Ronny's question disarmed me. "I... I don't know. For sure," I said. "I thought maybe I'd teach dancing."

"Jesus!" Ronny spouted. "There's no money in that! You should join the Army. You'd get three squares, a roof over your head and a

good education. And, you'd get away from Superior. There's nothing here for anyone."

Ronny's words stirred something inside me. "You mean, like the WACS? I never thought of that." By the time I got home and was lying on my mattress in my hideaway, my mind was reeling with thoughts of joining the U.S. Army. I broached the subject with Ma the next morning. She exploded. "That's a horrible idea! It's no place for decent girls. The Army attracts the dregs of humanity."

I couldn't believe my ears. "You don't know what you're talking about! Besides, you never went anywhere!" I couldn't bear the pain in my mother's sad eyes, but couldn't stop the anger that burst inside me. "I'll be damned if I'm going to get stuck in this one horse town!" With that I stomped out of the kitchen and returned to my room. There I contemplated other options. There was only one –marriage.

I'd begun to notice there was always a profusion of wedding and engagement photos in the Evening Telegram society pages every Saturday. Even some of my friends who'd quit school at age sixteen were getting married and having children. Not necessarily in that order either. A few of my current classmates were engaged and planning on marriage right after graduation, too. I wondered if I'd missed the boat.

Though I pined for a life-time love, my daydreams never extended beyond sex. I could not see myself stuck with one guy, like my friend Bella Jones. She'd just gotten married. Bella and her husband, at ages fifteen and seventeen respectively, lived in a housing project. She was four months pregnant, due in March. I decided it was time I telephoned her. She sounded excited at the prospect of seeing me. "Why don't you and your Ma come for lunch Sunday?" Ma was less than enthusiastic, but agreed to tag along.

We took the South End bus to Belknap and Tower, then transferred to the Duluth bus. Both buses were filled with chattering passengers. I was relieved that Ma didn't get into a conversation with any of them. The Duluth bus moved down Tower over the Soo Line railroad tracks. At Eighth Street the driver stopped to pick up another customer. Ma said, "The north end's sure full of riffraff. Too bad Bella can't live in a better area. Too bad she had to get married so young."

The Park Place Homes stretched between Fifth and Eighth streets from north to south and between Hammond and Baxter Avenues from east to west. The whole complex was filled with young families. We got off the bus at Fifth and Hammond and walked over to Eighth Street.

Bella's apartment was on the second floor at E59. The squalling of young children assailed our ears. "Uff," Ma said, "These kids look like ragamuffins. Their parents probably spend all their money on beer."

Shushing her, I said, "Geez Ma, don't be so critical."

I liked Bella's small apartment. It was compact and newly painted. "We just got a bedroom set," she said, as we toured the combination kitchen/living room. "Wanna see it?"

Ma shook her head no and sank onto the couple's huge, frayed sofa. "I would," I said. I trailed behind Bella through a closed door just beyond a small hallway. Inside I noted the bed linens were in a ball, clothes strewn across the floor.

Bella lowered her voice, "I'm glad your ma didn't want to see this. Me and Gonzie were in bed most of the morning." She chuckled like she was sharing a private joke. "We got the bedroom set on credit. At Arrowhead Furniture."[71] I promptly complimented her on her good taste and followed behind as she led me into the small bathroom. "We got a shower and everything," Bella said. All the while she was picking up crumpled towels and throwing them in a wicker hamper.

I noticed a cord strung across the bathtub loaded down with underwear. "We'll maybe get a washing machine in a couple months. After we pay off the furniture." She patted her watermelon sized stomach. "Gotta have a washer for the diapers."

Though still petite and cute, it seemed to me Bella's boisterous personality had dulled. She hadn't cursed or raised her voice once since we arrived. I felt myself sigh, thought, *Geez. She sure has got a lot to worry about.* "Where's your Gonzie?" I asked.

Bella laughed. "He's over at his mother's. Watching television." I was surprised that she didn't seem worried. I'd have expected her to be on the phone yelling at him by now. "We'll be getting our own set pretty soon."

"Gonzie got a job?" I felt heat rise on my neck. "Sorry," I said. "It's really none of my business."

Bella smiled. "That's okay. He delivers groceries for Bugel Brothers.[72] We do pretty good on welfare for now, though." All of a sudden I heard the toilet flush next door. "Damn," Bella said, "That's the only thing I hate about this place. The walls are paper thin."

Back in the living room Ma was flipping through the Sunday Duluth News Tribune. Looking up, she said, "It's a cute place. A bit small. But then there's only the two of you." It sounded more like a question than a

statement. "Is this a sofa-bed?" she asked, patting it with the newspaper.

"Yah. My ma gave it to us. Comes in handy when I baby-sit my little brothers." Bella went to the refrigerator. "You want something to drink? I got beer."

Oh geez, I thought. *That's all Ma has to hear.*

My mother carefully folded the newspaper. "I'd prefer coffee. If you have any." I could tell by the tone of her voice that she was sure Bella didn't.

Bella said, "No problem." She proceeded to fill a stainless steel electric coffeepot with water. "I got this at my bridal shower from my Aunt Gertie ."

I looked at Ma. Her face had reddened. "I'm sorry we couldn't come. I had a meeting that night." We hadn't gone to the shower as there wasn't any money for a gift. "We're still planning on getting you something. I wanted to see what you needed, first."

Bella's small-featured face brightened. "I could use some dish towels. Or lunch cloths. I know you do beautiful handwork. I like those ones with crocheting around the edges."

I could feel Ma's reserve thaw. "That's awful nice of you to say. I probably have some on hand." With that ma got up and took three coffee mugs out of Bella's cabinet. Pouring us each a cup, she motioned me to come and get mine. "Can I help you with the food?" she asked.

Bella was setting the table. None of the dishes matched. "Everything's ready, I just gotta put it out." Ma and I took our places around the small kitchen table. Bella removed a Pyrex baking dish from the oven. "I got a whole set of Pyrex from Auntie Rainey," she said. "Pass the plates." Ma immediately jumped up and collected our dishes. After they were filled, Bella came around with a pan of cream sauce and spooned some on each concoction. "It's salmon loaf," she said. "I hope it's not too dry."

Just as I gave Ma's foot a little kick under the table to keep her from saying anything, the door flew open. A huge, distraught woman burst into the room. Her loosely tied kimono barely covered her large breasts. "The son-of-a-bitch hit me!" she screeched. Her moon-face was blotched and streaked with tears. She let out a blood curdling wail. "He's down there smashing the furniture!"

Bella calmly rose from her chair. "Isn't this special," she said. Arching her penciled eyebrows into triangles, she pursed her lips "My charming neighbor Betty Heg has decided to join us." I detected the

old familiar sarcasm in Bella's voice. Her tone increased. "For God's sake! I've got company!" I felt gladdened that Bella still possessed her old spunk.

Betty sank into Bella's vacated chair. "I'm sorry," she sniveled. "He's really drunk this time. I don't know what to do!"

Bella shrieked, "You know what to do! I've told you a hundred times! Call the fucking cops!"

I glanced at Ma. She closed her eyes, shook her head in disgust and continued eating.

Betty wailed again. "But I love him!"

Ma put down her fork. "If he loved you he wouldn't beat you," she said, sounding like she knew what she was talking about. "You get right over to that telephone and turn him in."

Betty sighed and went to the black wall phone. She carefully dialed. In a weak and defeated tone of voice she said, "My husband's drunk and he's wrecking our house. I want you to put him in jail." After giving her address, she hung up the phone and began sobbing again.

"Oh for Pete's sake," Ma said. She rose from her chair, deposited her dish in the sink, and moved to the sofa. Picking up the newspaper, she spread it front of her face.

Bella tried to comfort Betty. "Don't worry. You're doing the right thing." Every time she spoke Betty wailed again. All the while I shoveled my food down.

Off in the distance I heard a police siren. "Ma and I'll wait upstairs," I said. "No need for us to get involved."

With that Bella and Betty left. Ma lowered the newspaper. "You see what married women have to put up with?"

I ignored her and looked out the window at the scene downstairs. There was a small crowd of neighbors standing around the squad. They all hooted when the two police officers brought out Betty's burly, drunken husband. Betty was sobbing again. She tried to embrace the man, but he pushed her away and hollered, "Bitch!"

The policemen laughed as they hand-cuffed him and guided him into the squad. One of them said, "Calm down, Mac. You'll be home in no time."

When Bella and Betty returned, Betty was inconsolable. "I'm gonna call and get him released," she wailed. "I don't want him to sleep in a jail cell all night." I began getting fed up with her hysterics.

Bella shrieked, "For God's sake! You don't know what you want!" She got up and made another pot of coffee.

After three cups Ma said, "We'd better go now. It's getting late." On the bus home, she harangued about bad marriages, lousy neighborhoods and poor choices. Though I agreed with most of what she said, I didn't open my mouth. I'd made my decision. Marriage was not for me.

The very next day after school, I went to see the Army recruiter.[73] The man was exquisite. On the tall side of six feet, he was thin, mustached and tawny-skinned. His Lieutenant's uniform fit him to a tee, emphasizing his broad shoulders and slim hips. When he came around his desk and clasped my hand, I was sure an electrical charge passed between us. "Lieutenant Joe McKnight, at your service," he said, waving me to a chair in front of his desk. After I sat down, he paced the room like he was giving a pep talk to a football team. He expounded on the benefits of Army life, including educational and travel opportunities. Those subjects especially spurred my interest. When he finished he asked, "Any questions?"

I said, "Sounds good to me."

"How old are you?" Lieutenant McKnight asked.

"Seventeen, going on eighteen."

"Oops," he said, his handsome face clouding. "When's your birthday?"

"In March," I said. "The nineteenth."

McKnight pulled open a file drawer and extracted a folder of literature. Handing it over he said, "No sweat. You can come back in March and we'll chat again." Noting the disappointment that must have shown in my face, he continued, "Better to be sure than sorry. If you're still interested by then, I'll sign you up."

I rose from my chair, felt the Lieutenant's eyes giving me the once over. "I'll definitely still be interested," I said.

McKnight extended his hand. When I clasped it he gave it an extra little squeeze.

Fall drifted into winter. All the while I was loving my life. I was doing well in school and in my dance pursuits. Ronny was a fairly regular lover and now there was a remote possibility that I had a future. I should have remembered that nothing came easy for me. ◆

70 - Douglas Tavern, 318 Tower Avenue.
71 - Arrowhead Cut Rate Furniture, 1002-06 Tower Avenue.
72 - 616 Tower Avenue, Bugel Brothers.
73 - US Post Office, Room 206, 1401-11 Tower Avenue.

Holiday Madness

When passion enters the front door,
wisdom goes out the back. —Fuller

Things seemed pretty rosy by the time holiday recess came. Though I didn't make the honor roll, I'd done well in all my classes. And except for a few brief encounters with Ronny, I hadn't gone haywire over sex. The thought flashed in my mind that I should reward myself for my good behavior. I wanted to get away from Ma as well, as she made me feel very dreary.

It came to a head on Christmas Day at Aunt Etta's. It was a long, dull afternoon. My siblings and I were on our best behavior, thanks to early morning warnings from Ma not to get into any discussions of Day's summer disaster. And though our grandmother was present, she seemed unusually reticent. I attributed it to a warning she may have received from Aunt Etta about family gossip. Howie was itching to get back to driving the car his boss had loaned him. When he offered to take Grandma and Day home early, they jumped at the chance to escape. Ma had accepted Aunt Etta's invitation for me and her to spend the night.

Uncle Arlo went to bed early. In the meantime, Aunt Etta, Ma and I watched the Bolshoi Ballet perform Swan Lake on her small black and white TV. Ma kept making comments like, "Wouldn't it be wonderful if you could become a famous ballerina?" and, to Aunt Etta, "Fran is doing so well with her dancing."

Aunt Etta snapped, "Is she that good?" Her rocker creaked as she shifted her obese frame.

Ma countered in just as snappy a tone, "She's the best in her class. She teaches too, you know." It occured to me that they acted as if they were discussing someone who wasn't even there.

Aunt Etta, sounding peevish said, "That doesn't pay anything." She drew up a heavy sigh. "You know Marie, you have a tendency to paint things rosier than they are."

Ma reddened. "I do not! I have confidence in my children. Is that so bad?"

360

"It is if you can't do anything to help them." Aunt Etta yawned, reminding me of pictures I'd seen in National Geographic Magazine of African hippopotami lolling in the mud. "The best thing they could do is get out of this sorry town. They should go someplace where there's money to be made."

Ma bristled. "That's ridiculous. They can do just fine right here in Superior. Money isn't everything." Her eyes searched my face for support. "Fran wouldn't want to leave her old mom, anyway." A syrupy smile filled her face like she was making a joke. I sensed she was serious, felt alarmed at the thought.

Aunt Etta burst out. "Ha! I'll bet she's dying to get out of town. Right, Fran?"

I felt heat grow on my neck. "Ah... well. I was thinking of joining the WACS."

"'Oh for Pete's sake!" Ma shrieked. "Not that again." She looked at Aunt Etta. "I told her that was out of the question. Uff. Nice girls don't go into the Army!"

Aunt Etta pulled down her lips and raised her eyebrows. "Hmmm," she said. "It's not a bad idea."

I blurted, "I know! You get your food and clothes and housing. AND you can travel all over the world. Oh yah, if you want, you can go to college!" I glanced at Ma. She was shaking her head and rolling her eyes. I plunged on, "I'd be retired by the time I'm forty. Then I could take care of you." I sounded desperate, like I was begging.

Ma's faced steeled. "You'll never get my approval."

Aunt Etta laboriously pushed herself out of her rocker. "It's past my bedtime," she said. I was surprised she'd given in. Lumbering to the stairway, she stopped at the first step like she'd forgotten something. Gazing at Ma, her words dripped with sarcasm. "Didn't you once tell me you wanted to go to Washington D.C. Marie? During WW I? Your parents forbid it. You were devastated. Ended up taking care of them until they died. I wouldn't wish that on my children."

Ma's eyes avoided mine. We listened in silence to Aunt Etta's grunts as she struggled up the stairs. Ma lowered her voice and hissed, "Her children wouldn't dream of taking care of her. Brenda doesn't even make an effort to show up at Christmas."

"Brenda's in Washington State for Pete's sake," I said. "Don't get yourself all riled up. Who knows what's coming, anyway."

My mother wouldn't be consoled. She relentlessly raged on that

night and for days after over Aunt Etta. "She's always tried to influence you," Ma contended. "I know you think she means well. But she's devious." I didn't dare protest. Didn't dare tell Ma I knew the source of her enmity. I knew she was jealous, knew she was afraid I'd turn against her and run to Aunt Etta. And though I felt an overwhelming pity for Ma, I could not bear listening any longer. On New Year's Eve I took off for Duluth, intent on having the time of my life.

Kytos Bar was packed. Though it was only seven o'clock, the wall-to-wall mass of humanity were in high spirits. Many were already drunk. I found Vernetta and Sophie at their station around the last table next to the blaring jukebox. A resounding rendition of *The Wabash Cannonball Polka* made it impossible to hear each other without screaming at the top of our lungs. "Frannie!" Vernetta jumped up and hugged me. I pulled off my coat and draped it across the back of a chair. Vernetta's eyes widened. "Where'd you get that gorgeous dress?"

I felt a warm glow at her compliment. I had thought maybe the hand-me-down, green sateen frock was too dressy. Especially since I'd added Ma's bright red huggy sweater to the ensemble. The dolman-sleeved, half sweater emphasized my pointy breasts. I sank onto the chair opposite Sophie. She spouted, "Jesus! You look like Jane Russell. What did you do to your hair?"

"Rinsed it," I said. "It's kind of purple looking don't you think?" I'd used a cheap dime store rinse hoping my hair would come out jet black.

"Looks fine in here. I wouldn't want to see it in daylight though." Her hooting laugh caused a fit of coughing. When she recovered, she handed Vernetta a five-dollar bill. "Go get us a round. No beer, though. Time for the hard stuff!"

As soon as Vernetta took off for the bar Sophie leaned forward. The jukebox had momentarily silenced. I watched the long arm inside the brightly lit machine drop another record. "Listen," Sophie said. "I know this guy who's loaded. He'll be looking for a good time. How 'bout it?" The wailing voice of Hank Williams Sr. began crooning *Your Cheating Heart*. I momentarily envisioned Ronny, quickly wiped his image from my mind.

I felt myself stiffen. "I... don't know... I don't usually like blind dates."

Sophie's raucous laugh exploded. "You don't know anyone here. So what's the difference? It's not like you'd be alone with him."

"Oh... you mean, we'd be here all night?"

Sophie's voice softened. "Whatever you want... if it worked out though..." She stopped talking as Vernetta approached.

Lowering a tray of tall glasses onto the table, Vernetta handed me one. "I got you a seven-seven. That's a good one for beginners. I'll be right back." With that she took the empty tray back to the bar.

Sophie lowered her voice, "If things work out you can use my room." I wasn't sure I'd heard her right, but didn't say anything, quickly took a sip of the drink in front of me. I was surprised how sweet it was, felt heat rise as the liquor coursed through me.

When Vernetta returned I complimented her on her outfit. It was a tight, black cocktail dress that enhanced her voluptuous body. Her long legs were encased in black nylons that emphasized her thin ankles. Her shoes were low-heeled, silver-colored creations that reminded me of tap shoes. "Thanks," she said, sounding like she was used to getting compliments.

I looked at Sophie. She had attempted to pile her dark frizzed hair on top of her head. Wisps of locks trailed across her forehead. She kept combing them back with the fingers of her right hand. She wore black too, though the effect wasn't at all flattering. The loose fitting shift did nothing to hide her lumpy frame. Both women were heavily made up. All of a sudden Sophie waved her arms and screeched, "Cute Willy! Over here!"

The object of her excitement came pushing through the crowd. He was a barrel-chested, florid man. A thatch of black, speckled-with-gray hair, curled out of the throat of his shirt. The matching hair on his huge skull was thinning. He had small eyes. They looked like shrewd little chips of quartz and were deeply set under prominent brows. There was a vivacity, an air of enjoying life about him. He strode to our table looking like he was raring to go. I noted his callused hands, his massive oarsman shoulders. His voice blared above the noisy room. "Sophie! To what do I owe this unforeseen pleasure?"

Sophie beamed. "Pull up a chair," she said. "You know Vernetta, my son's gal. This is Frannie. She's free as a bird." I felt myself redden. "Meet Cute Willy, everyone's sweetheart."

I wanted to ask Cute Willy where he'd gotten his strange name, but was afraid he'd think I was interested in him. I pulled my chair closer to Vernetta. "Where is Boomer?"

Before Vernetta could speak, Sophie answered my question, "He's working. He'll meet up with us at midnight." She turned to Cute Willy. "You look pretty dry. Can we get you something?"

Cute Willy jumped up. "I'll get a round. Whiskey okay?" Sophie nodded yes.

He returned with four shot glasses of gold-colored liquor and a stein of beer. "You ever drink a boiler-maker?" he asked as he passed around the glasses. I nodded my head no.

Sophie's cackling laugh burst out. "Frannie's a virgin. When it comes to drinking, anyway."

I felt myself bristle. "I'm drinking seven-seven. I don't want to switch." With that I took the shot of whiskey in front of me and dumped it into my first drink.

Willy's laugh boomed out. "Watch this," he said. He dropped his shot glass of whiskey into the stein of beer. Lifting the glass he chug-a-lugged half of it down. Wiping his mouth with the back of his hand, he said, "That's a boiler-maker," then he belched.

I gulped my drink. It tasted sharper than the first one. "I need some ice in this." Willy grabbed the drink and returned to the bar. "Geez," I said, looking at Vernetta. "I don't know if I can handle any more booze."

Vernetta laughed. "You'll do fine if you don't suck it up too fast."

Willy returned with my drink. "Here," he said. "Ice for my lady."

I tasted the drink. It seemed even stronger than before. "Did you put another shot in here?" My voice sounded peevish.

Sophie piped up. "You know how you hold your liquor?" I shook my head no. "By the ears." She, Vernetta and Willy howled.

I looked at them and shook my head in confusion. "I don't get it," I said, causing the three of them to laugh even more. Irritated, I took a long slug of my drink. It felt smooth going down. "This is pretty good."

I noted a conspiratorial glimmer in Willy's beady eyes. "Time for another round," he said. Without asking he took my glass and went to the bar. Sophie and Vernetta were leaning together, whispering.

"What's going on?" I snapped.

They immediately stopped talking. Vernetta looked at me. "Listen," she said. "If you wanna go somewhere with Willy, feel free."

I shook my head no, felt a wisp of dizziness descend. "I don't think so. He's kind of scary. And old."

Sophie curled her lips in disgust. "Whatta ya want? Clark Gable?"

I was about to tell her to shut up when Willy returned. As soon as he set down my drink I grabbed it and took a long sip, felt a rush of warmth inside me. I raised my glass. "Here's to the girl who lives on the hill. She won't do it, but her sister will! Here's to her sister!" I heard a

burst of high-pitched hysterical laughter, felt instant mortification realizing it was my laugh. Heat rose up my throat. I glanced at my companions. For a moment they seemed suspended in silence, then their raucous laughter engulfed me.

"That's the spirit!" Willy hooted. "I gotta take a leak. When I come back you and me are gonna hit the road!"

A wave of nausea rose in my throat. I jumped up and grabbed my coat. "I gotta get some air!" I didn't wait for Vernetta or Sophie to respond, pushed through the mob of revelers. ◆

A Sight For Sore Eyes

No faith is to be put in outward appearance. –Vergil

Exiting out onto Michigan Street I crashed into a guy attempting to turn into Kytos. He had the masculine smell of leather. "WHOA," he said. "What's the rush?" He smiled. It was a good smile. It warmed me.

I shook away the haze that had descended over me. "Sorry," I said. "I was feeling a little shaky." I'd given the man the once over, liked what I saw. He was tall, slim, mustached and a bit swarthy. I noted his sharp clothes. His tan, camel's hair coat was open, revealing a double-breasted, pin-striped suit. The white shirt underneath gleamed in the lamplight. "Nice tie," I said, "I love red. You look like you're going dancing or something."

The man smiled again. "Just cruising. Maybe you'd like to join me?"

I hunched my shoulders. "I was thinking about getting something to eat." I'd decided I could drink more if my stomach was full. "At the Deluxe[74] up the hill... or somewhere."

"We can do better than that." He touched my elbow, guided me to a sleek, finned car parked at the end of Fifth Avenue and Michigan Street. "Let's go to Joe Huie's.[75] Then we'll hit the Metropole."[76]

"I've never been to either one," I said as he opened the passenger door. I settled onto the sheepskin upholstery. "They got good food?"

My new friend smiled again. "Huie's does. The Metropole's a bar." He got in the car. Up on Superior Street we headed East to Lake Avenue. "I'm Gus. What's your name?"

"Fran." I nervously pulled out the pack of Pall Malls in my coat pocket. I was about to light up when Gus reached inside his suit pocket and extracted a thin, dark cigarette.

"Wanna try one of these?" I shook my head no, lit up the Pall Mall. He hunched his shoulders. "Maybe later." Gunning the motor, he turned the car onto the wooden Lake Avenue overpass that led to Canal Park. I could see the blinking lights up ahead. The two buildings were side by side. The Metropole light blinked, "Metropole Lounge and Hotel." I had

366

passed both establishments many times on bus trips with Ma to Park Point, but never at night. In daylight they resembled dilapidated barns.

Huie's was brightly lit, but empty. The small tables were covered with plastic table cloths. Stubby green wine bottles held flickering candles that centered the tables. As soon as we walked in, a suited man came rushing forward. "Gus!" He said. "Your usual table?" Gus nodded yes.

After we settled in, a frowzy, Oriental waitress appeared. Gus immediately snapped, "Coffee for my friend, scotch old-fashioned for me."

The waitress gave a little bow. "Right away, Mr. Gus."

Gus furrowed his eyebrows. "That's just Gus," he said, then looked at me. "What do you want to eat?"

My eyes were scanning the prices on the huge, plastic-coated menu. I skipped to the American food sector. "A hamburger?" It was the cheapest item listed.

"Jesus," Gus exploded. "You can do better than that." When the waitress reappeared he ordered two T-bone steaks with baked potatoes. "Lots of butter and sour cream," he added. After she left he said, "Gotta fatten you up for the kill." I felt myself blanch. Gus reached over and squeezed my hand. A huge diamond on his pinkie finger flashed in the candlelight. "Just kidding," he said.

After the waitress brought our food and I saw the huge portions, I said, "I don't think I can eat all this."

"Don't worry about it," Gus said. "You can take home the leftovers." With that we dug in.

Tender and savory, I began devouring the steak like it was my last meal.

Gus scowled. "Jesus, you eat like you've never had steak in your life."

"I haven't," I said, as I slathered butter and sour cream on my baked potato. "Mmmm –I love baked potatoes." I cut up the skin and devoured that too. Half way through the steak I began feeling bloated. "I guess I will take the rest home." I was thinking what a treat it would be for Ma. And, a great peace offering. After dinner Gus ordered brandy. I decided I was ready to start drinking again. The rosy liquid was sweet and burned a path all the way to my stomach. "Geez Gus," I said. "It sure would be easy to get used to all this good stuff."

His dark face broke into a warming smile. "And just think. The night's still young." He lowered his voice. "I got a room at the Metropole.[77] The real meat's up there. What say we go there first? We can hit the bars afterwards."

Though momentarily alarmed, I couldn't think of any reason not to. I figured I owed him big time. Nodding my head in agreement I said, "I got nothing to lose."

Gus's room was at the back of a long hallway on the second floor of the Metropole. Opposite it I noticed a door marked, "Stairs." I made a mental note. The room itself was small and sparse looking, though cleaner than the one I'd occupied with Ben at the Saratoga in Superior. As soon as we got inside, Gus pulled off his coat and suit jacket. Stretched across his muscular chest was a holster. He took off his tie, unhooked the black leather contraption and lay it on the night table next to the bed. It was then I saw the pearl gun handle. My eyes felt as if they would pop from my head. Panic filled me. *Maybe he's a cop! Maybe he'll arrest me! Maybe he's a gangster or a pimp!* Whole scenarios of disaster began unfolding in my head. I felt hot lead pierce my chest, saw myself dying in a barrage of bullets.

Gus was unbuttoning his shirt. "Wanna see my piece?" he asked, reaching for the gun. Sudden panic overwhelmed me. Feeling icy cold, I shook my head no. Gus stepped back from the end table and stripped to his tee shirt and boxer shorts. I was still fiddling with my coat buttons. "Hurry up," he snapped, then went into the bathroom and shut the door. "I'll be out in a sec!"

Before I realized what was happening I rushed from the room. Thundering down the stairwell, I burst onto Lake Avenue. Two taxis were parked in front. The driver of the first one got out. "Need a cab?" I shook my head no and rushed on, sure Gus would know everyone in the area and come looking for me. The overpass sloped down to the bright lights on Superior Street. Toward the bottom I saw a break in the wooden hand railing. Rushing up to it I realized it was a staircase leading to the railroad yards below. The tracks stretched in long weaving lines for as far as my eye could see. I was sure they'd lead me back to Kytos and my friends. I swiftly descended.

Through the dark, open boxcars brought thoughts of lurking maniacs. I convinced myself if I ran fast enough nothing could catch me. I thanked my lucky stars I had flats on inside my stadium boots. I took off running willy-nilly, remembering the dreams I often had of flying, wishing I could fly now. There was little snow in the yards, but there were icy spots where I had to slow. The clouds above were light colored and glowed enough for me to find my way. Still, every once in a while I stopped, alarmed by a looming shadow or an unidentifiable sound. About

three blocks along in my mad dash, something came bounding around the corner of a boxcar. "Oh my God!" I shrieked as I froze in my tracks.

It was a huge, black German Shepherd. He stood staring at me, a low growl rising from deep inside his throat. "Nice doggie," I said, my voice sounding shaky. He slowly approached and began sniffing my coat pocket. I detected the slow movement of his tail. I suddenly remembered my leftover steak. Smiling, I said, "I was saving this for Ma." Pulling the bag from my pocket, I threw it as hard as I could. The dog bolted away and pounced on the bag. "Eat hearty," I yelled and took off running again.

By the time I got to Kytos I was sweating and gasping for breath. I could hear the blast of party horns through the huge, wooden door with it's diamond-shaped window. I pushed into the tavern. Everyone was screaming "Happy New Year!" Balloons flew through the air. People hugged and kissed. All of a sudden someone screeched, "Frannie! You're back!" It was Cute Willy. He pushed away a tall blond who was clinging to him and lunged toward me. I fell into his arms and let him kiss me full on the lips. When I came up for air I gasped, "Geez! You're a sight for sore eyes!"

Willy immediately led me back to the table by the jukebox. The space was loaded with dirty glasses and an overflowing ashtray. Sophie was slumped forward, her hand clasping a glass. She raised her head as we sat down. "There you are!" Her words sounded slurred. "You came to your senses," she said, then slumped forward.

"Where's Vernetta?" I asked.

Sophie mumbled into her crossed arms. "Her and Boomer took off. Assholes."

Willy waved his hand at her like she was hopeless. "Forget them," he said. "You look like you need a drink." He went to the bar. Moments later he and I began sucking up booze. It was as if we'd reached a desert oasis after days of wandering near death from thirst. The more I drank the happier I felt.

Willy regaled me with obscene jokes and wild accounts of his adventures as a seaman. Most all the stories were about conquests he'd made in what seemed like hundreds of ports along the Great Lakes. When he finished with those, he launched stories about drinking bouts in Superior and Ashland, Wisconsin, his home town. The more I listened the more Willy appealed to me. I loved his devil-may-care attitude.

Every once in awhile he broke into song. I recognized the tune *MacNamara's Band*, but not the words. He even began looking good,

though hardly as slick and debonair as Clark Gable. He reminded me more of Humphrey Bogart as Sam Spade in <u>The Maltese Falcon</u>. Like Spade, I saw Willy as a hard, shifty fellow, able to take care of himself in any situation.

I heard myself blubber, "I wish I'd met you when you were in your prime."

"Shit!" Willy bellowed. "I am prime! Lots better than anyone you ever had. Or hope to have. That's for sure." With that he pulled me to him and planted a long wet kiss on my lips. The kiss felt overpowering and crude. I pulled away.

"What's wrong," Willy asked.

I hunched my shoulders. "I ah... there's too many people around." In actuality the crowd had thinned out. I could see the clock above the bar. It was three a.m. "Geez. Maybe I should get going."

Willy hooted. "Where? The buses ain't running and I sure as hell ain't driving back to Superior now." He reached over and shook Sophie's arm. "Hey! Hand over that key you promised."

Sophie raised her head. Her eyes rolled back. Willy cursed. "Shit, I'll have to drag her with." He looked under the table, found her handbag. Digging inside, he extracted a key. It was engraved with the number A12. "Come on, give me a hand."

"Where we taking her?" I asked, as I struggled to get her coat on her.

"Upstairs at the Fifth Avenue Hotel." Willy pulled Sophie to her feet and draped her around his shoulder. "Come on. You hold the other side." The three of us staggered onto Michigan Street and around the corner to the 5th Avenue entrance. We weaved our way into the dingy hotel lobby. The desk clerk was snoring, a newspaper spread across his face.

Sophie's room was on the first floor. The one bare bulb in the hallway ceiling barely cast enough light for us to find our way. At number A12, Willy propped Sophie against the wall. "Hold her up," he said as he fumbled with the key.

Inside the room there were two double beds. Dull light from a floor lamp cast shadows around the room, revealing heavy dark furniture. There was one window. The dim glow from a street light beyond cast weak beams of light through the flimsy lace curtains. I noted there were bars on the window. Willy unceremoniously picked up Sophie and dropped her onto one of the beds. She moaned heavily and then went silent.

"Geez," I said. "I'm not used to having anyone around when I..." my words trailed off.

"Not to worry. She's out for the duration." With that Willy pulled off his coat and started undressing.

I turned away, sank onto the empty bed and slowly unbuttoned my coat. "I a... I don't like to do it with the lights on," I said, thinking, *I hope I don't have to look at his naked body.* Willy went over and shut off the lamp. I closed my eyes. "No problem. I'll be out in a flash." He went into the bathroom, slamming the door behind him.

Thoughts of ditching Willy filled my head. *But... the buses aren't running. I don't have enough money for a cab. Maybe I could get some money out of his wallet. No, then I'd have him AND Gus gunning for me.* Stripping everything off except my panties, I carefully folded my clothes and draped them across a lounge chair in front of the window.

Suddenly the bathroom door flew open and Willy came rushing at me like a mad bull. Adroitly side-stepping him, I screeched, "I gotta go too!" I'd felt a gush of warmth between my legs. Inside the bathroom I confirmed what I'd suspected. My period had started. I yelled through the door. "Ah geez, I got the curse!"

I heard Willy's raucous yell, "Good! You can't get p.g. when you're flagging."

Geez, I thought, *What a pig.* Grabbing a hand-towel, I put it between my legs, then wrapped a bath towel around me.

Willy proved to be a superior wrestler. His love making was raw and rough. During his athletic maneuverings, I let my mind drift to more pleasant settings. I watched myself lying on a field of grass, watched fluffy clouds drift overhead. I couldn't block out the sound of sex though. It was the only reality in the room. When he was through Willy silently rolled onto his side. Pulling up the strongest tone of voice I could muster I said, "You'll have to go out and get me some Kotex in the morning." I heard Willy grunt as I slid out of the bed and rushed into the bathroom.

After I bathed I reentered the room. Dawn sun light was sneaking in through the shabby drapes. I pulled the thin chenille bedspread off the bed, wrapped it around myself and lay down on the floor. The noise of heavy snoring from both beds kept me from falling asleep right away. All the while I was contemplating the events of the night. Relieved as I was to have escaped Gus's clutches, I wasn't so sure I was out of the woods yet. ◆

74 - DeLuxe Cafe, 328 W. 1st Street.
75 - Joe Huie's Cafe, 103 Lake Avenue South.
76 - Metropole Liquor Co Inc.; 101 Lake Avenue.
77 - Metropole Hotel, 105 Lake Avenue South.

Wake Up Calls

Be sober and keep vigil. —Neale

I rose from the hard floor with a pounding headache. My tongue felt moss-grown and dry. Reeling into the bathroom, I found a tube of toothpaste in the wooden medicine cabinet above the sink. Squeezing a ribbon of paste onto my finger, I vigorously spread it over my teeth. I turned on the tap, scooped up water in my cupped hands and rinsed my mouth. My whole body felt bruised and sore.

I locked the bathroom door, filled the tub. Stretched out in the steaming hot water, I contemplated how I'd skip out on Willy and Sophie. I was sure they would sleep all day if they could, wondered what time it was. When my headache began fading and my body felt soothed, I rose from the water and wrapped a towel around me. In the bedroom, I quickly dressed.

All of a sudden the telephone between the beds blared. "Jesus!" Willy grunted.

I rushed to the phone, picked up the receiver. The whiskey-voice on the line barked, "Wake up call. It's eleven a.m."

Willy, sounding disgruntled, snapped, "Who the hell was that?"

"The desk clerk I guess. It's eleven o'clock.

Willy sat up in bed. "Holy shit! I wanted to be in Ashland by noon!" He grabbed his pants off the floor, looked at me. His eyes were bloodshot and bleary. In the light of day he resembled Victor McLaglen more than Humphrey Bogart. He stood up and pulled on his trousers. "Where the hell do you think you're going?"

"I... ah... I was going to wake you. I gotta get home." My voice sounded shaky, like I was afraid I'd be struck dead.

"Just hold up. We'll go for breakfast." He lurched into the bathroom and closed the door.

The thought of food made my stomach turn. I sank into the chair by the window, suddenly felt light-headed. *Maybe I'd better wait. Maybe I won't be able to walk to the bus stop.* Just then I heard a horrific moan from the bed where Sophie was lying.

"What the..." Sophie turned onto her side. Her frizzy hair stuck out on her head like bed springs. "When did you roll in?" She reached for a pack of cigarettes on the night stand, lit up. The acrid smell of cigarette smoke made my stomach flip-flop.

"Me and Willy brought you here," I said. "You were out of it."

"Thanks for nothing," Sophie snapped. "Where is the big jerk?" I nodded toward the bathroom. She shrieked on the top of her lungs, "Get your ass moving. I gotta get in there!" A fit of coughing overcame her as she rose to her feet. Her dress was wrinkled and twisted around her lumpy body. She looked down at it. "Jesus, did I sleep in my clothes?" I nodded my head yes. She staggered toward the bathroom door, stopped alongside the bed Willy and I had occupied. "Where the hell did all that blood come from?"

Heat grew on my face. "I... a... I got my period."

"Shit. There must be some Kotex around here. Go look in that bureau. The bottom drawer."

I moved across the room, pulled open the drawer. Tucked in a corner was a box of Kotex. I took out three pads, put two in my coat pocket, then stepped into the closet. There I removed the hand-towel I'd put between my legs, replaced it with the third pad. Back in the room I dropped the soiled towel in a wastebasket between the two beds.

I heard Sophie's raised voice from behind the bathroom door. "So what if she's not a whore! You still owe me for that mess you made in the bed!" I heard Willy mutter something. He pushed open the door, then slammed it shut behind him, "Money hungry bitch!" He pulled on his shirt and jacket. "Let's blow this rat-trap."

"What about Sophie? Maybe she's hungry."

"She can starve for all I care!"

On Michigan Street a snow-chilled wind blew up under my skirt. Curls of ghostly fog scudded around us. Willy stood gazing right and left. "Where the hell's my car?"

I hunched my shoulders. "I don't even know what it looks like."

Willy grasped my arm. "It's probably up on Superior Street." A light layer of snow had fallen during the night. Clutching each other, we slipped and slid up Fifth Avenue. The streets were deserted, barely any traffic moving. At the corner Willy shrieked, "There she is!" He rushed toward an old sedan parked behind a mound of snow. Tagging behind I noted there was a ticket on the windshield. "Damn!" Willy spouted. He pulled the ticket away, tore it in half and threw it into the

air. "Assholes," he said, "I ain't dropping any more cash in this God-forsaken town. We're going to Superior!"

I felt a wave of relief knowing I'd be on my own turf. *Maybe I'll get away now*, I thought. Willy had other plans.

Halfway across the Interstate bridge, Willy pulled the car up to the toll booth. Without warning the hood on the car flew up. I flinched in alarm, sure the windshield would shatter. The cashier leaned out his booth window and hollered, "Jesus! Get that hood down!"

Willy jumped out and hurried back to the trunk. Seconds later he loomed over the front of the car with a length of heavy rope. Working fast, he attached the rope to the front grill, then tied it to the Winged Mercury hood ornament. Back in the car he paid our toll, then spouted, "Shit! I gotta get to Ashland before this heap falls apart!"

I felt myself stiffen. "I should go home. My Ma will be worried."

"You've been gone all night. What's one more day?"

I shifted on the car seat and looked at him. "At least let me go home and change. This outfit's too dressy for traveling."

"You look fantastic! Like a movie star. Come here." Willy spread his arm and tilted his head. "I wanna show you off to my buddies." He turned the car east at the bottom of the bridge and raced to Highway Two.

I slid closer, let Willy lay his arm over my shoulder, thought, *Maybe it'll all work out.*

Twice before we reached Iron River, the rope holding down the hood loosened. Willy had to pull over to the side of the highway and speedily lash the rigging. Each time he shrieked, "God damn updrafts!" His antics brought to mind a Charlie Chaplin routine. I gave in to an overpowering urge to laugh. Back in the car Willy scowled. "It's not funny. I gotta find a station in Iron River. We can eat at the Ideal Hotel."

I felt myself panic. Maybe the bartender there would recognize me. Then Willy would find out I was underage. "Ah... I doubt if anything's open. It is New Year's Day you know."

"Oh shit," Willy said. "You're right. Guess we'll have to wait until we get to Ashland."

We made the twenty-six miles between Iron River and Ashland in forty-seven minutes. I was relieved that the car hood only flew up once more.

In Ashland, Willy parked in front of the Uptown tavern, one of several saloons on Main Street. Inside the stable-sized establishment we

sidled onto two stools at the end of the long bar. "Hey Lou!" Willy yelled.

The brawny bartender was pouring beer from the tap into a stein. "Holy Shit!" he hooted. "Hey guys! It's Cute Willy, back from the wars!" His horselaugh echoed through the vacuous Bar.

The six or seven male patrons turned to look at us. They emitted a collective shriek, "CUTE WILLY!" A short, wiry redhead hopped off his bar stool and sauntered over to us.

Willy roared, "EINO! You look like a freaking stumble bum! What the hell happened to you?"

Eino ignored Willy, looked me up and down, "Robbing the cradle now?"

Willy feigned a right jab at his friend. "Classy, ain't she?"

Eino laughed. "I guess SO. Looks better than your usual picks." He smiled at me. "Last time I saw Willy he was squiring a two ton heifer."

The bartender lumbered over and put out his ham-like hand to me. I flinched when he squeezed mine. "I'm Lou," he laughed, "What's your poison?"

Willy raised his voice, "Give her a boiler maker."

"I... ah... Nothing right now. My stomach's empty. I don't wanna get sick."

Lou snapped, "I got just the thing for you. A Bloody Mary. That'll put the hair back on your chest!" His horse-laugh rang out again. The rest of the patrons hooted with him.

"No booze, please." My voice sounded fragile. "I haven't had anything to eat since last night."

Lou scowled. "Jesus, Willy. That's no way to treat a lady." He leaned toward me. "A Virgin Mary for you my darling. Then I'll rustle you up some food."

I felt myself smile weakly. "That would be nice," I said. "Thanks."

Twenty minutes later I was gobbling down a greasy hamburger and fries. The food and the spicy drink restored me. When I finished my feast, Lou poured me cup after cup of black coffee. My head cleared, my perceptions felt lucid and sharp. I began plotting my escape.

All the while, Willy guzzled drinks with his buddies. They took turns buying rounds. Their ribald jokes and stories bounced back and forth. I'd heard most of them the night before in Kytos. Worst of all, Willy and his cohorts broke into the Irish ditty that Willy had continually sung. The tune

MacNamara's Band, had thundered in my head for hours after: *Ireland was a nation, when England was a pup. And Ireland will be a nation, when England buckles up!* I barely listened, felt wearied and numb.

The endless boredom I was feeling brought with it a terrible anguish. I agonized over the monstrous waste of time and energy I'd expended since the night before. I tried to avoid thoughts of Ma, but they kept forming in my head. As hopeless as it was, I wished above all else I could somehow be the person she wanted me to be. That thought steeled my resolve to take action. It was three hours into Willy and his friend's drinking orgy. I leaned over and snapped, "It's about time we got back to Superior."

Willy's huge head bobbed of its own accord on his massive shoulders. His eyes seemed unable to focus. "I... ah... I don't think I can drive."

Ah geeze, I thought. *He's dead drunk!* I spouted, "Well, then I'll drive!"

Willy hunched his shoulders. "Do ya know how?"

"Hells bells. I'm sure if you point the damn car in the right direction, I'll do fine." With that I slid off my barstool and jerked on Willy's arm. He sidled to his feet, his knees briefly buckling. Steadying himself on the bar, he whooped, "We gotta get to a hotel!" His buddies hooted their encouragement.

Behind the wheel of Willy's car, I felt a wave of doubt that I could do the job. Willy had turned on the ignition, put the car in gear, and got it out to the highway. After giving me a quick lesson on where the gas, clutch and break pedals were, we switched places. "If that damn hood flies up you're going to have to fix it," I said.

Willy lay his head back and shut his eyes. "There's no wind now. If you don't speed we'll be fine," he said. "Wake me when we get to Superior."

I looked at the dashboard clock. It was six p.m.

By the time I slowed the car through Iron River, I felt confident and a little cocky. The sweeping highway turns had been easy to maneuver at thirty-miles an hour. No traffic was moving in Iron River, the streets deserted. I slowed past the Ideal Hotel and Lounge, recalled my sojourn there with Claudia and Jeff. Outside of town we glided past The Green Top Restaurant. It stood on a hillock across the highway from us, its neon lights rapidly chasing themselves in long loops. I envisioned myself in their dining room sipping wine at a white-clothed table and feasting on a T-bone steak.

Willy was fast asleep, his low snore soothing. Afraid I'd doze too, I rolled down the window and let the cold air wash over me. Waves of boldness surged through me. I stepped on the gas. All at once a gargantuan Greyhound bus came barreling toward us, its lights momentarily blinding me. I closed my eyes and sent up a little prayer. The bus thundered by on the other side of the highway. The updraft shook Willy's car. I clutched the steering wheel, prayed the hood would hold. It did. Shaken, I slowed to twenty-five miles-an-hour. By the time we reached the outskirts of Superior, it was almost ten p.m.

Willy was snoring louder. Every once in a while he'd snort and mumble under his breath. I decided not to disturb him. *Hell, I made it this far. It's all downhill now.*

I remembered that the East Twenty-fourth Avenue turnoff connected to Stinson Avenue. I decided I'd turn there and head out to South End. Willy would be amazed at how smart I was.

A few blocks west of the "singing bridge" over the Nemadji River, I slowed the car. Up ahead was a short overpass. I knew the East Twenty-fourth Avenue corner was just below and that I'd have to make a left turn. Theorizing that if long, slow turns only required a slight twist of the steering wheel, sharp turns required lots of rotation. I turned the wheel as far to the left as I could. Then, I stepped on the gas. The car shot across the intersection. In a split second we bounced over the culvert, jumped a mound of snow and settled against a sapling tree. The hood flew up and slammed against the windshield. A huge crack lacerated the glass. Willy jerked awake, his head inches from the windshield. "Jesus! Where in hell are we!?"

My hands were glued to the steering wheel. Feeling slightly dazed I shook my head. "Ah... I was heading for Stinson Avenue."

"Why the hell didn't you wake me!?" Willy leaned over, turned the key and jerked it from the ignition. "Get out!"

I couldn't believe my ears. "Why!?"

Willy's squinty eyes were bulging from their sockets. "For Christ's sake, you're jail bait, that's why!" He dug in his coat pocket, pulled out a ten dollar bill and handed it over. "Find a cab."

"For Pete's sake, I don't even know where we are!"

Willy was beginning to sound frantic. "Go to the corner and head west to the Superior Theater. You can't miss it."

I sighed and dug in my pocket for my pack of Pall Malls. My finger nail got snared on a Kotex. I tried to shake the pad free, but it flew

out of my pocket with my hand.

Willy was giving me little shoves. "Out! Get out of the car!"

"Jerk!" I screeched as I tumbled onto the roadway. There I ripped the Kotex pad free and threw it at the car.

Oblivious to my action, Willy kept hollering "Run! Run!"

I loped to East Fifth Street. Looking up and down the street, I spotted the Superior Theater a few blocks to my right. Its towering marquee was ablaze in lights advertising <u>The Quiet Man.</u> Just as I turned and sauntered toward it I heard police sirens. I looked behind me. Two squads went careening around the corner I'd just turned off. *I hope they lock him up forever!*

Inside a tavern next door to the Superior Theater I called the Saratoga Cab Company. Ten minutes later I was heading home. As relieved as I felt, I dreaded the thought of what was in store for me there. ◆

Safe Havens and Side Trips

Out of this nettle, danger,
we pluck this flower, safety. –Shakespeare

Ma met me at the door. Throwing her arms around my neck she hugged me and sobbed, "OhmyGod! I'm so glad you're home. I was worried sick."

Slightly taken off guard, I said, "I'll always come home." Somewhere deep inside me I felt disappointed that she didn't lash out, didn't bombard me with accusations and scorn. "Don't cry. I'm okay."

Ma stepped back. "Are you sure? Where were you? Why didn't you call?!"

I hunched my shoulders. "I was with Vernetta and her boyfriend's mother. We were having such a good time I forgot."

"Where in the world did you sleep!?"

"At her boyfriend's mother's house. He was too tired to drive out to South End."

Though I was sure she didn't believe me, I knew Ma was trying hard to be agreeable. She sighed heavily, "I was so afraid you'd run away."

I felt a catch in my throat as I squeezed her hand and replied, "Geez, Ma. I'd never leave without saying goodbye. Anyway, I want to get my high school diploma."

With that in mind, I vowed to behave myself and get through the second semester of my last year of high school without any more detours. All was fine until March, when the Forensic squad traveled to Hurley, Wisconsin for the annual speech contest. I hadn't qualified as a contestant as there was no category for my submission, *SWAK - (Sealed With A Kiss)*, a parody on the receiving/sending of mail. Fourteen members were picked to compete. Mr. Maves allowed me to accompany the squad, "As a reward for your hard work and, as an observer," he said. The first thing I observed was the driver of the chartered Greyhound bus.

He was small and wiry, but looked larger and harder in his slick gray uniform. He stood beside the bus grasping the elbow of each girl and gently helping her up the steps. I noted his pixie-like, boyish face that brought to mind a merry leprechaun. Freckled, he had curly auburn hair and China-blue eyes. His easy-going smile convinced me he was a spur-of-the-moment kind of guy. When it was my turn to board the bus, I leaned into him. "You are some cutie," I said. "What's your name?" "Mickey," he answered. "You're not so bad yourself."

I hopped up the two steps and took a spot behind the driver's seat next to Elaine Berger. Elaine was a short lively junior with a square face and cropped, ebony hair. Her ivory complexion was flawless, her personality bubbly and open. We had gravitated to each other. I reveled in the light of her constant praise. She once said, "I'm having a grand time with you in speech class. You're the best one for telling stories and giving speeches," and, "You're a real Lucille Ball."

Now, as I settled in next to her, Elaine said, "Ouuu, that guy is sure a sweet fellow. He'd be perfect for you." Her conclusion surprised me. Though I had confided some of my capers to her, I'd never gone into detail.

Elaine was digging in a paper grocery bag. "I brought cookies to pass around. You can give some to the driver if you want."

Just then Mr. Maves boarded the bus. "We'll be arriving in Hurley in three hours and fifteen minutes," he said. "With one stop, in Ino." We clapped politely as Mr. Maves moved back into the bus and took his seat.

The forensic squad members were a subdued group. The eleven girls were social club members and honor students. The three boys, awkward and inhibited. I determined I'd have to tread carefully in my pursuit of sweet Mickey. When Elaine slid past me and headed up the aisle with her bag of cookies, I leaned forward. "So Mickey," I said. "Where do you live? Superior?"

"Naw. International Falls."

"Geez, That's a long haul."

"Not really. When I have a charter job, I stay overnight in Duluth. In a hotel."

Mickey's revelation tipped the scale of my interest. I was about to ask him what hotel when Elaine came bouncing back. I stood up to let her pass. "Here," she said, handing me the bag. "Give Mickey some cookies."

I waved the bag at Mickey, "Snack time."

The bus driver reached into the bag and pulled out a sugar cookie. "I love sugar," he said. "Bet you got lots to spare."

I glanced across the aisle to see if the two boys sitting there were listening. Both of them had their eyes closed. Their lips were silently moving. I was sure they were practicing their speeches, but, I didn't want to take any chances. I leaned down and whispered in Mickey's ear. "Maybe I'm more than you can handle."

"We'll see about that," Mickey said.

I sank onto my seat next to Elaine. She gave me a sly little smile. "I know what you're up to," she said, then began shuffling the papers on her lap.

I poked her with my elbow. "You're pretty smart for a junior. You better get busy with your speech, though." Settling back in my seat, I closed my eyes.

The low chatter that permeated the bus slowly ebbed. I slipped off my wedgies and slid my foot onto Mickey's arm rest, felt his elbow nestle on top of it. Soon I was dozing, gently rocked to sleep in the arms of my reclined seat.

At the small coffee shop in Ino, I maneuvered a spot in a booth next to Mickey.

Elaine slid in across from me. I felt a pinprick of panic when Mr. Maves joined us and took the space next to Elaine. Mr. Maves was bubbling with anticipation, talking to Elaine about past tournaments and giving last minute advice. All the while I could feel Mickey's hot thigh pressed against mine. Every so often he'd lower his hand under the table and squeeze my knee. After he finished his sweet-roll and coffee he got up. "Time for a smoke," he said and left the restaurant.

Mr. Maves and Elaine chattered on about the contest. I waited for an opening in the conversation. "I wonder if I could be excused after lunch in Hurley? I've got a cousin there I'd like to touch base with."

Mr. Maves smiled politely. "That should pose no problem. Most of our squad is scheduled for the morning session. Just be sure to get back before the bus leaves." He excused himself then and headed for the men's room.

Elaine blurted. "You're so sneaky. I bet you don't even know anyone in Hurley."

I was tempted to object, but knew Elaine was thrilled to be included in my little ruse. "Let me put it this way. You know I won't be missing the bus." With that I got up. "I'm going out for a smoke. See ya on the

bus." Outside I lit up and sauntered over to Mickey. "What would you say if I told you I'm going to be available after lunch."

Mickey's puckish face lit up. "Great! We can check out the local dives."

I felt a flush of pleasure. "I heard Hurley's wide open. We'll have to be careful though. If Maves smells booze on my breath, I'll be in deep shit."

"Not to worry. We'll drink Vodka. You can't smell that." Mickey butted his cigarette and headed for the bus. Moments later everyone was settled in their seats. Soon the bus was back on the highway.

Elaine leaned over and whispered. "Where you going with Mickey?"

"Probably to some of the hot spots. Bars."

"Ouuu, be careful. I wouldn't want you to get in trouble."

"I don't expect to, what with you covering for me." I could tell by Elaine's pleased little smirk that I could depend on her.

At the Hurley high school contest site, I doggedly moved from classroom to classroom per Mr. Maves' request. There I tried to concentrate on all the presentations. In truth, the declamations, four minute speeches and orations bored me to tears. The pros and cons of the St. Lawrence Seaway Project, the threat since Stalin's death and the Korean truce, held little interest for me. I was focused in the here and now of my impending tryst with Mickey. More often than not I had to resist the temptation to jump up and shriek, "Loosen up! Life's a ball!"

We regrouped in the high school cafeteria for a quick lunch of hot dogs, hamburgers and potato chips. I hissed at Elaine, "Geez, even the food is boring!" She was flushed and highly charged, having given the final presentation of the morning. Looking at her it dawned on me that I'd have to make some comment on her speech. "You were the highlight of my day," I said.

Elaine beamed. "You really think so?"

"Would I lie?" In reality I'd thought her subject matter of "Formosa[78] –Trigger To Atomic Warfare?" a drag. Her technique was book-perfect though and I was sure she'd gotten a high rank from the judges. "You barely used your notes and your logic was flawless."

Elaine beamed. "I was awful nervous. My face felt like it was on fire."

"Everyone blushed," I said. "That's normal." I knew I was parroting basic assurances, but couldn't help myself. My concentration had

382

slipped as I was watching Mickey. He sat two tables away from us with Mr. Maves and a gaggle of our squad females. I felt a prickle of jealousy at the sight of them fawning over him. When he caught my eye he winked. I felt a flush of joy. A half hour later, Mickey and I were sauntering to his bus hand in hand.

"We'll hit Silver Street. Most of the hot spots are there." He guided me onto the bus, then pulled me close. His lips met mine with a gentle, drugging kiss. A shiver of passion coursed through me as his hand slid down and squeezed my behind.

I leaned into him. My voice sounded breathless. "You're some kisser."

Disengaging himself, Mickey slid into the driver's seat. I perched on the seat behind him. "I'll park on a side street so no one hassles us," he said.

Though it was just a little past 1 p.m. the bars on Silver Street were overflowing with customers. Blaring hillbilly music blasted around us, making conversation nearly impossible. I did manage to learn that Mickey had a room at the Spalding Hotel[79] in Duluth. I was impressed, knowing as I did, that the imposing building was considered the second classiest hotel in Duluth. After the third bar and my third Vodka tonic, I began feeling light-headed and giddy. "Could I come to your room and check out your etchings," I laughed.

Mickey's cupid lips curled in roguish humor. "Not only can you check them out, you can feel them. I wanna catch some jazz before we hit the sheets though," he said. "At Green's."[80]

Wow, I thought. *This guy's a winner. Green's is Duluth's most popular nightclub.*

Mickey ordered another round. "One more for the road. Then we'd better get back," he said, even though I objected that I couldn't handle another one.

When Mickey pulled up in front of the Hurley high school our group was just exiting. They boarded the bus in a burst of excited chatter. Elaine was ecstatic. "We won six ribbons," she shrieked. "I got first place for my presentation!"

I tried to rise to let her pass, but fell back into my seat. "See... I told you you'd do great!" My words sounded slurred.

Elaine stepped over me. "What's the matter with you?"

I heard myself giggle. "I... ah... I'm a little tipsy."

Moments later Mr. Maves came to the front to make a few congratulatory remarks. He steadied himself on the back of Mickey's

high seat. Standing just above me he announced, "Miss Berger is going to lead us in community singing."

Rising, Elaine handed me a sheaf of papers. "Pass these around."

I waited for Mr. Maves to return to his seat, then staggered up the aisle, lurching from side to side. Once everyone had their paper in hand I pushed past Elaine and fell into my seat.

Elaine took the mic. "Let's start with *Onward Old Central,*" she said. A collective groan filled the bus. "Okay, okay," Elaine laughed. "How about *Home on the Range?*" Another low groan rose from the group.

Feeling irritated at their treatment of Elaine, I shrieked, "Give her a break! She is our champion orator."

With that everyone clapped. A couple of the boys whistled. Someone yelled, "You pick a song, Frannie."

I looked at Elaine. Her face flushed. Giving me a little nod, she said, "Go ahead."

Kneeling on my seat I faced the squad and scanned the sheets of lyrics. "How about *The Gang's All Here?*" My peer's clapping and whistling spurred me on. "Okay, here we go!" With that everyone joined in. I boomed out my ear-splitting, off-key rendition. We followed that up with several other old chestnuts, ending with *Show Me The Way To Go Home.* By then everyone was ready to call it quits. Elaine and I sank back into our seats. "You're a real hoot," she said as she curled up and closed her eyes.

Mr. Maves lurched to the front of the bus to confer with Mickey, then announced, "Due to the late hour, we'll only stop ten minutes in Ino." Mr. Maves leaned down to me. "Thanks for the show," he said. "A perfect end to a perfect day."

I looked up and smiled. "Would you mind if I had the bus driver drop me downtown instead of at the high school when we get to Superior?"

Mr. Maves nodded in consent.

When we got to town everyone except me got off the bus at Central High. Elaine waved as she descended, "Don't do anything I wouldn't!"

Mickey headed the bus over the Interstate bridge. At the turn-off to the Greyhound bus barn on Garfield Avenue, he said, "Duck down! I gotta check in then I'll come and get you." Ten minutes later we were in his car heading east on Superior Street. "I always park in the back of the hotel," he said. "We'll take the service elevator up."

Feeling strangely disappointed I said, "I thought we were going to Green's?"

"It's too early. They don't get going good until midnight."

In his room, more disappointment. While I waited under the luxurious bedding Mickey pranced around the room naked. He'd retrieved a pair of drum sticks from his suitcase and was rat-tatting on the bureau, end tables and lounge-chair arms.

I avoided looking at him, asked, "What the hell are you doing?"

Mickey laughed. "I'm a drummer. Gotta keep in practice."

"For what?" All the while I thought, *Geez, what kind of wacko have I landed now?*"

Without missing a beat Mickey said, "I might get a chance to play a set tonight."

I felt a wave of aggravation, "I didn't come up here to listen to drum solos."

Sounding hesitant, Mickey said, "Okay... I'll be there in a sec." With that he went into the bathroom and closed the door.

He was in the bathroom so long I dozed off. When I awoke Mickey was lying with his back to me sleeping. I shook his shoulder. "What the hell are you doing? I can't sleep here all night!"

Mickey rolled over. "I ah... I don't think I can perform," he said. "You'll have to help me out." With that he threw back the covers and pulled my hand toward his crotch.

"I'm not doing that!" I shrieked, jumping out of bed. Quickly dressing, I snapped, "You better get dressed. I need a ride home."

Mickey sounded hurt. "There's money on the dresser. Take a cab."

Oh for Pete's sake, I thought, *this is getting to be standard procedure.*

Moments later, in a phone booth in the posh lobby of the Spalding Hotel I called Ma. Before she could speak I said, "I'm just leaving Elaine's. Her folks had a little party for the forensic squad. See you in half an hour!" Hanging up the phone I thought, *This is it! No more detours, no more guys.*

My resolve set me straight for two months. Then all hell broke loose. ◆

78 - Taiwan.
79 - Spalding Hotel, 426 W. Superior Street.
80 - Green' Bar Inc; 508 W. Superior Street.

Rock Bottom

The bottom is out of the Universe! –Kipling

My last spring at Central High brought with it a sense of euphoria. To me it was a miracle that I'd come this far without getting pregnant, or diseased, or worse, ending up in reform school. In spite of an uneasy feeling that it was all just dumb luck, I walked on air anticipating my escape.

My classmates and I spent endless hours talking about our futures. The top students were in conference with college reps. My girlfriends with lower objectives kept saying, "Something will turn up." I knew they meant marriage or jobs at local businesses like the five and dimes or, if they'd taken commercial courses, in an office. I wanted none of that. I was hell bent on joining the WACS. Ever since my eighteenth birthday in March, I held off going to see the Army recruiter, Lieutenant McKnight, though. I was biding my time, sure that, by June, my juvenile police record would have disappeared from the books.

Meanwhile I dutifully attended the job fairs and counseling sessions given by the senior class teachers. They all suggested I move on to vocational school to learn a trade. I kept quiet, never mentioned my Army plans. Like all the other seniors, I was busy racing around getting friends and teachers to sign my Echo yearbook, sending out graduation invitations and picking up my gown and mortarboard. Ma even let me put a new suit on layaway at Glass Block.

Though I was on the straight and narrow, I kept up a furtive association with Ronny. He was gone a lot, so I felt as if I wasn't overdoing it. Though I knew Ma disapproved, she never spoke up. With Ronny, I at least came home for one thing. And for another, I seldom drank with him. Our encounters were short on sex and long on conversation. One night Ronny went off on a tangent on how much he enjoyed having sex with me because, "You're always relaxed. Like you enjoy it. Most of the girls I know are too tense." Moments later he snapped, "What's with the WACS? I thought you were going to sign up when you turned eighteen?"

I felt perturbed at his quick switch from compliment to criticism. "In due time," I said, sounding irritable.

Ronny took a swig from his quart of milk. He wiped his mouth with the back of his hand. "Aren't you graduating in two weeks? Seems to me it's time now."

After school the following Monday, I returned to the U.S. Army recruiting station in the Post Office. Lieutenant McKnight, looking as handsome and seductive as ever, beamed. "Frances! Have a seat." In a flash his whole demeanor changed. He was all business. "Did you bring the paperwork?" I nodded yes and handed over the folder of forms I'd filled out.

While I sat fidgeting in the chair in front of his desk, the Lieutenant scanned each page. From time to time he looked up and asked a question, confirming what I'd written. I felt tense, wondered what he'd say when he got to the dreaded question, "Have you ever been arrested?" The room was silent except for the squeak of Lieutenant McKnight's swivel chair. Suddenly he swung around, his back to me. He had stopped flipping pages. I heard his question through the fog of doom that descended over me.

"What's this?" I knew immediately what he was referring to.

"I ah... I was picked up for underage drinking." Quickly rushing my words I told him the whole story, concluding with, "Anyway, it wasn't my fault."

Lieutenant McKnight swung around and faced me. He leaned forward, his elbows on his desk. "No problem. We'll just confirm that your record's been cleared," he said, sounding confident. Dialing the phone, he turned his back to me again. I heard him speak into the receiver, "Lieutenant McKnight, U.S. Army recruiter here. I'd like to speak to the policewoman, Miss Stromlind."

Just hearing her name sent a ripple of fear through me. It felt as if every nerve leaped and shuddered inside me. I strained to hear what the lieutenant was saying. All I heard were repeated, "I sees," and long pauses. When he finished, he turned and lowered the receiver to its cradle. In a flat, inflectionless voice, he said, "We got a problem, Frances. Seems the record stands until you're twenty-one."

I felt a sudden flash. "Why!? Why would she say that!?"

Lieutenant McKnight looked alarmed by my outburst. "I don't understand, either. She said there were extenuating circumstances. A special case, is how she put it."

I barely heard him speak. Flashing into sudden fury, I felt my eyes fill. "She's a damn bigot!" Without thinking, I blurted the entire story about my sister and the racial hatred by the police. Glancing at the Lieutenant's face I realized he exuded a rare warmth, like he was in complete sympathy. A terrible sadness welled up inside me. I heard myself sob and blubber like a lost child. "She... she'll ruin my damn life," I wailed. "I'll never get away now." I felt McKnight's strong arm on my shoulder, let him pull me close.

"Come on now, get a grip," the Lieutenant said, "Things aren't that bad."

I wept louder. "They are too! You don't know the half of it."

McKnight handed me a box of Kleenex. "What you need is a stiff drink," he said. "It's almost six. I'll close up, then we'll get you a shot somewhere."

Suddenly aware of how awful I must look, I dabbed at my eyes with Kleenex from the desk. Extracting my compact and lipstick from my shoulder bag, I quickly freshened up. The action calmed me. "Could we go to Duluth? I don't want to go home just yet." I'd already decided that I was never going home again. "Let's go to Kytos."

McKnight sounded relieved that I'd calmed down, "Anywhere your little heart desires," he said.

It was a quiet night at Kytos. I felt disappointed. There was no one around that I knew. I'd been anxious to impress them with my hand-some escort. After two drinks I suggested we move on to another bar. McKnight looked at his watch, "Ah... I really can't make a night of it. How 'bout if we get a room for a while?"

I felt an electric sparkle, like knowing I'd soon be going on a long trip. "Sure!" I said. "Where?"

McKnight put some money on the table and rose. "The Spalding Hotel."

My heart skipped a beat. "Wow," I said. "That's a fabulous place." I caught myself and added, "I've heard."

I was surprised when the lieutenant walked right through the stately lobby of the Spalding up to the front desk. There, he said to the clerk, "Number 505, please." Trailing behind him, I entered the lobby elevator. The brown-uniformed operator set the lift in motion. I noted the smoke-mirrored interior and the thick bronze carpet, so different from the sparse service elevator we'd used when Mickey and I were here in March. Upstairs in the room I asked, "Do you live here?"

The lieutenant gave a short laugh, touched with embarrassment. "It's the Army's room," he said. "Sometimes we have dignitaries staying over." With that he slapped his hands together explosively. "Let's have a drink." He pulled open a drawer in a desk by the heavily draped window and extracted a bottle of scotch. "Get the glasses. They're in the bathroom." With drink in hand, McKnight lifted his glass, "Here's to happy days and long nights!"

I sipped on my drink. The liquid burned through to my stomach. Coughing I said, "Here's to sex!" The lieutenant swept me into his arms. His lips blazed a trail of liquid fire on mine. Quickly undressing, we vaulted onto the huge bed.

McKnight's knowledge of sexual arts was impressive. The carnal electricity that sparked between us felt magnetic. I found myself molding against him, wanting more. After an hour of steamy gymnastics the lieutenant leapt out of bed. "I hate to end this, but I gotta get cutting. As soon as you're ready I'll give you a ride home."

I turned onto my stomach and mumbled into the soft pillow, "I'm not going home."

"What!? Hold on. Where do you think you'll stay?" I felt the mattress tilt as he sat down next to me. I didn't look up, didn't want to see him naked.

"I'll find someplace," I said. "I know people over here."

"What about school? Your folks?"

"The hell with school. It's boring." I couldn't find any words relating to home, was afraid to pronounce the word. "No one gives a shit what happens to me anyway."

"Ah geez," McKnight said. "It can't be that bad. Think about it. I'll be out in a second." With that he got up and went in the bathroom. I shifted in the bed, pulled the sweet-smelling sheet over my face.

Moments later McKnight was back sitting next to me, pulling the sheet away. His soft sympathetic eyes brought a catch to my throat. I bit my lip to keep from crying. "Listen, Fran. You can stay here tonight. But you have to be out by noon. Got that?"

I felt myself smile wanly. "Thanks," I said.

The lieutenant got up. "I'll leave you some money so you can get something to eat in the morning. I'll call you at 0800." He leaned to me and kissed my forehead. "Sleep good," he said, then left.

Feeling suddenly exhilarated I got out of bed and prepared a hot bath. There I lay considering my options. I was sure I could find

Vernetta and her friends, was sure they'd be more than happy to help me out. Meantime I intended to languish in the luxury of McKnight's room. I found a menu in the desk drawer, ordered a sandwich and a pot of coffee from room service. "And a pack of Pall Malls," I added. When the waiter appeared with my order I signed the check, *McKnight, U.S. Army.* Hesitating, the waiter said, "Do you want to add a tip?"

I smiled. "You write it in." The waiter winked. After I ate, I crawled into bed, lit a cigarette and turned on the black and white TV, thinking, *this is the life!* Feeling warm and content, I felt sure that everything would work out.

The next morning I woke to the jangle of the telephone on the table next to the bed. "McKnight, here. You okay?"

"I'm great!" I said, "How are you?"

McKnight's voice took on an authoritative tone. "I think I should call your mother."

I felt myself panic. "No way! I'm not going home ever. I thought you were my friend. Some friend." A sudden feeling of spite over-whelmed me. "If you say anything I'll tell everyone we spent the night together." With that I slammed the phone into its cradle. Rushing, I pulled on my clothes. The phone rang again. I grabbed my purse and the twenty dollar bill McKnight had left on the dresser.

Fifteen minutes later I was in The Deluxe Cafe,[81] eating breakfast.

I wandered the streets all day, window shopping and spending the rest of McKnight's twenty.

That night I felt a creepy uneasiness at being alone on the street. It dawned on me that I had nowhere to sleep. I fought an obsessive fear that everything was going wrong. I headed to Kytos to look for Vernetta. The bartender said he hadn't seen her or Sophie for an age.

I was about to leave when I noticed a uniformed guy at the bar. He was hunched over a stein of beer, looking forlorn. I'd never seen any servicemen in Kytos before, felt drawn to his slick blue uniform with its shiny buttons. Sliding onto the high barstool next to him I asked, "May I join you?"

The guy's hooded eyes lit up. "No sweat," he said, extending his hand. "I'm Branch Kendall. From El Paso, Texas." His lilting south-ern accent sent a spark of joy through me.

Pleased to hear he was from out of town, I let him shake my hand. "I'm Fran from nowhere," I laughed. "You come here often?"

Branch swiveled on his barstool and faced me. "Nope. It's my first time." He spoke slowly, like he was feeling his way. I noted his wise little eyes, close-set on his square face. His small mouth was tightly drawn, his lips thin. Crew cut, sandy hair topped his big skull. If I hadn't been desperate for a place to stay I'd never given him a second glance. "I just got to Duluth yesterday," my new friend continued. "I'm stationed at the air base."

I leaned into him. "Why don't we blow this joint?"

Branch's tight little smile filled his face. "Sure. I'm dying to check out the local dives."

When Branch got up I felt my heart sink. He was two heads shorter than me. *What the hell,* I thought. *Beggers can't be choosers.* And so it was our little alliance began.

For four nights running we met at the Bowery Cafe[82] or the Lenox Bar and Grill,[83] caught a quick bite and then hit the bars. Our nocturnal jaunts began at the Dugout[84] or Kytos. From there we moved on to Greens or the Karsbar,[85] ending up at Norman's.[86] After the bars closed we headed to The Alexandria Hotel,[87] a wooden, ramshackle edifice that had a long wide porch in front. To me the building looked like it belonged in a farmyard. Our furtive, drunken couplings were exhausting. Branch left at six a.m. for the base. I slept until eleven then headed to the Deluxe Cafe for breakfast.

There was a close comradeship amongst the regulars at the Deluxe. The ragtag group of unemployed, runaways and homeless people, seemed to take comfort in each other's misery. Often when I felt down, one or another took the time to cheer me up with words like, "Shit, you're better off here than answering to some fucker who don't know what end is up." We shared cigarettes and money. One day, one of them gave me a pack of cigarillos. "Found these on a park bench. Figured you can use them." I was puffing away on the slim, brown cigar one morning when in walked my sister, Maizie.

She stood over me as though fastened to a wall. In a shaky voice she said, "Ma wants you to come home."

A couple of my cohorts at the counter got off their stools and headed toward my booth. I held up my hand. "It's okay," I said. I looked up at my sister. "What are you doing here? I thought you were working at Western Electric."

Maizie slid in across from me. "I'm on lunch. Ma wanted me to find you. To talk to you." Looking embarrassed, my sister's pale face

began to redden. "You're smoking cigars now!? Geez, Fran you look like a floozy."

Not wanting to get on the subject of Ma I sneered. "Maybe I am a floozy. Maybe I like being a floozy." Taking a deep drag on my cigar I blew the smoke into Maizie's face.

My sister waved away the haze. "Ma's sick with worry."

I was surprised how much I was enjoying Day's discomfort. "Oh sure. She probably called the police."

Maizie's eyes filled. "You know she'd never do that. She doesn't want you to get into any more trouble."

Feeling an overwhelming urge to hurt my sister I yelled, "Me?! Like you never did anything wrong? It seems to me you gave her more grief than I ever did."

My sister flinched as if her flesh had been ripped. "I knew it would be impossible to talk to you. I told Ma that." Her voice cracked. Bursting into tears, she rushed toward the restaurant door.

I yelled at her back, "Good riddance to bad rubbish!"

That night I told Branch about my encounter with Maizie. "No sweat," he said. "Next time I get a leave, you can come down to El Paso with me. You'll like Texas."

Branch's words settled an argument I'd been having with myself. I'd been debating whether or not I should dump him. As much as I wanted to leave town, I had no intention of going to Texas. The very word Texas evoked images of endless, barren wastes and wave on wave of stampeding cattle. *Hells bells*, I thought, *he isn't even cute.*

The next morning Branch bid me his usual cheery goodbye of, "See ya later 'gator."

"No sweat," I replied, thinking, *Hit the road Jack.*

It was the last time I saw him. ◆

81 - DeLuxe Cafe, 328 W. 1st Street.
82 - Bowery Cafe, 511 W. Superior Street.
83 - Lenox Hotel, 601 W. Superior Street.
84 - The Dugout Inc; 318 W. 1st Street.
85 - Karsbar Bar and Grill, 220 W. Superior Street.
86 - Norman's Inc; 113 W. 1st Street.
87 - Alexandria Hotel, 322 W. 2nd Street.

Friends and Lovers

Two is company, three is a crowd. —Fuller

I left the Alexandria Hotel at eleven a.m without looking back. On Superior Street I made my way to the Freimuth Department Store[88] bargain basement. There I bought two pairs of panties and a pair of nylons. I had decided to restock just in case I wouldn't have a place to wash the undies I'd been wearing all week. I managed to snitch a tube of lipstick and some powder while I was there too. Feeling smug, I drifted into the corner coffee shop and bakery. I had a terrible yen for one of the famous Freimuth cream puffs.

The waitress at the counter where I sat had her back to me. She seemed vaguely familiar. When she turned to take my order I about fell off my stool. "Vernetta! What the hell are you doing here?!" I was struck by how sensual she looked even in her plain, starched gray and white uniform.

My friend's full, red lips broke into a smart-ass little grin. Looking over her shoulder she said, "What the hell do you think? I work here." She leaned down, lowering her voice, "Gotta watch out for my supervisor. She's a real bitch."

"I've been looking all over for you and Sophie! I ran away from home."

"Keep your voice down. I'll talk to you on my break in five minutes." With that Vernetta poured me a cup of coffee, put the cream puff on a plate in front of me and walked away. Picking up the plate and coffee cup, I moved to a booth in the corner. Moments later Vernetta joined me.

Lighting up cigarettes we leaned forward. "Where you been hanging out?" I asked. "I've been down to Kytos every night looking for you."

Vernetta took a long drag on her Pall Mall, pulled the smoke up through her nose. "We had a little set-to there," she said. Continuing, she brought me up to date. Sophie was back at her daughter Myra's in Superior. Vernie had dumped Bubba and had a new boyfriend, a guy who worked on an ore boat. "He's a real sweetie," she said. "When he gets back we're taking off for Ohio."

393

I gave Vernetta a quick lowdown on my activities. I didn't mention I'd been rejected by the U.S. Army, but included my tryst with McKnight at the Spalding Hotel. "School got to be a real pain in the ass," I said. "I decided enough was enough. The same with home. I'm never goin back there." Anxious to change the subject, I asked, "Where do you live? I may need a place to stay for a while."

Vernie shook her head. "Can't be done. I just got a sleeping room. Gregg, he's my boyfriend, is due in at midnight tonight. What about that room that Army guy has at the Spalding?"

"Geez, I don't think I'll be able to get back in there." Suddenly a light went on inside my head. "A guy could though."

Vernetta raised her eyebrows. "There ya go. Who do we know? It'd be easy to check it out. You'd just have to be sure that the room's empty."

I was beginning to warm to Vernie's suggestion. "Well... there's Maurice –Ronny, I mean. I think you know him. He's a friend of that Killer guy you used to date."

"Oh yah," Vernie said. "Good looking guy. I wouldn't mind seeing him again myself," she said. Recalling the obsessive interest Ronny had had in Vernie, I felt a pang of jealousy.

Ten minutes later I was in a phone booth calling Ronny. A woman answered. "Who is this?" she asked.

Thinking fast I said, "Killer's girlfriend. I have a message for Ronny." Seconds later he was on the phone, talking low.

"How the hell did you get my phone number?"

"It's in the book for Pete's sake," I said. "Me and Vernetta are over in Duluth. How'd you like to meet us tonight? At Kytos?"

Ronny's voice softened. "I'll try to make it. But don't call here again."

When I told Vernie about my conversation with Ronny she said, "He's probably married. No matter. Men are jerks." I was amazed at her indifference. "Meet me out front at five. We'll get something to eat and then we'll hit Kytos."

At the appointed hour I was amazed to discover Vernie had a car. She explained, "It's Gregg's. He taught me to drive, but I don't have a license yet. I'm taking care of it for him." She headed the little coupe up the hill to Third Street. Vernie's rooming house was a red brick building that looked like it had seen better days. "I'll go change and be right out," she said. "We'll eat at Snyder's Drug. I gotta get some make-up."

Friends and Lovers

As I waited in the car I wondered if I was doing the right thing. I sure didn't want to get arrested for breaking and entering. But then, I thought, it won't be breaking and entering if we have a key. I rehearsed the little speech I'd decided would be appropriate for the Spalding Hotel desk clerk.

After dinner and a couple rounds of whiskey at Kytos, I was ready. In the enclosed telephone booth I dialed the hotel. When I got the desk I said, "This is Miss Brennan, Lieutenant McKnight's secretary. We have a gentlemen guest arriving tonight. His name is Major West. His luggage was delayed, but it'll arrive tomorrow. Please be sure he gets the key to room 505."

The clerk, sounding anxious to please, quickly responded. "No problem. The room is in good order. We'll be looking forward to greeting him."

Ronny showed up at nine p.m. When he looked at Vernie I saw something flicker far back in his dark eyes. "Long time no see," he said, smiling. Without looking at me he added, "So Fran, I thought you'd be gone by now." I gave him a kick under the table, hoping he'd back off. He did.

"I got sick of all the bullshit," I said. Getting right to the point I told him about our plan of action at the Spalding. "All you have to do is look military and ask for the key to room 505."

Ronny took a sip of the scotch he'd ordered. "What's in it for me?"

Vernie chuckled. "Us," she said.

No way in hell, I thought, remembering the long ago reference my friend Marvel had made to a ménage á trois. "You can do what you want, but I'm not into three-somes. I'm just looking for a place to sleep." My voice sounded snappish. I was hoping Ronny would back me up. He didn't.

Ordering another round he said, "We'll see what we'll see."

An hour later I began feeling edgy. "If we're going to do this we'd better get cutting. I need a good nights sleep." With that we headed out. In the street I said, "Vernie and me will take the service elevator to five and meet you there."

Ronny looked impressed. "Geez, you got this all worked out."

Vernie laughed. "Fran can be a sneaky little bitch when she wants to. You'd better be careful."

The plan unfolded without a hitch. In the room Ronny, Vernie and I toasted its success with a shot of scotch from the lieutenant's stock. "Thanks Ronny," I said. "I'll make it up to you."

Ronny's handsome face twisted into a maddening leer. "You can make it up to me right now. What's your problem with the three of us hitting the sheets, anyway?"

I suddenly hated Ronny, wanted to tell him to get out. Before I could say anything Vernie said, "It's no problem for me."

All the while I half wished Lieutenant McKnight would show up so this nightmare would end. "Well, it is for me! You guys go ahead. I'll wait in the bathroom."

"Ah geez," Ronny said, pulling me close and kissing my neck. "We've never been in a bed together."

That was true. "Well then, she can wait in the bathroom," I said.

Vernie hunched her shoulders. "Whatever." She sauntered into the washroom, undulating her hips. I heard the door lock behind her.

My coupling with Ronny was less than enthusiastic. I kept thinking of Vernie waiting her turn. *Shit, you can't trust anyone.* All the while I was sure Ronny was anticipating bedding Vernetta. His actions didn't seem very ardent. He didn't even kiss me. I had half a mind to tell him what a jerk he was, but didn't.

Suddenly the bathroom door opened. I saw Vernetta's long-legged, naked body silhouetted against the light behind her. I pushed Ronny away from me. "*Ah Geez,* I thought, *This is so sick.*

I heard Ronny say, "Holy shit!" as Vernie approached the bed.

I rolled away, rushed into the bathroom and slammed the door. Locking it, I turned on the tap in the bathtub and sink, hoping the sounds of sex wouldn't penetrate through the door. Suddenly Vernetta's sensuous voice rose to a shrill pitch. "Do me!" she hollered. "Do me!"

I put my hands over my ears, my mind filling with thoughts of the obscenity of the situation. I halfway wished I'd never left Branch. All the while I prayed no one else would hear them, prayed no one would call the manager. Meantime I sank into the hot tub-water and closed my eyes. A terrible anger burned inside me. I felt confused. Was I insane? I was furious. Was I crazy? I felt like I was going to explode, after what seemed like hours I rose from the tub, wrapped myself in a towel, burst into the room and switched on the light. "That's it!" I hollered. "Out! You guys get out!" Vernie and Ronny were in each other's arms, sleeping. I rushed to the bed, shook Vernie's bare shoulder. "Vernie! Get up! It's almost midnight!"

Vernie shook her head, looked at her watch. "Oh shit," she said, jumping from the bed. I looked away as she rushed naked to the bath-

room. Minutes later she was dressed and heading out of the room. At the door she turned, "I'll call you in the morning," she said. "Don't turn in the key."

It took half an hour to get Ronny moving. "I don't see why I can't stay," he said, sounding like a spoiled child.

My words were sudden and raw and very angry. I snapped, "Let me tell you why. You are a two-faced creep that's why! And as far as I'm concerned I never want to see you again."

After Ronny finally left, I felt tears well up. It was as if every bad coupling I'd ever endured for the last four years had climaxed and now was being expelled. I pulled the bedspread off the bed and curled up in a lounge chair. *No way am I getting in that filthy bed again,* I thought.

Sleeping fitfully, I fell into an old vivid dream from my childhood. I was airborne, flying just above the treetops. People on the ground were stretching up, trying to catch me. With each attempt I artfully evaded their clutches and flew off. In the middle of my dream I heard a terrible pounding. Jerking awake I realized someone was at the door. I looked at the clock. It was two a.m. Terror ran through me. Cautiously I said, "Who is it!?"

I heard Vernie's response. "It's us. Open up." ◆

88 - Freimuth Inc. Dept. Store, 2-12 W. Superior Street.

Moving On

*What's the use of running
when you're on the wrong road. —J.Ray*

Vernie and her boyfriend pushed into the room. "This is Gregg," she said, sounding flippant. "We decided to stay here. Better bed."

The boyfriend rambled into the room like he owned it. Looking around he said, "It's not all that classy." He was running his finger over the console television. He leaned over and looked at the back of the set. "Nice piece," he said.

I took an instant dislike to Gregg. He had a burned-out, cynical look about him. Though his face was clean-cut, almost perfectly symmetrical, his eagle eyes stared down from a heavy nose. Tall and muscular, he moved with a slovenly, bloodhound gait. Snapping his fingers at Vernie, he said, "Where's the scotch?"

She pulled the lieutenant's bottle of scotch out of the desk drawer and poured Gregg a drink. He slipped off his black leather jacket, slouched into the chair I'd just vacated. "So," he said, "Vernie tells me you cooked up this slick scheme." His tight lips broke into an indulgent smile. "I like smart females. How'd you like to go to Ohio with me and Vernie? She tells me you ran away from home. We could rake in a lot of bucks with her body and your brains."

I shifted uneasily, thinking, *Geez, he thinks I want to be a whore! I'll never stoop that low.* "I'm not interested in selling my body," I blurted.

Gregg's eyes clouded. "Who said anything about that? Scams are what I'm talking about."

I wasn't sure how to answer. Still, I thought, *I would love to get out of town.* "I a... I'll think about it."

Gregg kicked off his loafers, tilted his head at Bernie. She slid onto his lap, slung her arms around his thick neck. Gregg looked up at me. The message in his eyes was starkly sexual. "You'd better think fast. We're hitting the road in a few hours." Without pausing he added,

"First we'll all have a quick roll in the hay."

Lying, I sputtered, "Not me! I got my period."

Vernie laughed. "She's chicken shit."

Gregg pulled Vernie to him, kissed her long and hard. Suddenly pushing her away, his eagle eyes met mine. "You'll come around eventually."

I quickly rushed past them and locked myself in the bathroom again. There, with the bedspread wrapped around me, I lay down on the floor. My mind raced. *Scams? What does that mean? Bilking people of their money? Cheating and lying on a daily basis? Becoming a con artist?* I shook the thoughts away, fell into a restless sleep. An hour or so later I heard Vernie through the door. "Frannie, get up! We're hitting the road."

Out in the bedroom I noted both Vernie and Gregg were already dressed. "What time is it?" I asked.

Gregg looked at his watch. "It's only five-thirty, but we gotta get out early. We have to pick up our stuff and have breakfast." He snapped his fingers at me, "Get moving." Sauntering over to the television, he looked behind it again. All of a sudden he leaned down and pulled hard on the cord.

"What are you doing?" I shrieked.

"Taking this with us," Gregg snapped. With that he gave the cable another jerk, pulling it free. "We'll sneak it down the service elevator before any maids show up."

I rolled my eyes, grabbed my clothes and rushed back into the washroom to dress. All the while I envisioned we three robbing banks and breaking into houses. *Maybe that's the kind of scams that freak is talking about.* When I came out Vernie, Gregg and the TV were gone.

Moments later my friends were back. "All set?" Gregg asked.

In the car I felt compelled to object. "You shouldn't have taken that TV. McKnight will get in a lot of trouble over that. Maybe he'll figure out I was there." My voice sounded shaky.

Vernie snapped, "You know he's not going to say anything about you. He'd be in deep shit if he did. Besides, it's his problem, not yours." She edged closer to Gregg, squeezed his knee. "You worry too much about everyone else, Frannie. Think about yourself for once." I was thinking about myself. Thinking how in the world I'd gotten myself into such a mess.

At their boarding house I helped Vernie and Gregg stuff their suit cases in the car trunk next to the stolen TV. As hard as he pushed,

Gregg couldn't get the trunk closed. Unloading the suit cases, he shifted the television. The cord fell out. I said, "This thing isn't any good. It hasn't got a plug." I knew I sounded snappish, but I didn't care. *Maybe he'll leave it in the street. Then at least we won't get arrested.*

Gregg lowered the TV back into the car trunk and looked at me. His eyes were hard and pitiless. Shaking his finger in my face he said, "You're really getting on my nerves." Picking up the cable, he examined it. "Shit! We'll have to dump it."

Downtown, at the Bowery Café, we ate a huge breakfast in silence. Back in the car Gregg announced, "We'll dump the TV in the bay, then head over to Superior." He looked at his watch. "It's almost seven-thirty. Hopefully we'll be on our way in half an hour." He looked at me. "And don't drag a lot of shit along. You'll be making enough money in Ohio to buy some decent clothes."

There were few cars on the Interstate bridge. Halfway up the overpass, Gregg pulled alongside the balustrade. We all got out of the car. It was a brilliantly pleasant Saturday morning. Fluffy clouds scudded across the sun. St. Louis Bay was unruffled, it's surface glassy smooth. Seagulls dipped and drifted on the updrafts above us. Their shrill screams sounded scalding. We three managed to hoist the TV onto the railing and push it over. The console plummeted straight down, hitting the water with a plop. A plume flew up. The television vanished instantly.

Though relieved at being rid of our larcenous burden, I was overcome with a vague sense of unreality. The feeling intensified later when we stopped at the intersection of Belknap and Tower waiting for the red light to change. I watched pedestrians saunter across the street in front of us. Suddenly I realized one of them was Ma.

Focusing as hard as I could, I watched as she plodded along. Her shoulders drooped, her gait was slow and unsteady. Her head was down, her face a mask of hopelessness. I felt a shock of pain at how old she looked. When the light changed and Gregg drove the car through the intersection, I turned and tried to keep her in sight for as long as possible.

A deluge of thoughts flooded my mind. *Look what you've done. You're killing her. She doesn't deserve to suffer like this.* I felt a terrible heaviness in my chest. Though I was sure bad luck stomped through my life, I never thought it concerned anyone but me. That

sudden insight sealed my decision not to go to Ohio. When Gregg parked the car in front of our old duplex, the sun broke out from behind a cloud. My eyes stung from the blinding light. Jumping from the car I slammed the door. "I changed my mind," I said. "Send me a postcard."

Gregg snarled, "Bitch!"

I ran alongside the house to our backyard, heard the car speed away. Rushing across the alley, I headed over the railroad tracks to the field beyond. There, in an open space near the old brickyards, I lay on my back on the soft grass. I looked up. The sky had transformed into a blanket of blue. I prayed aloud, "Please God, make everything right." All at once it occurred to me that I only prayed when I wanted help. Warm tears streamed down my cheeks. I called out to the sky, "Forgive me!" My prayer brought a quiet calm inside. I lay back and, for the first time in months, felt at peace.

I went in the house. No one was there. I stretched out on the sofa bed in the living room and waited. All the while I tried to envision the reception I'd receive from Ma. Nothing in my wildest imaginings matched the scene that unfolded.

As soon as the door opened, I was on my feet. Ma dropped the packages in her arms, rushed forward and embraced me. "Thank God... thank God," she sobbed.

I was weeping right along with her. "Don't cry," I said, "I'm okay. And... I'm so sorry, Ma. So sorry I hurt you."

I heard my mother's muffled words. "That's okay. You're home now. That's the main thing." We sank onto the sofa side by side. Ma held my hand in both of hers. "I prayed you'd come home." I began to tell her what had happened, but she didn't want to hear any of it. "Let's have some coffee," she said.

At the kitchen table Ma bubbled with news. "I gave notice to the landlord last week. Found an apartment for us downtown."

"But... you've been in South End ever since you came from Norway. Your roots are here. Grandma and Grandpa are buried here." It was inconceivable to me that she should make such a big sacrifice.

Ma shrugged. "What's past is past." She smiled then. "We'll make a new start." Her words rushed on. "You can get a job at Western Electric. Day says they're always hiring. She got engaged to some Air Force fellow from Connecticut. They'll probably get married next year. And Howie is talking about joining the Army. You and me will

do just fine downtown. I'll get a job too. We'll share everything, fifty-fifty." She chuckled at that, and added, "The apartment's upstairs of a store. No neighbors to deal with."

My head swam in alarm. "But... we haven't got much time. I'll have to stay home and help you get packed."

Ma shook her head. "No. I'll do it. You're going to get that diploma."

"But... maybe I got expelled. Being away so long."

"It's all taken care of. I called the school and said you were sick. I just knew you'd be coming home." She lowered her voice, put her hand over mine. "You know Fran, I've never asked for anything. Never expected much. But this time my prayers were answered. I have so much faith in you. I know you'll be all right."

"Geeze Ma," I blurted. "Everything always works out in the end. "Don't you know that by now?" ◆

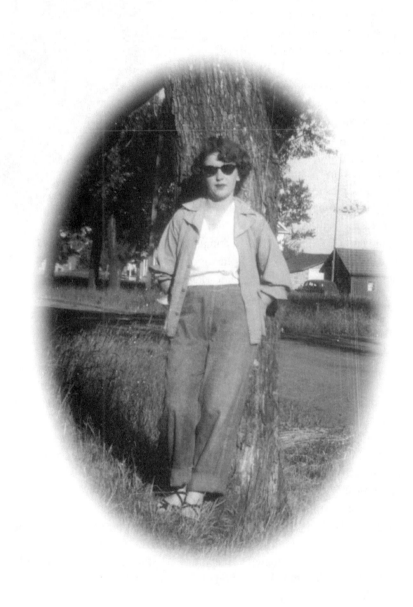

About The Author

Born and raised in Superior, Wisconsin Frances graduated from Wm. C. Bryant Grade School in 1949, from Central High School, in 1953. Her first job was at Western Electric, Duluth, MN. In 1955 she lived in Chicago for a short time, returned to Superior and worked at Crystal Waters Lodge, Grand Rapids, MN. Back in Chicago in 1956, she began her thirty-four year tenure at American National Bank & Trust Company, 33 N. LaSalle St; as a company cafeteria employee, rising from various clerical positions, to Security Vault Manager. During her years at American National, Frances attended classes at the YMCA, Chicago City Junior College and Northeastern Illinois Univ.; where, at the latter institution, in 1989, she received her BA degree in Communications/Creative Writing.

During her Chicago years Frances traveled extensively in Greece, Great Britain, the Netherlands and Norway, as well as the United States. She was married to the late Ernesto Garcia Gabino from 1959 to 1972. She is a double cancer survivor.

In 1990 Frances took early retirement and returned to Superior, working for Manpower Inc; Duluth, MN; Garon Knitting and K-Mart, Superior, followed by five years as a home-care provider. At present she is employed part-time at The Big K-Mart in Superior.

Since returning to Superior, Frances has attended writing workshops at The Depot, Duluth MN; Univ. of Iowa, Iowa City, IA and at Fergus Falls Community College, Fergus Falls, MN. Besides creative writing, her interests include Genealogy, History and Norwegian culture. She is a life-member of Sons of Norway. Frances has a website: www.bitchingpost.com

Her email address is: fgabino@aol.com

404

Other Savage Press Books

Business

SoundBites by Kathy Kerchner
Dare To Kiss The Frog by van Hauen, Kastberg & Soden

Essay

A Hint of Frost, Essay on the Earth by Rusty King
Battle Notes: Music of the Vietnam War by Lee Andresen

Fiction

Mindset by Enrico Bostone
The Legacy by Judge Mark Munger
Burn Baby Burn by Mike Savage
Keeper of the Town by Don Cameron
Something in the Water by Mike Savage
The Year of the Buffalo by Marshall J. Cook
Voices From the North Edge by St. Croix Writers
Walkers in the Mist by Hollis D. Normand

Local & Regional History, Humor, Memoir

Beyond the Mine by Peter J. Benzoni
Blueberry Summers by Lawrence Berube
Crocodile Tears and Lipstick Smears by Fran Gabino
Jackpine Savages, or Skinny Dipping for Fun and Profit
by Frank Larson
Some Things You Never Forget by Clem Miller
Stop in the Name of the Law by Alex O'Kash
Superior Catholics by Georgeam Cheney & Teddy Meronek
Widow of the Waves by Bev Jamison

Outdoors, Sports & Recreation

Cool Fishing for Kids 8-85 by Frankie Paull
Curling Superiority! by John Gidley
Floating All-Weather Sailboat Log Book, Coast Guard Approved
The Final Buzzer by Chris Russell
The Duluth Tour Book by Jeff Cornelious
Stop and Smell the Cedars by Tony Jelich

Poetry

Appalachian Mettle by Paul Bennett
In the Heart of the Forest by Diana Randolph
Gleanings from the Hillsides by E. M. Johnson
Moments Beautiful Moments Bright by Brett Bartholomaus
Nameless by Charles Buckley